THE

PHOTOGRAPHER'S
ALMANAC

THE
PHOTOGRAPHER'S
ALMANAC

Peter Miller
Janet Nelson

Little, Brown and Company Boston · Toronto

To the memory of Gene Smith and to what he has left us — glorious art, the sense of perfection, total commitment and giving a damn. He would never have read this book.

FIRST EDITION

LIBRARY OF CONGRESS CATALOGING IN PUBLICATION DATA

Miller, Peter, 1934–
 The photographer's almanac.

 1. Photography, Commercial—Handbooks, manuals, etc.
2. Photographs—Marketing—Handbooks, manuals, etc.
3. Photography—Business methods—Handbooks, manuals, etc.
I. Nelson, Janet. II. Title.
TR690.M54 1983 770'.68 82-24932
ISBN 0-316-57364-7
ISBN 0-316-57365-5 (pbk.)

MV
Designed by Susan Windheim
Published simultaneously in Canada
by Little, Brown & Company (Canada) Limited

PRINTED IN THE UNITED STATES OF AMERICA

Acknowledgments

A book like this one is not only the work of the authors; it is also a communal effort of all the professionals we talked to and of the many articles, books, pamphlets, and catalogs used as resource material. As such, this book is a work of journalism, for it distills the knowledge and experience of many people. We are indebted to those who have freely given their expertise so that we can pass it on to you.

Some have given more than their share to this project and we owe them special thanks: Bill Pierce, Robert Pledge, Whitney Lane, Howard Chapnick, Bill Jay, Simon Nathan, Joe Scherschel, Peter Krause, Burt Glinn, Dick Weisgrau, Bill Owens, Michael O'Connor, Robert Galassi, Peter Vaeth, Bruce Cratsley, Eve Arnold, Marty Forscher, Andrea Alberts, William Kennedy, Chuck Fishman, Chad Weckler, Dave Lyman, Elaine Sorel, Martin Satloff, Ken Poli, Jack Manning, Jill Freedman, Larry Fried, John Stage, Stuart Kahn, Charles Hulcher, Fred Hill, Jill Vig, Russ Atha, David Brownell, Henry Wilhelm, Bill Edwards, Jay Maisel, Irv Hansen, Marcuse Pfeifer, Chuck Queener, Michel Bernard, Jennifer Coley, Jane Kinne, Stanley Kanney, Jeanne Upbin, Kenneth Pepper, Harvey Zucker, Alex Coleman, and Timothy Greenfield-Saunder. We also thank the many companies that answered very specific questions about their photographic processes and equipment. And a special thanks to the American Society of Magazine Photographers and its members for allowing us to share their vast background and experience in the business of photography.

Above all, we applaud the editor of this project, Dick McDonough. It was his enthusiasm that carried us through the year that it took to put this book together.

PETER MILLER AND JANET NELSON

Introduction

This book is an attempt to answer many of the questions that professional photographers are asked. How do you sell a picture? How much do you sell it for? What lenses do you use? What film do you use? Where should I have my prints made? What camera should I buy? Where should I buy it? And so on.

This book has no intention of telling you how to take a picture. There are hundreds of books that tackle this question from a dozen different directions, technically, by the numbers, aesthetically, philosophically, psychologically, whatever. We believe that a good photographer is born with a sense that tells him or her what a good photograph is. Many picture editors can tell this from glancing at a contact sheet.

However, this sense can be sharpened and directed — by knowing how to use equipment, how to edit your pictures, and how to sell them or seek advice from your peers. In the past most photographers learned by apprenticing, or by being an assistant, as it is normally called. Now many photographers are learning this craft in school. Some are learning the technical side, others the artistic sense of photography, and some the commercial and photojournalistic skills. All to the good, but the real skill in taking photographs professionally is on the firing line — by taking many pictures, editing them, showing them, selling them, comparing them.

This book, then, is advice from professionals — from us and our friends — on what we have learned as professionals. The book is based on the opinions and experience of professionals in the field. We have not leaned on classic textbooks or technical pamphlets; we're just passing on to you what we have all learned through the years. We have included a number of references and sources that we think are helpful.

And if you think the book is biased, well, it is, from a professional viewpoint — we are the ones who make the pictures, who buy the equipment, have it repaired, and know that our reputation is as good as the last photograph we sold.

Contents

1

WORKING AS A PHOTOGRAPHER

The Professionals

A professional photographer is not one who knows more about cameras and the magic of making beautiful pictures. A professional photographer is one who makes his or her living full-time by taking photographs. In other words, photography may provide sustenance for the soul and mind, but it also fulfills the practical needs of shelter, food, film expense, and, if the photographer is good, a penthouse loft in New York, a farm in Pennsylvania, a condominium in Aspen, and a Mercedes.

There are some professional photographers who take passport photographs and portraits. Some of them consider photography no more than a living, and a meager one at that. Their photographs can be mundane, but they can also be viscerally artistic. An example that quickly comes to mind is the portraits of Disfarmer, a man who led a singular, lonely (lonely if you do not consider his many friends, his photographs) life in Heber Springs, Arkansas.

There are other photographers who shoot technically — stop-motion studies for manufacturing processes; public-relations pictures of people shaking hands and grinning at the camera; photographs of dead bodies, car crashes, and fingerprints; close-ups of surgical operations, computer chips, or cells through an electron microscope. Their work may be horribly mundane, gorgeously beautiful, or historically grim. Some photographers have gone beyond those levels to achieve images that put our lives and society into perspective: Weegee's photographs of the murdered and murderers, Lennart Nilsson's pictures of fetuses and blood clots, the deadly boring photographs that appeared in a book by Garry Winogrand called simply *Public Relations*, Edgerton's and Gjon Mili's first uses of repetitive strobe — a drop of milk splattering, the exquisite beauty of a ballerina in motion.

There are other photographers who worked hard, but not commercially, for they considered their photography an art form. Atget did this. He was a former sailor and painter, and we don't know how he paid for his film — whether he sold prints or some rich aunt left him a bundle — but his photographs of Paris are not only documentary, they reflect the past and present in mysterious ways. Atget died broke. Stieglitz was loaded, so he could become a fine arts photographer and promote other photographers' work. Paul Strand was an artist. So was Edward Weston, but he wasn't above shooting portraits or doing commercial work.

There are fine arts photographers who make a living doing nothing except photography, but few names come to mind. Paul Caponigro, Ansel Adams, and George Tice make beautiful photographs and portfolios. Some art photographers live quite handsomely off their sales, but they usually also teach or are pitchmen for a product. Most fine arts photographers, in order to survive, teach. Or they have a trust fund or another profession — stockbroker, architect, tailor, financial analyst,

Some Photography Professions and Approximate Salaries

In-house Corporation Photographer
Does public-relations work, technical studies, time-lapse photography, product use, work on employee relation themes, sometimes annual reports and product advertisements. Salary: $25,000.

Medical Photographer
Photographs operations, medical procedures, records of cases, does macrophotography of cultures, tissue, and all sorts of microbes. $20,000.

Commercial Photographer in a Small Town
Weddings, family portraits, school portraits or commercial assignments for local ads, construction progress photos, product still lifes, documentary photos, and, yes, passports, too. Works too damn hard. $10,000–$40,000.

Press Photographer
On staff of a newspaper or wire service. $150–$500 a week.

Photojournalist
Shooting for magazines or agencies. Lots of write-offs if you travel and are not on staff. $10,000–$60,000.

Feature Photographer
Often works for a number of magazines. Again, lots of write-offs. $30,000.

Stock Photographer
Shooting basically to sell single photographs with at least one specialty. Lots of write-offs if you travel. $20,000–$100,000.

Photoillustrator
Shooting for annual reports, company brochures, advertising companies. Can be location or studio photographer. Some specialize in people, others in fashion, still life, aerials, architecture, and so on. $60,000–$600,000.

farmer. Many of the students now in school, working so hard to make abstract hand-colored images of bits of hose or corners of swimming pools and déjà-vu photographs, should consider the awful fact that a parallel career, say as a typist or plumber or Tiffany salesperson, might pay the bills as they pursue their art.

For those who want to be professional photogra-phers outside the fine arts field, the world is getting tougher. Magazines are the most tightfisted buyers of photography. They'll pay a space rate of say $250 for an inside color page, but for an advertisement they will charge $20,000 a page and throw a $5000 party for the advertising client, and the next day, in a budget cut, lay off an underpaid editorial assistant. The editors are also sniping at photographers' rates. They claim the $350-a-day rate is too high and besides, many photographers will work for less. They also say that those new automatic cameras are so easy to use, it no longer takes any skill to make a photograph. So they hire editors who can write and use a camera or they send their editors to a photo seminar to learn how, so that when they are on a story they can shoot the photographs as well as write the story.

The fallacy in this is that editors are usually the opposite of photographers. Editors use the reasoning, logical side of the brain, thinking in beginning and ending paragraphs. Photographers use the aesthetic, intuitive side of the brain and their gut. The two are as different as dogs and cats and they fight the same way.

However, there is always room for good photographers. It takes a long time to learn how to light an interior and shoot with an 8 × 10 so the result will look good in *House and Garden* or *Architectural Digest*. It takes talent to photograph fashion, and technical wizardry and an aesthetic eye to do still lifes. Few can shoot journalistic assignments without a knowledge of people and technique. Not many photographers know how to control fluorescent light to make pleasing photographs, or how to shoot a formal portrait of a corporate president in five minutes.

Some working photographers may, in the future, be revered for their high art, and their work could hang in the permanent collections of museums around the world. Irving Penn's photographs of tribes, cigarette butts, and nudes will bear up under time. So will some of Avedon's fashion shots. Will the Marlboro photographs be considered works of art in fifty years? How about those simple, mood-setting Martell ads, or Northrop's series of airplanes so cunningly done in abstract they become works of art? And there is probably some photographer in some small city doing school portraits and weddings who will, after he dies, be recognized as the greatest

documenter of America who ever lived. In the art world, we all know that to make it well as a photographer, it is best to be dead. In the real world, it is best to take photographs and live as well and happily as you can.

Most working photographers are free-lancers — they are their own boss, they work for whomever hires them, or they work for those they like. Their income reflects their ambition and photographic likes and dislikes. At the top end are the advertising photographers who call themselves photoillustrators. They usually maintain studios filled with expensive strobe equipment and regularly hire photographic assistants, stylists, prop specialists, location finders, and others. There have been a few ridiculous cases where an advertising photographer has made as much as $500,000 for a week's work, but a top illustrator can bill out $400,000 a year, out of that paying his studio rent, salaries, and equipment and repair costs. Photographers' fees in this field can run $1200 to $5000 a shot for national advertisers.

At the bottom end are the photographers who work on assignment for magazines. Their pay is supposed to be $350 per day, but most magazines refuse to pay that much and try to get the rate down to $200. Hungry free-lancers, particularly the young, will snap at $75 a day, to the detriment of the professionals and of the quality of the magazine's content.

Here are the life-styles of a few photographers in different fields.

Photojournalist

Bill Pierce is a forty-six-year-old free-lance photojournalist who is a contract photographer with *Time* magazine and on the side writes a nuts and bolts column for *Popular Photography*. He is lucky to be on contract because few photographers survive in photojournalism unless they work for an agency or a magazine. Being on contract means that a magazine guarantees the photographer a minimum amount of work per year. If the photographer is any good at all, he will push that minimum into as much as possible. Pierce says that *Time* takes up most of his time. He can free-lance his work elsewhere and he owns all his negatives and transparencies,

BRIAN F. ALPERT/KEYSTONE

Bill Pierce

which he can pass on to stock or news agencies. He does not have such Time, Inc. goodies as profit sharing, pension, or medical insurance. Pierce photographs just about everything for *Time*, but most of what you will see is one small picture and a few covers.

"Anyone who goes into this business for profit is an ass. It is not a business that will make you rich," says Pierce. "You have to be very productive or starve yourself, turn grouchy, and take lousy, bitter pictures. You need a semblance of comfort to work well. You've got to love your work so much that the picture gives the emotional needs, and there is free time to devote to personal work. Everyone I know in this business is a crazed enthusiast who has learned the trade on his own.

"A good photojournalist (on contract with an agency) can make between $50,000 and $75,000. He will live intensely and travel a lot, but you never really know where you are — only where you have been.

"Most photojournalists have something to say before they become photographers. They often start

The Change in Magazine Photography

God, remember those beautiful essays in *Life*? Smith's Spanish Village, Eppridge's essay on drug addicts, Haas's color essays on New York and bullfighting, Duncan's Korea, McCombe's tender stories on just living?

Well, they're long gone. Occasionally you will find one of these style essays in *Geo* or perhaps *Smithsonian*, but mostly they're gone the way of big cars.

When the old *Life* and *Look* died, the surge toward truth in photography waned as advertising photography — the setup photograph — became more prominent than the editorial pages. As production costs rose, paper quality went down and with it the need and desire for high-quality color reproduction. Editors turned more wordy; it was as if they were getting even for all those glorious essays with so little text. Some, of course, say that television became the visual medium and therefore there had to be more columns of text — more brainy, analytical writing.

However, *Look* came back, ever so shortly; *Life* came up with a flash as a monthly, and *People* turned on strong. They used photography, but they began to use it as a creative director and photoillustrator would work it out on Madison Avenue. The shots were produced — constructed, manipulated — to become not a flow in a story, but an opinion, an editorial. Many of the new *Life*'s stories have this slickness to them. The photography seems too manufactured, too well done. It lacks humanity, sacrificed for color and thrills. A good example was *Life*'s story on the low-slung hot-rodders of Los Angeles. The story was brilliantly photographed, but the pictures were set up. They showed excitement, color, a bit of sex, but no humanity. *People* tries hard to express itself through photography, and it comes off, but with a close look, it comes off as an expanded version of the old *Life*'s entertainment section — you know that in many cases the stories have inbred in them the genes of publicity and promotion.

Too many magazines look like a package that is made as appealing as possible to the advertiser instead of the reader. In making the package, editors, art directors, and photographers, perhaps unwittingly, have copped the style and direction of the advertising agencies' creative directors and their pet photographers.

It would be nice to see again the humanity that so many photographers and writers could capture so well for the pages of magazines, if they were given a chance.

taking snapshots of people around them to say things they cannot say in words. Finally they find they can get paid for taking photographs. I know I started taking photographs at summer camp with a Brownie Duaflex.

"Most photojournalists I know sort of sidled into the business. They didn't study journalism in a fixed scholastic environment. It is best to study something else; it's like the difference between typing and writing. Many schools teach you the photo equivalent of typing — they teach you to mix chemicals and work a meter and learn about the past, but don't give you something to say. A photojournalist needs a background of politics, art, history, science, and literature. He has to be curious. A photographer is always going through learning experiences because he has to go through the real thing to photograph it, while a reporter can learn after the fact — he doesn't even have to be there.

"A guy in Ireland with the IRA thinks of himself as a warrior and revolutionary and that fighting, killing, and terrorizing are justified. You can relate to him without believing in his politics and philosophy, for you both have to duck the same bullets. I had a fascinating three-day talk with physicist John Wheeler on black holes. We discussed theology, international politics, and we went way beyond physics to see elegance in the universe through black holes. I've had the same experience talking with policemen in action precincts.

"A photojournalist is a human being who takes pictures. But he must be professional about deadlines. He must know how to talk to people to make arrangements to take pictures. For an assignment you may have a few days to sell the photo idea to the picture editor and a few days to arrange the photography, take the pictures, and air-freight and caption the material. Or, you may do all this in a day and a half with no phone calls, no letters. You are on your own except for air freight.

"The photo editor wants to know if you have the stuff to do all that, whether you are well-dressed, neat, well-spoken, not overboard on the expense account, will represent the magazine well and do accurate captions. There are many times when the editor takes a harder look at you than at the pictures. For that reason many times form letters from photographers asking for work go into the wastebasket. It is hard to turn aside a human being.

"Some photographers sell themselves. They say, 'Aren't I important! Aren't I clever! Me! Me! Me!' I know I am not exceptional or famous. Hell, ask

the guy on the street who Gene Smith is. No one knows. What you do is sell enthusiasm and competitiveness and the subject — you talk about the importance of shooting the troubles in northern Ireland or a new medical development or the space shuttle or the tragedy and travesties that are happening in eastern Africa. An exciting idea is best sold by you yourself rather than a wife or rep hanging around showing some enlargements and saying, 'Isn't he an incredible artist!'

"Whenever I shoot for *Time* I always shoot the subject as an essay and they usually select a single photograph. I could pursue a few free-lance essays for *Geo* or *Life* if they would have me but I have two kids in school, divorce payments, and want to eat nicely on the road, and *Time* gives me consistent employment.

"One of the things a photojournalist has got to know is how to travel. I believe there are real values in roots and everyday existence and routine, but it is not for me. I think a nice steady life is wonderful, but I don't know how to go about that. I've gone through the basic photographer's divorce. I get bored easily. When the story is done, I've got to move on — that can happen within one-half day or a month.

"For most assignments, you should learn to travel light. But Ralph Morse went to shoot the space shuttle with about twenty-five cases of equipment and I spent a week in White Sands doing nothing but waiting for the shuttle to possibly land there. I and another photographer air-freighted out two large tripods and eight crates of about three hundred pounds each, filled with lenses up to 800 mm and remote equipment.

"I was recently supposed to follow an Australian trip with an assignment to Ireland. I shipped cold-weather clothes and film to London, then took off for Australia with four cameras (Canon Fs, and three Leica range finders). I took mechanical cameras because I wouldn't find batteries in many of the areas I was to photograph. For the range finders I had lenses from 15 mm to 90 mm. For the reflex cameras I had lenses up to 300 mm and a doubler (to make a 600 mm). In some places you just walk closer. In Ireland it is not a good idea to use long lenses as someone will think you are shooting at them and then kill you.

"I also had one spot meter and two incident meters with one that did double duty as a flash meter — the Minolta Flash III. For lighting I took one Kako 2500 strobe that was equipped with a very long synch cord, an umbrella and light stand. It is a good unit because the power can be turned down to make fill when using existing light. In fluorescent work I put a 30 green [color compensating filter] over the strobe and a 30 magenta on the camera and I fill and balance out the fluorescent lighting. If necessary, I rent the big equipment on assignment — Balcar strobes that can be rented all over the world, or 8 × 10 view cameras.

"Unfortunately, there are problems with equipment. Many of the new electronic cameras are playthings and overfeatured, like portable radios. Breakdowns become more of a problem, and you need to carry along backup bodies. For the first week of the Three Mile Island incident, I made many exposures at night, using electronic cameras, and went through seventy dollars in batteries. I was shooting the Democratic convention in New York in an air-conditioned hall with two automatic cameras. I went out on the steamy, humid street and condensation covered my cameras and without my help they both clicked off thirty-six exposures. I couldn't do anything about it.

"The lighter, more compact cameras with automatic exposure may have been created with amateurs in mind, but their features can be useful to the photojournalist. Unfortunately, you have to keep your eyes on the batteries that run these cameras. Batteries only die when you are about to take an exceptionally important picture. But, we are beginning to see electronic cameras built to professional standards from manufacturers like Canon and Nikon. Hopefully these cameras will offer us the convenience of electronics with the ruggedness needed by professionals.

"There is no good photojournalist who doesn't move his film out quickly and know how to get into countries. Sometimes it is best to take a taxi across Africa to get into a country. On a fast-breaking story one photographer goes out and he takes all the film, or it might be the TV guys. When I covered Three Mile Island, nothing was flying into Harrisburg and I couldn't deliver my film, so I called a Radio Taxi in New York City and they came and picked up my film and delivered it to *Time* in New York.

"The business, in a way, is an adrenaline pumper.

It strangely educates you and makes marvelous people you like to associate with. You know, photographers are ageless, you can never guess their age, just like you never can guess the age of a Bowery bum. It says something for this career."

Photographer-Writer

There is a move afoot by some editors and publishers to hire, for assignment or staff, writers or editors who are skilled in photography. Their reasoning is bottom-line simple — they want to cut costs of photo assignments and travel. "If you can send one person to do the work of two, then the bottom line will be more in our favor," they say.

Much of their reasoning is swayed by how wonderful their own photography is, for they all own automated cameras. They find their exposures are correct and as photography mania creeps through our society, and the equipment gets that high-tech gloss to it, more and more editors consider themselves photography pros. The same goes for art directors. Instead of assigning work, they do it themselves, and often are paid the page rate.

Unfortunately, it is not that easy. *Life* magazine, in its heyday, never mixed writing and photography, unless it was as the result of some exclusive newsbreak. There are photographers and there are writers, was their law, and never mix the two. The reasoning was simple — there was often not enough time for one person to do both jobs superbly.

There is also the fact that visual people communicate with images, and writers do so through interviews, quotes, and research. Very few people successfully combine the two skills.

Peter Miller, a living exception, is a writer-photographer. He is not always successful at both, but in many instances, the two talents have upped his cash flow. Miller became interested in photography as a teenager and he taught himself photography with the goal of one day becoming a *Life* photographer. He helped pay his way through university with photography and became an assistant to Yousuf Karsh, the Canadian portrait photographer, when he was photographing some of the world's leaders in politics and art. Miller published his first text and photographs in a national magazine when he was twenty. He was a military photographer in Paris and his experience there soured him on photography. "I had NCOs who showed me how horribly boring photography could be."

Miller vowed to give up photography, and when he left the military, became a reporter for *Life*. He worked there five years, rarely using a camera, but learning how *Life* photographers and writers worked and how layouts were made. "It was the best apprenticeship in the world," says Miller, "but I was never cut out to work for a corporation. I wanted to be my own boss." He quit in 1964 and has been free-lancing ever since in Vermont and New York, working as a reporter, writer, photographer, and editor. Photo and writing assignments have taken him around the world, and his articles and photographs have appeared in many international magazines.

"People ask me what I am and I used to answer, photojournalist. I am not that, as most of my work is feature material, so now I say I am a photographer and writer. Sometimes I am more of a photographer, sometimes more of a writer. Right now I feel like quitting writing and becoming a photographer. Then I swing the other way.

"The truth of the matter is that a writer-photographer, if he wants to be excellent, usually settles for mediocrity in the two. If you do a text piece well, the photography suffers, and vice versa. It's as though one part of the brain overpowers the other.

"I wrote a piece for the *New York Times Magazine* on skiing steep slopes. It was beautifully received and I thought well written and edited. It opened with a spectacular color spread of a skier on a steep mountain in South America. People complimented me on the beautiful photograph, which I did not take; I located it through Liaison Agency. The fact is, I sat down for three horrible weeks and did nothing but interview people on the phone, translate some French, read, delve into my own experience, and then suffer to put it in words. I didn't go anyplace. All of it was done vicariously. I was paid $1000 for the article, the fee they pay for writers who have not appeared in their pages before. The photo rights were $500 for the spread, and it was a stock sale. The photograph was sold two more times in other countries due to the article (which I did not sell in other countries). The photographer didn't lift a finger for these sales, and he made more than I did for the writing.

"Writing is insufferable agony that is very poorly paid. You turn out magazine pieces and you'll be lucky to make $20,000 a year. Books pay poorly unless you hit the jackpot, and the trick is to garner enough cash through an advance to pay for your time and hope there will be some royalties. The best way for a writer to make money is through scripts for TV and movies or pounding out hackwork all day long, doing three-paragraph shorts for $25 to $50, dumb pieces for cheap magazines for $300, and occasionally a long piece for a major magazine at $1000 to $2000, but then the research can take so long, it becomes an unprofitable venture.

"Photography, on the other hand, pays space rates and can be put into stock, while most articles cannot be sold repeatedly. A photographer finishes up after a day's work, while a writer has to transcribe notes, do calls, check, recheck, write, and edit, and hope the editor who reads the result isn't having a hemorrhoid attack.

"Yet, between the two I can gross between $40,000 and $50,000, depending upon the ups and downs of the year. Articles that I sell for $300 are suddenly worth $800 to $1000 with the photographs. A fishing article I sold for $1500 with photography caused an additional sale in Japan of $3700 in photography. My stock sales through agencies have doubled in the past year and I have started to shoot photographs just for stock. I do not know my net income. All I know is that as a traveling photographer and writer, my write-offs are high, and I spend too much money on photo equipment.

"I use two typewriters, one for the office and a portable for trips, and two Sony recorders for interviews. I own twelve cameras — five Nikons, a Nikonos, a Leica range finder, a Veriwide, a 6 × 7 Pentax, a Widelux, a 4 × 5, and a pocket Pentax. Lenses run from fish-eye to 500 mm. Most of the work is with the Nikons and I carry too much equipment, but if I don't bring it with me, I'll find I have a need for the piece left behind.

"Writers, like photographers, should specialize and my reputation is in outdoor sports, notably skiing, fishing, and hunting. I sort of sidled into that specialty because I liked those sports and became expert at them. Skiing predominated and I gained a reputation first as a ski photographer, then as a writer and editor. Now I am on contract with *Ski* magazine as a contributing editor. My job is to write, consult, take photographs, but most of all to improve the visuals in *Ski* through photographic essays. Few of my photographs appear there; what I try to do is get the best photographs from ski photographers in the field, put them into a coherent essay, working with the art director, and sell the package to the editor. So I am now mixed up as a photo editor, visual consultant, writer, editor, and photographer.

"Being labeled as a specialist can be harmful. It is hard, for instance, for me to pull down some assignments that I find interesting, but that most editors would not assign me because they know me as an outdoor photographer and not as a trained journalist. Thus it behooves me to do more assignments on my own. Time, here, is the enemy. If you are a writer, it takes so much time that there is little left over for self-assignments in photography.

"The best part of being a writer and photographer is you learn how editors think and how layouts work. You learn quickly to translate ideas visually. The worst part is that you can muff assignments. I recently photographed beautifully a fishing trip to New Zealand. My writing on that trip was horrible. One of the reasons was that I saw New Zealand visually, and my photographs reflected its beauty and people and fishing, which was the nature of the assignment. Their trout are god-awful big. Mentally, I had a potpourri image of the trip, and a poor understanding for the editorial use of the article. Writing needs reflection and mental editing. Photography on this trip seemed to consume those elements. Yet this assignment is being published, and with some rewrite will be seen in more magazines before I retire the photography to stock.

"All in all, I would say, learn the craft of writing and editing and layout. It takes about ten years. But be more of a photographer. It pays more, it is more fun, you get outside, meet more people, and it is much more satisfying. You become more open.

"Photographers are often egomaniacs, extraverts, at times crude and pushy, shallow thinkers except for the photojournalists, poorly read, and too often money mad. Either that or they are so far up in their ivory darkrooms you cannot make sense out of their syllogisms.

"Writers, on the other hand, are paranoiac introverts with easily destroyed egos and given to fits of depression. They have a paunch from sitting at the

typewriter too long, a distrust of editors and other writers, a cynicism from knowing how quickly people lie and obfuscate, a dislike of bankers, lawyers, and publishers, and a neurotic tendency to dissipate themselves in the misery of their writing. Writers tend to be loners, alienated from the rest of society, which they see too clearly. 'What do I do when I write?' Red Smith purportedly said. 'I sweat blood.'

"Anybody who calls himself a writer-photographer is a bloody schizophrenic."

Fashion Photographer

"It takes lots of hard work mixed with luck to make it in this field," says Andrea Alberts, a young, energetic New York fashion photographer who is on her way up — fast. "The hardest part is getting the first job, to get one client to use your images. You get exposure and chances are after they give you the first job — unless you totally bomb — they are going to give you another job. Just one magazine is all you really need. Other editors look at the magazines and they call you for another assignment."

Alberts's fashion pictures appear in *Mademoiselle*, *Vogue*, *Self*, and *Seventeen*, she's done advertising for AT&T and catalogs for Bergdorf Goodman and Marshall Field. Her income — about $70,000 in 1981 — has doubled each of the last two years. All of this was accomplished in less than four years, following apprenticeship, education, and a short detour in magazine editorial work.

Alberts's father has been a wedding portrait photographer in southern California for about forty years, so she had an early orientation in photography, but no actual experience in camera handling. She took a BA in art history at Mills College and it was there during her senior year that she began taking pictures with a thirty-dollar Minolta. Her interest increased and about ten years ago she went to New York to become a photographic assistant.

"At that time it was a very male-oriented field and no one wanted to hire a woman as an assistant," she says. "I managed to get a job working for George Meluso (he does catalogs for Sears and other fashion work) as his Gal Friday. I wasn't his major assistant, but I worked for him for a year and learned a lot — it was invaluable experience, the best on-the-job training."

She also worked for James Moore, a fashion photographer. Again the job was answering the phone, booking models, doing bills, getting lunch, vacuuming, and running, but he let her use the studio after hours. Her third assistant's job was with George Barkentin, well known in the beauty and fashion field, and he let her do darkroom work and printing and more technical tasks on the sets.

Even with this experience, Alberts couldn't manage to get assignments on her own. "I built up a portfolio, but it was too personal with black and white portraits of friends — not commercial enough," she says.

But with a change in location — she moved to a farm in Massachusetts — Alberts got a job teaching photography at the University of Massachusetts. For a time she even contemplated doing this as a career and so commuted every week to New York City to take a masters degree in photography and filmmaking at New York University. She also incorporated

Andrea Alberts

So Who's Spoiled?

In the sixties the advertising photographer — the photo-illustrator — was king. Shades of Avedon, Milton Greene, Bert Stern, and Irving Penn. They were paid stupendous rates, they could do anything, go anywhere. They were the glamour boys. Bert Stern became almost as famous as his picture of a dry martini performing before the Pyramids. Milton Greene became synonymous with Marilyn Monroe photographs, as did Bert Stern.

Alas, a recession or two, and all of a sudden the wonder-boy photoillustrators were knocked down. Along came a new wonder-boy, the creative art director. For some unknown reason, advertising executives (most of them raising flags upside down to see what they looked like) decided that the American youth movement should be reflected by their creative directors and they hired these kids to find and direct photographers. They wore shades and leather pants and kept their offices dark, smoked pot in the corner, and decorated their walls with nubile nudes about fourteen years old or pictures of dead pigeons in the streets. Most of them didn't know a pica from a Type C print.

Eventually they faded away with lost accounts and another recession. Photographers struggled along with "bottom line" creative directors who think that the least expensive way to buy photographs is from a stock agency, or to shoot the pictures themselves.

The best photographers in the photoillustration field, at least those who count creative directors as personal friends, are riding high but not as high as the models, who are collecting phenomenal fees. In Boston, Dallas, Chicago, and in the West, a model's top day rate is about $750. Out in the boondocks you pay a pretty or handsome face about $75. But in New York a few models, for four hours' work, can pull down $5000. The standard day fee in New York is $2000. Superstars are asking $2500 and some models are asking $3000. If you want three top models in one photograph, the fee can be over $6000, while the photographer, who makes the models famous, is getting $1500 to $2000 for a top national ad. Some of the photographers, on big shoots, are importing beauty from England or Paris, or going abroad to shoot their assignments.

Perhaps the increase in model fees is the wake following the escalating salaries of superjocks, who reason that their financial life is limited by injuries and loss of coordination and they should be paid accordingly. Models might be thinking the same way — each day a model is a little older, and if they fool around with model chasers, boîtes, discos, and drugs, the aging comes a little faster. So maybe they should make what they can while they can. Then look at their new competition — thirteen- and fourteen-year-olds, dressed like snaky Barbie dolls, snatching away some of their jobs, inching up into the top brackets. A few of the biggies — Lauren Hutton, Cheryl Tiegs — have long-term contracts and are millionaires, but there is not yet a Dave Winfield among them. We're waiting.

a book, called *Made with Oak,* into one of her credit projects.

Returning home to California with every intention of working in television for Norman Lear, Alberts lucked into a chance to assist in a beauty shooting. "A friend of my sister's had just become beauty editor of *Seventeen* and was out there on location with George Barkentin and needed an assistant to help shoot five issues in two weeks," says Alberts. "She offered me fifty dollars a day and we were out on the job every day at 6:00 A.M. I did everything. She'd say, 'We need a horse,' and I'd run and get a horse or whatever. I guess I was resourceful, because she asked me to come back to New York and work for her as associate beauty editor. I learned the beauty business and I learned to write copy, too."

The editors eventually gave Alberts a monthly column that included some black and white photog-raphy, but after just one year in editorial work she decided to go out on her own. "I was twenty-nine years old and I said to myself, 'Let's get serious now. Are you going to continue to be an editor or be a photographer?' Also, I got a lot of support from different art directors and editors. They said, 'You can do it.' So I decided to try. If I failed, I would fail, but this was the time to try."

This is where the luck came in. Condé Nast, publishers of *Vogue* and *Mademoiselle,* started *Self* magazine. The creative director there recognized a kindred photographic style in Alberts's work for *Seventeen.* Her first assignments were more journalistic than fashion-oriented, covering real people, their life-styles, fashions, and ways of dressing. *Self* became her major client and then *Seventeen* and *Vogue* started giving her small jobs.

"I really started from zero," says Alberts. "I had a couple of cameras — hardly enough equipment

— but I had luck and the drive to make it work. I also had some contacts in the magazine and beauty business.

"But starting in fashion photography — or any field — is like starting a new business: you have to be prepared for lots of slim months when you might not get work. You should have some resources (dollars) to carry you through. You don't want to give up in six months and say, 'I can't afford this thing.' You have to plan your move.

"If you work as an assistant to another photographer in fashion, you meet people in the industry — stylists, hairdressers, models, makeup artists, and clients. The more of those people you meet, the better. They all help each other and they recommend each other.

"But it's definitely *not* just a matter of knowing the right people. You have to have a *strong* portfolio. How you get the work is based on your portfolio. Lots of times you don't even meet the people who make the judgment on hiring you. You take your portfolio to *Vogue*, for example, and just drop it off there. You don't always get to see the art director. So your book has to be strong and show what they are looking for.

"If you want to do illustration photography, you can't show them rock formations or landscapes or pictures of your friends. If you want to do still lifes, take pictures of perfume bottles. If you want to do people, take shots of people in different situations applicable to advertising or magazines. Once you get published, you have tear sheets to show and you can make a book of that material and about five to ten sheets of color slides. Then the editors might say, 'Well *Self* uses her all the time, let's give her a chance.' And then, hopefully, another magazine will call, and so on.

"Right now I have an agent to take my book around, but in the beginning I did it myself. I would set aside two to three days when I did nothing but call on ad agencies and magazines and try to make appointments to show my book. At the same time, I was doing jobs. It was a lot for one person to do in the beginning.

"Now I've put together three books with about two dozen pictures each. My agent takes one around; I take one around if I'm not busy; and I have one for the studio in case the others are in use.

"Lately I've been going to Europe to do assignments. That's important to have in your portfolio, even though magazines over there don't pay as well. Most of the magazines here want to see what you are doing in Europe, just like the Europeans like to see your American tear sheets.

"The European fashion/beauty industry is a bit different. The magazines there give you more freedom to do things in a different style, to be more dramatic, to take a few more chances. Maybe they aren't as commercial as American magazines. The English magazines seem to give me bigger pages, and bigger pictures with very little copy.

"What seems to attract people to my work — here and in Europe — is that it looks lively and spontaneous. The girls look happy — like they are having fun. I try to put humor into my pictures and I like to use natural makeup and natural-looking models. I'm pretty happy-go-lucky myself and I like to show that in my pictures. I also do serious, romantic, quieter pictures in the studio.

"Editorial shooting is like making a mini-movie, particularly when it's two to three days of shooting — it's definitely teamwork. Most magazines now gear their pictures toward reality. Even if they use models, they can't be just standing there posed by a lamppost. They should look real so the reader can identify with the situation. I took a picture of a model who was supposed to look like a teacher. A little girl came down the street with her mother. I grabbed her and said, 'Can I photograph your daughter?' The mother loved it. We got a release and I sent her some slides.

"Advertising work pays quite a bit more money than editorial work. It's very well planned out in advance, and on the job it's not just one editor and one photographer working together to take pictures to please the editor in chief and the art director, but it is the art director, the account executive, the clients — several people come to the shooting. It's kind of nerve-racking."

Alberts's studio in Manhattan's "Photo District," near Fourteenth Street and Fifth Avenue, is a large, white, bare space. The walls have built-in closets to hold equipment, there is a table/desk with a file cabinet in one corner and on one wall a few chairs and a sofa. A clothes rack and an ironing board in the middle of the room are the only indications that this is a serious fashion forum. In this simple setting, every wall and even the polished oak floor can be

used as a backdrop for pictures, and the large south-facing windows provide plenty of natural light.

"I usually work with an assistant, but I consider myself a minimal photographer as far as equipment is concerned," says Alberts. "I have a few cameras — Nikon FMs — and motor drives. In lenses I have just what I need: the 180 mm that I use a lot for fashion, and a 105 mm, a normal, a 28 mm, and a 35 mm. If I need any special lenses I'll rent them. I use Norman 2000 strobes and I like mixing strobe with daylight to get a natural effect. I learned a lot about lighting in the filmmaking courses I took getting my masters. The filmmaking department at NYU, where I made a movie, was terrific experience for photography.

"But actually I think I learned more about photography on the job, doing a book and working with other photographers. All sort of trial and error. A lot of people think photography is buying the most expensive camera and equipment and using it once a week. I think it's better to have just a simple camera and then forcing yourself to shoot a lot of film, even when you don't feel like doing it, shooting ten to twelve rolls a week and looking at the contacts and slides and developing and printing — that's how you learn photography. The more you do it the better you get. You have to discipline yourself to do it.

"Now I know I can take good pictures. I'm very serious about my work and I've done enough jobs so I don't get insecure about the technical parts. I'm really confident about it and I think that's important. Once you're confident, you can take the most beautiful pictures but you are never satisfied with your work. You still strive to better your photography and take more beautiful pictures.

"Some people say to me: 'Do you still take personal pictures?' For me it's become one and the same thing. It's not that I'm doing this work and then running out to do some landscapes because I hate fashion and beauty pictures. I really love what I'm doing."

Photoillustrator

Most often photoillustrators maintain studios in the big cities. Usually they specialize; some work for

Peter Vaeth and his dog Ben

large catalog studios, others are good at photographing brassieres, still lifes, cars, or jewelry.

Peter Vaeth is a photographic illustrator whose studio is on Madison Avenue near Forty-second Street, New York City. A couple of stone's throws away are some of the world's biggest advertising agencies. Vaeth, thirty-seven, is a low-key, high-strung photographer (he keeps his frustrations inside) whose specialty is photographing people in natural surroundings to appear in advertisements for such clients as Cuervo Tequila, Avon, Johnson's Baby Oil, Head and Shoulders, Winston, Rums of Puerto Rico, Minolta, and other heavy hitters.

Vaeth, a photographer for twelve years, is a graduate of Rochester Institute of Technology. He was an army cinematographer and after discharge moved to New York City to pursue his ambition to be an advertising photographer. He prepared a portfolio and showed it during the week and made photographs on weekends to update his portfolio. He eventually broke in with an ad for De Beers

diamonds and editorial photographs for *McCall's* magazine.

"What I try to do is to make my photographs human. I shoot mostly on location and try to use local people as subjects. If I shoot photographs with a country environment, I think the faces should reflect naturalness and openness. I have set up a production center in Weston, Vermont, and for the last three years we have been doing advertising up there. In 1982 we launched our first feature film about the young underground of the United States and it is being filmed in Vermont. Much of the funding for this film will come from my advertising photography fees."

Vaeth, with the help of an extensive staff, is a master of production. He did a well-received Cuervo Tequila ad of three cowboys in a round water trough in a western field. In the background was a wooden fence, a dilapidated windmill, some livestock, the sun, and a few saguaro cacti. Vaeth's production assistant found the location near Phoenix, Arizona. The saguaro cacti were growing there and the sun was not moved. But the water trough was trucked in, the dilapidated windmill was constructed by a Phoenix production service, the fence was built to look old, the cattle put in position, and the three models told to take a dip.

Vaeth has built floats to hold rugs in a beaver pond in Vermont, brought artificial snow to the country in the middle of summer so he could fake a snowy day, artificially fogged fields to bring about instant mist, and in general has built sets using the country as a backdrop.

For location shoots Vaeth loads his six-wheeler Dodge truck with thirty cases of equipment and several production assistants. Cars with models; hair, makeup, special-effects people and their assistants; and, most important, clients, follow. The shoot usually lasts for several days to a week. When Vaeth flies, the equipment he plans to use is in the hold in the same plane and it is not unusual for his freight bill to be five hundred dollars.

"In my line of work, production is 90 percent and the photography is 10 percent. A job must be produced perfectly. On an average job, a photoillustrator nets $3,000 per day. Remember, I am paid not only as a photographer, but as a contractor. There is a lot of fear in this business — the creative director, the account executive, the client, have their expertise on the line. A lot of money is laid out to create an advertising photograph. No one really knows why the product sells. Sometimes it is the product itself, sometimes marketing strategy. Many times great marketing strategies have been destroyed through poor photographic illustration. So the clients and advertising agencies like a photographer who can finesse production and take good pictures.

"I happen to have a strong feeling for working with people. There are about twenty creative directors I like to work with and they come in and talk about assignments and we work out the idea. Sometimes I create the thought behind a photograph, but very often I work from sketches made up by the creative director. This creative person from the agency should interlock with the way I see, and I with his thinking. Lack of communication between photographer and creative director is no one's fault. It is simply bad communication.

"Often creative directors search for the young inspired photographer who they hope can create a new brilliant photographic approach to their marketing problems. There is a deep need for inspired young photographers. I was told, when I first came into this business, that there is lots of room at the top but no room for one more mediocre photographer. This business has an almost perfect grapevine and the word spreads quickly about photographers and their work — who is good and who is botching up. Sometimes it is not only the photograph that can make or break a career. This business is no place for prima donnas and a photographer must always remember that he is the supplier and must please the client. It took me a long time to learn to handle my temper."

One recent Vaeth assignment was to photograph animatics for a TV throwaway test of a product. The photographer shoots a number of stills that are put in sequence onto videotape and tested somewhere in TV land, and then the viewers are called and asked if they recall the product. It is cheaper than making a commercial. The total bill was nearly $30,000. Vaeth's fee was $5,000. The rest was for expenses — film and processing, $3,500; Polaroid tests, $300; Polaroid scout (an assistant goes out and scouts locations and brings back Polaroids), $300; stylists, $800; transportation, $1,200; location fees, $2,500; insurance, $600; telephone calls, $200;

props, $2,500; lifeguard, $100; assistant, $1,000; miscellaneous out-of-pocket expenses, $200; creating a fake moon, $750; per diem expenses, $3,500; and so on.

Vaeth spends about $50,000 a year on film. He uses Kodachrome 64 because he finds it the best film to replace the old Kodachrome II that Kodak discontinued. Although Vaeth started out with a Nikon F and two lenses and found it adequate, he now owns most Nikkor lenses, a complete stable of Hasselblad equipment, plus 4 × 5 and 8 × 10 cameras and lenses. He has some special equipment that he might use once a year, but that one time pays for it.

Vaeth sells his own work, and although he feels a photo rep may cut too many communication corners between him and the buyer, he now uses one. He has a large portfolio of photographs and advertisements that he has created and it is impressive.

"When I started I did multiple images because I found no one else, save Art Kane, was doing it well. I made in-camera multiple exposures. Some were romantic and some pretty scary. It took a lot of work; sometimes I exposed five images on a single frame.

"Along the way I found that I had a talent in directing people and that I could do crazy things behind the camera and it worked to make my subjects at ease. More and more people began to hire me. It was this knowledge that has pointed me in the direction of producing feature films in Vermont.

"When I first came to Manhattan to work, I had a small, live-in studio in Carnegie Hall. Now my shooting space is forty-seven stories over Manhattan. Expenses are way up, and I am able to pick and choose some assignments. Work is like a siphon — once it starts, it keeps going.

"Our workday is longer than most. We start at 8:30 and often go until midnight. A lot of our time is planning carefully so the work and production and photography progresses fluidly. If you are lazy and nothing goes well, you ought to feel guilty. I think we are living proof that the work ethic in the United States is not dead.

"Now my field of photography is overcrowded. All the war babies are now working. You have to be terrific in your field of work and the standard of quality is up 50 percent compared to what it was five years ago. Most of my clients are fine photographers. Creative directors need a reason to use someone other than themselves. You must have a different approach in this field and if you emulate a heavy hitter, well, there is already one of those and you won't go anywhere."

One Reason You Need a Lot of Lenses

The photographer is on assignment in the Caribbean, on Aruba. With him are two models, male and female, an assistant, a hair stylist, and the ad agency creative director. The male model looks a little piqued, and so does the creative director, and the female model and the photographer wonder just what is going on.

Their job is to photograph happiness on the beach to promote a suntan lotion.

The models are in position on the beach, the photographer ready to shoot. The creative director looks through the lens.

"Ought to have a wider feeling here of freedom."

The photographer takes off the 35 mm lens and puts on a 28 mm. The creative director takes another squint. "Hmmmm. Wider yet, don't you think?"

On goes the 24 mm. He takes another gander. "How about closer and lower to the ground with the same width?"

The photographer says nothing. He is an old pro and at the moment trying to think pretty thoughts — bluebirds in spring, fall in Vermont. He puts on the 20 mm.

"It just doesn't look right, you know?" says our creative director. Our photographer moves back and puts on a 55 mm. His assistant, who has been handing him lenses, looks as though he wants to kick the creative director.

"Gosh that looks good," exclaims the director. "Let's shoot it that way, but also with more of a telephoto." The hair stylist goes back to work. Finally the shot is made, with the 55, an 85 mm (the 105 mm was a bit too strong), and the 28 mm. The 28 mm shot wins on the layout table. If the photographer hadn't had the right lens, the creative director would have given him one of those looks and said to himself, "I sure got myself a turkey photographer this time."

Commercial Photographer

Not all photographers go to the big city in search of big checks. Some of them are country inclined,

Fred G. Hill

and those who move to the country or small towns as photographers usually have two choices if they wish to live off the local economy: to be a studio photographer shooting portraits and weddings as well as advertising and illustrations; or to be a commercial photographer who does just about anything including product shots, copies, construction progress, architecture, and just about every miscellaneous job that comes down the pike.

Fred G. Hill, forty-six, is a commercial photographer located in Burlington, Vermont, a rapidly expanding small city located in northwestern Vermont next to Lake Champlain and a few miles from the best ski resorts in the East. The region has a population slightly over eighty thousand. Burlington is a shopping and warehouse center and has attracted some large corporations — General Electric and an ever-growing IBM plant. There is a printing industry and there are a few smaller manufacturers and distributors, particularly in the ski field. Burlington summers are glorious, the winters wind-whipped chilling. The people are friendly and there are many social clubs for men and women.

There is a very good hospital and the University of Vermont keeps the town youthful. It remains a slightly naive town, with old American customs and traditions of respectability that are slowly being covered by a thin veneer of sophistication. It is an ideal small country city, good for living, good for future growth. Burlington is all what Rotary stands for.

Hill studied science at MIT and for several years worked in and near Boston in chemistry, then for a commercial photographer in Boston. City life after fifteen years palled: he disliked hassling with landlords, fighting the traffic, and breathing the air.

"I left Boston in 1970," says Hill, "and came to Vermont, where I toured the state looking for a job in photography. There was none. Commercial photographers were one-person operations, working out of their homes, and the few studios were small and portrait/wedding oriented. The biggest city, Burlington, also had the greatest concentration of business and industry and was the most likely place for work, so my family and I settled here. (It was clear that a city was necessary for livelihood. In fact, while I wanted to get away from cities then, I really find a city more congenial than a small town.)

"Initially, I was offered a partnership with a portrait photographer in Burlington. His business acumen was low and the terms he finally offered were unacceptable, but I think that it was psychologically a help to start out that way. I had him as a model to reject and my former boss in Boston as a model to emulate.

"My equipment was considerable: a Nikon, a 4 × 5 view camera, lenses, two enlargers, and some lights. My portfolio was from Boston, mostly product photography, and sometimes over the head of a prospective customer: one person asked if the Polaroid cameras that I had photographed for an ad represented my own equipment! My first significant work was for a printer who had several national accounts, and an in-house art director from New York City. That printer is still a steady customer. Other early work I found was product photography for a small manufacturer of medical safety instruments, and construction progress photography. I diligently visited almost every remotely likely prospect that I could cull from the Yellow Pages, the newspaper, and a state guide to manufacturers. I earned $200 the first seven months and $3500 each of the next two years.

"Now the business comprises about 30 percent product photography, 30 percent copy work of all kinds, and 40 percent everything else, mostly involving people, from passport photography to an occasional illustration with models. Most of the work is for steady customers: manufacturers and craftspeople, importers and distributors, banks, printers, and a few ad agencies. I don't know how to answer when someone asks me if I am a 'free-lance' photographer; I seldom have to seek out work and I have a studio. The studio, about twelve hundred square feet, has a shooting space, a darkroom, two copy rooms, and an office, and is too small. The volume of work is almost overwhelming, so that I tried a temporary assistant this year and will soon have a permanent one.

"An economic perspective is in order: Last year I grossed about $44,000; the year before, $32,000. This year it could reach $60,000. Profit rate is about 30 percent but will go down sharply when I start paying wages. In fact, I earn just about minimum legal wage, myself, and am financially comfortable only because I work sixty to eighty hours a week, which is what the business requires, and because in Vermont one can live easily on what would constitute poverty in larger urban areas. I, of course, do all of my own bookkeeping, billing, housecleaning — everything, menial and grand alike. While I like most of the photography that I do, I dislike most of the business end of it. And I shall certainly dislike being an employer, but if I don't stay ahead of the demand for my services, I might find the demand diminishing. For the same reason, I buy equipment with all my spare money, and thus have no savings account.

"Burlington could comfortably support about half the number of commercial photographers that are here. (I think the same is true of any area in at least this country; photography is too popular and initially easy to be a good profession.) There is only one other commercial studio here with a decent amount of space, and there is a photographer who works out of his home and has more business than I do. But after that, there are perhaps a dozen people who are more or less qualified, but are unable to make their business take off. And there are probably dozens who are not seriously in business at all, but who siphon off a little work here and there. There are also two portrait/wedding studios and a great number of full- or part-time wedding photographers, whose impact on the commercial business is only that of siphoning.

"One thing Burlington offers that is unavailable in larger urban areas is an atmosphere in which one feels one can 'do it oneself': start a new enterprise, create something, or even just live, without having either great talent or abundant resources. I like it here. At the same time, I'm afraid that I like to see it getting bigger and more urban. On such conflict is wisdom confounded (which also is not necessary for getting along here)."

Ski Photographer

Skiing around all day, taking photographs, not having to be somewhere from nine to five — this has got to be the world's best way to make a living. Yes and no.

Being a ski photographer is a business. You've got to be there, you can't waste time, you have to look

Jill Vig

at skiing as a form of transportation, the hours can be extremely long on any individual day, and the work takes self-discipline. "It is a wonderful life. I do travel the world taking pictures and I do ski," says David Brownell, whose photographs appear in *Ski* magazine. "But usually I'd rather work taking pictures than play at skiing. That gives me more satisfaction than a good day of skiing."

Brownell sums up the attitude of three photographers who specialize in skiing, but whose orientation is entirely different.

"Any one of our staff photographers might be asked to photograph every lift ramp on the mountain for a safety study," says Jill Vig, who heads the photo department at Vail. "Or they might cover celebrities or movie stars visiting here. Or photograph action shots, restaurant interiors — we do whatever the corporation wants and requests."

Vig's training for photography began when she was a reporter/writer for the *Vail Trail* newspaper in 1976. "They said, 'Here you do your own pictures for stories.' Well, I knew nothing about photography, I didn't even like cameras and had only owned an Instamatic. One of the other reporters set the camera controls and I went out for my first picture. I was dumbfounded at how neat that first picture was and I became interested immediately."

From that initial interest, Vig asked Peter Runyon, Vail's staff photographer, to teach the *Vail Trail* reporters more about taking pictures. On her own she read, learned darkroom techniques, and advanced from snapper to picture maker.

When Runyon needed a temporary assistant in 1978, she signed on with Vail Associates and stayed to move up the corporate ladder. Today, at thirty-two, Vig has the title of editorial director and head photographer with a staff of two full-time photographers working for her.

"In corporate photography we cover news events as well as setup situations for advertising and brochures in both black and white and color. I also do feature stories for our in-house publications so I combine photography and writing."

This kind of photography is both journalism and art, according to Vig. She says it is important to have an eye for news and to be able to push your way into a news situation. "In a successful news picture something is happening," she says. "That is,

Doing It in the Snow

Cold weather cannot be avoided by skiers, snowmobilers, winter hikers, and those who are sent out on assignment to cover a polar expedition. The problem is to keep functioning — the photographer and the equipment. To that end, cold-weather photographers have a number of tips that help them make great photographs in the world of wind-chill factors.

- Dress warmly. This means layers of clothes — long underwear, turtleneck, flannel shirt, sweater, down jacket, warm-up pants, a long scarf. For a top layer, photographers often prefer very loose-fitting parkas with big pockets and openings that allow them to reach inside. The loose fit permits the photographer to carry cameras under the parka and keep them warm. Photographers usually wear liners under gloves or mittens to keep the fingers from going numb when changing film. Such liners may be silk, but often they are nothing more than cotton darkroom gloves.
- At 20 degrees F, camera batteries lose 70 percent of their power. Keep batteries warm and carry a spare set in an inside pocket. Use fresh batteries. Some cameras, such as the Nikon, Canon, and Pentax 6 × 7, can be wired so batteries can be kept in a pocket while the camera is in use. When using nicads, make sure they are fully charged. Some suggest nicads should be completely discharged, then charged to full power to operate at capacity in cold weather.
- At about −10 degrees F, mechanical shutters slow down. When that happens, only half a frame is exposed because the shutter is sluggish. Most high-quality cameras function equally well in cold and warm weather as long as they are not left out in the elements. For severe cold weather work, a camera may have to be winterized. Check with the manufacturer to find out the camera's tolerances. One small camera, the Rollei 35S, is made (ac-

it is not perfect. It is also important to fill the frame and get in close to the subject."

Photographers at Vail Associates start at about $15,000 and usually come with college photographic training as a qualification. Most ski resorts don't have a staff the size of Vail's, but many do hire a photographer for the winter season.

Vig says she learned to ski at Vail and is now a

cording to the manufacturer) to work in temperatures as low as -40 degrees F.

- Taking the camera from extreme cold to warm interiors can cause condensation on the camera and lens. This can short out circuits and eventually cause rust and malfunctioning of lens diaphragms. When coming inside, put the camera in a plastic bag and seal it shut. This will keep the moisture off equipment as it warms up. Also, when you go outside, the camera will be moisture-free.
- In cold weather, never leave a camera outside in a car, even in a backpack or suitcase. It will drain the batteries, freeze the shutter, and probably the camera will be stolen to boot.
- Fast winding of the film may cause static marks on the film — they look like lilliputian lightning bolts. What happens is that the film, when pulled through the felt strip on the 35 mm canister, is electrically charged. When it touches the pressure plate, which is metal, the film is grounded and the charge streaks across the film. Motor drives also are notorious static-makers, in the wind or rewind modes. In very cold dry weather, wind film slowly and don't use the motor drive (the film is often very brittle at these temperatures and can tear). Use antistatic fluid or liquid detergent. Put it on a soft cloth and rub it gently on the pressure plate.
- In very cold weather film leaders can snap when you attempt to load the camera. Put the film leader in your mouth to warm it up before attaching it to the film spool.
- A chamois cloth is very handy to remove moisture from the camera body and lens barrel. It is more absorbent and works faster than cloth or tissue.
- Photo meters with cadmium sulfide cells can be shocked by too much light, like conditions found in high-altitude snowfields, and may be off by as much as two stops. Silicon photodiode cells are preferred for winter work as they have no "memory."
- Snow, because it is so bright, will cause a meter to give too high a reading, and in its effort to translate the white of snow to the tone of a gray card, the meter produces underexposured readings. Increase exposure by one and a half to two stops when snow is the predominant subject that the meter is reading. In backlit mountain scenes, do not increase exposure, but underexpose. This creates silhouettes and drama by darkening the snow and sky. Nothing looks worse than overexposed snow.
- An automatic camera usually will not give correct exposures on snow unless there is an exposure compensation dial. It should be set to overexpose one and a half stops on the average (two stops in March when the sun is high).
- Snow scenes are often bluish because of the intensity of a clear blue sky. To take out the bluish cast, use a warm-up filter, such as the 81B or 81C. The Nikkor A2 is also a very good blue-removal filter. At high altitudes, invisible ultraviolet rays can turn pictures very blue. Use a UV filter on those crystal-clear days in the high mountains.
- Film used on very bright, snow-washed and sunlit days should be low in contrast because there can be a large difference between highlights and shadows. The best film for snow is Kodachrome 25, or Kodacolor II for prints. Both have the most latitude you will find in color films. Conversely, Tri X and HP-5 are the best black and white films for bright snow. For dull days, Kodachrome 64 and Plus-X, Panatomic-X or FP-4 are preferred because these films increase contrast.
- The best light on snow is found early in the morning and late in the afternoon. Overhead sun, particularly later in the year when the sun is high, is very flat.
- In subzero weather, metal objects, such as cameras, can sting or stick to flesh that is wet. Tape the camera and eyepiece with electrician's tape and do not stick your tongue out when taking a photograph.

good, strong skier, able to get down any slope and manage any conditions. She is usually out shooting on the hill two to three days a week — races, ski school, guests having fun, lift buildings, anything — on specific assignments or for stock. "On the best days, it's the best kind of work. But it can also be the coldest, grimmest, most exhausting work imaginable," she says.

You don't have to tell that to Russ Atha, a photographer who has his own on-hill business in Steamboat. Atha takes the gondola up in the morning before the area is officially open. He sets up an easel showing examples of pictures to customers, loads his cameras, and gets ready to photograph skiers. He or one of his staff of six is there every day that there is skiing, and sometimes they get

Russ Atha

prepared only to discover the weather is too bad for the mountain to open.

In addition to shooting individual and group portraits at the top of the gondola, Atha and his staff photograph every racer in the NASTAR courses. Whatever is shot in a day is displayed after skiing and into the evening at Beckett's Drug Store at the base of the mountain.

Is this a way to make a living? "About 50 percent of the NASTAR racers buy color prints," says Atha, "while a smaller percentage of individuals buy portraits, but about 90 percent of the club groups buy. Last winter, I sold about 10,000 color prints from 3½-by-5 to 20-by-24-inch poster-size pictures."

Atha, who is thirty-three, got into this photo business by accident. He came to Steamboat for a winter of skiing back in 1971 and got a job in a retail camera store. He had previous experience working for a photographer in his hometown, Kansas City, after completing a BA in psychology at the University of Kansas. He stayed around Steamboat and eventually moved to the hill to set up his own business in 1973. At first he did action shots and family groups in black and white. "Back then, I did it all: shoot, sell, and print," says Atha, "and I was just about burned out by the end of the season." He finally gave up the black and white and now farms out color printing to a lab in town that does the work overnight.

Atha also does some of the ski resort's promotion pictures and is getting into more sales to magazines. In the future he plans to expand with more photographers covering more spots on the mountain. "It's a very speculative business," he says. "We shoot a thousand rolls of film in a season and there is no obligation or fee charged — until the customer buys a print."

But the buying continues by mail order long after people have left the ski resort, and it resumes in late fall when they order prints for Christmas cards. In between, in summer, Atha is a partner in a studio in Steamboat, shooting weddings, portraits, or anything else that comes along.

"Most of the money I earn I pour back into the business," he says. "So my net is something under $10,000. But it has its good side, like being outdoors, skiing and taking pictures. You have to like working with the public, working long hours, and you have to be willing to stand around waiting for people who want their pictures taken. It takes patience."

For David Brownell, patience takes a different form. He has to wait for the clouds to be just right, for it to stop snowing or start snowing, for the light to change, and for every detail to be in place. Brownell shoots color ski photography for magazine articles, as well as corporate accounts that include ski resort brochures and clothing and equipment catalogs and advertising.

You might say Brownell, thirty-five, is in the most glamorous end of the ski photography business, working with models and setting up situations to be photographed. But he went through an apprenticeship and long lean learning years to get there.

"The best thing that ever happened to me was getting fired from the Aspen Ski Corp," he says. Brownell went to Aspen in 1972 to spend the winter skiing. He had raced in college (Clarkson College of Technology in Potsdam, New York), and managed to get a job as pacesetter for NASTAR races. "It was fun, secure, and hard to quit," he admits.

David Brownell

But he offended the resort management and was fired. "At that time I had been taking pictures for four or five years and photography was my strongest hobby and biggest interest. So it was a good kick in the pants to get out and do photography full time."

In 1976 he started doing photographic jobs around Aspen — weddings, portraits, anything that paid — and gradually accumulated ski pictures that he thought were worth selling. He got a couple of covers — *Aspen* and *Ski* magazine — and branched out to editorial coverage in other publications.

"It would be difficult to get started in ski photography if you didn't live in a ski area," says Brownell. "In Aspen there was a big market for pictures, both locally in publications and magazines, and nationally. And, there were other professional photographers there to talk to and ask questions. There were about ten top people who competed for jobs, but worked together, too. It was almost like going to college."

Besides asking questions, Brownell read books

and bought photographic equipment, about $25,000 worth to date. But the big lesson he learned was that to be successful as a photographer you have to be part artist, part technician, and part businessman. It helps to have a specialization and if that is skiing, it helps to ski well. "I get in some difficult places and with a thirty-pound pack of valuable equipment, skiing well can be important," he says.

In June of 1981, Brownell moved east to Hamilton, Massachusetts, just north of Boston. "I wanted to live near a big city and near an ocean. From here I can go wind surfing just five miles away, I have picked up a lot of New England ski resort business, and I can fly easily to distant places," he says. Brownell is also expanding his agency contacts in New York and Boston and picking up more assignments doing peak-action sports pictures. He has a full-time secretary and several reps selling his work around the country.

"It's hard to say how much money I make. Between $20,000 and $30,000 net, but then I can legitimately write off all kinds of business expenses, so the net is a lot less," he says. "If I take a trip, I'm working so it's a tax write-off, as a business expense. I guess it is fair to say that I get paid for work that other people consider a vacation."

Magazine Staff Photographer

When general interest magazines were fat and wealthy with advertisements and circulation, it was generally conceded that their success was due to the editorial content. At that time — before the 1970s — magazines offered fascinating reading, whether photojournalism as found in *Look* or the old *Life*, or fine writing edited into *Esquire* or *Atlantic Monthly*. Unfortunately, bottom-line publishing has done away with editorial directness. Many magazine publishers combine advertising and editorial content into something they call *adveredit*. Public relations firms produce editorial articles with photographs for slick consumer magazines, and the cost is paid for by clients of the public relations firm. Editorial budgets are shrinking; consequently, there are fewer editorial pages. Editors of some magazines are slowly losing journalistic control.

At the beginning of this swing to *adveredit*, *Life* and *Look* folded, and their large and very fine staffs

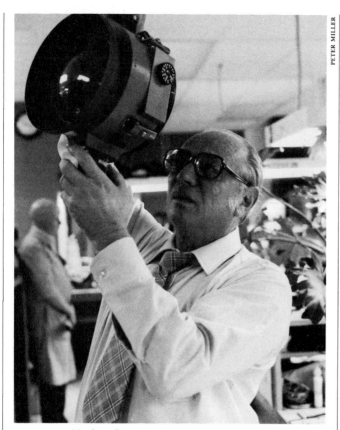

National Geographic's *Joe Scherschel*

of photographers found themselves on the street, picking up new careers as free-lancers. Eventually *Esquire* lost its literary direction that had been so brilliantly manipulated by Arnold Gingrich.

Yet during this decline and fall of American magazine journalism, *National Geographic* became healthier. Its articles, photography, and layout improved and it retained the largest staff of photographers of any American magazine. It also has photographers on contract and uses independently free-lanced articles and photographs.

National Geographic has a number of pluses going for it. It is nonprofit and has a loyal, full-paying list of subscribers — some ten million of them — and as much advertising as it wants.

The nut of the magazine is the color essay, which can run to thirty pages of beautifully reproduced color photographs. The *National Geographic* remains this country's most eye-appealing magazine.

National Geographic has a permanent staff of twenty photographers with an additional eleven on contract. The contract photographers are guaran-

The *National Geographic* Suggestion Mill

Staff members, contract photographers, and free-lance photographers and writers continually make suggestions for features. Each suggestion is initially given the same consideration. Most photographers send their suggestions to Bob Gilka, senior assistant editor of photography, or Joe Scherschel, assistant editor of photography, although a query could be sent to any editor.

Every suggestion is channeled to the Planning Council, which is made up from staff members in eleven departments. Every six weeks there is a Planning Council meeting to discuss the suggestions. Every suggestion is voted on by each member. If there are less than four votes, the idea is more than likely rejected. Five or more votes means the council will discuss the suggestion before either accepting or rejecting it.

There have been times when a good story was poorly presented. A fireman sent in a story idea on fire. It did not receive the required number of votes but one member, Joe Scherschel, brought up the suggestion at a meeting and thought it could become the basis for an expanded feature. Fire is used in all parts of our society, in religion, industry, in the home, for social gatherings. When approached from this angle the fireman's initial idea became the seed for an interesting and complex feature.

Writing and photography are most often assigned separately. Unknown photographers who submit suggestions that are accepted are asked to show a portfolio. If the staff feels the photographer (or writer) is incapable of doing the story, they pay for the idea.

One fellow sent in a story idea about walking the Canadian Dew Line. It was the kind of adventure story that *National Geographic* likes to do from time to time and they accepted the idea. However, the hiker knew nothing about photography or writing. The *National Geographic* staff gave him a quick schooling with a camera and explained what they wanted for notes and sent him off on his northern Canadian hike. Later a staff photographer rounded out his take and staff writers produced the story. Free-lancers receive a guarantee against what gets published — the page rate is $300 when on assignment.

The *National Geographic* has a spec sheet on the requirements for photographers or writers who wish to send in suggestions. The sheet can be ordered by writing to the Editor of Photography, National Geographic, Seventeenth and M Streets, NW, Washington, DC 20036.

teed so much work per year at a set fee per month. They may, of course, produce more stories than their contract calls for. *National Geographic* also ac-

cepts suggestions from the outside and gives assignments to independent free-lancers. Each year approximately 45,000 rolls of film are exposed by photographers on assignment for *National Geographic*.

Not too long ago many *National Geographic* stories were written and photographed by the same person, but as the magazine expanded and refined its editorial content, it became evident that photography and writing should be separate jobs. The skills needed cause a conflict between the visual and the analytical and, if one person is responsible for both photography and writing, the words may suffer if the pictures are good, or vice versa. Now *National Geographic* assigns a writer and a photographer to a particular project. Often they work together at the beginning of a story so that each has a similar approach toward the theme they are developing. Then they go their separate ways as they work on the assignment. This is an astute policy, for photographers often depend upon the whims of the weather, and once they find a good location for a photograph, they will wait and wait, or return in four months to the same location. Photographers can develop a great deal of patience when they have a particular picture in mind, and a writer's time is much better utilized interviewing, say, an expert on New Guinea's climatology than carrying a photographer's equipment.

Staff photographers have developed their skills through years of experience rather than relying on the intuitive sense many young photographers have who work for agencies that specialize in stories on disasters and wars. Some photography experts have claimed a photographer will produce his best work before he is thirty. *National Geographic* photographers are at their peak when they are in their forties. They are in good shape, for assignments are often strenuous. Some are experts on underwater photography and some are specialists with natural history. Most have developed their eye and story sense by spending an apprenticeship of several years on a newspaper, doing spots, features, hard news, or whatever the picture editor sent them out to cover. As they developed their eye and learned to adapt to different environments and situations, they learned to create stories with a beginning and an end. It is a very difficult feat to produce twenty to thirty pages of pictures on the same subject, and to do so takes time, awareness, and above all a curiosity to find photographic situations that might be missed by a less dedicated photographer.

A typical *National Geographic* story can take three to four months and is often split into several shooting sessions. One reason for dividing the photography time is so that different seasons and different festivities can be covered and shown in the same story. A photographer who is working on the same story week after week needs a break or he can lose his perspective and enthusiasm. Another important consideration is that photographers do need time off to keep their domestic life on an even keel. Many photographers devote too much time and energy to travel and assignments and consequently have lost their families or close friends, and, in the long run, lead a lonely life except for their profession, which often is their first love.

A number of *National Geographic* personnel other than the photographer and writer are responsible for the success of an assignment. An editor oversees the journalistic development of the story. Bob Gilka, senior assistant editor of photography, acts as chief coach to photographers and reviews the work that comes in to see that they are working to the best of their ability. Joe Scherschel, a former *Life* and *National Geographic* photographer, acts as technical chief and looks at all incoming slides to make sure there is no mechanical problem, such as a faulty shutter or diaphragm, that the photographer might not be aware of. Scherschel is also in charge of all equipment, much of it customized by staff technicians so the photographer can capture a difficult or "impossible" photograph.

Joe Scherschel is *National Geographic*'s straw boss on equipment and with him works a large staff of technicians who maintain the cameras that the staff photographers put through the most rigorous use. The staff and two large machine shops can create just about anything a photographer might need for an assignment.

The *National Geographic* supplies its staff photographers with all their equipment, from cameras and lenses down to camera boxes and bags. This same equipment is also available for contract photographers.

On the shelves in the stockroom are Nikon, Olympus, Minolta, Canon, Leica, Pentax, and Contax camera and lens systems. Many photographers

prefer a camera and lens with a focus ring that turns to the right, or an f-stop scale that turns to the left, or they just like the feel of a particular type of equipment. Also, the *National Geographic* is very diplomatic — it supports the camera companies, for some of them take ideas from the *National Geographic* and turn them into new items for their line.

Some of the photographers who work for the magazine go forth on assignment with three or four camera bodies and four lenses, while others may take a dozen camera bodies and twenty lenses. Robert Sisson is a *National Geographic* natural history expert and recently traveled to Hawaii to photograph fourteen newly discovered species of carnivorous caterpillars. From there, he flew to California to do another assignment on tide pools. The two projects took nine months and nineteen cases of equipment. According to Scherschel, there appears to be a rule of thumb at the *National Geographic* — the smaller the subject or the longer the assignment, the more equipment the photographer will be loaded down with.

On a three-month assignment, a photographer often takes six camera bodies, two motor drives, and a winder. Lenses are 15, 20, 24, 35, 50, 105, 300, and 500 mm, and sometimes the photographer takes along backup lenses, in case one breaks down or gets dropped into some bottomless lake. Most assignments are completed with lenses from 24 mm to 105 mm. Some lenses go through phases. The fish-eye and the 180 mm are not as popular as they were and zooms, even the 80–200 mm Nikkor, are not used as much as they were a few years ago.

After an assignment, a *National Geographic* photographer returns his cameras — which in most cases have suffered a 50 percent casualty rate. The breakdown level of the new electronic cameras is very high and only recently have new cameras, such as the Pentax LX and Canon's new Fl, offered both manual and automatic operation at the higher speeds. Staffers have found the Nikonos IV, an automatic camera, has a tendency to overexpose underwater, and they have been buying up obsolete models of the Nikonos. The 180 mm Nikkor f/2.8, *Geographic* technicians found, has spherical aberration. They discussed the problem with Nikon, which subsequently came out with the Nikkor 180 mm ED f/2.8, which is much sharper and free from aberration.

The lament from the technical men at *National Geographic* is that there have not been professional cameras on the market, as there are professional cinema cameras.

Lighting, when traveling, is a big problem and staff photographers go to either very big or very small electronic flash units. For the large job the storeroom offers 1000-watt Balcars. Many, though, travel with up to six Vivitar 283's, a small flash originally designed for amateurs but found to be very reliable. The units are converted to a different synch system and use fast-recharging batteries by Armato Photo Service of Glendale, New York (see box on page 115).

The preferred film is Kodachrome and most popular is ASA 64. Ektachrome 200 is heavily used, but Ektachrome 400 is unpopular as the yellow dye layer in the film does not have good definition and fails to separate well.

The most innovative work is done by the *National Geographic* technicians when they custom design equipment. They made a rain jacket for an Olympus so it could be used on canoe trips, in the surf, in rain forests, and so forth. They attached a permanent sport finder to the Nikon FE (which is made so the prism is not changeable), made a special underwater housing for it, and then rewired the new finder so it would be automatic.

They made a splash housing for an Olympus and Nikon FE for Bill Garrett when he had a story to do on rafting the Grand Canyon. It is made of polyvinyl chloride, has a waterproof zipper, and keeps the water out down to fifteen feet.

A recent project has been to make a strobe that shoots twenty frames a second through fiber optics. It all started when Bob Sisson began photographing those carnivorous caterpillars that reside in Hawaii. As Sisson was using a strobe to photograph the caterpillar about to attack an unsuspecting insect, the flash caused the caterpillar to jump and the insect won his freedom. Eventually the lab figured that an ultraviolet cutoff filter over the strobe would help, and it did. Without the filter, the strobe was giving the insect an instant sunburn. The fiber optic strobe is designed to be used with objects about 10 mm long. Two fiber optic heads will allow Sisson and other nature photographers to create modeling effects. The UV cutoff filter will be built into each flash head.

Tom Smith, senior editor of illustrations, is responsible for the presentation of the article and helps determine when a take on an assignment is complete.

While in the field, a photographer usually returns his film in batches of 30 to 40 rolls. A photographer on a major story will expose between 150 and 800 rolls of film. Staff photographers are more selective in their shooting than contract or free-lance photographers, for contractors and free-lancers are allowed to keep and resell all photographs not selected for the story, while every transparency shot by staffers becomes the property of the magazine.

Photography for the *Geographic* can be arduous. In some instances it takes half a year for a photographer to produce the photos, and much longer before they appear in print. The photographer is assured tremendous backup in logistics and support to achieve the best pictures possible, but the final result, for a photographer, is to be able to say that his work has appeared in the *National Geographic*, which is more of an accolade to the magazine.

What It Takes

Getting into photography is tough, but one man who made it to the top of the photoillustration field in twelve years is William Kennedy. He does advertising photographs of people with products in his New York studio and at the four corners of the world.

Kennedy has this to say on where photography is going and what it takes to stay with the trends.

"Getting into this business, you have to research what is ahead. You can't just go get a loft downtown and try to start. You have to realize what kind of money is involved to start on the level at which you are going to have to compete.

"This kind of work — at least for me — is a sixteen-hour-a-day involvement. That would be a minimum. Anytime I shoot something, it must be edited and no one can do that but me. There are hours and hours spent editing or looking for locations. Your eyes are your life. If you are really involved, you are constantly looking for exciting images. Photographing probably takes the least amount of time in the job. It's the preparation; talking with the client, getting props and locations, then after the shoot it's editing, more talking with the client.

"The qualities it takes to be successful at this work begin with the ability to have an enormous amount of concentration — you can't let anything intrude on you. It takes a great diplomatic ability. It takes talent, having the correct graphic eye, the ability to interpret trends and be ahead of trends. You also need an eye for casting — you develop that by recognizing a model's weaknesses, then you know where a model can be used. You have to be com-

PETER MILLER

William Kennedy

pletely unflappable no matter what the situation is while you're shooting.

"Most people go wrong in getting into photography because they haven't investigated the business. And it is a business; there's no other way you approach this. You need a business sense, even if you have an agent to handle that part of it.

"As far as education is concerned, there are only a few schools in the country that are worth a young photographer's time: Brooks on the West Coast and maybe Rhode Island School of Design or Visual Arts and Pratt Institute in New York City. Other than that, just get into the business as an assistant and work. It's an apprenticeship. You will learn more in one year, than in four years at one of the supposed art schools.

"What the schools do wrong — unless they have working professionals teaching — is they are archaic most of the time. The technical aspects roar past you. The technology today is so fast and the changes are so radical that you can have a tool and a week later something comes along to replace it. What's happening today is that still photography is a field that is totally saturated. I tell young people, forget stills, go into film. There has been an enormous shift in money that has gone from one portion of the media to the other."

Kennedy wrote these comments about being a professional photographer in *Photo District News*:

The exhausting part of photography is due to the total concentration necessary while at the camera over extended periods of time.

I recoil when I hear the words: 'It's just a simple shot.' There's no such thing as a simple shot. As we all know, a photograph isn't just physically shooting a picture; it most frequently involves hours or days of advance preparation.

My studio is a controlled-light environment. This has taken great expense, time and experimentation to perfect. To compete on a professional level anywhere in New York City, it will cost in the neighborhood of $50,000 to over $100,000 to get properly started in the business. The days of renting a loft, buying a 35 mm camera and labeling yourself a 'commercial photographer' or 'advertising photographer' are over.

Creativity is an all-consuming life-style in which finding and arranging colors and shapes into unique designs becomes an obsession. This obsession is carried into every waking hour. I constantly compose with my naked eye even as I move around the city.

A creative day is an experience in momentum. If I'm not bothered by mundane details, I find creative thoughts feed upon themselves forcing my mind onward to more exciting images.

Love, music and superb films influence my work.

When I travel extensively and shoot constantly, I find that a worldwide palette will fire my imagination. When I'm shooting places or people, I look for unusual compositions which contain brilliant or monochromatic color or a combination of both. When people are discovered within these scenes, they must contrast violently with their surroundings. Next, I compose using the law of thirds to create as much tension as possible within the frame. Then silently my eye commands my finger to fire. I keep remembering, only strong, highly graphic, individual images will sell.

Using blur effectively in your photographs can be highly advantageous. Abstractions don't need model releases; therefore, they are very salable.

Shoot what interests you the most and what you feel most deeply about. Know when *not* to shoot. Don't undertake jobs that do not fall within your expertise.

Remember, you're only as good as your last job.

2

GETTING EDUCATED

Education:
The Limits of Learning

Learning to be a photographer is a lot like learning to play a musical instrument: you learn the fingering and the skills required to manipulate the equipment and you learn what can be produced under a given set of circumstances. You acquire these mechanical and technical abilities by practicing, memorizing, and repeating until they are ingrained.

What neither a musician nor a photographer can learn, however, is the art, the emotion, the involvement that results in the expression of a persuasive new idea; in short, the creative act.

Education in the formal sense is so accepted in our society that it is assumed one learns even this, creativity, in the school environment. Yet, many — most — of the great and successful photographers came by their professional achievements through the less formal means of trial and error, looking, thinking, and doing. Today, everyone is in a hurry to be at the top and education seems to be the shortest route. Certainly, most people do not lack visual stimulus and variety on paper, film, and tube. What they may lack is depth in seeing and a sense of how visual recording and interpretation evolved — a knowledge acquired through familiarity with painting, sculpture, architecture, and design. They also may lack a sense of understanding people — both the subjects of photographs and the viewers of photographs — that comes from literature, history, psychology, sociology, and just plain living.

But formal photographic education has some dis-tinct benefits. First, there is the discipline of doing assignments and projects, as well as the stimulation and mental stretching from sharing experiences and ideas with like-minded students. For most people, the greatest benefit is probably the task of focusing their values and intelligence to establish what they are and how they think — their distinct interpretation of the world about them.

However one becomes educated in photography — through schools, workshops, by reading about and looking at pictures, by being an apprentice, or by solitary practice — the successful result is the ability to absorb what one sees, clarify it, express it, and make the image comprehensible to the viewers of the pictures.

The Education of a Photojournalist

Chuck Fishman is a free-lance photographer who worked with Contact Press Images in New York for about five years before going on his own as a free-lancer. He got assignments through Contact and also created story ideas independently.

Photo assignments have taken Fishman to many countries in Western Europe, Poland, the Carib-bean, Greece, Africa, Turkey, Egypt, and Israel, as well as throughout the United States. At twenty-eight years of age, he has published one book of photography, *Polish Jews: The Final Chapter*, and his

RUDI FREY/CONTACT

pictures have appeared in most newsmagazines around the world, including one *Life* cover. He's followed the Pope on tour, traveled in chauffeured limousines, and slept in mud huts.

What preparation and route are required to reach the goal of becoming a photojournalist? Fishman's road may not be typical, but it worked at least once.

"The first class I took in photography was my last year in high school," he says. "I had to struggle to get in because it was filled, but I was referred by an art teacher and I was accepted. I bought a camera from a friend — I think it was an Argus 35 mm. I liked the teacher and made a couple of nice pictures.

"With my graduation money and a little more from my parents, I bought my first new camera, a Pentax. Then, when I got to Northern Illinois University, the first thing I did was try to get a job on the newspaper, but I was told there was no room. Every few weeks I would call to make sure there was still no room and whenever something hap-

Chuck Fishman of CONTACT in Poland

Chuck Fishman with Lech Walesa on assignment in Gdansk, Poland, in December 1980

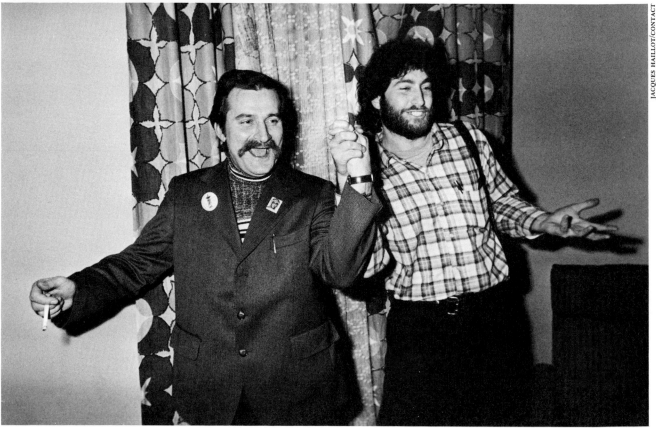

JACQUES HAILLOT/CONTACT

pened I would bring in some pictures just so they'd get to know my face.

"After that first semester I was allowed to work on the newspaper, and that's where I got my start shooting film. Everyone else was paid, but I wasn't because they still said they had too much staff. I took every photography course they had at the school, which wasn't much, and I majored in liberal arts.

"That summer I was still with the newspaper and a bunch of us crammed into a car and drove to Miami Beach for the Republican National Convention. There was gas and riots and I still remember what I was wearing: cutoff shorts and a T-shirt, but with that I got on the convention floor.

"Kodak processed our film there in Versimat machines in three minutes, and they had little darkrooms where you could make contact sheets. *Time* magazine had a desk and I took my contacts over there to Alice Rose George, who was then a photo researcher. (She later became picture editor for *Geo* and then for *Fortune*.) She circled a couple of frames and I was in heaven. Nothing got published, but that was my first professional connection.

"When I went back to school in the fall I was made chief photographer, largely because I was the only one who lasted long enough. So that next year I worked on the newspaper and I was paid."

Fishman earned enough money on his newspaper job and doing sorority group pictures to decide to see something of the world. He bought a round-trip ticket to Amsterdam and hitched around Europe and the Mediterranean, and wound up in Israel for six months. He had planned to take pictures and then sell them on his return to the United States, but the theft of his camera in Rome changed that. Instead, he spent the war of 1973 working on a kibbutz as well as in a hotel.

But the year on his own in foreign countries solidified some goals for Fishman. He decided that he liked the life-style that went with travel and world events, and he decided to study photography seriously.

"After that year I got back to the States and I looked for a place where I could major in photography. There were places like Rochester Institute of Technology, but that was highly technical with emphasis on commercial aspects and laboratory work. I didn't care about that, but at Southern Illinois

A Few Facts about Photographic Education

- According to a survey of educational institutions offering instruction in photography sponsored by Eastman Kodak, growth in photography departments and courses peaked about 1976–1977. Since that time there has been a steady decline in the increase in the number of students and the number of programs offered.
- California, New York, Texas, and Pennsylvania lead among states with institutions offering photography instruction.
- Of the 995 institutions responding to the Kodak survey, the number of students enrolled in still photography classes was: 91,980 undergraduates, 1593 in masters programs, 73 in doctoral programs, 460 in other programs (often associate programs), for a total of 94,106. This compares to 110,972, 2904, 76, and 755 for a total of 114,707 during the 1976–77 survey period.
- The number of graduates from those institutions in 1979 was: 1841 bachelors, 409 masters, 116 doctorates, 2020 associates, for a total of 4386. This compares to 1328, 273, 42, and 1293 for a total of 2936 in 1976.
- Photography jobs filled by the 1980 graduates were: 161 in free-lance photography, 144 in fine arts photography, 65 in newspaper photography, and 13 in magazine photography. This compares to 742, 601, 455, and 106, respectively, in 1976.

University they had a four-year major in photography. It was a state school so all my credits from Northern Illinois transferred. I knew I wanted to get a university degree — because I promised my parents that I would return to the States and get *them* a degree.

"The Cinema and Photography Department was in the College of Communications along with television and journalism. It was not in the Art Department, but you could take fine arts photography as well as portraiture, journalism, illustration, studio photography, and history of photography. I spent a lot of time in labs — more than the accredited hours.

"To get in the department you have to have a portfolio. A student can't just walk in and say, 'I'd like to take a class' — he or she has to know about photography. In the first class you learn to use a

4 × 5 view camera and review the basic lab stuff. A later class covered magazine layout of photography, and I spent the whole semester doing four or five stories and laid them out for a magazine. In different studio courses we learned about lights and working with models and products, and doing color photography.

"Right away I got a job on the school newspaper, which was very helpful, and I would recommend that to anyone interested in a career as a photojournalist. Not that it's such a great job, but the only way you can improve yourself is to keep shooting film and seeing and making mistakes. A job like that provides the opportunity to shoot someone else's film while you learn. Most of the time I was either working or taking classes.

"The summer after the first year at Southern Illinois, I went to Poland with a writer on a joint project. We went as a team to do a book about the Jews there and were in Poland a little less than two months. I came back and printed the portfolio and got credit for it as an independent project.

"Five months later, over the winter semester break, I went to New York City with that portfolio of Polish Jews and spent three weeks seeing photographers, magazines, agencies, and publishers. Robert Pledge, who is now with Contact Press Images, wanted the portfolio and he was interested in another idea I had planned: to shoot the old New Orleans jazz people. It was totally different from the Polish Jews story.

"The trip to New York worked because I knew what I wanted and I knew my market was photojournalism."

Fishman returned to finish school and had tentatively accepted a job in the library at Magnum, but it wasn't immediately available when he graduated. Then an assignment in Louisiana came through Contact and Fishman was on his way to cover it and to begin a career as a photojournalist.

"I found the university education was valuable because it gave me four years in which to grow up and make mistakes," he admits. "And in the photography department, the most beneficial course was magazine layout. Portraiture is something you always need to know and in commercial courses with the 4 × 5 camera you learn little things about technique and perfection and patience to make sure the shot counts. History of photography is valuable, to

know how your profession came about. But the worst course was color printing — a total useless hassle. I would never do color printing.

"The work on the college newspaper was the most valuable, because with a press pass and a lot of fast talking you learn to get into anywhere you want to go. And that kind of skill is absolutely necessary to do the kind of work I'm doing now. You have to deal with people in a very short time and if you don't deal with them correctly, you are totally shut out. On a newspaper assignment, you have to — must — come back with a picture even though there is nothing going on. You learn to see things even though nothing is there."

Both the Polish Jews and the New Orleans jazz people were published as portfolios in several magazines and both were exhibited in the Modernage Gallery in New York. His book was published after Fishman was established at Contact.

"The important thing about a photographic education is not to exclude any part of it because you think you won't use it. The worst thing that will happen is that you'll be bored. And you never know when some obscure aspect of what you learned will come in handy. But I still wouldn't make a color print for anything."

The Making of a Photographer's Assistant

Chad Weckler has a soft voice, winning smile, and warm blue eyes. He's self-assured, strong, helpful, and you just know he would be kind to little old ladies crossing the street. At twenty-eight, Weckler was one of the top photographer's assistants in New York City, having worked for more than thirty photographers over a six-year period. His personal qualities as well as his technical know-how put him in a position to call the shots on assistant jobs. From that position he moved into a career in photography and film production. But beyond that, Weckler's experience as an assistant made him realize the need to educate assistants about the job of being an assistant in order to get educated about the job of being a professional photographer. He organized and directed an assistants' committee for the American Society of Magazine Photographers, organized an

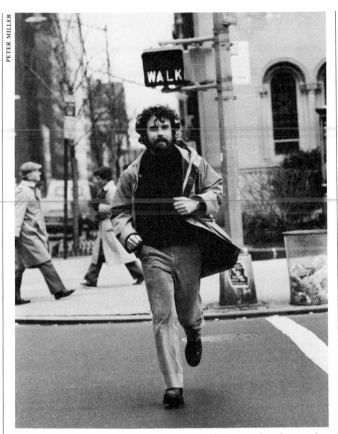

PETER MILLER

Super Assistant Chad Weckler is now a full-time free-lance photographer

assistants' handbook, and started an assistants' referral program.

"My father is a photographer and was always one of the top guys when we lived in San Francisco and now is also in New York City. He never encouraged me to get into this business," says Weckler. "But I was interested and I wanted to be the best."

Weckler spent three and a half years at Brooks Institute of Photography in Santa Barbara, California, studying industrial and scientific photography, portraiture, illustration, and motion picture techniques. He also devoted time to the study of photography annuals starting back in the fifties and sixties. He reasoned that all the photographers represented there were going to be his competition, so he wanted to learn from them. After formal studies, he went to New York City to specialize and learn the business side of photography. In the first two years, he worked for two photographers on a full-time basis and then did free-lance assisting in a broad variety of fields.

"Formal education is important to becoming an assistant and I recommend it," says Weckler. "There are good schools like Brooks, Rochester Institute of Technology, and the Art Center College of Design. But ultimately you have to ask yourself: What am I interested in and what kind of photographer do I want to be? You have to think on a long-term basis. This investigation takes time, but you won't waste time later doing the wrong thing. The best way to do this is to look at the books — *Communication Arts* and other annual awards publications. This research is your foundation. It's like building a house: you must first have a good foundation to hold it up.

"Then you should go to a city and work for somebody who does the kind of photography you want to do. When you assist for different types of photographers you get a lot of insight about business practices and photographic styles, but if you want to specialize, in say still life, work only for the best still life photographers. That way you gain a reputation for yourself, because people hear you worked for so-and-so and believe the seed must not fall far from the tree.

"You can specialize in some cities like Chicago, Atlanta, Los Angeles, and Dallas, but one year as an assistant in New York City is equivalent to two years in most other places, because there's more happening, there's more business, there are more photographers, and you are constantly involved in new experiences. I know photographers who have been working in their own businesses in other cities who go to New York to assist for a year or two just to get the experience and then they go back.

"In fact, there is no barrier on who becomes an assistant. Some are teenagers, others in their twenties or thirties or forties — they come in all shapes, sizes, and ages. Sometimes they are people who have been working at something else — some have been art directors — and they know that assisting is a good way to learn and be paid for it.

"There is, unfortunately, some sex discrimination, though. I know women who telephone a photographer for an interview and can't even get them to see their work or see what they can do. Photographers say the women can't do the job because they can't lift things. Occasionally there is lifting of heavy equipment in an assistant's job, but not all men are capable of lifting either. I tell women they have to keep trying and not give up. Show the photogra-

Where Credit Is Given

The Photographic Arts and Sciences Foundation (P.O. Box 143, Huntingdon, PA 16652) is an accrediting agency for schools teaching professional photography curricula. Based on courses taught, faculty, and facilities, these are the schools that organization has accredited:

Brooks Institute (Bachelor's Degree)
2190 Alston Road
Santa Barbara, CA 93108

Fanshawe College (Associate Degree)
57 Oxford Street East
London, Ontario N5W 5H1
Canada

Hallmark Institute of Photography
 (Diploma)
At the Airport
Turners Falls, MA 01376

New England School of Photography
 (Diploma)
537 Commonwealth Avenue
Boston, MA 02215

School of Communication Arts (Certificate)
2526 Twenty-seventh Avenue South
Minneapolis, MN 55406

The American Council on Education for Journalism (Box 838, Columbia, MO 65205) accredits four-year colleges offering journalism curricula. In the photojournalism sequence, these institutions have been accredited:

Bowling Green State University
Bowling Green, OH 43402

Indiana University
Bloomington, IN 47401

University of Minnesota
Minneapolis, MN 55455

University of Missouri
Columbia, MO 65201

Syracuse University
Syracuse, NY 13201

University of Texas at Austin
Austin, TX 78712

Western Kentucky University
Bowling Green, KY 42101

pher they have respect for themselves and respect for the photographer."

Weckler says the way to get into the business of being an assistant is to start making telephone calls. Get appointments, go to the studios, and even during short visits and interviews, keep your eyes open to learn how things are set up. Follow up your visit with a résumé and a note, and then start the process all over again.

"There's increased competition in recent years for the jobs available," says Weckler. "Unfortunately, there are too many people who want to be in this business who don't know photography. Most photographers want people with experience because they don't have time to train them. Even with experience when you get hired, it's 90 percent personality. If you have 90 percent experience, but your personality is wrong, you won't get hired.

"An assistant does everything from sweeping the floor to cleaning out the toilets to picking up the laundry, processing film and printing pictures, loading cameras, pre-lighting the set, working with art directors — even 'producing' the assignment and taking over for the photographer to take the pho-

tograph. It's important to realize that being a free-lance assistant is a business. My aim is to get away from the so-called assistant who is called a 'gofer' or a 'slave' or a 'schlepp.'"

Weckler sees assistants falling into five categories based on experience and education. First there is someone with very little or no experience and some educational background. At this level the pay scale should be at least the minimum wage or $25 to $30 a day for free-lance work, $125 a week for full-time jobs. Second, there are people who have more experience and a better understanding of studio and professional work. They should receive about $50 a day as free-lancers, $175 or more per week. Third is someone with at least two years as an assistant for several photographers and who knows a lot more of the business. Here the pay should be about $60 per day, $250 per week. In the fourth category, assistants begin to have titles: "first assistant" or "studio manager." This person can take over a lot of the direction of a studio or a shooting and supervise other assistants. The pay at that level is $75 a day, $300 or more a week. An assistant in the fifth category might be called a "technical adviser." This is

an assistant photographer who knows how to light a set, arrange a shooting, and who can really produce the job by him- or herself. At that level the pay should be about $100 a day or more, and $400 to $500 and more a week. Some assistants with this experience may get a percentage of a job, working more as a partner to the photographer who gets the assignment.

"There are a lot of other benefits to being an assistant," says Weckler. "You can work with good people, travel, have fun, learn about the business. It's a profession and a learning experience. I've been to London, Paris, Mexico, and half the states in the United States doing just about every kind of job. On assignments I've had to wear everything from three-piece suits to bathing suits. Once on a free-lance assisting job with Steve Steigman we did a shot illustrating a 'bumper crop.' So we went to a farm with a small field in front of a farmhouse and I had to help plant aluminum car bumpers on end in the ground. I worked for Scavullo on a free-lance basis. He uses two assistants, one who does the lighting and one who loads the cameras.

"There are hazards to the business, too. At the beginning level — in the first category — some people get duped into working free for photographers. Some photographers say: 'Well, I did it that way ten or fifteen years ago, and these new people should do it that way now. Maybe they should be paying me, in fact.' Remember, being an apprentice does not mean you work for free. It never has. Working for free is working for free.

"Some assistants get burned out. Photographers yell and scream at them to show the amount of power they have and the assistants think it's part of their job to put up with that. They really don't have respect for themselves. They're afraid if they ask the photographer to stop yelling, the photographer will say, 'If you don't like it, get out.'

"That's the worst of it. The best is working for someone like Maureen Lambray, who specializes in portraits of film personalities. She gives assistants responsibilities and challenges, and she is respectful to them and everybody else. Tom Hollyman, an industrial and corporate photographer, is another good one. When we're on a job, he introduces me as his associate. We're more like a team. I'll put up lights, but Tom will put up lights, too. I'll get the camera ready, but he'll do that, too.

"As a technical assistant you may be hired to actually produce the picture — the photographer clicks and gets the check. Some photographers make a business out of taking pictures, but they are not necessarily experts at taking pictures. They may have been around photography in different capacities — as an art director, designer, artist, publisher, or editor — and think it's an interesting profession where they can make some money. Because they come from agencies or magazines, they have friends who give them jobs. Sometimes it's more than they can handle. Their attitude might be, 'Oh boy, I've got a problem here. There's a still life to do and I've never done a still life. But the job pays $1000. I'll hire an assistant for $50 a day who will set the whole shot up and I make $950 on it and I may get future work from the tear sheet.'

"The other type is the photographer who is honest and a reasonable human being and who says: 'I've gotten the job, but I don't know how to do it. I'll hire an assistant and *split* the fee. I'll get a learning experience and the tear sheet, but the assistant has the opportunity to use his skills and get a monetary reward, too.'

"On the other hand, you can gain a reputation for being a top assistant and negotiate fees to give you a good living. There's a parallel to the film business, where you have a director and assistant director, first assistant, production managers.

"Most assistants begin to make portfolios for themselves while they're assisting. The biggest problem with these portfolios is that there's no consistency — they have a little fashion, a still life, and an industrial shot — it's all a jumble. But after about four or five years you can build a consistent portfolio, you have the stationery, the telephone number, and some equipment, and can go out and get your own photo assignments.

"One big problem with some young photographers is cutting expenses and doing jobs for practically nothing in order to get tear sheets. Then later, when they become more successful and as a result get more overhead and want to make more money per assignment, they get cut out by other, younger, photographers who are repeating in their footsteps.

"Photography is a very popular field to get into. It's glamorous, it can be creative, you can be your own boss, have your own business, and make a lot

Sources of Courses

- *Popular Photography, Modern Photography,* and other consumer magazines regularly list workshops and seminars in photography, particularly in the spring issues. Names, addresses, and brief descriptions are provided.
- *A Survey of Motion Picture, Still Photography and Graphic Arts Instruction* is published periodically by Eastman Kodak. The seventh edition, prepared by John Mercer of Southern Illinois University, covers the period 1979–1980. Colleges and universities are listed with addresses and courses offered.
- *Photography Market Place,* by Fred W. McDarrah, lists universities, schools, and workshops offering photography instruction. Along with address and telephone number, the director's name is given and there is a brief description of subjects taught and facilities provided.

of money at it. But it's really like a funnel; the small end is the number of people who get into it and the big end is all the people who want to. Five or ten years ago, there was a lot more work for photographers and the rates — especially editorial — were higher. Advertising rates have gone up a little, but not compared to inflation, and editorial rates have even gone down in some cases.

"As a photographer, the pressure is making sure you stay a photographer. Some photographers have gotten high blood pressure, bad backs, ulcers, arthritis, and eye problems from being in this business. Especially in advertising, it's dog eat dog, too hectic, a lot of work, and some people in the business may not be totally honest.

"I believe photography is reaching its peak. It's beginning to decline and will continue to decline. We already have TV annual reports, twenty-four-hour-a-day news service, and TV magazines. We'll always have photography as an art form, but the business is on the decline. I tell people that if you want to stay in this business for a long time, if you want to be a survivor, you have to build up that foundation. You must understand photography is a business."

Workshop Shopping

Every summer there's a photographic migration to rustic seaports, picturesque country villages, and epic mountain settings. These attractions draw photographers and would-be photographers, not just because they're there and photographable, but because they are the sites of summer workshops.

Photographic workshops have been growing in number, format, location, style, and offerings for the past decade. Each spring anybody who ever chanced to get his or her name on a mailing list associated with photography is inundated with brochures, posters, and appeals about photographic workshops — each one proclaimed as the greatest thing since stop bath. And most photographers — no matter what their level of competence and experience — are sooner or later susceptible to a fortifying of the will, a resuscitation of the eye, and therapy for the tender photographic ego.

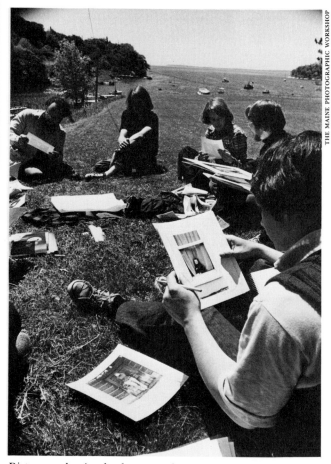

THE MAINE PHOTOGRAPHIC WORKSHOP

Picture evaluation by the sea at the Maine Photographic Workshop

What Is a Workshop?

Photographic workshops are short, intensive periods of work, learning, and personal growth, an opportunity to live, breathe, and eat photography twelve hours a day for a week or more. A workshop is a place to become totally involved in your photography, to increase your knowledge, improve your technical skills, and expand your ability to visualize — to see. There are no distractions here, no interruptions, no outside demands to take you away from this process of working and learning. A workshop is not a vacation, *it is work*, but you will leave with new inspiration, new insights, and new friends.

A workshop is also an experience, and one that may change you, may alter your opinions and your way of seeing. A workshop is a process — a process of growth, and growth means change. But this process is slow and requires at least a week of hard work. The process, we find, rarely begins for our students before midweek. By this time you are rolling along, comfortable in your new environment, producing work and images that are consistent with your normal work. But this is not enough. The instructor demands more — you demand more. You begin to work in new areas of craft, vision, and creativity. You explore new ideas and concepts, make new friends and develop new relationships, and discover new facets of your own abilities and personality. These are not really new; your ability to see them has been sharpened, you have become more aware.

Something often happens toward the end of a workshop week. Something snaps. You find yourself pushed past your normal level of work and perception, pushed toward a new level of understanding and appreciation. This is risky business. Part of this process requires you to attempt new things and there is always the possibility of failure. It is dealing with this risk, with the possibility of failure, that allows the process to work. You leave after a week of work and exploration refreshed, enthusiastic, full of new energy and inspiration. But this works only if you allow it to, for it requires an open mind, a willingness to experiment and participate, and a deep involvement in photography.

For some, the workshop experience is a long-awaited trigger that may result in a change of career and life direction. For others it is a new level of self-awareness and self-confidence and a clearer way of seeing. For still others the workshop process is an opportunity to meet their peers, share their frustrations and joys, and gain new inspiration for continued work at home. For everyone, a one-week workshop in Rockport is the chance to meet fellow photographers, acquire new skills, and learn more about their craft. This is the least we can do — the most that can be done is really up to you.

The Workshop in Rockport is unlike other educational experiences. Here the challenge of the work and the joy of sharing our work and photographs create the experience. Here the craft of photography is both the end in itself, and the means to a greater end. Every photographer needs the tools of his or her medium, but the learning of the craft can be an experience resulting in a greater understanding of life and self, and end with a deeper appreciation of excellence and of our own creative powers.

The emphasis here is on doing it, rather than talking about it. Assignments are opportunities to try something new, to stretch, to explore. Competition is strong, but that competition is within each of us, not between individuals. The learning process comes from the interaction between workshop participants, their relationship to the material and instructor, as much as from the work done.

A workshop is very much like a gathering of musicians who have come together to rehearse and practice their music. The group has selected a conductor (the instructor), a theme — jazz, classical, folk, or pop (the landscape, portraits, still lifes, and so on) — and now is ready to perform. Each player has come with an instrument (camera) for which he or she possesses a degree of expertise, along with a knowledge of music, tempo, rhythm, scale, and the ability to express these individually. It is the same for photographers, but this experience of playing together is strange; most photographers work alone. But here, working together, sharing our images, our creativity and problems, learning from others, helping others, is not only a valuable educational experience, it is a joy.

— David H. Lyman
Director, Maine Photographic Workshops

Well, why not enroll in one of them?

There is an assumption in our society that all education is good; ergo, photography courses are good for photographers. In fact, after trial and error, more and more victims of these summer camera clambakes call them a waste of valuable time and money. That's probably the least of it. Some workshops disseminate misinformation, cause frustration, damage the muse, and most likely are fattening to boot.

Lists published in four periodicals one year indicated that there were more than two hundred different workshop offerings in every kind of setting across the United States. And each year the number

grows. This represents only a small part of what is actually available from public and private schools, colleges, Y's, community art centers, museums, and individuals with enlargers in their basements. With the proliferation of cameras and camera enthusiasts, the number of people who think they can teach photography increases proportionately. "Those who can, do; those who can't, teach," is the old saw that sums up a type of chutzpah — often combined with the principle of simply staying ahead of the students. Thus, the hazards in selecting a worthwhile workshop are great.

Strictly speaking, it's difficult to define or even categorize photographic workshops. They range in scope from a two-hour session once a week to two weeks in the New Hebrides to two months in residence at an isolated farmhouse to two years of work/study leading to a "certification of completion." The workshop focus may be aesthetic or technical, artistic or commercial, theoretical or psychological. The experience may include outdoor camping, canoeing, hiking, sailing, or beaching. It may encompass personal fulfillment and self-expression. It may deal with the nuts and bolts of subjects like lighting portraits, still lifes and illustration, or making solarized prints. Workshops may be for beginner, intermediate, advanced, or professional photographers. They may be located in the city, at the seashore, or in the canyons of the Southwest.

Photographic workshops may be any of the above, but never all — although some of the literature would make them seem to be. "It's frankly a matter of economics for many of these workshops," says Rae Russel, who runs small, specialized classes in Mount Kisco, New York. "You need fifteen or so people to profitably run a class, so people say they can offer everything to everybody."

The buzzwords for identifying the all-purpose type of workshop are: "geared to the student's interests" or "adapted to the student's needs." With a limited amount of time and talent for teaching, these freewheeling classes must necessarily meet the needs of the lowest ability level in the class. More informed students have their questions ignored or are ostracized by class members because they know more. Either that or they become instructors out of self-defense.

One student found himself in a studio photography class in which it was obvious that, even as an

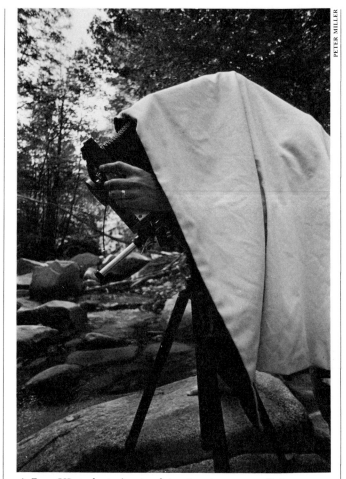

A Zone VI student aims to abstract a stream near Putney, Vermont

amateur, he knew more than the instructor. Eventually he learned that the instructor was a substitute who had worked in the studio of a famous-name pro. The famous name was called to a highly profitable assignment and sent his new assistant of one week. The "student" set up lighting demonstrations, explained techniques, and created assignments for himself and the other students. "I wanted to send the 'workshop' a bill, but decided to leave and forget it," he said.

But big names don't necessarily mean knowledge or good teaching or even a pleasant personality. One workshop offers "name" photographers two weeks of free room and board in beachside apartments in exchange for spending time with paying students. Most of these pros are dedicated and interested enough to make themselves available, but without formal class arrangements, a few of them

are more absent than present. One former student said a couple of the stars came and waved a wand once in a while or told a few anecdotes about other famous photographers ("what Stieglitz said"), but didn't mix much with the students.

Name photographers do, however, usually offer more than merely panache to a summer workshop. "If you go with a guy who can photograph and you are a good learner, you'll find the inspiration in yourself," says Fred Picker, who conducts summer workshops in Putney, Vermont. "When I took a course from Caponigro, a grunt was more informative than a whole speech from some other guy."

Less renowned instructors, on the other hand, often have a greater dedication to teaching and sharing. The photography teacher whose vocation is teaching may have more time to spend looking at student portfolios, supervising darkroom work, going on field trips, and meeting structured course objectives. At less advanced levels, a non-name with credentials and knowledge may be preferable to a bored big name without communication skills.

Probably the greatest hazard in selecting a workshop is the self-promoted "big name" whose salesmanship supersedes his photographic knowledge or ability. One professional photographer who does creative slide presentations attended a commercial illustration course for "advanced amateurs and professional photographers." From the beginning he realized the other students were less than aspiring amateurs — dilettantes. The instructor was basking in their admiration.

"At the first class meeting this guy handed us a sheet of rules of conduct during the workshop — it was like est or some kid's school — and I counted more students than the maximum stated in the sales brochure," says the photographer. Eventually he also found there was to be no model for photographic sessions as was stated in the brochure, the darkroom was small and used for demonstrations only, the instructor experimented unsuccessfully with a new type of color enlarger head during the class sessions, and the course was a lecture ego trip without the "work" implied in *workshop*. "The guy kept telling us we could make money by selling to calendar and greeting card companies. I had done that and it's peanuts," says the former student. "He kept pushing certain brands of cameras and one afternoon took us to a local camera store like a shill

in a Moroccan rug market. I should have known I was in the wrong place when the motel prices were twice the amount advertised in the brochure."

That may be the grossest example of a bad work-

21 Questions to Ask While Workshopping

1. What do you really want and need from a photography workshop?
2. What is the major theme of your work?
3. What photographer(s) would you turn to for inspiration or use as a model?
4. Are you willing and able to work hard and complete assignments?
5. Can you remove the pressures and problems of your home and job life while at a workshop session?
6. Can you be open-minded about new or unorthodox ideas?
7. What are the scope and emphasis of the course as stated in the brochure (aesthetic, technical, beginner, advanced, and so on)?
8. How much (or little) is promised in the literature?
9. Does your self-evaluation (above) match the course content?
10. Does the instructor fit your description of a model or inspiration?
11. Do the instructors go on field trips, work in the darkroom, participate in discussion groups with students?
12. Do they critique your portfolio and work during the sessions?
13. Is the class formally or informally structured?
14. What facilities and equipment are offered for your use?
15. How many people will be in the class?
16. Are people of different ability levels combined in the same class?
17. Do you like the locale?
18. Will the workshop provide names of previous students for references?
19. Does the workshop want to know something about you before accepting your money? (A portfolio for advanced classes or a biographical sketch.)
20. Do they ask you what you already know about photography and what kind of work you are doing now?
21. Is the workshop's refund policy fair according to your needs?

shop experience, but in fact even the most ethical workshop operators admit that not everyone can be happy in photography courses. Some people drop out because of fear of exposing their work to criticism; others because they cannot adapt to a group experience; others because course content comes too close to some inner psychological mechanism. A major complaint of students is overcrowded classes that don't permit individual attention and assistance. Via Wynroth, director of the Education Department of the International Center of Photography in New York City, answers that criticism with the admonition, "Be greedy. It's your time that's important and you have to get the most out of the instructor yourself."

Even at prestigious Rochester Institute of Technology in Rochester, New York, students have found courses not as they seemed to be. "There have been times when the course description didn't live up to expectations," admits Andrew Davidhazy, adjunct chairman for the Photography Department at RIT's College of Continuing Education. "When the instructor's description of the course was not the same as that in the catalog, we gave full refunds provided it was very early in the class session."

More typical is the Maine Photographic Workshops' policy of a full refund minus the fifty-dollar cancellation fee and fifteen-dollar application fee thirty days before the course begins. A refund of half of all fees paid is granted prior to completion of one-fifth of a course. The working axiom is: if you're unhappy, get out early.

If you are unsure about what course is right for you, go to a workshop at which several different courses are run simultaneously. If you are in the wrong course, you might be able to transfer to a different course or sit in on lectures and discussions with other instructors.

Fortunately for workshop operators, there's a growing group of attendees who are never unhappy with the content, the instructors, the other students, the place, the facilities, even the weather: the workshop junkies. These people simply like the atmosphere at workshops. They are not particularly photographically inclined and not even selective about what courses they take. Their whole idea is to commune over cameras while they explore themselves and look for relationships. After all, it's a great way to take a vacation.

The Essential Photographic Library

A spin-off of the photography boom of the past decade is a boom in books of and about photography. These range from the most elementary instruction books (for example, most of Kodak's output) to highly technical treatises describing esoteric photographic processes; from finely printed monographs of inner messages produced in limited numbers to mass-produced best-sellers that photographically extol the banal or obvious.

Yet, a wide selection of photographic books are worth studying because of the impact that the photographer or author has made on photography. They may be landmark records of one person's way of seeing (Henri Cartier-Bresson's *Decisive Moment*, W. Eugene Smith's *His Photographs and Notes*, Robert Frank's *Americans*, Ernst Haas's *Creation*). Others are important because of their basic reference value (Ansel Adams's *Negative* and *Print*, the *Photo-Lab Index*, David Vestal's *Craft of Photography*, and Beaumont Newhall's *History of Photography*). Still others are significant because they reflect unorthodox photographic vision or thinking (Richard Avedon's *Portraits*, Elliott Erwitt's *Photographs and Anti-Photographs*, Joel Meyerowitz's *Cape Light*, and Susan Sontag's *On Photography*).

The list following does not include all of the books that have made a major contribution or have influenced the photographic medium in recent years, but it does encompass a basic, well-rounded library from which to get information or inspiration.

Basic Instruction

Ansel Adams, *Camera and Lens*; *The Negative*; and *The Print* (New York Graphic Society, Boston, Massachusetts). Essential texts that delve deeply into the fine points of the craft. With careful and continued reading, one can learn the necessity for matching the lens, negative, and format size to the print. Good lessons in developing negatives and how to manipulate prints.

Eastman Kodak, *Filters and Lens Attachments for Black-and-White and Color Pictures* (Rochester, New York). Simple, well-illustrated review of the glass that goes in front of a lens. Covers basic filters as well as special-effect attachments. Section on the use of a matte box.

———, *The Joy of Photography* (Rochester, New York). A big book full of practical and easily understood information about the basics of photography. Answers many questions and is illustrated with very effective photographs.

———, *Professional Photographic Illustration Techniques* (Rochester, New York). Top commercial photographers share step-by-step procedures in creating advertising photographs. Lighting techniques are illustrated, secrets are revealed, and ideas are explained.

Maitland Edey and Constance Sullivan, *Great Photographic Essays from "Life"* (New York Graphic Society, Boston, Massachusetts). Twenty-two of the

powerful and moving essays from the heyday of *Life* magazine are presented as they appeared originally. Names include Abbott, Bourke-White, McCombe, Eisenstaedt, and Smith. The story of the merging of photography and journalism.

Arnold Gassan, *Handbook for Contemporary Photography* (Light Impressions, Rochester, New York). A technical manual that ranges from beginning darkroom work through esoteric advanced steps for art photography. Solid and reliable, but heavy going.

Wilson Hicks, *Words and Pictures* (Arno Press, New York City). *Life's* former picture editor gives his versions of creating the message in the medium. An intelligent approach to combining photography, layout, and journalism.

Henry Horenstein, *Black and White Photography: A Basic Manual* and *Beyond Basic Photography: A Technical Manual* (Little, Brown, Boston, Massachusetts). Both books written in simple and clear language, but containing solid information of value to photographers of all levels. Authoritative and well illustrated.

John Hedgecoe, *The Art of Color Photography* (Simon and Schuster, New York City). Geared to workers at all levels. Each spread covers a different topic with instruction that's fairly basic. But lots of very good illustrations to inspire new approaches and ideas for color work.

Eleanor Lewis, *Darkroom* (Lustrum Press / Light Impressions, Rochester, New York). Interviews with a number of photographers reveal details of their techniques for print making. Besides interesting insights into approaches, there are a number of good ideas on tools and recipes.

Life Library of Photography (Time-Life Books, Chicago, Illinois): *Color*; *The Camera*; *Light and Film*; *Special Problems*; *Photography as a Tool*; *Frontiers of Photography*. The series that did much to advance the photography boom in the seventies is revised and updated. At times the books tend to be simplistic, but text and pictures often spark new approaches and ideas. Some from the first series are still a good buy, if you can find them.

Jack Manning, *The Fine 35 mm Portrait* (Amphoto / Watson-Guptill, Cincinnati, Ohio). This *New York Times* photographer shares his experiences photographing celebrities and common-folk in the line of duty. How he prepares for an assignment,

Buying Books

Bookstores are the obvious places to buy books, but they are not necessarily the most complete, least expensive, or most innovative source for photographic books. However, in many large bookstores you will find the popular trade books that deal with photography.

For more obscure books (those published by small presses or by the photographer him- or herself), for very specialized books (on a particular aspect of photography or by a lesser-known photographer), or for books out of print, you'll need to go elsewhere.

Most major cities and many smaller towns have galleries that specialize in photography. Often these galleries sell books, postcards, and posters as an extra source of income. Museums, whether or not they do photographic shows, are also good sources for photographic books. Many museums publish catalogs of books they carry as well as reproductions and other gift items. In New York, the International Center of Photography has a large store devoted to books and posters, and publishes a catalog with a selection of its stock.

Photographic books that are out of print are a bigger problem, particularly since many books are now collector's items. A source close to home might be an older relative's bookshelves or attic. Interesting photographic books can still be found at flea markets and in antique shops, but most such sources have been picked clean by professional collectors. One dealer in old books (and other photographic collectibles) is Tom Burnside (Pawlet, VT 05761). He publishes a catalog, *Photographic Antiques and Literature*, for $5.

solves problems, and handles people is clearly explained.

Fred Picker, *The Zone VI Workshop* (Amphoto / Watson-Guptill, Cincinnati, Ohio). Covers the entire sequence of taking a picture to making a print with data on equipment, chemistry, and tests to determine how well they function. Easy-to-understand description of the Zone System.

Ernest M. Pittaro, editor, *Photo-Lab Index* (Morgan and Morgan, Dobbs Ferry, New York). A straight reference book with data on film, weights, and measurements, chemical formulas, developers, and other essentials. Also available in compact form.

Arthur Rothstein, *Photojournalism* (Watson-Guptill Publications, Cincinnati, Ohio). Looking at photography as communication, Rothstein explains

the how-to of news, features, and essays in photography. There's much about the history and technique of photojournalism.

Harvey Shaman, *The View Camera: Operations and Techniques* (Amphoto / Watson-Guptill, Cincinnati, Ohio). A well-illustrated primer on using the large-format camera, with clear explanations of controls and movements. Also, how to preconceive an image to get the right effect.

David Vestal, *The Craft of Photography* (Harper and Row, New York City). A chapter-by-chapter account of how to get a good photograph and print. Very clearly written and illustrated. Authoritative.

Black and White Classics

Ansel Adams, *Singular Images* (Morgan and Morgan, Dobbs Ferry, New York); *The Portfolios of Ansel Adams* (New York Graphic Society, Boston, Massachusetts); and *Yosemite and the Range of Light* (New York Graphic Society, Boston, Massachusetts). Adams's sensitivity to light is so acute that every photographer can profit by a periodic review of his pictures. Reproductions in these books are worthy of the master's great printing.

Diane Arbus, *Diane Arbus* (Aperture, Millerton, New York). Her penetrating photographs of the insane, nudists, homosexuals, fanatics, midgets, and giants changed the subject matter of photography. Few can look at them without a personal reassessment.

Eugène Atget, *The World of Atget* (Horizon Press, New York City). These pictures of Paris at the turn of the century were among the first highly realistic studies of light and space. As recordings of a place in time, they have yet to be duplicated.

Richard Avedon, *Portraits* (Farrar, Straus and Giroux, New York City). Many critics believe that Avedon permanently influenced the art of great portraiture. These stark studies of the famous and the near-famous are as chilling as they are revealing.

Bill Brandt, *Nudes, 1945–1980* (New York Graphic Society, Boston, Massachusetts). Using a wide-angle lens, Brandt began a series of studies of the nude form in 1945 that broke with established tradition. Since then he has periodically returned to the subject with more original views.

Henri Cartier-Bresson, *Henri Cartier-Bresson: Photographer* (New York Graphic Society, Boston, Massachusetts); *The Decisive Moment* (Simon and Schuster, New York City); and *The World of Henri Cartier-Bresson* (Viking Press, New York City). As a photojournalist and as an artist, Cartier-Bresson was a pacesetter in modern documentary photography. These monumental works have influenced scores of professional photographers. Composition, movement, timing, can be studied here.

Direct-Mail Dealers

Besides specializing in photographic books, these dealers sell books by mail. Visual Studies Workshop and Light Impressions also publish books. Visual Studies carries many limited-edition titles, those from small presses, and rare artist's books. Light Impressions also carries an array of other hard-to-find supplies and tools for use in photography. A Photographer's Place has a stock of out-of-print books and specializes in bargains obtained from publishers, bookstores, and distributors. The International Center of Photography has a catalog of distinguished photographic books. *Daguerreian Era* is a catalog of photographic antiques and literature, most of which is rare or out of print.

Daguerreian Era
Tom and Elinor Burnside
Pawlet, VT 05761

The Focus Gallery
2146 Union Street
San Francisco, CA 94123

International Center of Photography
1130 Fifth Avenue
New York, NY 10028

Light Impressions
Box 3012
Rochester, NY 14614

A Photographer's Place
133 Mercer Street
New York, NY 10012

Visual Studies Workshop
31 Prince Street
Rochester, NY 14607

Witkin Gallery
41 East Fifty-seventh Street
New York, NY 10022

Direct-Sales Publishers

Some publishers sell their own books directly to the public. Catalogs provide lists of books.

Addison House
Matrix Publications, Inc.
27 Benefit Street
Providence, RI 02904

Amphoto
Watson-Guptill
1 Astor Plaza
New York, NY 10036

Aperture, Inc.
Elm Street
Millerton, NY 12546

Arno Press
3 Park Avenue
New York, NY 10016

David R. Godine
306 Dartmouth Street
Boston, MA 02116

HP Books
P.O. Box 5367
Tucson, AZ 85703

Eastman Kodak Company
Rochester, NY 14650

Morgan and Morgan, Inc.
145 Palisade Street
Dobbs Ferry, NY 10522

New York Graphic Society
34 Beacon Street
Boston, MA 02108

Bill Owens
Box 588
Livermore, CA 94550

Petersen Publishing Company
Book Division
6725 Sunset Boulevard
Los Angeles, CA 90028

Time-Life Books
Time and Life Building
541 North Fairbanks Court
Chicago, IL 60611

Elliott Erwitt, *Photographs and Anti-Photographs* (New York Graphic Society, Boston, Massachusetts). Seeing humor and anticipating events require an eye that is sophisticated and quick. Erwitt, a master of the pun and the put-down, conveys messages with his craft as much as with images.

Walker Evans, *American Photographs* (East River Press, New York City); *First and Last* (Harper and Row, New York City); and *Photographs for the Farm Security Administration* (Da Capo, New York City). The essence of time and place is captured succinctly and powerfully in Evans's work. With or without people, you have a clear picture of the personalities who occupied his spaces. His photographs set a standard that later influenced American journalism.

Robert Frank, *The Americans* (Grossman Publishers, New York City). A definitive book with a sharp, brutal view of American life. Highly influential after the work of Evans.

Jill Freedman, *Circus Days* (Harmony Books / Crown Publishers, New York City). Documentation of life on the road reveals much about people and animals in this unreal/real world. A long essay sensitively treated and selected. Freedman took the time to capture the essence and spirit of circus life.

André Kertész, *Sixty Years of Photography* (Grossman Publishers, New York City). One of the first street photographers, Kertész captured life on the move, often with an ironic twist. A highly effective melding of composition and content.

Josef Koudelka, *Gypsies* (Aperture, Millerton, New York). A single-handed documentation of a dying culture that captures the spirit of a people. Powerful emotions and a sense of destiny are starkly portrayed.

Dorothea Lange, *Dorothea Lange* (Museum of Modern Art, New York City). Lange's most famous pictures have overshadowed the breadth of her work. Her statements influenced not only photojournalists but social history as well.

Lisette Model, *Lisette Model* (Aperture, Millerton, New York). Capturing the instant of self-revelation, Model established a way of seeing that later influenced numerous photographers. Her eye saw humor, complexity, subtlety, as few photographers did before or have since.

Arnold Newman, *One Mind's Eye* (David R. Godine, Boston, Massachusetts). Environmental portraiture that captures not only the character of the sitter, but the mood of his or her life space as well. Portraits as an art form, practiced by a master.

Bill Owens, *Suburbia* (Straight Arrow Books, San Francisco, California). "This is how it is" photo-

journalism. Owens's view of life in a suburban California community has so much truth it hurts. A model of discipline and craft.

Irving Penn, *Worlds in a Small Room* (Viking Press, New York City). People from around the world photographed as records of physical presence in a stark, portable studio. The austere environment gives Penn's subjects a new look and dynamic.

W. Eugene Smith, *His Photographs and Notes* (Aperture, Millerton, New York) and *Minamata* (Holt, Rinehart and Winston, New York City). Smith is deeply dedicated to photography as a truth-sayer, and his work exemplifies the ability of the medium to deliver a message. His pictures are moving and illuminating essays of events, people, times, and places.

Paul Strand, *Sixty Years of Photographs* (Aperture, Millerton, New York). The substance of much of Strand's work is a combination of inner searching with world themes. His vision influenced artists and journalists.

Weegee, *Weegee* (Alfred A. Knopf, New York City). One man influenced the perspective of photojournalism: Weegee. He photographed the grim events and the personalities of New York, but he looked over his shoulder as well as in front for unusual and revealing shots of people experiencing the main event.

Edward Weston, *Fifty Years* (Aperture, Millerton, New York). Clouds, landscapes, nudes, peppers, shells — the visual world as an emotional experience is revealed in Weston's work. His great skill gives depth and feeling to the most mundane object.

Color Milestones

Eve Arnold, *In China* (Alfred A. Knopf, New York City). The mystery of this hidden country and its people is revealed through the skilled vision of Eve Arnold. A landmark in color photojournalism.

Harry Callahan, *Color: 1941–1980* (Matrix Publications, Providence, Rhode Island). Known for his black and white studies, Callahan moved into color and excelled himself. Superb use of color to convey depth and form as well as mood and light.

Kodak's Words

One of the largest publishers of photographic information, books, pamphlets, brochures, and data sheets is Eastman Kodak. Wisely, they publish an annual detailed index to all this outpouring and will send it free for the asking. Called "Index to Kodak Information," it is available from Eastman Kodak, Rochester, NY 14650.

Ernst Haas, *The Creation* (Viking Press, New York City). Simply what color photography is all about and where its potential is. One of the few books that show color used so freshly by a photographer who sees within for his vision without.

Neil Leifer, *Sports* (Harry N. Abrams, New York City). Capturing the peak moment and planning for the epic event are the essence of sports photography. Leifer's aim and timing are as fine-tuned as the skills of a world-class athlete.

Joel Meyerowitz, *Cape Light* (New York Graphic Society, Boston, Massachusetts). Everyday scenes and events are captured with a subtle and luminous vision beneath the summer light. Each picture leaves questions for the viewer as to the mystery of its content.

Fulvio Roiter, *Venice* (Vendome Press, New York City). In what is more than a picture book of a city, the unique form and substance of Venice are portrayed through color. Weather, time, mood, light, are beautifully captured.

Criticism and History

A. D. Coleman, *Light Reading* (Oxford University Press, New York City). A collection of this very opinionated and controversial critic's writing in recent years. Bound to stir a reaction whether you agree or not.

Gisele Freund, *Photography and Society* (David R. Godine, Boston, Massachusetts). A fascinating study tracing the history of documentary photography as it evolved through and within society.

Nathan Lyons, *Photographers on Photography* (Prentice-Hall, New York City). An anthology of essays

Book Clubs

Two clubs specialize in photographic books. As is the case with most book clubs, new members receive a batch of books at a bargain rate. From then on the price is lower than the published rate, but not a big discount when you add postage and handling. Biggest advantages are the convenience of ordering by mail and the preview of recently published books.

Photography Book Society
Front and Brown Streets
Riverside, NJ 08370

Popular Photography Book Club
1515 Broadway
New York, NY 10036

by photographers past and present. One of the first efforts to have photographers verbalize their philosophies and points of view.

Janet Malcolm, *Diana and Nikon* (David R. Godine, Boston, Massachusetts). A collection of articles that appeared in *The New Yorker*. Malcolm applies classical aesthetic standards to modern photography.

Beaumont Newhall, *The History of Photography* (Museum of Modern Art, New York City). A classic text tracing the roots of photography with historical photographs. Important for understanding how we got here.

Susan Sontag, *On Photography* (Farrar, Straus and Giroux, New York City). Moral and ethical questions are raised about the seemingly mundane occupation of photography. This book has been studied and criticized.

John Szarkowski, *Looking at Photographs* and *Mirrors and Windows* (Museum of Modern Art, New York City). A basic pair of books: the first studies photographs that have withstood the test of time, and the second those that are trendy and might (or might not) withstand the test of time. The Szar-

kowski perspective is highly influential, although not universally accepted.

Handbooks

John Hedgecoe, *Pocket Guide to Practical Photography* (Simon and Schuster, New York City). A condensed review of material contained in his books. Each spread deals with a particular topic in text and pictures explaining and illustrating the points. Good to carry for inspiration.

Eastman Kodak, *Professional Photoguide* (Rochester, New York). Invaluable for the photographer in the field. Data on films and reciprocity, color temperatures, and available-light work. Many charts and tables for reference.

Larry L. Logan, *The Professional Photographer's Handbook* (Logan Design Group, Los Angeles, California). A truly professional reference to be carried in a camera bag. Major topics are: exposures, focal lengths, filters, and applications of electronic flash; close-up, infrared, and underwater photography. Marvelously complete and informative.

Publishing:
Where the Magazines Are

Photographers love to read about photography. At least it would seem so, because there are close to three hundred photography magazines, newsletters, tabloids, journals, and other scheduled publications published throughout the world. These range from the mass magazines to newsletters about photo contests. There are publications for members of photographic organizations, for people who work in specialized fields of photography, for those who collect cameras, those who are concerned with the history of photography, and those who want to sell pictures.

Publications come and go so fast that there is no central method to maintain contact with all of them. Two books that have lists of publications (although they are outdated even before they go to press) are *Photography Market Place* and *Stock Photo and Assignment Source Book*, both by Fred W. McDarrah. The *Stock Photo Book* has lists of foreign as well as U.S. publications, and both provide addresses, telephone numbers, rates, and circulation data.

The Ad/Edit Connection

Publishers love photographic magazines, for they are as light is to moths — they attract readers and pages of advertising. This wealth of advertising can be a blessing, but it can also cause skepticism among readers. Too often the coverage of new equipment is backed up with advertising, and in tests of a comparative nature between products, they usually say nothing, positive or negative.

The fact is, advertisers and publishers of magazines are applying more and more pressure on editors to "lace" the editorial content in favor of the advertisers or potential advertisers. This is a factor with photographic magazines as well as other specialty magazines that must utilize one industry for advertising. Once advertisers achieve the upper hand and realize power, they can blackball a magazine.

However, photographic magazines have proliferated in the past five years as photography has gained favor in the fine arts field and located itself in the new pop culture of snapshot "creativity."

Modern Photography and *Popular Photography* are hand-in-hand competitors. They are the oldest publications, the most technically oriented, edited for a mass audience, and the most successful in terms of circulation and the number of advertising pages. They can drive you cross-eyed with long reviews of new cameras, lenses, and film — *Pop Photo* even shows pictures of all the parts that make up a camera, as if this would help the reader take better photographs. Occasionally these magazines have important technical articles, particularly on processing black and white. Both magazines have very good columnists who are often experts in their field, such as electronics and large-format cameras, or are nuts-

and-bolts working photographers. *Modern Photography* has gained respect for tests on equipment, especially lenses, but the tests of color film often let the reader guess which is best, and the guess is muddled as the examples are poorly reproduced by the printing process. The best thing about these magazines is that the reader does learn about new equipment, through either the edit or ad pages, and where to buy at the least expensive price in America. In retrospect, these magazines are best at selling the products that are on the advertising pages.

Petersen's Photographic is designed for the do-it-yourself and gimmick photographer. The editors go into detail with schematics, on how to build a light box or solarize in color or otherwise mutate a photograph. It is truly an experimental amateur's magazine.

American Photographer is a relatively new magazine now owned by CBS. It originally was directed at art photography, but pulled back to discuss the inner workings of the professional and art photographer. The magazine tends to be too cute, especially with the In Camera column, Assignment spread (readers contribute to that page), and occasional sophomoric parody articles. However, it has a very perceptive photography critic in Owen Edwards, and some of the articles, particularly profiles, are superbly written by free-lancers. Equipment is not discussed much and when it is, it is discussed poorly. This magazine is the literate photographer's magazine, which is an anomaly, for most photographers work with the gut and the eye rather than the brain.

Camera Arts is published by Ziff-Davis, which also publishes *Popular Photography.* It is the company's answer to art photography. The magazine is lushly printed, as is *American Photographer,* and can be far-out or trendy to the point where one wonders who in America is the taste arbiter in fine arts photography. Apparently there is minimal arbitration on what is good or awful.

These are the most popular magazines found on newsstands. There are also a number of tabloids that show the work of young photographers. Some of these tabloids are startling, some are good, some are terrible. They can be bought in art stores or at leading photo galleries.

An Interview with a Photography Magazine Editor

Ken Poli is the editor of *Popular Photography,* the largest-selling photography magazine in the United States; perhaps in the world. In this interview he answers questions about the influence of the consumer magazines on the phenomenal growth of photography and where we may be headed.

Q **You've been with *Pop Photo* for sixteen years. What changes have you seen in photography in those years?**
A There's a tremendous loosening up of approaches to pictures. There has always been this nutty argument: is photography art or isn't it? Well, my contention is that it's a medium and it's nothing but a medium, the same as oil paints are to painting. Art is created with them when Michelangelo uses paint and a house is painted when somebody else uses paint. The analogy holds in photography. It's not an art, but there are artists using cameras. Always have been. But now more people are using cameras and therefore the medium itself is being either

Pop Photo's *editor Ken Poli*

stretched and widened or violated, depending on your point of view.

If you take the medium of color photography and apply the technology of laser photography to give a different feeling or to alter colors in the image, I would consider that legitimate handling of a photograph. You're starting with a hard reality and altering it without departing too far from the medium itself, which is basically technical. On the other hand, attacking SX-70 Polaroid prints with an orange stick — that may be art, but I really don't think it's photography, particularly because you very often end up with something that could easily have been done with a pencil or crayon or another medium. So there is a crossing of lines now among the graphic arts, and photography is becoming more at one with them.

At the same time the hardware itself is getting closer and closer to electronics — active little solid state brains are going into cameras and the actual skill of handling a camera, handling the medium to a great extent, is not needed by a photographer now. In other words, some of the reason we're getting more people into the art side of photography is that they don't have to discipline themselves for as long to learn how to handle complicated equipment and to handle exposures. The need [for mastery] is still there, but ideas of self-expression *can* take place without that mastery. I don't think that is necessarily a good thing, because I think the discipline of learning the medium should be at the basis of every photographer, the same as a painter should have a solid basis in that skill.

Q Haven't the consumer photographic magazines been largely responsible for this simplistic approach to art photography?

A I think the photography magazines are reflecting that approach because their audiences come from all directions, they come in at all levels, and they come because photography is such a catholic medium. I mean, if you are interested in optics, you may get into photography; if you're interested in chemistry, there's that in photography; art, there's that; gadgetry, God knows if you're a gadgeteer it's the fields of heaven for you in photography. So the audience of photography represents a big cross section. And then within the field you've got all the divisions: portraits, industrial, commercial, photojournalism. The magazines have had to expand the breadth of coverage as the interests of the audience expand. It's also difficult just from a photomechanical point of view to illustrate the latest advances in photo chemistry and materials because the state of the art is so high and the differences are so fine that you really have to get into extreme enlargements — let's say twenty to forty times enlargement — to show grain differences. Whereas on a practical basis, most readers are only going to see eight

or ten or fifteen times enlargements where the difference would hardly be visible to the eye. I think that some current technological arguments are like medieval ones about angels standing on the point of a pin — more technical than practical.

Q As far as the photography magazines are concerned, has the content changed dramatically since you've been in the business?

A I don't think too much, aside from the widening, because you still must have your basic stories on overexposure and underexposure, how to use exposure meters, how to control the meter built into your camera. The basic ways of talking haven't changed too much because

Covering the District

Two years ago Carl Pugh was a photographer's assistant looking for work. Today he is the publisher of the world's only newspaper for professional photographers, *Photo District News*.

Pugh's enterprise started innocently enough when he was looking for a place to advertise his services as an assistant. There wasn't such a medium, so he bought a book about how to start a newspaper, followed its directions, and in the process switched careers.

Although *PDN* was originally directed toward the professional photographers in New York City's photo district (the Twenties, east and west of Fifth Avenue), its appeal has grown and now there are about 4000 subscribers in New York and 6000 elsewhere in the United States and foreign countries.

The main thrust of *PDN* is to provide business advice to photographers in the advertising and illustration fields. There are articles on taxes, finding a rep, creating business forms, hiring an accountant, and designing a proper studio. *PDN* does profiles of photographers, art directors, camera store owners; reviews restaurants in the district; carries a little humor; runs a page each for Los Angeles, Chicago, and the Southwest; and has a classified section. It also carries lots of advertising for professional equipment and does short coverage of new equipment for pros.

Photo District News does not do how-to articles.

While *PDN*'s direct audience is professionals doing fashion, still life, industrial, and illustration work and to some extent those doing editorial and journalistic coverage, it is not aimed at wedding or portrait photographers. Still, they read it — as do students, art directors, and assistants.

Subscription price is $8 for 11 issues (they skip July). Contact: New York Photo District News, 156 Fifth Avenue, Room 816, New York, NY 10010.

beginners still have beginner problems. Not as acutely, because some of them are solved by the equipment, but the curiosity is still there, the questions are still there in the minds of the readers.

The use of color film has increased the amount of color reproduction needed by the photo magazines, because the emphasis on the part of hobbyists is trending into color. So I think the magazines are using more color pages in the course of a year and more of them are given over to tutorial material, whereas fifteen years ago you just had pretty pictures.

Q What's the profile of your readers?

A Mostly they are serious hobby photographers who are pretty well along in their skills, taking satisfactory pictures. They don't have too many failures when they come back from a vacation, but they always want to go onward and upward. At least, they want to emulate the best works they see.

We have a number of beginners — I don't know what their numbers are — but the turnover in readership is once every three or four years. After that length of time many serious photographers feel they have learned all that a magazine can teach them. If one wants to get more skills or more personal instruction, he or she perhaps goes to a school or a workshop or an individual teacher. But this kind of reader is constantly being replaced over the years by beginners coming in at the bottom and working up. Of course, we do have readers who say, "I've been reading your magazine since 1937," and so forth, but there is a constant turning over. That's why I said the problems or concerns stay pretty much the same, but

The Wolfman Report

Each year the definitive economic survey of the photographic industry is published and distributed to about 12,000 people in the marketing and financial world. These may be stock analysts or Japanese businessmen watching their profits.

The Wolfman Report supplies statistics, research reports and sales figures such as:

- There are approximately 16 million 35 mm single lens reflex cameras in use in the United States.
- In 1979 approximately 2.6 million cameras were shipped to retail outlets; 2.2 million were SLRs.
- The typical SLR user is male (three out of four times), between twenty-five and fifty years old, married, with children. His median income is $24,500.
- There are between 100,000 and 120,000 full-time professional photographers in the United States.

usually with variations because the materials are different and there are technological breakthroughs from time to time.

The kind of pictures, of course, have changed too. You're not getting all the pictorialism that you used to. People's ideas of what a photograph should be have changed over the years and I think the magazines reflect that because they reflect what is coming in. And what's coming in is quite wild sometimes. Some of the work you see in the galleries we simply wouldn't use because we do go into homes where there are young children.

Q Yet, people say as far as the picture pages are concerned, you have to have a gimmick to get published. How important are the oddities and far-out things rather than just fine pictures?

A I would like to think we're reflecting what's happening. Perhaps there is a certain media effect where photographers may be shooting this kind of stuff thinking that if they do we'll use it. But we don't pick on the basis of gimmickry, but rather by how striking the stuff is. Of course, the problem is that in twelve issues a year plus other publications we have here, you have to have variety. You can't have the same feeling every month or it would get boring. And you're also dealing with a medium that is based on reality: it's the real world that is photographed, so there are only a certain number of variations you can work with. With the huge upsurge in the number of pictures being made, in the number of art photographers, so called, who are working and submitting, I think they have to go farther and farther out just to be different among their peers. I think it's regrettable, but it's what is happening.

And yet, some of the best pictures that come in are used just because of the way some photographer has seen an event or a scene. It may be quite straight work, but done in a very individual way. There may be nothing unusual about the picture subject matter except for the way the photographer saw it.

Q Although your audience is getting younger, there have been comments on your fuddy-duddy old approaches, particularly in columns.

A One man's "fuddy-duddy" is another's experienced adviser. I'm here sixteen years, but some of the people in the office have been here twenty years or more and we're growing gray together. That represents a lot of experience in the medium. I don't know where that criticism came from, but I suspect it came from other magazine people and that wouldn't surprise me. I get lots of letters here with criticism, but that particular one hasn't come in from readers. Meanwhile, we have more readers than any other photo magazine on the planet.

Q It appears that photography is peaking out in growth. Is that reflected in any way in readership?

A It has not yet been indicated by circulation, which is about 860,000 and has been growing every year. It was around 400,000 and something for many, many years and it was about that when I got to be editor. I wish I could take a bow for the growth, but it was just then that photography began to take off, because I know that our chief competitor's growth on a percentage basis has been close to ours. They've always been somewhat behind and the gap has stayed almost the same, but their circulation has increased, too, since the time when ours was lower. The field is now supporting *American Photography, Darkroom* magazine, *Petersen's* — all magazines that didn't exist a few years ago — and new ones keep coming up. Our sister magazine, *Camera Arts,* is just about a year old and flourishing.

Q How do you compare the character or personality of the two major consumer magazines?

A I think *Pop* and *Modern* are the shotguns, the broad gauge approach where we try to touch most aspects of photography. We also concern ourselves quite a bit with the hardware, because the tools are basic to photography, and the people who are about to use them, particularly beginners, want to know more about how they work. Optics and photo chemistry also need to be expanded. Also, a lot of readers like to make things, they like to make their own equipment and darkroom gear, a hands-on kind of thing, and they like to save money because photography can be an expensive hobby. So we have to have fairly broad coverage.

Q Do you see a difference between the two magazines?

A I'd like to think that we're a little bit more concerned with the aesthetic side of photography than *Modern* is. I don't know that that's absolutely true, because I've never done a total analysis.

Q Is there anything in either magazine that would interest professional photographers?

A Yes, I think professionals are always interested in how their peers work, what they're doing. So interviews with working pros interest them. We do that fairly often. But that's one of the problems for all magazines in the field. Although the number of pages in the magazine is greater than it was some years ago, the increase isn't proportionately as great as the expansion of activity in the field. Therefore it's more difficult with a broad coverage magazine to do everything you think you should do. There simply isn't space, although our editorial/ad ratio is about 40/60.

Q What is the influence of advertisers on your editorial content?

A Minor, I would say. Of course, we are pressured to give good reviews to certain cameras and other equipment — I'd be lying if I said not, but if we get a camera in here and check it out and it doesn't cut the mustard, we just won't report on it at all. We ignore it. I don't think we've ever given a good review when it wasn't deserved. There is fierce pressure sometimes, but we've never reviewed anything as being good if it didn't meet some minimum requirements.

Q Do readers ever question or comment about the fact that you don't really say that this one is the best one or that one is not as good?

A Sure, sure. But I say that there's more to choosing a camera or a lens than just the objective tests. You have to handle it yourself to make up your mind. People may want you to make up their minds for them, but with the general level of equipment today, it's pretty generally going to be satisfactory. There are a lot of individual things, like the brightness of the finder, where controls are located, where your fingers fall on them, which way the lens turns to focus — these are often more important in choosing a camera for *personal* use.

Q Yet, professionals have definite preferences about which equipment to buy. There are about four brands that professionals use and they don't use any others. Are you suggesting that other brands are just as good and professionals don't look at them?

A If you're talking about the very low end versus the very high end, there are bound to be corners cut internally and in construction details. But there are other things, like how handy are the service facilities when things break down (and they all break down sooner or later), how quickly do they get them back to you, do they stand behind their warranties, how good is the quality control. Lab tests can't determine much about quality control; you have to be in the factory to judge that.

Q How about the mail-order advertisers in the back? Do they pressure you?

A If they do it's through the publisher and he's been a good buffer. I've been pressured by being asked to use a product and presumably write it up. I did try one and I didn't like it, so I didn't do anything with it. *Modern* had a big column about this product. Maybe they liked it, but I didn't.

Q As editors, do you get a lot of equipment dumped on you to try? Is it given to you?

A At *Pop* we have a check-in/check-out system to keep the equipment under control as to what comes in and goes out. Minor things you might get free, but major things like cameras, lenses, enlargers, and that sort of thing are controlled. Manufacturers and distributors are sent a request form when we want to test or borrow equipment and it's only valid with a couple of signatures from specific people here. So they don't ship us anything unrequested if they expect us to be responsible for it. If editors do get something without that form, the magazine is not responsible for it. We are making a real effort to

keep it controlled. I have no firsthand knowledge of out-of-channels equipment.

Q What future changes do you see in photographic magazines?

A Crystal balls have a tradition of being very cloudy, but if video disk players ever get the mass usage that TV sets now have, I could conceive of a publication with a floppy disk bound in. It would be removable and put onto video to supply moving images for instruction that you can't put on printed pages. I don't think you can successfully replace printed pages, though, because you can't get in-depth information in a small enough space in other media.

I think the main problem is going to be with the photographer's own vision. I think a great many of the technical problems are now behind us — the hardware will do almost anything you want it to, lenses are marvelously versatile and relatively inexpensive. But ways of seeing are being burned up so fast, the same way television burns up a comedian's material. A guy who could go on a vaudeville circuit for two years with an act, burns it up with one appearance on television. An image, a way of seeing, gets into a couple of shows, into a magazine with large circulation, and everybody has seen it. Then, that's dead, in

a way, and he has to find another way to be original.

The way things have been going, good, clean, straight, hard-edged work is going to be the new avant-garde. These will be pictures that can be looked at simply as observations, not as an examination of the artist's insides or an abstraction or an expression or a symbol for his fears. They will speak directly, forcefully, and quickly to the person who is looking at them. That sort of picture will always find a place.

What I find difficult are the things that are so navel-contemplative. When you look at them you think, "There has to be *something* that he must have meant." You say, "I don't get it, is there something wrong with me?" You begin to have self-doubts. After a certain time you realize, there's less there than I think or the guy didn't know what he was talking about or something. I think there's an awful lot of stuff now like that. A lot is being shown now and things are being read into it by whomever is hanging the show or doing the commentary. It may be there, but it may not be there.

That's always been the case with the graphic arts, which don't begin necessarily with an image of the real world. But photography that really does have something, after a certain number of years, will still hold up.

3

EQUIPPING YOURSELF

Cameras:
The Compleat System

For a serious photographer, buying a camera is a bit like marrying into a large Italian family — you are not marrying only the camera, but a family of lenses and accessories. You try not to make mistakes.

There are several rules to observe when buying a camera for professional use. Buy only the best, even if the price is high. By buying the best you are buying quality in material, design, and workmanship, and hopefully, the camera will last a long time. Buy a camera that is adaptable to your specialty. A journalist wants a camera that will stand up under dust and bumps, and might opt for the Nikon or Canon mechanical cameras, or might settle on Leica range finders, which focus very fast in low light levels with wide-angle lenses. A backpacker would appreciate the light weight of the Olympus series of single lens reflexes, while a serious landscape photographer producing calendars and posters might prefer a medium-format 6 × 7, a field 4 × 5, or a large view camera.

The next question the photographer asks is how adaptable the camera is to his or her needs. A sports photographer needs the maximum speed in rapid sequence, of five to six frames a second, which Canon, Nikon, and Pentax yield. Interchangeable viewers, such as a right-angle or sport viewfinder, are important to natural history photographers. If the camera is going to be used for remote control work, it had better have the accessories for that work, and should have automatic exposure. The camera selected should be well built, flexible for a variety of jobs, and equipped with accessories to complete special jobs.

But, as any damned fool should know, it is the lenses that make the pictures that the art director views and that provide you your living. The camera is no more than a box that receives information

Photo Equipment Guides

There are guides, tomes, catalogs, and numerous books on photographic equipment. Most of them talk about one make of equipment, or just accessories, or use the scattergun approach to photography.

An exception is *In Focus*, by John Holtz ($9.95, Harper and Row, New York City). *In Focus* talks about the best of the equipment and is extremely informative in explaining how much of the better equipment evolved. Simon Nathan's editorial hand seems to have wandered through this book. It is very useful, and, most important, it tells you how cameras and lenses work.

Released in the fall of 1981, *The Handbook of Photographic Equipment* ($15.95, Alfred A. Knopf, New York City) is a very thorough book on equipment, prepared by Adrian Holloway. It lists cameras, lenses, filters, tripods, flashes, studio equipment, films, papers and darkroom equipment, and setups. It's a good reference book with a number of photographs and illustrations. In each section is a buyer's guide listing the leading manufacturers and points to look for when buying. If you don't have a pro to clue you in, this book can point the way.

Two formats set up and waiting for the moon to rise

from the lens. A professional photographer must ask the question: How good are the lenses?

The manufacturers who are best at producing systems, make or design their own cameras and lenses. The lenses are compatible with the camera — they have the same type of mount, the same metering and aperture control systems, the same focusing system, and often the same objective diameter, so only one size of filter needs to be purchased. The lenses themselves are usually of very high quality and there are many different lenses for different uses.

The system photographer gets to know his or her equipment well enough to operate the cameras and the lenses in the dark — what direction the shutter-speed dial turns to increase or decrease speed, what direction the lens turns to focus to infinity, and in which direction the aperture control turns for larger or smaller f-stops. The system photographer can take a lens on or off in a split second.

It is after dark, the camera is on a tripod, and the

decision is to use a 180 mm for a 10-second exposure at f/8, when the flashlight conks out. The professional photographer should be able to do the following without looking at the camera: set the aperture to f/8, set the shutter speed at bulb or time (or, if the shutter speed works for 10-second intervals, it should be set at that speed). Reciprocity effect should be figured in and the double-exposure button pushed to increase exposure to the correct amount, using the shutter speed as timing. The mirror should be locked up to avoid vibration and the cable release attached to the release button, or the self-timer activated so the camera is not touched during the exposure. The photographer should be able to take the photographs in the dark, then rewind the film, reload, and shoot again, still with no light.

Long use of a system allows a photographer to perform these maneuvers by touch.

The system style of photography adds up to a large cash investment. Most photographers own at

least four bodies of the same-model camera, three motors, up to fifteen lenses, and accessories such as bellows, viewfinders, filters, remote control, dedicated flash. The price for all this can be over $15,000.

Equipment hustlers, photographers who jump from one system to another, make mistakes that can be costly. Divorce from a system should be done carefully, weighing a number of factors. Are the lenses as good as the former system and of enough variety? Will the body hold up? How is the price?

Single Lens Reflex Cameras

All of the systems on the market are good; the difference is that some have features others lack. The brands favored by most professionals are Canon, Nikon, Olympus, Contax, Minolta, Pentax, and Leitz.

Leitz is recognized for its superb lenses, as is Contax (Zeiss lenses), and Nikon for its ED telephoto lenses and general high quality of other optics.

Olympus is noted for the compactness and lightness of its equipment, Canon for its mechanical F-1 and programmable A-1 camera bodies, and Pentax for being the first to make a camera that is both mechanical and electronic. (Most electronic cameras operate mechanically at one shutter speed, usually about 1/90. Pentax's mechanical shutter works from 1/90 second to 1/2000, and the Canon New F-1 from 1/125 to 1/2000.)

Canon and Nikon have captured most of the professional market, primarily because they have been around long enough for professionals to have

Where to Find It

Names and addresses of manufacturers and distributors can be found in:

Photographic Catalog — published annually by Ziff-Davis and distributed (usually free) in photo stores

Studio Photography Magazine — carries a list in its annual reference edition in December

Photography Market Place, by Fred W. McDarrah — has a comprehensive list that includes telephone number, names of key personnel, and the products carried or manufactured

invested so much in their cameras that they can't afford to switch. Both brands have a large number of camera models and accessories. Nikon, for instance, has sixty different lenses, from a 6 mm f/2.8 220-degree fish-eye to a 360–1200 mm f/11 ED zoom lens. It also makes dedicated flash units, motor drives, extension kits, bellows, remote control devices, intervalometers, 250 and 750 exposure backs, special viewfinders, and much, much more.

Nikon equipment is expensive and it is well built. Canon and most of the other favored cameras are not quite as expensive, except the Leitz system, and you must be very wealthy to buy a working system from Leitz.

All of the above manufacturers make several grades of cameras, and though most are noted for their top-of-the-line products, their middle and low-end cameras can be good buys. This is important to someone buying into a system — the photographer can put money into a good lens or two made by the manufacturer and buy a cheaper camera. Later, when the photographer is flush, he or she can switch to the top-of-the-line camera and still use the lenses purchased initially.

A rundown on the best buys from the best systems:

The Canon A-1 was the camera that, in a way, opened Pandora's electronic box. Now all the camera manufacturers are turning inside out in their race to outpace the electronic wizardry of the A-1.

The first of the electronic whiz cameras, the Canon A-1

The Canon A-1 works like a small computer. Electronically, you have your choice of exposure control, which is aperture priority (you pick the f-stop), shutter-speed priority (you pick the speed), complete automatic control (you do nothing), and stop-down

aperture automatic exposure. There is manual exposure, but only at 1/90. The camera has an enviable LED (light-emitting diode) digital readout viewfinder that provides readings in half f-stops and between shutter speeds, and automatic flash exposure control.

Many professionals have moved to the A-1 and think very highly of it. There are about fifty Canon lenses to choose from.

The New Canon F-1 Professional camera is an updated version of the old mechanical F-1, now discontinued. The New Canon F-1 is the most advanced *professional* 35 mm single lens reflex now on the market.

The basic New F-1 is a manual-exposure match-needle metering camera, but it is a hybrid. Batteries operate the shutter from 8 seconds to 1/60, but the shutter speeds from 1/125 to 1/2000 plus bulb are mechanical. The shutter release can be either mechanical or electromagnetic. What all this means is that the camera will operate at the upper speeds if the batteries are dead or the circuits go haywire. This type of double insurance was first used in the Pentax LX.

Canon has included another feature that the Pentax LX has. It has moisture-proofed the camera. Circuit boards are in front of the camera, easy to get at, and are coated with a plastic film. The shaft opening and joints are also sealed. This gives great peace of mind to the photographer working against spray, condensation, sand, dust, and grit.

There are a few other special features to the New F-1. Use the AE Finder FN (a prism viewfinder that

Canon's New F-1 is a hybrid, for it can be used electronically or mechanically

is not standard), attach the motor drive to the camera, and the camera's metering system can be used as shutter priority, aperture priority, stopped-down automatic exposure, or manual (Canon is recognized for having designed one of the most accurate and dependable 35 mm through-the-lens meters).

There are thirty-two focusing screens available, some of them laser-matte designed and 20 percent brighter than the average screen. However, the focusing screens can also change the type of metering. The photographer has the choice of center-weighted averaging metering, central-area metering, or 3 percent spot metering. Center-weighted is best with automatic exposure. Central-area and spot metering work well when the camera is in manual mode, which is how most professional photographers use their cameras unless they are working remote or do not have the time to set the camera controls. Central-area metering is effective for backlit situations and close-up subjects. Spot metering works well with long telephotos, macro and stage applications.

The camera also has the usual controls: automatic exposure compensation (alas, none of these controls yet works to give the photographer automatic bracketing), double exposure control, dedicated flash technology, 100-exposure back, over- and under-exposure warning, and waist-level and sport viewfinders — invaluable for underwater photography, goggle and eyeglass wearers, and for cameras mounted on gun stocks. However, this camera does not have a mirror lockup, and the lack of that feature could turn off photographers who use long exposures or work with long telephotos with short exposures.

The Nikon F3 became available in 1980. The camera can be run automatically, with aperture-preferred exposure, or manually (only at 1/60 second). There is automatic exposure for flash that takes the flash exposure reading off the film plane. The LCD (liquid crystal display) viewfinder, which takes very little power compared to an LED, shows shutter speed, aperture setting (through a readout window), over- and underexposure. It also has on the camera controls that should be on all models — automatic under- and over- auto-exposure compensation, a memory hold button for automatic exposure, multiple-exposure button, mirror lockup, depth of field preview, interchangeable viewfinders (including a

NIKON INC.

Motorized Nikon F3 is the workhorse of the pros

NIKON INC.

The FM2 is gaining in popularity with pros. It is the first focal plane to have a top speed of 1/4000, but more important, it has a focal-plane flash synch at 1/200, very valuable for daytime flash fill-in.

NIKON INC.

The FG is Nikon's reply to Canon's A-1. The camera can be used automatically, in aperture-preferred mode, or manually.

PENTAX CORP.

Asahi Pentax LX works as an electronic and manual camera and is well sealed against moisture and dust

clarity are the Nikkor 24 mm f/2, the 55 mm f/2.8, the legendary 105 mm f/2.5, the 80–200 mm f/4 zoom, and the ED telephotos.

Asahi Pentax was the first to come out with a single lens reflex; then it didn't push for a top-of-the-line camera and rested on its fame as an optical company that makes sturdy cameras. In 1981 it introduced the *Asahi Pentax LX* and it appears to be the camera of the future. It is the first electronic camera (aperture-preferred automatic exposure control) to offer a working range of mechanical shutter speeds, from 1/90 to 1/2000. The camera will operate even if there are no batteries.

It also has auto flash metering and easy-to-read color-coded LEDs that indicate warnings such as auto-exposure compensation and low shutter speeds that need a tripod or other support. The Asahi

special finder for those who wear eyeglasses) and back, and, of course, motor drive.

The plus with the F3 is that it has proved to be very rugged. Most valuable in use is the motor, which shoots up to six frames per second. When the motor is attached, the eight AA batteries or nicad battery pack drive the motor and the camera — they override the two 1.5-volt batteries and run the camera. This is a very nice feature for extended use and for cold weather.

Most Nikkor lenses are superb. Famous for their

In a Class of Its Own

A new, revolutionary 35-mm single lens reflex is the Rolleiflex SL2000F, a modular, box-shaped camera. Some of the features this camera has:

- A built-in 5-frames-per-second motor drive
- Interchangeable film magazines
- Interchangeable film inserts for 20-, 24-, and 36-exposure film
- Multiple and single exposure control
- Built-in eye and waist-level finders
- Snap-on battery power unit
- Aperture-preferred automatic shutter with manual override
- Off-the-film-plane metering; automatic flash exposure
- Built-in diopter finder correction

The camera is designed for in-studio and on-location advertising work. It is not a Let's-go-out-in-the-street-and-grab-a-few-shots camera.

Contax RTS is mated with the very high quality Zeiss lenses

YASHICA INC.

BERKEY PHOTO INC.

BERKEY PHOTO INC.

Rolleiflex SL2000F is a revolutionary, modular 35 mm SLR

Pentax LX has built-in diopter correction in the viewfinder for eyeglass-wearers and has grommets and special gaskets to keep out moisture and dust, a very valuable consideration for photographers working outdoors.

The LX has a five-frame-per-second motor, and a number of accessories, including a unique action viewfinder. It is an ambitious effort by Asahi to make a professional camera to compete with and,

in some cases, surpass the best on the market. There are presently fifty Pentax lenses available, ranging from 15 mm to 2000 mm.

Contax was at one time Leitz's chief competitor, and the Contax range-finder cameras were recognized as some of the best made. Better yet, the camera used, and still uses, Carl Zeiss lenses, which happen to be among the best you can buy (they are still made in Germany). In 1976, the Zeiss company of West Germany had a powwow with the Yashica Company of Japan and the upshot was that Yashica would make the Contax single lens reflex cameras, which would operate with either Zeiss or Yashica bayonet-mounted lenses.

The Contax RTS is a no-nonsense, well-made reflex with aperture-priority auto-exposure with manual override. There is a full line of system accessories. The best feature of this camera is that when it is fitted with Zeiss lenses it is fitted with some of the best lenses in the world. They have sharp resolution, but more important, good color and contrast. The lenses are not cheap. The list price varies from $330 for the Distagon T 28 mm f/2 to $22,450 for the Mirotar 1000 mm f/5.6. Zeiss makes twenty-seven

OLYMPUS CORP.

Olympus OM-2N has a superb, dual-level through-the-lens metering system

The Best of the Best Single Lens Reflexes

The Best System Cameras
A system camera means the manufacturer makes a line of cameras, lenses, motors, viewfinders, filters, bellows, winders, motor drives, remote control devices, remote control releases, data backs, and probably system T-shirts.

1. Nikon
2. Canon
3. Olympus
4. Minolta
5. Contax
6. Pentax

The Best Lenses
Lens quality is based on not only resolution but color contrast — how well it is color-corrected and how much contrast or "snap" it puts into the lenses.

1. Leitz
2. Zeiss (Contax, Hasselblad, Rolleiflex)
3. Nikon
4. Canon
5. Minolta

The Most Automated Cameras
Those that give the photographer the most options for exposing.

1. Canon New F-1
2. Pentax LX
3. Canon A-1
4. Leica R4 MOT
5. Minolta XD-11

The Best Mechanical Single Lens Reflexes
What happens when you have an electronic camera and your batteries give out and there is no store that sells them for a thousand miles and you have another two weeks of photography to do? Or you have to photograph a monsoon and the electronic circuits fizz out? You had better have a camera that is mechanical — works on springs and gears. They also take the most knocks.

1. Canon New F-1
2. Olympus OM-IN
3. Pentax MX
4. Nikon FM2
5. Minolta SR-T 201

(In a special category is the new Pentax LX, which is an automated camera, but has mechanical backup for shutter speeds from 1/75 to 1/2000 second.)

Most photographers have their A and B team cameras — an automated set, such as the Nikon F3's, and a backup set of old, beaten up Nikon F's or F2's, which are mechanical cameras, or the newer and lighter mechanical Nikon FM2.

Lightest, Most Compact Single Lens Reflex Cameras
If a photographer wants a light camera, it means he is going to travel with it, much of the time on foot. To a backpacker, lightness is next to godliness. The camera should also be mechanical so no extra batteries need to be carried.

1. Olympus OM-1N
2. Pentax MX
3. Nikon FM2
4. Canon AT-1

The Best, Least Expensive Single Lens Reflex Cameras
There are many cameras on the market that are less expensive than those listed below. In the trade, the cheap cameras are known as disposable cameras — people use them for a couple of snapshots a year. The cameras listed here are made by reputable manufacturers and are part of a system; the camera and lenses are interchangeable with other cameras and lenses from the same line. Most important is that the photographer like and respect the line and know what use he will put the camera to, for this first step is often a commitment that can cost thousands of dollars.

The cameras are listed by price, and not quality. The final decision in this first purchase should not be so much the price (unless you can't pay your bar bill), but what system you wish to grow with.

1. Pentax K-1000 — $244.00 with 50 mm SMC Pentax f/2 lens
2. Minolta SR-T 200 — $349.00 with 45 mm f/2 MD Rokkor-X lens
3. Nikon EM — $357.50 with 50 mm f/1.8 Nikon Series E lens
4. Olympus OM-10 — $359.00 with 50 mm f/1.8 F Zuiko Auto S lens
5. Canon AT-1 — $387.00 with 50 mm f/1.8 Canon FD lens

Good for the Amateur, Good for the Pro
The Nikon EM was designed by the company to attract the amateur photographer. It is a tiny 35 mm single lens reflex electronically operated and completely automatic, although there is an exposure compensation button so you can override the meter by plus or minus two stops. There is an automatic flash and a very small motor drive.

Five Nikon Series E lenses are made for the camera, ranging from a 28 mm f/2.8 to a 75–150 mm f/3.5. The lenses are much less costly than the Nikkor A1 series, although all the A1 series will fit the EM. (The EM's do not fit other Nikons.)

The EM is a nifty little camera (16 ounces without lens) to use for backup or for starting out, and what is most surprising about it is that the EM lenses have received very high praise for their sharpness and contrast. This is especially true with the new 75–150 mm zoom. This zoom alone gives the camera a special value.

lenses for the Contax, ranging from the superb Distagon T 15 mm to the 1000 mm Mirotar. This system proves that the quality of the lenses separates the wheat from the chaff.

Miniaturization has been the name of the game with the Olympus people, who are also well known for their medical instrumentation. They were the first, in 1972, to introduce a full-frame, compact single lens reflex. They did it with panache, for this camera had a full-sized mirror and a large viewfinder; there was no cutoff with long or short focal lenses, and the operation was very quiet, due to what is called a well-dampened mirror. The *Olympus OM-2N* is the latest model of the compacts, an automatic camera with no mechanical backup except at bulb. What it does have is the most sensitive metering system of any camera. The OM-2N has two meters — one that measures light received on the image, and another in the viewfinder that provides exposure information in the viewfinder.

The photodiodes, at speeds from 1/125 to 1/1000, measure the light from the lens that is reflected onto what could be called a white screen printed onto the focal-plane front curtain.

At low speeds the Olympus sensors select exposure information from the curtain and from the film image. At long exposures the meter reads directly from the film, which means time exposures at night or dusk will vary only according to the light that reaches the film. It is a great way to shoot lightning. The meter is sensitive enough to give automatic exposures as low as 30 seconds at f/1.4 with ASA 25 film.

The Olympus is a full-system camera, with motor drive, power winders, a dedicated flash system (which also is controlled by a meter that reads reflections from the focal-plane screen), intervalometers, and the best of all macro systems. The lenses are good, some are superb, but not as highly regarded as Zeiss or Leitz. The Olympus OM-2N, because of its compactness, is somewhat fragile and needs to be handled with care. It is the perfect camera for the traveler, hiker, and naturalist.

Leica, the company that developed 35 mm photography, is famous for its range-finder M series cameras, its superior lenses, and its very high prices. Its most respected single lens reflex was the SL-2, now discontinued. It was heavy, built like a panzer, and came with a very large, heavy mirror. It was a handful, and one of these dropped five miles and, in a way, survived. Now there have been changes in design and manufacturing. The *Leica R4 MOT* is of superior design, but is a mixed bag — the camera is assembled in Portugal, parts come from Germany and the Far East.

The R4 MOT is an electronic camera with aperture priority, shutter priority, and programmed exposure automation. The meter measures full-field or spot. The viewing screen has LED readouts to tell you the exposure, what mode the camera is set for, whether the meter is on spot or full-frame. It is a well-thought-out and well-designed camera. There have been problems in the past with Leica reflexes — they were built to such close tolerances that a few grains of sand or too much dust could cause the camera to jam. Leitz has to work out some of the manufacturing problems in Portugal, but the camera is continually improving, not only in quality but also in higher price.

What the photographer buys with this reflex are the lenses. The Elmarit, Summicron, Summilux, and Telyt are absolutely superior. What divides them from other lenses is their snap and color contrast. Few people know that the Macro-Elmarit R 60 mm surpasses the legendary Nikkor 55 mm f/3.5 Macro. The long, light Telyt-R is fast to use and incredibly sharp, although Canon, Nikon, and Minolta are making inroads with their fluorite, ED, and APO lenses with lower f-stops.

The Leica R-4 MOT and the lenses are known as the millionaire's line. They are good but they are overpriced. The least expensive Leica lens is the Summicron R 50 mm f/2 ($333) and the most expensive is the Telyt-S 800 mm f/6.3 ($11,470).

Minolta was the first to come out with an electronic camera with shutter and aperture-priority automation. *The Minolta X-700* uses an LED readout that warns of over- and underexposure when in manual mode. In program mode f-stop *and* shutter speed are selected. There is a multi-function data back for imprinting the film and it is also equipped with a built-in intervalometer. It is another solidly made camera.

Minolta has been making cameras and lenses for fifty years and their products are well designed. Most intriguing are the Minolta Rokkor X lenses. The prices are moderate, the quality excellent, and some of the telephotos are superb. They also make

Range-finder Cameras

Leica R4 MOT is rugged and is mated with the incredibly sharp and contrasty Leitz lenses

Minolta X-700 is their new system camera that can select both aperture and shutter speed. It has a multi-function back that can be programmed in many different ways.

A unique lens — the Minolta 85 mm Varisoft that has a built-in diffusing dial

a number of special lenses, such as the 85 mm Varisoft (a diffusing lens), and a complete line of accessories.

In the last two decades range-finder cameras have been shortchanged by photographers and manufacturers. These cameras have tiny viewfinders, and the difference to most people, after viewing through a single lens reflex and a range finder, is the difference between viewing a movie on a Cinerama screen or a miniature TV set. The range finder is also limited to short-focal-length lenses; the longest used, without special housing, is the 135 mm.

Ahhh! But the range finder does have some outstanding benefits. Most of the famous photographers — Robert Capa, Alfred Eisenstaedt, Henri Cartier-Bresson, Eugene Smith, Leonard McCombe — used them, and the famous photographs that appeared in *Life* were taken with Leica, Contax, Nikon, and Canon range-finder cameras.

The range-finder camera is quiet; there is no KLUNK of the mirror banging up and down. It is small and unobtrusive and, when you combine these qualities, you have a camera that works well in theaters, churches, during intimate moments, and in dangerous places where the photographer does not want to attract attention.

Range-finder cameras focus wide-angle lenses much more accurately than single lens reflex cameras, and this is particularly true in low-level lighting. As one photographer put it, "The range-finder camera focuses with superb accuracy, but it doesn't see very well. The reflex camera sees beautifully, but it doesn't focus worth a damn."

Range-finder cameras are mechanical and very rugged. They have lasted for years and are so simply designed they rarely break down. They also have an intangible quality in the way photographers view through them. Many range-finder photographers who are familiar with single lens reflex cameras say that they see differently through the two systems. A range-finder camera allows the photographer a more intimate view, which is three dimensional; when the photographer looks through the range finder, he sees directly what he is focusing on; there is foreground, middle ground, background, and in some sense an honest understanding of the scene to be photographed. Perhaps this is why Cartier-Bresson's pictures have such a depth to them, such a close feeling of people and space.

When looking through an SLR, the photographer

sees an image of an image. The information is there, seen through a mirror and a prism. It appears life-size to the mind, but there is a slight unreality to the photograph; it seems to be all on one plane — a one-dimensional photograph, a graphic representation of what appears to be reality. Perhaps the reason so many advertising photographers appreciate the single lens reflex is that it puts the elements into a graphic perspective.

With a reflex camera a photographer often looks *at* his subject. With a range-finder camera, he often sees *through* his subject.

The bad news is, there are few range finders around today. The good news is, the best one is still being made. It is the *Leica M4-P*, which has viewfinder frame lines for the 28, 35, 50, 75, 90, and 135 mm lenses. The camera is now made in Canada. Recent models have not had that technical tightness and the beautifully machined parts that went into the Leica M-4 and earlier models that were made in Wetzlar, Germany. Still, it remains one of the best-designed and -made cameras today and it is equipped with some of the finest optics available.

Many professional photographers prefer the Leica range finder for journalism or for their wide-angle shots, because of the ease in focusing. It remains the best of all cameras for street photography, particularly for black and white.

The camera is simple. It is mechanical, it has a very bright coupled range finder–viewfinder, and if you need a meter, a small one fits on top of the body. The lenses are bayonet mounted and there is a motor available.

Many Leica lovers prefer to buy the older M-series cameras that were made in Germany. The M-4 is their current love and a price for a used M-4 can run up to $1200, not including the lens. The price is high because Leica collectors are so

The M4-P is the latest of the Leica M series range finders. It has the reputation of being the best-designed camera now manufactured.

E. LEITZ CO., ROCKLEIGH, NJ

When You Have a Five-Eye Problem

The camera is another eye and to those who wear eyeglasses, seeing with this fifth eye can be troublesome.

Light through the viewfinder of a reflex camera forms an image that appears to come from infinity. For those with normal vision, the image is sharp. For those who are nearsighted or farsighted, the image is blurred.

There are several solutions. Most photographers who need prescription eyeglasses use the glasses when they take pictures. The image will be sharp as seen through the viewfinder, but there could be a problem in seeing the entire image. If it is a problem, sport viewfinders can be placed on some cameras. The sport viewfinder allows focusing with the eye away from the viewfinder. The new High Eye Point viewfinder for the Nikon F-3 also permits a full view of the frame for eyeglass wearers.

Those who are nearsighted generally leave their glasses on, for they need to see sharply all the time. Farsighted and nearsighted people who wear glasses can have diopters placed in the viewfinder of their camera. The diopters will balance the camera's way of seeing with the photographer's vision. Some farsighted photographers use diopters in their camera, but also hang a pair of reading glasses around their neck for reading dials or for close focusing on view-camera screens.

Bifocal wearers should have the bottom section of the lenses (for close reading) set low in the glasses so that it does not interfere with viewing through the camera. Some photographers have the lower lens made to focus at eight inches (normal is twelve to fourteen inches). This allows them to read camera dials at close distances, as when the camera is slung around their neck. One photographer with the bifocal problem had the upper section of his prescription glasses made so he could see 20/15, which is sharper than normal vision (his glasses were ground so he could see at twenty feet what the normal eye could see at fifteen feet). The close-up, or lower, section of the glasses was ground to focus at six inches.

The best way to solve vision problems is for the photographer to take his or her cameras to the optometrist, who can help work out the corrections and the type of glasses that may be needed or the diopter correction that should be placed in the viewfinder of the camera.

Eyeglass wearers have the problem of scratching their lenses against the viewfinder. This is particularly harmful if the glasses are made of plastic. Some camera viewfinders have a rubber ring or rubber cup that keeps the eyeglass from scratching on metal. Unfortunately, these usually fall off. One solution is to surround the frame of the viewfinder with electrical tape. The best, though, is to wear contact lenses, if you can stand them.

The discontinued Leica M-3 single stroke has the brightest view-finder, but does not have frame lines for the 28 and 35 mm lenses, as does the M4-P

Minolta CLE is a range camera with interchangeable lenses and automatic exposure system

eager to buy anything made in Wetzlar that they keep pushing it up. The best buy, at the present, is the Leica M-3, made in the mid-sixties. The price is about $500 without lenses and it is reputed to have the brightest viewfinder of all the M-series Leicas.

Minolta CLE is an updated version of the Leica's younger cousin, the discontinued Leica CL, which became the Minolta CL. The new Minolta CLE is available with three Rokkor lenses, the 40 mm f/2 M, the 28 mm f/2.8, and the 90 mm f/4. It is an electronic camera, with aperture-priority automatic exposure and manual override. In the viewfinder is an LED readout of shutter speeds and over- and underexposure warnings.

The Minolta CLE is the first of the automated coupled range-finder cameras with interchangeable lenses. What is unique about the camera is its automatic exposure control. The metering is taken from the shutter curtain of the film as it is reflected to a lens/mirror/prism system that focuses the light onto a photocell. It is the most accurate method of metering, similar to that in the Olympus automatic cameras.

The Minolta is new and has not been given a good test in the field. The camera does take the guess-work out of shooting and will be appreciated by those who don't want to think about exposure, or don't have the time. It is also, because it is automatic and electronic, much more fragile than the mechanical Leica.

Medium-Format Cameras

As the 35 mm single lens reflex cameras become more sophisticated, more untrained photographers are taking better pictures — the cameras do the thinking for them. There was one case where a young college graduate who was smart and personable landed some photography assignments from an agency. He was amazed and pleased with the results, but was swiftly knocked off the ladder he had climbed when he was given assignments that required larger-format photography and lights.

Many professionals realize that the proliferation of 35-mm-sized images is increasing competition. Hoping to keep their foot in the door, they are moving up in size to larger format cameras. They know that larger images yield better quality, are more impressive, and sell better (although many stock houses prefer the 35 mm size because of ease in filing).

There are also definable differences between 35 mm and medium-format photography. Most often the difference is in depth of field, or, to be more specific, lack of depth of field when using large apertures. An out-of-focus background helps

Which format is best? Take your pick — all are the original negative size. No. 1 is 35 mm taken with a 300 mm lens; No. 2 is 6 × 7 cm (2¼ × 2¾ inches); the dotted line shows the popular 6 × 6 cm, (which is 2¼ inches square). The 6-×-7-cm picture was also taken with a 300 mm lens. No. 3 was photographed with a Brooks Veriwide with a 47 mm lens. It is no longer made, but the Plaubel Proshift (see page 75) yields an equivalent negative of 6 × 9 cm (2¼ × 3½ inches). No. 4 was taken with the 35 mm Widelux, which uses a 26 mm lens that swings from left to right during exposure. Angle of view is 140 degrees. The image is slightly wider than the one produced by a 6-×-6-cm camera such as the Hasselblad. The Widelux is described on page 76.

concentrate interest on the main subject. In black and white it gives a bit of grandeur to the subject, akin to the images taken earlier in this century that had such elegant composition. The reason was that the background went quickly out of focus because of the lenses and large format that were used.

Many calendar photographers know that large formats are best for scenics — they give detail to the leaves, shadows, and fences. Many calendar publishers refuse to look at transparencies smaller than 6 × 6 cm.

So why not go to 4 × 5, 5 × 7, 8 × 10, view cameras? There is a time when they are needed — for advertising, still life, architecture because of swings and tilts, and for fine arts, when absolute definition is required, à la Edward Weston and the early Ansel Adams. However, sheet film costs are high, and are growing more so. A 6-×-7-cm (2¼-×-2¾-inch) camera takes 10 frames to a 120 roll. A roll of Ektachrome 120 E-6 costs $6.30 to purchase and develop. Ten sheets of 4-×-5-inch Ektachrome

cost $23 and 10 sheets of 8-×-10-inch Ektachrome are up to $70 in purchase and development costs.

Medium formats are more versatile than 4 × 5 view cameras — they are quick handling and lenses are interchanged quickly. They can be used for grab shots and for setup photo situations. There is no argument that medium-format photographs sell better than 35 mm and that the medium format is more versatile than the larger formats.

One plus for the 35 mm cameras — Kodachrome 25 and 64, the best film made — is not available in medium-format size. Ektachrome, which is used by most medium- and large-format photographers, does not have the color saturation, the sharpness of grain, and the longevity of Kodachrome. If Kodak ever decides to produce Kodachrome in 120 rolls, and they should, there will be a scramble to the larger formats.

The favorite medium-format sizes:

4.5 × 6 cm (1⅝ × 2¼ inches). This is a relatively new format, using 120 film and producing 15

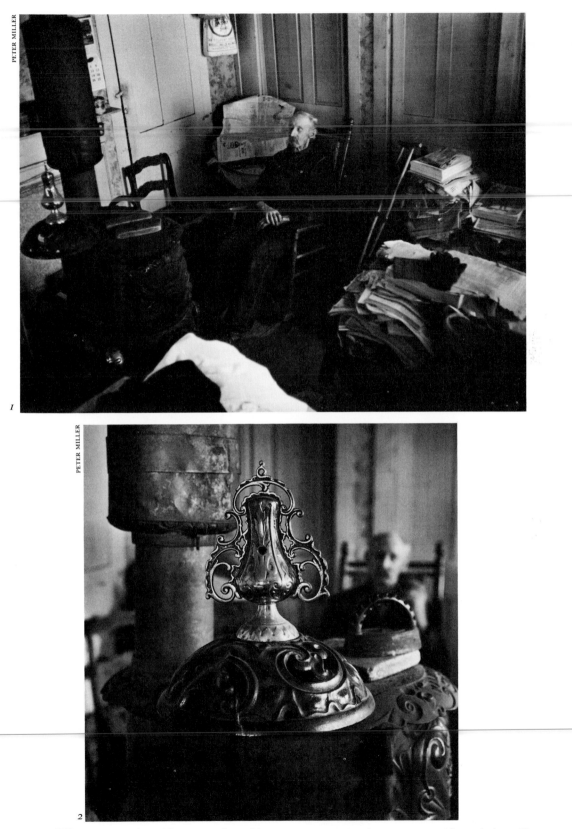

The same room, two different perspectives. No. 1 was shot with a 35 mm camera using a 35 mm wide-angle lens. No. 2 was shot with a twin lens 6 × 6 cm (2¼-inch-square negative) Rolleiflex with an 80 mm lens.

BELL & HOWELL/MAMIYA CO.

Mamiya M645 1000S gives fifteen 1⅝-×-2¼-inch frames on one roll of 120 film

frames per roll. The film size is three times as large as the 35 mm image and is well proportioned for enlargements to 8 × 10. The camera is like a large 35 mm and handles rapidly. Wedding, commercial, and portrait photographers and serious amateurs like this size.

Mamiya M645 has interchangeable film inserts rather than magazines and uses a focal-plane shutter (no leaf shutters in the lenses). Its shutter speed is 1/1000 while that of the Bronica ETRS is 1/500. The two are comparable in price.

VICTOR HASSELBLAD INC.

Hasselblad 500 C/M, the Rolls Royce of 2¼ cameras, was designed in the 1940s as a modular camera — interchangeable lenses, film magazines, and viewing systems. The shutter is in the lens rather than in the camera.

VICTOR HASSELBLAD INC.

Hasselblad 2000 FC is electronic, has a focal-plane shutter, and accepts the old shutter-equipped lenses and a new line of lenses without shutters. You could call it the Ferrari of the 2¼ cameras.

Bronica ETRS is compact, quick handling, and can be used at eye or waist level. It has interchangeable backs, a motor drive, and is electronically controlled. Exposure is controlled through leaf shutters built into the lenses.

6 × 6 cm (2¼ × 2¼ inches). This has been the most popular of the medium-format sizes, producing 12 square frames on a 120 roll. The square format means that the camera is never turned vertically, unless it is used photographing around corners. Photographers learn to compose square photographs (as did travel photographer Fritz Henle) or they shoot and then crop to vertical or horizontal 8-×-10-size prints. The 6 × 6 cm has been the favorite size of the advertising photographer, mostly because of the Hasselblad. The format became popular with the twin-lens Rolleiflex, which is now discontinued but remains a superb camera and commands high prices.

Hasselblad makes five models, two of which interest the average wealthy photographer — the 500 C/M and the new 2000 FC. They are the state-of-the-art in medium-format cameras that are designed basically to be used on a tripod. They are modular — interchangeable lenses, backs, and viewers. The 500 C/M is a mechanical camera with the shutters built into the lenses. The 2000 FC is an electronic camera that has a focal-plane shutter and instant-return mirror, among many other refinements. It accepts the shutter-equipped lenses designed for the 500 C/M and a new line of lenses (all made by Zeiss and so sharp they can cut your eyeballs) without shutters, which can thus be designed to focus closer and have lower f-stops.

The Hasselblad C/M has been the advertising photographer's workhorse, particularly for those working in fashion. It is easily used with synch sun, something a focal-plane shutter cannot be. It is a marvel of design and a brilliant match between the Hasselblad body and the Zeiss lens. But oh, do you pay for it. List price for the new 2000 FC with an 80 mm f/2.8 Zeiss Planar is $3000. Additional lenses can run as much as the cost of the camera body. Because of the high price and the good quality, used Hasselblads are sold at a premium.

Bronica SQ was introduced in 1981 as a redesign of an older model, the Zenza Bronica M series that was discontinued a few years ago. The Bronica SQ is an electronic camera that uses Zenzanon lenses

Zenza Bronica is the Japanese answer to the Swedish Hasselblad. It is much less expensive.

Rolleiflex SLX is futuristic and beautifully designed. It is the first 2¼ to have a built-in motor and automatic and manual exposure controls.

inches. A good photographer will fill the frame with the 6×7, just as with the 35 mm camera. The quality this size gives is phenomenal. One roll of 120 film yields 10 frames.

Mamiya RB67 Pro-S is another studio camera, designed to be used on a tripod. It has interchangeable magazines, and a revolving back so the frame can be shot vertically or horizontally without moving the camera. Lenses are equipped with leaf shutters and there is double-exposure prevention (or the camera

Mamiya RB67 Pro-S is a 6-×-7-cm camera with a revolving back. It works best in a studio on a tripod.

Mamiya RZ67 is their high-tech eighties model, an all-electronic camera

Pentax 6 × 7 cm is a well-balanced field camera that handles like a 35 mm, only it is heavier. It is very popular with European and Japanese sports photographers. Some use it only for black and white, as the lenses have such sharpness and contrast.

equipped with leaf shutters. There are three backs with interchangeable inserts for 120 and 220 film. The viewfinders are interchangeable, including those with internal metering. Lenses and accessories are being designed for this new camera and it is a comparatively inexpensive alternative to the Hasselblad.

Rolleiflex SLX is in another world of design. It, too, is a studio camera, box shaped, but has many qualities other than interchangeable film inserts and leaf-shutter lenses. It is electronic, with shutter-priority automation and a built-in motor that can program exposures at 1.6 frames per second. It is the first of the medium formats with a thinking electronic winder. Like the Hasselblad, it uses the incomparable Zeiss lenses.

6×7 *cm* (2¼ × 2¾ *inches*). Known as the ideal format, 6×7 cm enlarges perfectly to 8×10

can be programmed for multiple exposure). A power drive is available. The camera is bulky but well made for its purpose as a studio camera. Twelve Mamiya Sekor lenses are available, including a 37 mm f/4.5 fish-eye, a 150 mm f/4 soft-focus lens, and a 500 mm f/8 telephoto.

Mamiya RZ67 is Japan's answer to the automated Rollei. This camera is a modernized RB67 — which means it is electronic, has an electromagnetic shutter system, motor drive capability, and remote control. The revolving back on this camera is connected with a mask in the viewfinder, which changes automatically to vertical or horizontal as the back is revolved. This camera accepts the older RB67 lenses, but there are eleven RZ lenses specially designed for this camera. These are slightly shorter in length because of a different design of the mount. Mamiya claims the new lenses have better resolution and color contrast, and less distortion in the wide-angle lenses. As a result of the new mount, there is increased light in the corners of the frame in the longer lenses. Although this camera is designed for on-tripod studio use, the prism head allows it to be something of a hand-held camera, although a bulky one. It is a very complete system camera designed for the photographer of the eighties, who thrives on LED metering and power winding.

Asahi Pentax 6 × 7 is no more than an overgrown 35 mm. As opposed to the other 6 × 7 cameras, it is made to be hand-held. It balances beautifully and gives marvelous images on a series of Pentax lenses that range from 35 mm fish-eye to 1000 mm. The body is electronic with speeds up to 1/1000 second. There is a mirror lockup, which is very important when using low shutter speeds and long exposures.

Plaubel Makina 67 is the only 6-×-7-cm camera that is light and folds into a smaller package. Two models are available, one with an 80 mm lens, the other with a 55 mm lens. The wide-angle model is more practical in the field.

BERKEY PHOTO INC.

Field photographers prefer this camera. The great mountain images made by the Japanese photographer Yoshikazu Shirakawa were made with the Pentax 6 × 7. It is also favored by those who shoot black and white and need crispness in their enlargements. There is a CdS metering prism, which is sluggish. There are rumors that Pentax is redesigning the body, but the fact is that the present body, although no fancy Dan in the electronics field, gives very good service. Users would like interchangeable backs and the provision for multiple exposure, but they probably would not like any more weight added to this five-pound, five-ounce camera.

The Plaubel Makina 67 is a modern camera with a lovely anachronistic design — it is a folding camera with a fixed lens and range finder that has a built-in meter. The camera folds to 6⅜ inches wide, 4½ inches high, and 2¼ inches deep, a very small package. The lens is a Nikkor 80 mm f/2.8 (there is a new model equipped with a 55 mm lens), which is equivalent to about a 40 mm on a 35 mm camera. It is a well-designed camera and a perfect medium-format pack-along camera. You might say this is the medium-format answer to the Olympus XA and Minox GL.

View Cameras

View cameras have qualities that are not found anywhere else — extra-large format, swings and tilts, shifts and rises of the lens to correct perspective and give depth of field. Such cameras are indispensable for still life, architecture, and in any case where fine detail is important. More and more fine arts photographers are turning to the larger format, particularly 8 × 10. A contact of 8-×-10-inch color or black and white renders incredible detail and subtle tonality. Because the contact is not enlarged, it gives a quality of naturalness. Edward Weston, Paul Strand, and Group f/64 were firm believers in the 8 × 10 format. So are Meyerowitz, Tice, and Caponigro.

Some photographers feel the large format makes them better. Others believe in the high quality. What this camera really does, is make you think out each picture carefully, for 8 × 10 film is not cheap. Another plus for the 8 × 10 is the availability of Polacolor. It won't be long before many art directors

Wista Field 4 × 5 is a 3.4-pound field camera made in cherry or rosewood that swings, tilts, and rises. It is a beautiful camera that is strong and well made. Importer is Foto-Care Ltd., 170 Fifth Avenue, New York, NY 10010.

Sinar P is the sine qua non of optical bench (monorail) view cameras. Many who cannot afford this wizardry settle for the Omega Monorail.

accept a Polacolor 8 × 10 print as the finished product.

Although the aesthetes and purists are into 8 × 10, 4 × 5 is doing very well and is much more practical (the best size would be 5 × 7 as a compromise, but it is not popular).

There are two basic types of view cameras: field camera, and monorail. The field camera folds into itself, is very compact, and is not as versatile as the monorail camera. Prime examples of field cameras are the *Toyo Field 45 A,* the *Wista Field,* and the *Deardorff.* The last two are wood, and come in 4 × 5 and 8 × 10.

Monorail cameras are actually optical benches and are often modular; different bellows, backs, and fronts can be attached. *Toyo, Omega,* and the American-made *Calumet* are inexpensive, versatile, and good buys. For those who can earn over $3000 a day doing studio work, the camera to own is *Sinar-P Expert,* which is available in 4 × 5, 5 × 7, and 8 × 10 sizes. It is the modular camera with special backs, electronic front boards, in-camera metering, and a special focusing system. It takes the guesswork out of the large camera.

Pocket Cameras

Every working photographer carries a pocket camera. One never knows when a situation will come up when that camera will make a poignant, personal picture or a news shot worth $50,000.

There are three cameras to consider, all of them about the size of a pack of cigarettes.

The Olympus XA is a very sophisticated miniature 35 mm camera that has a dust cover. When the dust cover is opened, it electronically activates the camera, which is aperture priority (set the lens opening and the shutter speed adjusts itself) and has speeds up to 1/500. There is an exposure compensation

Olympus XA fits in a pocket as snugly as a derringer. It is automatic with an exposure override and a range finder. Here it is dwarfed by the motorized Nikon F3 with a 500 mm f/8 mirror lens.

Minox 35 GT is the latest model with automatic exposure and override. The camera is smaller than the Olympus XA. The lens is 35 mm and extremely sharp.

E. LEITZ CO., ROCKLEIGH, NJ

Rollei 35 SE is rugged, mechanical, has a sharp lens, and will function at −40 degrees F. It is a favorite of mountaineers.

BERKEY PHOTO INC.

button that allows 1.5 stops more exposure than the meter would allow. The camera is a coupled range finder, so it can be focused. The lens is sharp and crisp. The shutter release is electromagnetic and lies flush on the camera top. It can very easily be set off accidentally when the dust cover is open. Some photographers glue a rubber tab on the release, so they can feel it with their finger.

The Minox 35 GT is slightly smaller than the Olympus and has a folding front. The camera is also electronic with aperture priority. Speeds are to 1/500 and there is an override to allow more exposure.

The lens is a 35 mm f/2.8 and is zone focused (there is no range finder as there is in the Olympus

XA). The lens is extremely sharp and contrasty and in one case beat out a 35 mm Nikkor f/2.

The Rollei 35 SE is an old favorite of mountaineers. It is all metal (the other two are made from high-impact plastic) and is mechanical and slightly bigger than the Minox and Olympus.

There is no range finder and all controls are set manually. There is a meter with red and green LEDs to warn of over- and underexposure. It is a great camera for trekking and cold weather, as it is not automatic and does not run on batteries. It is designed to function to −40 degrees F.

The lens is a Zeiss Sonnar f/2.8 40 mm. It is on a par with the lens in the Minox (a Leitz lens) and thus remains one of the best that can be bought.

Special Cameras: For New Ways of Seeing

Superwide Cameras

Professional photographers are continually looking for new ways to photograph their assignments. Sometimes an assignment is technically challenging. Other times an assignment calls for a special piece of equipment that might never be used again. Photographer pack rats will go out and buy that equipment, while the average photographer will try to rent it. Some go to great lengths and have cameras made or adapted to their special uses. The late Ben Rose was an electronic wizard with his computerized cameras and lights. Simon Nathan has had a number of cameras made and adapted so they take pictures the way he sees.

Special cameras for general use fall into two categories: panoramic, or wide angle, and high-speed motorized cameras.

Hasselblad Superwide C is a fixed-lens camera with a 90-degree angle of view

Most wide-angle problems can easily be solved with a view camera using a bag bellows and one of Zeiss's extreme wide-angle lenses. Unfortunately, it is not always possible to tote around a view camera or have the time and space to set it up, focus, and use a slow shutter speed. So there are smaller cameras with faster lenses designed for extreme wide-angle work.

Wide-Angle Cameras

Hasselblad Superwide C is a fixed-lens 120 roll film camera equipped with a 38 mm f/4.5 Zeiss Biogon that takes an angle of 90 degrees. The lens is rectilinear (it does not bend lines when leveled). Like other Hasselblads, the Superwide C is equipped with interchangeable backs. The drawback of this camera, aside from its price, is that it squeezes all that photographic information onto a 2¼-×-2¼-inch format.

Plaubel Superwide Proshift 69W is manufactured by the Doi Manufacturing Company of Tokyo working in conjunction with Plaubel, a German camera company. The Plaubel 69W is a 2¼-×-3½-inch-format (the actual image width is 3.3 inches) camera fitted with the incredible Schneider 47 mm f/5.6 lens. As there is slight fall-off of light at the edges of the film, due to the width of the image, the lens is

Plaubel Superwide Proshift gives a 93-degree view on a 2¼-×-3½-inch negative. Horizontal and vertical shifts make the camera valuable for architecture.

equipped with a centered neutral density filter to balance the exposure density on the edges with the center of the film.

The camera uses 120 and 220 film. Its most interesting feature is that the lens shifts 15 mm vertically and 13 mm horizontally. The shift helps reduce or make disappear converging lines and gives added dimension for distortion correction. This is extremely valuable in architectural or cityscape photography, when the ordinary camera has to be tilted up too much. The viewfinder compensates for the amount of shift so the photographer knows what the lens is covering. This camera gives a 93-degree field of view, which is comparable to that of a 21 mm lens on a 35 mm camera.

The Plaubel Proshift is the first of the medium-format cameras to have built-in horizontal and vertical shifts. Some photographers have had their old Veriwides and Hasselblad Superwides customized so the lens shifts. There are a few 35 mm lenses (see page 94) that also have shift controls. The advantage of this wide-format camera is the incredible sharpness of the lens and the great detail the image size gives. It has interesting uses for landscape and documentary work. Unfortunately, the camera is not designed to take a Polaroid back.

Panoramic Cameras

The first panoramic camera, called a von Martens Megaskop, took a 150-degree photograph and was invented in 1844. The first 360-degree camera, the Strin Wonder, was invented in 1889. Panoramic cameras currently made are:

Linhoff Technorama 6 × 17 produces an amazing image that is 2¼ × 6¾ inches long (6 × 17 cm). The lens is a 90 mm f/5.6 Schneider Super Angulon. A neutral density center filter is available (for about

$500) to prevent fall-off in the corners of the image. The filter also requires about a one-stop overexposure.

The camera takes 120 or 220 film and produces 4 images on the 120 size. There is a unique optical

Linhoff Technorama makes a 6¾-inch-long negative. Some art photographers do all their work with this camera.

system that includes a level, very important because this camera should be kept absolutely level unless the photographer is experimenting.

Panon Widelux 140 is a 35 mm camera equipped with a revolving 26 mm f/2.8 lens. Exposure is made by a slit that passes over the film, which is curved on the film plane to match the arc of the lens as it swings from left to right. There are only three speeds, 1/15, 1/125, and 1/250, and the speed determines how fast the slit crosses the film plane. At 1/15 second the slit takes slightly more than a second to expose the entire image. The camera focuses at infinity only at f/8 and f/11, giving a depth of field from approximately 2½ feet. At f/2.8, for instance, the lens focuses from just under 5 feet to 49 feet.

It takes a bit of practice to learn to use this camera. Foreground is important, for the 26 mm lens can flatten the background. The camera has great creative uses, particularly at 1/15-second exposure. Modigliani-like portraits are possible. When the

Panon Widelux has a revolving lens that is sharp at infinity only at f/8 and f/11. The camera has tremendous creative attributes when used with motion.

Special Cameras for Special Photography

Simon/Wide is the name of this camera which takes a picture 2¼ x 7" on a normal roll of 120 film. It is not wide angle and it is panoramic. The camera presently has three interchangeable lenses. Film magazines are interchangeable and Simon also has a ground glass back for the camera that he hardly ever uses.

It is essentially a hand camera, shooting action up to 500th sec, electronic flash, time exposures, multiple exposures, you just name it.

Originally built to photograph transport aircraft, the camera has been used on 15 major motion pictures all over the world to produce special still photography. These include 3 James Bonds, Khartoum, Waterloo, Charge of the Light Brigade, Devil's Brigade, Scalphunter, The Way West, Adventurer, etc. You've seen Simon/Wides used in annual reports, in Fortune, Life, Epoca, L'Europeo, as the wraparound cover on the book LIFE'S GUIDE TO PARIS, the four covers of NYC community project book WHO NEEDS PARKS? in the London Times, The New York Times, The New York Herald Tribune (sob, sob,) The Suffolk Sun (sob), the Washington Post, and more.

Each 12 exposure roll of 120 film delivers four Simon/wide transparencies. Camera exists in one edition only, shown herewith.

CHRYSLER AIRFLOW on 2¼ X 7" Simon/Wide

If there is any gimmick in the Simon/wide result you might say that it is simply quality. Any 35mm negative can be cropped and enlarged to the same 1:3 ratio, but when you start with a 7" across color transparency with

CHRYSLER AIRFLOW on 35mm

CHRYSLER AIRFLOW on Hasselblad format

sharp detail you are a winner before the engraver gets it.

When you have a choice as to which of these three starting points you likely will wish for the next larger transparency. The camera is more of an attitude about photography than a special device. This is no miracle idea. Panoramic cameras go back to the Civil War times. Sometimes they were called banquet cameras, sometimes school graduation picture cameras.

This is a scaled down version of whatever you call it, into a hand camera that uses modern lenses and emulsions. Audio/visual folk sometimes lift five super slide screens from a single Simon/wide.

Simon's Simon/Wide

Nathan's Manhattan as seen by the Cyclopan camera fitted with a 210 mm f/5.6 Symmar. Angle of view is 118 degrees.

camera and the subject are moved there can be effects similar to those produced by a strip camera, either elongating or shortening the subject, depending upon in what direction the subject is moving in relation to the lateral movement of the lens.

The Panon Widelux is presently distributed by Olden of New York. The manufacturer, Panon, keeps promising to update the camera and come out with a 2¼ version, which they manufactured previously.

There is a Russian version of this camera called the *Horizont*. These show up every so often as used cameras, and are supposed to work well. The problem is, what do you do when it breaks down and needs parts? A trip to Russia could be about the

same price as having a camera machinist renovate or re-create the innards.

Globuscope is a 360-degree panoramic camera (designed and manufactured by three brothers) with a circular vision coming as close as you can get to the fourth dimension — taking continual motion and depth and laying them out as a time-motion on a flat plane. The camera can take 8 360-degree, 6-inch-long panoramic images on a roll of 35 mm, 36 exposure film. The camera has three speeds, 1/100, 1/200, and 1/400, which are regulated by three interchangeable slits. The lens is a 25 mm f/3.5 Gauss-designed lens.

What is so unusual about the Globuscope is that it also can be used as a slit, or scan, camera. In

NORMAN ROTHSCHILD

Simon Nathan of Simon/Wide

King of the Wide-field Cameras

Simon Nathan has a large head and his eyes are set far apart, and perhaps this is why he has such interest in wide-field and panoramic cameras. Nathan, who is a freelancer, had a hobby of photographing airplanes and his problem was that no camera could make the airplane look big and long. This interest led to the development of the Simon/Wide, which takes a picture 7 by $2\frac{1}{4}$ inches. It is almost the same ratio as the Cinerama screen, and Nathan has used the camera to photograph special stills for twenty major movies, including three James Bond flicks.

The camera evolved from one designed by Frits Rotgans, the Dutch wide-field specialist who loves to make ships in Amsterdam look long and lovely. The Simon/Wide was built by a subcontractor for Nikon in Japan, the Beauty Camera Company, and is no more than a long box that has interchangeable 120 film magazines, a Linhoff handle and viewfinder, and uses interchangeable Schneider lenses (121 mm, 210 mm and 360 mm), made for view cameras, that cover a 10-inch circle.

The Simon/Wide solves the problems inherent in many so-called panoramic cameras now on the market — those cameras take a wide photograph but use a wide-angle lens, squeezing smaller the image size of the subject. This can be crucial when the photographer is trying to show the majesty and grandeur of a mountain range like the Grand Tetons. By using long focal length lenses made to cover view-camera formats, then using 120 film, Nathan has managed to make the image of the hand-held Simon/Wide look big and long.

Unfortunately, the Simon/Wide is a one-of-a-kind cam-

GLOBUSCOPE, INC.

360-degree Globuscope is a panoramic slit camera

normal operation, the large head of the camera revolves as the film revolves, to produce the panoramic picture. In the scan mode, the large head is manually held stationary and only the film revolves. The camera then becomes a scan, or slit, camera, the type used for photo finishes of horse races. Say, for instance, that the camera in scan mode was used

GLOBUS BROTHERS

era. If you want to make one, give Nathan a jingle (212 873-5560) and he'll point you in the right direction. Probable cost (excluding those expensive Schneider lenses): $2000.

Nathan was also instrumental in having Hulcher design the Hulcherama, which Nathan first used to photograph the Republican convention in 1976.

Some of Nathan's other specials:

• The Bullseye Camera. A hand-held camera with a 5-×-7-inch back. The camera can be used with two different fronts equipped with different lenses. The 53 mm f/4 Schneider lens creates a large diameter 112 mm circular image on the 5-×-7-inch sheet film, creating a non-fish-eye look on a large hunk of film. The other front has a 90 mm f/5.6 Schneider Super Angulon lens attached to it, which covers the 5-×-7-inch film. "The reason for the camera," Nathan says, "is that you can have detail and definition on a larger film. There are more interesting wide-angle lenses for 35 mm cameras, but what's the point of reducing the detail onto a smaller film before playing it back as an engraving? Information is the name of the game, isn't that correct?"

• The old Veriwide camera, with the lens changed to a 53 mm f/4 Schneider Super Angulon. It takes a photograph 2¼ × 3½ inches.

• A camera that makes a photograph with the left side sharp and the right side blurred. It was designed to take photographs of stationary cars, but to make them look as though they were speeding down the highway.

• Highspeed Sequence Simon/Wide built by Hulcher in 1964 (Hulcher makes an updated version of the camera).

• A 5-×-7-inch Big Bertha (used in the old days to photograph baseball) equipped with a 2¼-×-7-inch Simon roll-film back and 500 mm and 900 mm lenses.

• A Nikkor 16 mm f/3.5 fish-eye with cross star (to make star effects in highlights) etched onto the colored filters.

Nathan's interest in photography began during his university days at Dayton, Ohio. He was so fascinated with photography that he offered to work for nothing for a photographer. The photographer was reluctant, but Nathan bugged him for seventeen visits on fourteen days in a row until he was given a job. At night he worked in the post office. He then worked for UPI after moving to New York. "If you want to be a photographer," Nathan warns, "don't do something everyone else does, and you had better be a good salesman."

Nathan is an opinionated equipment expert and has written columns for most of the photography magazines, including *Modern Photography* and *Popular Photography*. He is too honest and blunt, and is now persona non grata with the magazines and most manufacturers because he has roundly criticized the industry for promoting shoddy equipment. The only way Nathan remains as a self-appointed and -anointed ombudsman to the photographic industry is by publishing a journal, called *Simon Says: Photography Newsletter*. It is $75 a year, from Simon Nathan, 316 West Seventy-ninth Street, New York, NY 10024.

to photograph a person who revolved on a turntable at the same speed the film moved through the camera. The person — literally all physical sides — would be laid out sharply on six inches of film.

The camera is operated by a spring motor and has a fluid drive. It can be hand-held, although the hand-held shots may turn out to be more creative than exact, and — this is the charm of the camera

Globuscopic view of the Brooklyn Bridge

— it can provide horizon-straight documentary photographs, creative blurs (what would happen if, when photographing the Empire State Building, the camera was moved vertically and laterally back and forth?), and scan-type photographs. The camera is made by Globuscope, Inc., One Union Square West, New York, NY 10003.

The *Hulcherama* is the Globuscope's big brother and its inventor, Charles Hulcher, has acted as big brother to the Globus brothers. The Hulcherama preceded the Globuscope by a few years and has a few advantages — it is a 120-film-size camera that has a wide range of shutter speeds and f-stops, so it can operate at low light levels. It is also a much more intricate and expensive camera. (See page 85 for address of the Hulcher Company.)

High-Speed Sequence Cameras

One of the most popular models that are on the market is the Canon Pellix, a special camera that takes 9 frames a second. However, the serious boys go for the Hulcher series. They are the best high-speed cameras made, in 35 mm and 70 mm sizes. Their speeds are adjustable up to 65 frames per second.

The Wizard of Hulcher

"What am I? I'm a professional mandolin player." That is Charles A. Hulcher talking as he leans back behind his antique desk at his office in Hampton, Virginia. Hulcher has the charm of a septuagenarian porch sitter who plays the mandolin. He also has a very acute wit, which can be humorously withering.

Hulcher is better known as the inventor of the Hulcher Sequence Camera and the Hulcherama, which takes a 360-degree panoramic picture. He is one of the few independent camera makers in the United States and his cameras do very amazing things. Some call Hulcher a wizard, others believe he is just a plain genius.

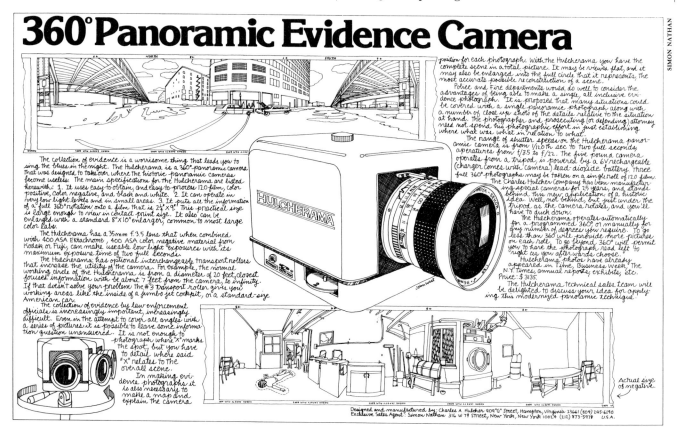

Hulcheramania according to Simon Nathan

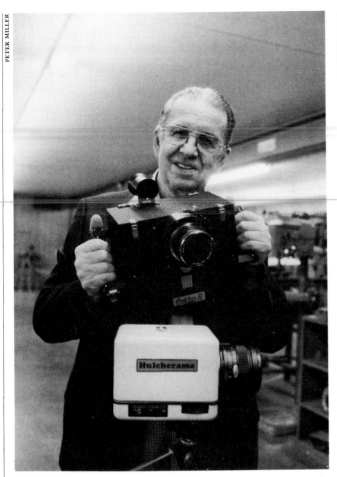

Charles A. Hulcher in his factory with two of his offspring, the high-speed sequence Hulcher 70 and the panoramic Hulcherama

Hulcher began working in the thirties for the National Advisory Committee on Aeronautics, the predecessor of NASA. He was in charge of dynamic model building and then became supervisor. Eventually he became involved with the missile program.

In the early 1950s, at the beginning of the space program, for no apparent reason, the missiles fell apart after blast-off. Motion pictures of the missile launches did not show anything, as the frames were too small and the missile too far away. Hulcher, who was at that time in charge of photography at Wallops Island, was told to come up with something that could photograph the launching and show what was going wrong.

"We had a K 24 aerial camera that could take a picture every second on five-inch film," says Hulcher, "but that didn't work, for whatever was going wrong was happening in less than a second. So I designed a camera that took ten frames a second. When we looked at the negatives, we could see what happened. A rocket blast-off is straight out of hell, hot and fiery, and we could see from the photographs that the power of the blast-off was unscrewing the casing of the rocket and it would then fall apart.

"NACA allowed me to put the camera on the market and it was soon used at Cape Canaveral." In 1954, Hulcher left NACA and started his own company, and since has improved the camera and designed numerous others for a variety of uses — "Some scientific, some for sports, some just plain kooky, and some that I can't tell you about."

Hulcher now makes five models of his sequence cameras, in 70 mm and 35 mm (using 100-foot rolls) with sequence speeds of 5 to 75 seconds. The basic camera costs from $2420 for the 3½-pound Hulcher 35 mm Model 112, which shoots from 5 to 20 frames per second (it can be adapted for speeds up to 65 frames per second), to $8600 for the Hulcher 70 mm Model 104 with frame rates of up to 75 per second. One of these sequence cameras is designed to take 5-inch pictures on 70 mm film. Shutter speeds at these high speeds are up to 1/16,000 of a second. The camera uses a beam splitter so there is uninterrupted viewing through the reflex housing. The camera is adapted for the Nikon lens system, or other types in the 35 mm format.

Hulcher cameras are made in a large workroom a few doors away from Hulcher's office. All parts, gears, drives, belts, and even some electronic components are made and assembled by a staff of eighteen. The Hulcher Sequence cameras are equipped with a rotary shutter with wedge-shaped slits of various widths. As a motor pulls the film from one spool to the other, the shutter rotates. Speeds are determined by the width of the wedge and the speed at which the film is pulled through the camera. When the camera is set on 10 frames per second the speeds are 1/25, 1/50, 1/250, 1/1000, and 1/2000 second. The camera is also designed so it can be used to take single photographs or used with strobe. A rotary "beater" system causes the film to start and stop for each picture.

Hulcher also makes a strobe that can fire 22 frames a second from a 1,200 watt-second power pack, which yields 40 watts for each flash. Leonard Kamsler has used the unit for golf pictures. *Sports Illustrated* photographers John Zimmerman and

PETER MILLER

Neil Liefer have used the Hulcher to cover sport events.

The camera has proved itself. For instance, a downhill ski racer traveling at 80 miles per hour is moving slightly faster than 117 feet per second. If a photographer were shooting the racer with a camera that takes 5 frames per second, the camera would stop the skier every 23.4 feet, and an awful lot can happen in 23 feet. With a Hulcher set at 20 frames a second, a picture of the skier is taken every 5.85 feet.

The Hulcher Sequence cameras are still used at Cape Canaveral, and a number of them were in use during the space shuttle lift-off. Ralph Morse, who has photographed every important lift-off from Cape Canaveral, was down there for *Life* magazine. He went with cases of equipment, including a number of Nikon bodies, six Nikon short-length lenses, and the 400, 600, 800, and 1200 mm nesting telephotos, a spare 1200 mm and 400 mm, and electronic gear to set if all off. He also went down with two Hulchers. Photographers were kept three miles away (it gets sort of hot around the rocket at lift-off time), but photographers could rig their cameras for remote operation at closer distances. Morse picked out a location and set up two Hulchers equipped with long lenses and set at 10 frames per second. Both cameras were loaded with color negative film, as the light could change and cause over- or underexposure with the narrower-latitude transparency film. Morse, who has good contacts with the NASA people, hooked both cameras into the computer that was rigged into the countdown, and the cameras were set to go off at minus seven seconds and stop at plus twenty-five seconds. Both Hulchers produced the best shots of the lift-off.

At the instigation of that wide-field-camera buff, Simon Nathan, Hulcher designed the Hulcherama, a new panoramic camera that shoots a 360-degree picture on 120 or 220 roll film. The camera, powered by a 6-volt rechargeable battery, rotates automatically for 360 degrees or can be run manually to operate for less than 360 degrees. The film is exposed through an adjustable slit, controlled from outside the camera, and the rate of rotation can be varied from 2 to 64 seconds per revolution. There are 9 shutter speeds with 24 combinations of slit widths (aperture) and rotational speeds. The camera weighs about 5 pounds and is equipped with a

Doing It in the Deep

First of all, the smart photographer takes a certified course in diving, unless buried within him are suicidal tendencies. One of the best courses is conducted by the National Association of Underwater Instructors (NAUI), P.O. Box 630, Colton, CA 92324. They run courses throughout the country, throughout the year.

Once certified, learn about underwater photography. The bible for this skill is *Underwater Photography for Everyone*, by Flip Schulke ($18.95, Prentice-Hall). The book, first published in 1978, is being revised.

Flip Schulke is an underwater photographer from Florida who has worked for all the major magazines and has designed his own equipment. He is a photographer first, diver second, and that is why his book is so good. Even a professional can learn from this book. (Schulke also gives underwater photography lessons at certain times of the year — Flip Schulke, P.O. Box 430760, Miami, FL 33143).

Read through *Skin Diver* magazine for underwater photography weeks or seminars. The Brooks Institute of Photography, 2190 Alston Road, Santa Barbara, CA 93108, has formal courses in underwater photographic techniques.

Underwater photography also has specialties — scientific, archaeological, sport, and naturalist. And some photographers specialize in photography at depth while others work just under the surface.

Equipment begins with the Nikonos — small, practical, and quite professional. Then you can begin to use an in-air camera underwater in a special housing. The Nikonos I, II, and III are preferred by many (the automatic Nikonos IV is viewed as a camera designed for amateurs). The standard lens for the Nikonos is the 28 mm, which is designed for underwater use and is equivalent, due to refraction, to the angle of view obtained with a 35 mm lens. The Nikonos 15 mm is the second most popular lens, and underwater it becomes equivalent, in angle of view, to a 20 mm.

Dome ports have been built to hold other lenses onto the Nikonos, including the circular and full-frame fisheye. An alternative to the Nikonos 15 mm, which is not as expensive and only one degree less in underwater angle of view, is the dome-mounted Sea Eye 20 mm. The company that manufactured this dome-mounted lens went out of business, but Oceanic Products (see address below) is manufacturing the lens.

Dome ports also adapt in-air lenses to underwater use. There are technical advantages to this system that are explained in Schulke's book, but the biggest effect is the degree of refraction. These lenses can be used half in and half out of the water and will not magnify the section underwater (to keep drops of water off the dome, very

NIKON INC.

The electronic Nikonos IV-A. Many pros still prefer the earlier, nonautomated models.

PETER MILLER

Nikonos II fitted with a dome and 180-degree circular fish-eye lens

PRENTICE HALL, INC.

The best book on underwater photography

PIONEER & CO.

EWA's underwater housings are also valuable in dust situations.

important when using fish-eye lenses, coat the dome with liquid car wax, or, in a pinch, saliva). Circular and full-frame fish-eye lenses have been mounted to the Nikonos via dome ports. Unfortunately, these domes are no longer manufactured, and must be custom-built.

More photographers are using underwater housings for their single lens reflexes such as those made by Ikelite, Rollei, Hasselblad, and Oceanic (for the Nikon and Canon). The best underwater housings have a large dome port so a number of lenses can be used without changing ports.

EWA-Marine makes an all-weather flexible underwater housing that is good to ten meters and is made in nineteen sizes, for cameras with and without strobes. It is extremely useful for work just under the surface or in spray, in rain, or in the dust and grit of rodeos or motorcycle courses. The housing has an optical port for the lenses, another for viewing, and a "glove" insert so the camera controls can be operated. It is a solid, reliable housing that can solve a number of underwater problems.

Sekonic makes the best underwater meters, including the Sekonic Marine II, which can be mounted onto a handle that fits on the Nikonos or an underwater housing. The handle also holds strobe lights.

Professionals prefer the Subsea MK 100 strobes and the Oceanic 2001–2003 series of strobes. The new Nikon strobe and Sunpak are also worthwhile.

Favorite film is Kodachrome 64. Filters are indispensable, as reds are filtered out at a depth of twenty feet, oranges disappear at thirty feet, and yellows are gone at sixty feet. The favorite is the CC 30 R, which can color-correct under certain conditions to about twenty-five feet. Some photographers prefer to correct the color of their underwater slides by duping them and using CC filters.

The favorite close-up lens is the 100 mm macro in a housing. There are close-up lenses that fit over the Nikonos lenses. Subsea, Oceanic, Aqua-Craft, and Nikon make, among other underwater products, close-up kits.

Underwater Equipment Manufacturers
Ikelite Underwater Systems, P.O. Box 88100, Indianapolis, IN 46208
Pioneer and Company (EWA-Marine flexible all-weather houses), 216 Haddon Avenue, Westmount, NJ 08108
Copal Corporation of America (Sekonic all-weather meters), 58–25 Queens Boulevard, Woodside, NY 11377, or 22010 South Wilmington Avenue, Carson, CA 90745
Oceanic Products, 1333 Old County Road, Belmont, CA 94002
Scubapro, 3105 East Harcourt, Compton, CA 90221
Aqua-Craft, Inc., 7992 Miramar Road, San Diego, CA 92126

35 mm Mamiya lens (equivalent to about an 18 mm lens on a 35 mm camera). It takes a 360-degree picture that is 2¼ inches wide and 9 inches long and can be enlarged using an 8 × 10 enlarger. (One user made prints over 13 feet long, using a $45,000 German enlarger. The prints cost $750 each.)

The camera is also available with a 50 mm lens, which would give a larger image size, valuable for mountain panoramas, but the 360-degree picture is 12½ inches long. An 11 × 14 enlarger is needed to produce enlarged prints. Price of the camera with the 35 mm lens and battery is $3450. The camera has been used for photographing Hollywood shows, architecture, and even the Kentucky Derby (the image taken with the camera was duplicated, then transferred to baseball hats sold at the Derby).

Hulcher has designed a number of one-of-a-kind cameras. "You need a periscope camera to use on atomic submarines? If you want one, we'll make you one, but somehow I can't find a list of buyers," he says. "We made thirty of them. The atomic submarine's periscopes are fifty feet long and cost one million dollars. Unfortunately, they could not see through the periscope and take a picture at the same time. The camera we designed worked from underneath the periscope using a mirror at forty-five degrees and a shutter that has a slit that moves back and forth.

"An Indian from Bombay came in and wanted a nine-lens stereo camera for 35 mm that used a hundred-foot roll. It had to take nine photographs simultaneously with focal-plane shutters. When reconstructed in the darkroom, a print from each lens was enlarged on a single piece of paper and it looked terrible until it was covered with an 11 × 14 lenticular lens screen. Then it produced a beautiful three-dimensional picture. It was used to shoot the Concorde when it first landed in Washington, Muhammad Ali fights, and even President Ford. The Indian was a very persistent man. Once he had the camera he died of a massive heart attack at the age of thirty-six.

"The Globus brothers, triplets with frizzy hair — they reminded me of Little Orphan Annie after she put her finger in an electrical socket — came to me and wanted a streak camera, which takes pictures as the film moves past a slit. We designed a camera that used a four-hundred-foot magazine and could shoot for twenty-six hours without stopping. It was

made to be used with a zoom lens and the speed of the film would change as the lenses were zoomed in and out. You could do a million things with it — put a vase on a turntable and the camera would lay it out flat. They photographed the banks of the Mississippi from a barge and zoomed in and out. Then we made them two crawl projectors, so they could project the film the same way as they took it — through a slit as the film passed in it. It is like a motion picture, but there is no flickering.

"The film they took was projected on screens, one projected right and the other left with the projection crisscrossing onto the two screens. It looked as if you were in the cabin house and were watching the Mississippi River go by. They used an endless loop of thirty feet of film and dubbed in sound. It was one of a kind and was used at the Smithsonian Museum in Washington. They spent ten thousand dollars for that camera. The Globus brothers are very intelligent and creative and have done some remarkable work. Now they are making a hand-held 35 mm panoramic camera. I do not know much about it."

Hulcher has also designed a number of aerial cameras, some of them secret. One of the cameras he made for the Department of Agriculture uses six 2.8 Xenotar lenses that make six pictures simultaneously, each with a different filter so that a large range of the spectrum can be duplicated. By combining the filtered pictures in a laboratory, the viewer could see two hundred feet into turbid water, count sick trees or any problems a forest might have. Canadian officials use the camera from airplanes to tell what is wrong with crops and particularly to tell when croplands need more or less water. It is also used in India for the same purposes.

Hulcher designed another camera for the Federal Aviation Administration, a stereo camera that is operated in a pilot seat of new models of airplanes, to see if there is enough visual space. He also made wide-view cameras for Simon Nathan and is working on a panoramic camera for a Texas photographer. Photographer John Zimmerman is having a streak camera designed.

Perhaps Hulcher's most difficult assignment was for a Canadian astronomer who wanted a camera to find meteorites in the Canadian north. He wanted to know where they landed, so he could find them.

"I learned a lot about astronomy and meteors,"

says Hulcher. "They go like a bat out of hell and are very bright. The brightness of a meteorite is greater than that of the sun.

"We worked with five cameras in a cluster, aimed from the horizon on up, covering the sky. We used photoelectric cells so the camera would go off automatically, but only for meteorites — not for satellites, which are too slow and not bright enough, and not for airplanes and UFOs. The cameras were fitted with filters of different densities and loaded with high-speed, high-contrast black and white film.

"Those cameras were in operation for seven years up in the north — fifty-five of them, in eleven clusters, and they didn't photograph one meteorite and I didn't know if the damned things worked. Then a meteorite of about ten inches in diameter fell near one of the stations. The cameras worked and they triangulated where it fell and they found the meteorite. The astronomer said it was worth waiting seven years for the discovery."

If you want a 360-degree panoramic camera that takes interchangeable lenses, Charles Hulcher will make you one. He will also make just about any other camera, if you and he have the time and patience. Write to Charles A. Hulcher Company, Inc., 909 G Street, Hampton, VA 23661.

Lenses:
The Photographer's Eyes

Good photographers create pictures. Cameras take pictures. Lenses *make* pictures.

The lens is the most important element in the mechanical process of taking a picture. Except for those photographers who sport styles that are based on soft focus and blurs, the lens is all-important. A good lens makes a photograph sharp, bright, contrasty, and color-corrected. It gives a photograph authority.

A lens should be sharp — it must have strong resolving power, good definition. It should have high contrast, or what photographers call "snap," and it should have good color correction. There are a number of books and pamphlets that describe in detail optical construction and faults called aberrations. The most serious faults are pincushion or barrel distortion (vertical lines curve in or out), chromatic aberration (the three primary colors do not focus on the same plane), flare, and coma. Test reports on lenses give a hint as to their performance, and the best test reports are in *Modern Photography*. This magazine also will supply, for a fee, particular test reports that have appeared in back issues. Some photographers like to do their own tests, using specially prepared charts. (*Modern Photography* sells a lens test kit.)

Most professionals buy lenses from reputable manufacturers and the lenses they buy have a proven track record. Their tests are usually done in the field. Some shoot portraits and scenics and in-clude in the photograph a color scale. They use a high-quality viewing loupe and eyeball the transparency to see if there is good definition in eyelashes, contrast or "hardness" in the reflections in the white of an eye, and contrast between bright and dark tones, as in the outline of a cheekbone against dark hair.

Mechanically it is best to have lenses made by the same manufacturer so that they adapt easily to the camera, but more important is that they function the same way. The lenses should have aperture dials

Lens Trends

Amateurs often buy cameras equipped with a standard 50 mm lens. Most professionals do not like this standard lens — they feel the 50 mm does not have a wide enough field and is not strong enough to be of use for head shots.

The professional will buy a camera body and stick a 35 mm lens on it. The 35 mm is fast, gives a wide image without distortion and without shrinking the image too much. It is known as the universal lens.

Some professionals even favor the 28 mm over the 35 mm. The 28 mm lens designs have been improved and their speeds increased. Photographers feel that this lens is better suited for street photography, scenics, and interiors. The 28 mm lens puts more information into the image.

A number of years ago the favorite medium telephoto was the 85 mm. This lens fell out of favor when the 100

Minolta's family of lenses — more than any photographer needs

and 105 mm were designed. All these lenses are very good for head shots, but the newly designed 85 mm lenses are faster (Canon makes an 85 mm f/1.2) and allow the photographer to work closer to his subject, a valuable consideration in crowds, at news events, and in establishing a relationship between the photographer and the person he or she is photographing.

Zooms had their heyday with professional photographers, but now are taking a backseat to fixed-focus lenses, although all pros own one zoom and sports photographers thrive on them. The zoom is hard to focus and doesn't have the snap and contrast of a fixed-focus lens. A contact sheet can also appear to lack structure when a zoom is used extensively. Fixed-focus lenses seem to dictate awareness in composition and a natural progression in the viewing process from one frame to the next.

The 180 mm has waned in popularity. This lens gained great favor in 1937 when Zeiss designed the 180 f/2.8

Sonnar for coverage of the Olympics. The lens was, and still is (as the Zeiss Sonnar T 2.8 180 mm, an updated version), incredibly sharp and contrasty. Similar lenses that followed the Sonnar did not match it in quality, and photographers moved to the 200 mm lens. Now there are new 180 mm lens designs and it may come back into favor.

The circular fish-eye is completely out of favor; there seems to be prejudice against it. The simple reason is that this lens was so overused that the images made with it became clichés. Photographers moved to the full-frame fish-eye, but even that lens has lost out to the very wide angle rectilinear lenses that do not bend verticals and horizontals when used level.

For all this trendiness one should not forget, as previously mentioned in this book, that one of the world's great photographers, Cartier-Bresson, did most of his work with a Leica equipped with a 50 mm lens.

and focusing rings that turn in the same direction so that operation of all lenses can be a subconscious act.

Zeiss and Leitz lenses are reputed to be the best made. The longer lenses that use optical glass to limit chromatic aberration and increase color contrast are an immense improvement in design in recent years. Leitz Telyts, Nikkor EDs, Canon FLs, and Minolta Apos all use special optical elements and are superior lenses. The 105 mm f/2.5 Nikkor is legendary for its crispness, and so is the Canon f/1.4 24 mm. The Zeiss Distagon T 15 mm is incredibly sharp. Olympus has some very good compact zooms and macro lenses. The Nikkor 80–200 mm zoom has been the standard by which to judge all others.

Lenses should be made to last. A lens that has a light mount and is shoddily constructed mechanically could disintegrate within six months — the diaphragm could shake apart after a long car or plane ride, the lens element could be knocked off kilter if the mount was bumped or dropped. Good lenses are invariably built into rugged mounts.

The most popular lenses used by the professional are the 28 mm or 35 mm and the 85 mm or 105 mm. Next on the list would be a telephoto, either the 180 mm or 200 mm, and the extreme wide angle, such as the 20 mm or 24 mm. These are considered basic lenses. Some photographers cover these lens sizes (except for the 20 mm) with zooms. However, zoom lenses have slower optics than regular lenses, they are not as sharp, and are hard to focus. Zooms are important to amateurs, to those who have to work in a bloody hurry, such as photojournalists, and to expedition, sports, or action photographers.

Photographers on a job might need one particular lens that is oddball. Sometimes they rent it, but most of the time they buy, when the money is available. The special lenses fall into several categories.

Super Wides

Circular fish-eye lenses were first designed for close-up work and to show what the inside of a pipe looks like. There are two different models; one takes a 220-degree picture, the other a 180-degree. Most photographers misuse the fish-eye lens by shooting subjects that become grossly distorted. Fish-eyes are practical to photograph small spaces, as in research submarines. Creatively they are best when they photograph an image that appears well in a circular format — the horizon, a string of pearls on a beach against the sea, the interior of the Guggenheim museum in New York, looking straight up and straight down. The 220-degree lens has applications in sports. Strapped to a skier's or a biker's waist or mounted on a helmet, it can show the front, side, and 20 degrees to the rear. The picture would be an exciting view of a skier swishing through powder, or a biker at the start of a race. (Figure $6000 to buy the 220 mm f/2.8.) The 180-degree lens can also be adapted for underwater work and, held just under the surface, can give a fish-eye view of an angler netting a fish.

Full-frame fish-eye lenses also cover 180 degrees, but fill the 35 mm frame, and curve lines the same way the circular fish-eyes do. Most fish-eyes have built-in filters, but the new Nikkor f/2.8 16 mm fish-eye has a bayonet-mount system on the back of the lens for special filters made by Nikon. The full-frame fish-eye is more versatile than the circular fish-eye; the image is larger, and so does not distort as much. Minolta made the first full-frame fish-eye lens.

Rectilinear super-wide-angle lenses are designed so the images are not distorted. When they are used properly, straight lines remain straight. The lens is the opposite of the fish-eye, or curvilinear, lens and is a valuable lens to show interiors, very wide landscapes, or crowded, vertical cityscapes. The widest

The effect of focal length on a picture, taken with 35 mm equipment.

PHOTOS BY PETER MILLER

7.5 mm fish-eye

16 mm full-frame fish-eye

55 mm

20 mm

105 mm

35 mm

180 mm

300 mm

500 mm

420 mm (300 mm plus 1.4x converter)

*700 mm
(500 mm plus
1.4x converter)*

80–200 mm zoom, lens zoomed down during slow exposure

of these lenses is the 13 mm f/5.6 Nikkor and it is priced about the same as a compact car with a few accessories. The most popular rectilinears are the 15 mm lenses, and most of them, including the Zeiss Distagon, have f/3.5 apertures.

Super Longs

Long telephotos are lenses with a focal length of 300 mm or longer. Popular with sports photographers are the super-fast 300 mm f/2.8, 400 mm f/2.8 and f/3.5, 600 mm f/4, and 800 mm f/5.6. They are true telephoto lenses and are long and heavy compared to the mirror lenses. The longest of these telephotos is ED Nikkor 1200 mm f/11. It is 28½ inches long and weighs just over 8 pounds.

Mirror lenses can be half the length (and sometimes less) of a regular telephoto (the 1000 mm mirror lens, which provides images 20 times as large as the standard 50 mm lens, is 9½ inches long, one-quarter the length of its actual focal length). The mirror lens, called catadioptric, uses mirrors to "fold" and magnify the image before it strikes the image plane. The lenses are light and have fairly fast fixed apertures, good resolution, and are less expensive than the long telephotos.

However, mirror lenses have limitations. Because they do not have diaphragms, they cannot be stopped down — if a mirror lens has an aperture of f/8, that is the only aperture it can be used at. Exposure is controlled by the shutter speed or by neutral density filters that screw into the back of the lens. Because there is no diaphragm, the depth of

Rules about Telephotos

- A telephoto should focus down to twelve times its focal length so it can be used for head shots.
- Rule of thumb is that a telephoto, when hand-held, should be used with a shutter speed equivalent to, or higher than, the telephoto's length in millimeters. (A 200 mm should be used at 1/250 — the closest shutter speed — or faster.)
- Long telephotos tend to overexpose because of atmospheric conditions, even when used with meters. Bracket exposures on the low side.

Nikkor 300 mm f/2.8 is dressed in black, Canon's equivalent is dressed in white. With extenders these are the super spies of sports cameras.

field remains the same; it cannot be increased or decreased as in an aperture-controlled telephoto.

Often the mirror lens is not contrasty enough, does not give "snap" to a picture; and some of them, when shooting clear areas such as the sky, will have a higher-density circle in the center of the image when transparency film is used. This is caused by the mirror that folds the light onto the film plane. Also, out-of-focus highlights, when taken with a mirror lens, appear as circular "doughnuts," a reflection from the mirror lens aperture. Some people like the doughnut images, others find them annoying, particularly in news shots where they distract from the subject.

The longest focal length in a mirror lens is 2000 mm and the price ranges from $2.80 to about $5.50 per millimeter for this focal length.

The extra-fast telephoto lenses — the 200 mm f/2 and f/2.8, the 300 mm f/2.8, the 400 mm f/2.8 — are ever increasing in popularity. The longer lenses sell (at discount) from $1800.

Canon and Nikon are leading the pack in producing these lenses and there are several good reasons for investing in them. New optical materials make the longer lenses very sharp — they cut down dispersion of light and bring together the three primary colors so there is little chromatic aberration and the long lenses can be sharp at their largest openings.

Most professionals realize that Kodachrome 25 and 64 have the best color, contrast, and grain structure of any film and are favored for large blowups and posters. The new lenses allow the photographer to use these films with higher shutter speeds (the lenses are almost always used wide open). This is particularly valuable for sports photography. Go to any major sports event, such as a tennis match or a

Teleconverters

Teleconverters are a very compact way to increase the focal length of a lens. The cheap teleconverters are not really usable when the lens is wide open — they are too soft and the prime lens has to be stopped down two or three times. With a poorly designed 2X extender, for instance, an 80–200 mm f/4.5 zoom becomes a 160–400 mm zoom, but the smallest effective f-stop becomes f/9. To make the photograph sharp the lens should be focused down to f/16.

There are excellent teleconverters that yield sharp pictures at full aperture. These are matched teleconverters made by the manufacturers for the lenses they produce. Usually they are made in two models, for focal lengths under 300 mm (2X converters), and for lenses over 300 mm in length. They can be expensive, but can produce exceedingly sharp images.

Converters that are customized for certain lenses may produce good results on lenses they were not made for but, unfortunately, the best converters have fixed mounts designed to be used with a specific camera line.

The best converters are made by Nikon, Canon, Leitz, Minolta, and Olympus.

ski race, and there in evidence will be a gaggle of photographers equipped with these 300 mm and 400 mm behemoths attached to their cameras with the shutters set at 1/1000 and 1/2000.

The lower f-stops transmit more light into the viewfinder, and this makes focusing easier (focusing with a 300 mm and 400 mm on a moving object takes much practice). The low f-stops on these long lenses also whack the background and foreground out of focus. This shallow depth of field tends to isolate the subject. It is a valuable consideration in sports photography, fashion, and for any photograph that will have type written over it, such as those on magazine covers.

These lenses are very versatile when used with teleconverters, provided the teleconverters are made by the manufacturer of the lens and designed specifically for their long focal length lenses. The 1.4X converter made by Nikon converts its 300 mm f/2.8 into a 420 mm f/4. The Canon 2X extender supplied with its 300 mm f/2.8 and 400 mm f/2.8 turns those lenses into a 600 mm f/5.6 and 800 mm f/5.6, incredibly fast for such long telephotos. (Nikon and Minolta also make 2X extenders for their

long lenses.) Basically, these converters turn one lens into three, and the savings amount to thousands of dollars.

Oddities

The Makowsky Katoptaron is a rectangular, box-shaped all-mirror 500 mm lens that has variable f-stop controls from f/8 to f/32. There are no lenses in the Makowsky Katoptaron — a Zeiss-developed optical-quality ceramic is used for the mirror blanks. Actually, since there are no lenses in the lens, it really should not be called a lens. The advantages of the Makowsky are that there is no doughnut effect (because the lens does not have a central disk), no chromatic aberration, no interference by ultraviolet and infrared wavelengths. Thus the lens has extremely high contrast and resolution. The lens does not change focus during temperature changes (a fault with some catadioptric lenses), uses 67 mm filters at the front opening, and focuses down with a macro provision to 6¼ feet, which gives a 1:3 image ratio.

Several new versions of this lens are being designed. One will have mounted on the top a zoom rifle scope with cross hairs. The scope will be the very accurate viewfinder — center the cross hairs on a flying bird and the bird will be perfectly framed through the mirror lens.

The EM model has macro accessories. An extension tube with an eyepiece fits between the camera and lens. The Katoptaron has a floating mirror design, which allows the mirrors to be tilted to focus at near and far range. With the eyepiece, the photographer can stand a few feet away from an ant and fill the frame with it. Exposure is long and flash is a necessity when photographing moving subjects.

The lens is distributed by Infinity Optical Systems, Inc., 3000 Colorado Avenue, Suite 1-120, Boulder, CO 80303.

The Questar 700 mm Mark II Manual Fast Focus is made by a small Pennsylvania company that specializes in compact telescopes. Questar is renowned for its excellence in producing superior optics in rugged and beautifully finished mounts. The 700 mm Mark II has an aperture of f/8, is eight inches long, and weighs four pounds. The lens does

Questar 700 mm Mark II is American-made and of very high quality

not have fall-off on the edges as do some other mirror lenses, and has superior resolution. The Mark II has a special fast-focusing lever so that focus and exposure can be controlled by one hand. The lens should become a favorite with nature photographers for long-distance and close work — the lens focuses down to ten feet to give an image ratio of 1:4. Questar Corporation, Department 700, New Hope, PA 18938.

Zooms

Zoom lenses are the manufacturers' l'il darlin's — their sales appeal seems to be irresistible.

Zooms have improved tremendously since they were first introduced. Definition and contrast are better than they were, the lenses are not as bulky, and there are wide-angle zooms (24 mm to 50 mm), wide-angle to telephoto zooms (28 mm to 85 mm), telephoto zooms (80 mm to 250 mm), and super-telephoto zooms (360 mm to 1200 mm).

Zooms are handy — an 80–200 mm zoom replaces four commonly used fixed-focus lenses — and many of them have macro ability so they can close focus. Some of these lenses are of very good quality, not only the big-name zooms such as Nikon and Leitz, but also brands such as Vivitar Series I and the Kiron and Tamron zooms, which have tested out with good to excellent resolution and contrast.

However, most zooms are infested with a number of aberrations, mainly because of the complexity of the optical system. The lens flare causes softness on the edges of film, they are susceptible to chromatic

aberration, spherical aberration, edge astigmatism, and so on. What this means is that vertical and horizontal lines can be distorted and flare can soften the picture when the photographer is shooting toward the sun, and coma can cause little burned-out spots. Many of these lenses have a delicate softness to them and don't have good color balance. However, the 80–200 mm Nikkor zoom has the reputation of being the best — sharp, good contrast for a zoom, little distortion, good color balance.

Zooms are simply no match for a fixed-focus lens — zooms are harder to focus and they do not make as good photographs. Yet, zooms are handy, quick to use, compact compared to carrying three camera bodies with three different lenses on them, and can be used creatively by zooming during a long exposure. Regardless, most zooms do not have the crisp clarity of a fixed-focus lens.

The favorite zooms are 35–85 mm and 80–200 mm. Jock sports photographers — those who cover football, baseball, and soccer — dearly love the long-focal zooms, 100–500 mm, 200–600 mm, and the 360–1200 mm (list price $10,502).

Not all zooms operate the same way and some are not even zooms. A zoom stays in focus when the focal lengths are changed, while a varifocal has to be refocused. Some zooms are called two-touch — one ring turns to focus, another turns to zoom. These lenses are often sharper than the one-touch zooms, where one control ring is simultaneously pushed/pulled for zooming as it is turned to focus.

The one-touch zoom is the favorite because a zoom works best for action in sports, news, or wherever there is motion. A well-trained photographer can keep the subject in focus as he zooms to keep the subject full frame, such as a jogger coming toward the camera. One hand does all the work. One-touch zooms are bulkier and harder to focus, but the working convenience makes the difference.

Miscellaneous

Macro lenses are designed to give a flat field (no curved lines on the edges) and high contrast and resolution at short distances (magnification up to 10X but usually at a 1:1 ratio). A true macro is a marvelously brilliant lens, such as the Nikkor 55 mm f/2.8 Micro (a macro lens but it is easily adapted to

a microscope) or the Leitz 60 mm f/2.8 Macro-Elmarit-R. Good macro lenses have helical mounts, which mean continual focusing from infinity to their closest focusing range, usually 1:2, which is one-half life-size. An extender makes these lenses focus down to 1:1, or life-size, where it magnifies a subject to the same size as the 35 mm frame — an object 24 × 36 mm (under 1 × 1½ inches) would fill the frame.

Macros are invaluable for photographing such objects as bees playing in pollen, praying mantises, coins, documents, and slides. The newer macros are also superb general lenses and are corrected to produce good results at infinity.

Macros are designed in 55 mm and 100–105 mm lengths. Nikkor also makes a 200 mm micro that is razor sharp and gives a 1:2 image. The 55 mm lenses are generally rated at f/2.8, the 100–105 and 200 mm lenses at f/4. The longer lenses are much more adaptable in the field, for there is not that smothering invasion of privacy that is a habit of the shorter lens — at a 1:1 ratio the 55 mm is eyeball to eyeball with the subject. If it is a frog, that close distance might have him leapfrogging away. The 105 mm and 200 mm (which close focuses at 26 inches) do not frighten the creatures so much.

Some field photographers prefer to put extension rings on their long telephotos, such as the 300 or 400 mm lengths, and give their subject even more breathing space. Often they are only using the center of the lens and don't care about fall-off on the edges of their pictures.

An unusual close-up lens is the 200 mm f/5.6 Medical Auto-Nikkor. Originally designed for surgical and dental close-ups, it also works well for nature close-ups. The lens has a fixed focus at 11 feet, which provides a 1:15 reproduction ratio. Sup-

200 mm f/5.6 Medical Nikkor can make the subject three times life-size

The Ten Most Important Lenses for the Average Professional Photographer

1. 35 mm of an aperture of at least f/2
2. 85 mm or 105 mm, f/2.8 or faster
3. 180 mm or 200 mm f/2.8
4. 20 mm f/3.5
5. 80–200 mm zoom f/3.5 or f/4.5 (for sports and backup)
6. 50–60 mm macro
7. 300 mm f/2.8
8. 28 mm f/2
9. Tele-extender for 300 mm f/2.8 and 180 mm f/2.8
10. 15 mm rectilinear

plementary lenses can be attached to the lens to shoot at shorter distances with ratios up to 3 times life-size (3:1). The lens has a built-in electronic flash and four incandescent bulbs that work as modeling and focusing aids. A small battery power pack runs the flash and modeling lights. Automatic exposure can be ensured by setting the ASA film rating with the reproduction ratio. This presets the automatic diaphragm. There is also a 120 mm version of the Medical Auto-Nikkor.

Certain macro lenses are designed for use with a bellows, which can give magnifications from 1.8X to 10X. Canon, Zeiss, Leitz, Minolta, and Olympus makes these types of lenses. They should be used on a bellows that is built rigidly, for focusing macro lenses at long extensions is a very critical task.

Shift lenses, also known as "perspective control" lenses, are 35 mm lenses that borrow viewfinder principles — the lens shifts laterally, which gives lateral and vertical shifts, depending on how the camera is held. Shift lenses are most valuable in architectural photography to prevent converging lines. If a normal lens is tilted up, say at a building, the lines in the building will converge. With a shift lens, the camera can be kept parallel to the lines of the building and the lens shifted to gain height and keep the lines true. The shift lens can also be used to eliminate foreground or increase the vertical coverage, and can be a creative tool for landscape photography. There are also interesting applications when the shift is used in stages during multiple exposures.

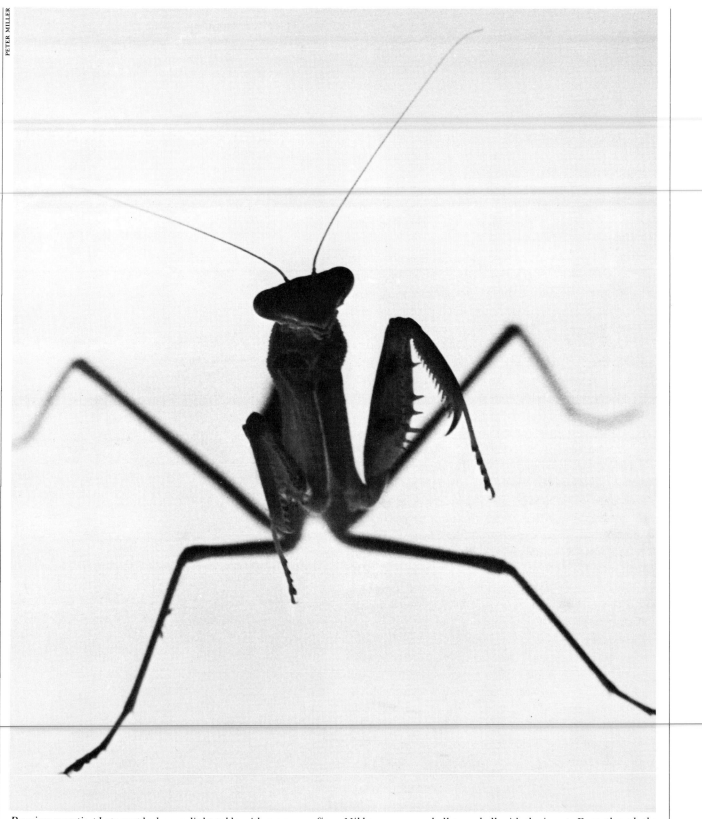

Praying mantis photographed on a light table with a 55 mm f/3.5 Nikkor macro, eyeball to eyeball with the insect. Even though the insect was fed some vodka to calm it down, it still wanted to fight, and after the session, flew off, slightly out of control, into the night.

NIKON INC.

Perspective-control lens, such as this 28 mm Nikkor, is invaluable for shooting architecture

PHOTOS BY PETER MILLER

1

The shift lenses are made in 28 mm and 35 mm focal lengths. They function as shift lenses because the lens angle of coverage is larger than the 28 × 36 mm format of the 35 mm frame.

The most interesting shift lens is the Canon 35 mm f/2.8 TS. The lens not only shifts but also tilts, like that of a view camera. This means that the camera can be tilted up and the lens tilted and shifted to control perspective. The tilt can also be used to control the depth of focus.

The *Minolta Varisoft* is an 85 mm f/2.8 portrait lens that has a built-in softness control ring. The lens can be sharply focused; then by turning the soft-focus ring, the image can be made soft. The effect is achieved by changing the spherical aberration of the lens. Most soft-lens effects are done with filters, by crushing cellophane and putting it over the lens, or by smearing a filter with Vaseline. For the soft-focus romanticists, portraitists, and nymphet photographers à la David Hamilton, the Minolta Varisoft is the eye that does not wither age and that renders beauty, such as it is, in diaphanous artificiality.

Anamorphic lenses were designed to give wide-angle effects on the screen. They can be adapted to still cameras for some odd effects. Remember the crazy mirrors at the county fairs, that made you look short and squat or long and skinny? Well, that is what the anamorphic lens does. It can be used effectively in sports, to enhance motion or steepness, or to give an eerie feeling to a Charles Addams house or Frankenstein castle.

2

3

Anamorphic lens set to squash (1) and to stretch (2) the Empire State Building. No. 3 was taken with a normal 55 mm lens.

Filters:
For Better and for Worse

Filters have been the secret weapon of the professional photographer. However, the photo-culture boom has taken photography to the masses and the manufacturers have finally given the public "creative" filter systems, so they too can alter colors and create their own form of pop art. Many amateur photographers use filters badly.

Filters are no more than colored squares or circles of glass, gelatin, or plastic. They pass their own color through the filter and block, to varying degrees, other colors.

Filters are used in general color photography for the following purposes:

1. To correct color temperature. These filters will move the ambient color temperature up or down the Kelvin scale to give a corrected color balance to the film. For instance, light from a cool white fluorescent tube appears greenish when photographed with daylight film, but a CC 30 M filter will balance the color so that it appears normal to the eye. Filters are also needed to correct color changes due to long exposure (reciprocity failure).

2. To enhance color. Few photographers realize how a very faintly tinted filter can enhance a scene. A CC 10 Green can add lushness to a still life of lettuce. A CC 10 Yellow creates warmth in a green woods scene. Sometimes the change can be drastic — a deep red filter can bring out, psychologically, the emotions of danger or sexiness.

3. To protect the color. Ultraviolet filters help screen out rays invisible to the eye, but that can give a transparency a blue or purple tinge. These rays are particularly troublesome in the high mountains. Haze filters warm a photograph by correcting the bluish cast caused by the sky. Haze and ultraviolet filters are also used to protect the lens from moisture and scratches.

4. To cut reflections or emphasize saturation of colors. This is accomplished by using the polarizing filter. When used at right angles to the sun, the filter deepens the sky to a dramatic blue and also cuts haze. It will cut reflections that appear in windows and in water, but it also cuts reflections or shiny spots on leaves or faces, and thereby deepens, or saturates, the colors.

5. To lessen contrast or to cut exposure. Neutral density filters do not change colors, they block some of the light coming into the camera. They are valuable when there is too much light and the photographer wants to use a low f-stop to isolate the subject or a low shutter speed to create blurs. Neutral density filters also help lower contrast and are valuable for sea and snow scenes, and for duplicating color slides. Because NDs lower contrast, photographers prefer to use the polarizer when they wish to maintain contrast but lower the amount of light entering the camera.

6. To add something to the photograph that is not there. This is the bag of tricks that many photographers use and some overindulge in. These filters include

Tips on Filters

- Never use more than three filters at a time. Neutral density could build up, resulting in underexposure.
- Meters do not read the ends of the spectrum well, particularly blue.
- Filters tend to enhance the color in the low-key areas of the subject. Ultraviolet light affects black and white panchromatic films, which are less sensitive to yellow and more sensitive to blue. A yellow filter, No. 8 or No. 11, darkens blues and lightens yellows. The latter has a tinge of green in it and makes for better flesh and foliage tones.
- The light yellow filter, made for black and white, has a pleasing effect on some scenes photographed in color, particularly in the woods or in fog.
- The graduated-density filters, particularly the red (or tobacco), blue, green, and neutral density can make an ordinary scene more dramatic. The ND makes the sky darker, the blue can make water a deeper color, the green works well with grass, and the tobacco can touch up a sunset. The graduated filters are half clear glass, half filtered.
- Use neutral density filters to reduce contrast.
- The Ektachrome films have a bluish cast to them when used outdoors on a sunny day and can be greatly improved by warming up the colors with an 81 B or 81 C filter.
- A hazy or cloudy day increases the bluish cast. Use a strong warm-up filter. One of the best warm-up filters is the Nikon A 2, which is coral colored, similar to the Harrison and Harrison filters.
- Buy the same type of filters if possible. Color cast and exposure factors can change between brands. If shooting in a hurry with several lenses, make sure each has the same type of filter on.
- Some camera through-the-lens meters do not read polarizer filters correctly. Check with the manufacturer to see if a special polarizer has to be purchased.
- Use the *Kodak Professional Photoguide* for detailed information on filters for fluorescent lighting and for the charts on contrast control, and for the very useful dial for balancing color temperatures with filters.
- In artificial-light situations, there are times when the filters should be placed over the lights, or some of the lights. With fluorescent lighting it is often more practical to balance the strobe light (which is daylight balanced) to the tungsten light and filter them both at the camera lens.
- Above all, remember that muted or subtle colors are intriguing. Very bright colors appear best in very graphic, bold compositions. Break the rules to shock.

prisms that create a number of images on the same frame, color diffraction filters that break highlights into the spectrum, fog or diffusion filters to create misty or soft-focus scenes, and garishly colored filters. In this category are those cutout frames that put an outline on the film, such as a heart, a keyhole, a binocular effect. Ninety-nine times out of a hundred, the pictures made with these filters are horrible.

7. *With infrared film.* This film reads an invisible part of the spectrum and when used with certain filters can turn grass magenta, and blue sky lime-colored or orange.

Filters are used with black and white film to correct or change tones. The basic filters are red, blue, green, and yellow. Red creates a dramatic black sky, cuts haze, and creates night effects. Blue creates an atmospheric or misty effect. Green makes foliage lighter and enhances skin tones. Yellow is the most valuable, for it creates a natural tone — blue sky is slightly darkened, stone, sand, and snow gain texture, portraits become flattering (but not as textured as with the green filter). Polarizers are used as they are in color — to create dark sky and reduce reflection — and a polarizer combined with a red filter turns blue sky black.

Filters for black and white film pass their own color, and, as with color film, block other colors. To make the subject lighter, use a filter of the same color. To make it darker, use a filter of the opposite color. A red filter will make red against white appear very light. For emphasis, a green filter should be used, as it will make the red dark and contrasty against white.

Yellow filters not only add tone to panchromatic films, they also lessen the exposure by one stop. This is important with fast film, for the filter allows a lower f-stop. Normal outdoor exposure with ASA 125 film is 1/125 at f/16 with bright sun behind the photographer. With a 35 mm lens, this gives great

depth of field that can complicate a picture by creating confusion in the foreground and background. The shallowest depth of field at that exposure value is 1/1000 at f/5.6 or 1/2000 at f/4. The filter allows an extra stop of exposure and with 1/2000, allows the lens to be opened to f/2.8. Former *Life* photographer Douglas Duncan knew the value of the yellow, or K 2, filter, as he showed in his war photographs. The filter gave more contrast and therefore drama to his pictures, and let the backgrounds go fuzzy, isolating the soldiers and drawing impact away from the scene and to the human and emotional aspect of any war. *Some* critics might say that Duncan romanticized war by his approach to photography.

Filter Series

Most filters are made in series, numerically graded (sometimes in a very confusing system of numeration).

Light balancing filters (otherwise known as color conversion filters). There are two systems, Decamired and Kodak Light Balancing Filters. The decamired value equals ten mired. A mired is equal to one million divided by the color temperature in degrees Kelvin. This technical gobbledygook means that the lower the mired or decamired value, the

Camera System Filters

Many camera system manufacturers make their own series of filters and multicoat them (all good modern filters are multicoated to reduce flare). Some, however, put the same coating on their filters as on their lenses. Nikon does this on the L37C (ultraviolet) and L1BC (haze). The point here is that if a photographer spends much money for a very good lens, why ruin its characteristics by putting a cheap filter over it?

Leitz produces the Black and White series of filters that are optically superior, as are the filters made by Zeiss. Canon, besides producing the 80, 81, and 85 series, also makes a diffusion filter and filters to correct fluorescent light. The leading filter maker in Japan is Hoya and its filters are sold under the names of different distributors. Tiffen and Harrison and Harrison are the leading American filter manufacturers. Kodak, though, produces the greatest variety of filters as gelatins.

Kinky Infrared

Infrared is the weirdest film. The black and white film can produce ghostly whites. The color film is very unpredictable. Infrared film reads the invisible (to our eyes) spectrum and should be used with special filters (red, or IR filter No. 89B) with black and white infrared film.

Kodak Ektachrome infrared film is supposed to be exposed through a Kodak Wratten filter, No. 12, which is deep yellow. However, some odd combinations make some odd colors. Without a filter the picture is magenta. A 23A filter (light red) with a polarizer turns the sky dark green, trees bright orange. A purple filter (No. 22 gel) and a light green filter will turn the sky black and the trees red. The reason the film acts peculiarly is that the green layer of the film produces a yellow color, the red-sensitive layer turns magenta, and the infrared-sensitive layer produces a cyan tone. The film is designed for scientific purposes, particularly for aerial and medical work. It can make very weird photographs under the right conditions. However, the infrared waves are affected by a number of variables and it is difficult to know what color will be produced except when using the recommended filter, Kodak Wratten No. 12.

bluer the filter. The higher the decamired, the redder the filter. Tiffen filter company, for example, makes a decamired set that consists of eight filters, four grades of blue and four grades of yellow to orange.

Kodak Light Balancing Filters come in a set of sixteen, eight grades of blue and eight grades of yellow to orange.

Decamired and Kodak Balancing Filters are used to correct color temperatures. The filter to be used is selected by guess or by gosh, by experience, and with precision when using a color temperature meter.

What these light balancing filters can do:
- The 85 B, the deepest color range, will change 3200 K tungsten balanced film (indoors) to 5500 K balanced (outdoors).
- The 80 A, a blue filter, will change 5500 K balanced film (daylight) to 3200 K lights (tungsten).
- An 81 A filter, pale yellow, is often used with electronic flash to remove some of the blue inherent in strobe light (some flash manufacturers build the 81 A filter into their units).

The Most Important Filters

1. *Haze or UV* to cut blue and protect the lens
2. *81 B or C* to filter Ektachrome and for use on dull days
3. *Polarizer* to cut reflections and saturate colors
4. *81 C, 81 EF, or 85 C* to further warm up colors on dull days and in the shade
5. *85 B* to add color to sunset and to change tungsten film to daylight-sensitive film
6. *80 A* to add mystery and a night feeling to predawn and postsunset pictures, to add blue to water, to convert daylight film to tungsten
7. *30 M or special fluorescent light filters* to correct for fluorescent light situations, to redden sunsets
8. *Half-field neutral density filter* to darken the sky
9. *Half-field green filter* to freshen up wilted grass
10. *CC 10 M* to add color and warmth to a picture

• Overcast sky gives a blue tinge to the ambient light and should be corrected by the yellow series, the 81 B or C. Hazy skylight can be even more blue and may need the correction of an 85 C.

• The 80 A and 82 C combined create night-scene effects.

• Many photographers, to add warmth to their photographs, leave an 81 B over their lens rather than the haze filter. Some claim that pollution is destroying the ozone layer, which lets more ultraviolet light creep down to earth and causes not only skin cancer, but more blue in the average picture.

The Flare Stop Box

It's called a compendium and a very unwieldy box it is — a bellows-type attachment that fits to the front of the lens and extends and retracts, according to the length of the lens. It is the ultimate sunshade and keeps the lens flare-free when working in situations where backlight could bounce around within the lens. The compendium can vignette wide-angle lenses. For critical work (when the creative director can't wait to look through the lens) it produces a picture that has more contrast and pizzazz. One of the best "compendia" is made by EWA, which developed the device for cinemaphotography.

• The 81 EF, 85 B and the 85 are very good filters to enhance the colors of a sunset.
• 80 A and 80 C deepen the color of water and help create deep, deep blue sky with photographs taken at twilight.

Color compensating filters were originated by Kodak and are made as gelatin filters. They are thin films that are tinted in the primary and secondary colors of red, green, blue, cyan, magenta, and yellow, and in six grades of neutral density. They can be cut and taped to the back of a lens or put in a metal gelatin holder that attaches to the front of the lens. Each color comes in six degrees of color density — CC 05, 10, 20, 30, 40, 50.

The late Eliot Elisofon of *Life* magazine was the first photographer of note to use color filtration effectively in his work for *Life* and as color consultant for the movie *Moulin Rouge*. His book *Color Photography* (Viking Press, 1961) is a brilliant analysis of the psychological interpretation of color and remains a valuable reference.

"Don't overload your picture with color just because you have paid for color film," said Elisofon. "A lot of color does not necessarily make a good color picture. Do not look for obvious color; look for the subtle."

Elisofon used the Kodak CC filters effectively, but usually not one more powerful than a CC 20. CC filters can be used to add a touch more color. Elisofon often enhanced the predominant color by making that color stronger with the use of the CC filter of the same color. At times he used the filters to alter the psychological feeling of the picture. Elisofon was a painter and spent much of his time studying the works of Impressionists to see how he could translate their use of color into film. A *Life* colleague of his, Yale Joel, once said he shot a picture of a room that was to evoke a death scene, and he used a yellow filter. Elisofon was shocked. "Yellow is not the color of death!" he said. "Purple is! You should have shot the room with deep blue and magenta filters." Both, however, were right. Joel worked on the nostalgic feeling of time past, as in a sepia-toned print. Elisofon interpreted the scene through the mystery and mysticism of death as a transition. Both tackled the problem through filters.

Harrison and Harrison filters are made in Los Angeles and were designed primarily for correction and effects in movies. They have two series, a bluish

green and a coral-colored series, and both are extremely effective. The coral is more reddish than the 81 series. Harrison also makes special-effect filters, for fog and night scenes. Elisofon used these filters to good effect and in many cases preferred their tints to those of the CC series.

Black and white filters, Wratten series, come in seventeen usable shades of yellow, red, blue, and green. They are used for contrast control, particularly in copying, and for faithful reproduction of color into black and white tones. A black and white photographer needs only a few filters in yellow, green, and red. Landscape and architecture photographers use these filters to manipulate contrast between stone, grass, sand, and sky.

Creative Filter Systems

The creative filter system was initiated by a frustrated French photographer, Jean Coquin, who wanted to increase the beauty and drama in his photographic assignments. The result is now marketed as the Cokin system, and there are several competitors, Ambico, Multifilt (Acme Lite), and Hoya.

The filters are squares made of plastic compounds. Cokin and Multifilt are made of CR 39, the same plastic used in eyeglass prescriptions. The filters are dyed in the molten state, while Ambico uses plastics that are of the same quality, but with the colors coated on the plastic. The filters fit into slots on the lens adapter. Up to three filters can be slipped over the lens.

A typical creative system will have seventy-five to a hundred different filters. They include the normal skylight or haze filters and color conversion filters made by Kodak, but there are also pastel and sepia filters, prisms, graduated filters, which are half clear and half colored, multiple image filters, diffusers, star filters, polarizing filters, preshaped frames, linear filters that duplicate the effects of a strip camera, and blur filters that make a stationary object appear half blurred.

In creative hands, the filters can be valuable. However, they will probably be used for "trick" photography and the results could become clichés. Professional photographers often have to work with subtle ranges of reality and use filters to enhance

Do-It-Yourself Filters

Edmund Scientific Company is a mail-order house that sells goodies that benefit the innovative photographer. They have specials on small motors, lenses, and prisms that can be adapted in a number of ways to photography. They also sell a filter kit that includes a few pieces of frosted glass, a Fresnel lens for making multiple images, and diffraction grating. The diffraction grating, in rolls, is a good buy. The clear diffraction paper can be cut and sandwiched to produce color starburst effects that look much more real than those produced by the "starburst" filters that are sold by the filter companies. The silvered diffraction paper makes a very interesting reflector and can reflect the spectrum onto the subject. Edmund also sells a book of color gels that can be used over lights for special effects. Edmund Scientific Company, Edscorp Building, Barrington, NJ 08007.

that reality. Photographers need great taste and discipline when they move photography into a world of color fantasy, and few use filters well. Art Kane and Pete Turner are exceptions, having created very strong photographs that are graphic and startling statements. Mitchell Funk uses bold filtration in his multi-images. Many times his photographs affect the libido like an LSD trip.

Plastic system filters have their place. So do glass filters and gelatin CC filters (the system manufacturers would do well to create the CC or Harrison and Harrison type of tints in their filters). The best you can say about plastic filters is that they are inexpensive and diversified. The worst you can say about them is that they scratch easily. An entire Cokin system runs well over a thousand dollars.

Variable Density Filters

Variable density filters were first popularized by Spiratone of New York City and called Colorflow. Colorflow filters consist of two filters, a polarizer and a dichroic polarized element. By turning the polarizer, the color of the filter can be varied from a very pale to a very deep shade. Some variable density color filters are single colors, such as the red filter, which changes from very light pink to deep red as the polarizer is rotated. These are known as single-color variable density filters.

Bicolor variable density filters have two colors in them, and when the filter is turned, the colors change from one to another; for example, light red into magenta and then into blue. Using the filters is something like taking a space trip through the spectrum.

The entire line of filters includes six single colors (red, yellow, orange, green, blue, and purple) and seven dual-color filters (red-blue, red-green, red-yellow, yellow-green, yellow-blue, orange-green, green-purple). The same colors are available in graduated filters, where half the filter is a color, and half is clear glass.

The filters can be very useful for special effects but they must also be used with caution — they must be compatible with the subject, or the most god-awful color combinations can result. The filters can also be used without the polarizer, as straight color filters.

Meters: Exposure Control Starts in the Head

"The more I know about exposure, the less I know," commented a sage old professional. Exposure is an integral part of the magic in photography and it is why the nonromanticists in the field call photography an inexact science.

Many variables affect exposure — film, development, the camera's shutter and length of exposure, the intensity and contrast of light, the degree of reflectivity of what is photographed, the color temperature of the light, the type of meter used and its calibration, and the way it is used. Add to this the creative element, and the end exposure is both an objective and a subjective statement that may be correct for one photographer and completely wrong for another.

Exposure control begins in the head. It is a knowledge of the film's exposure latitude (its sensitivity to light), the camera's true shutter speeds, and the subject to be photographed. If the film is black and white, the exposure should be keyed to a standardized system of development, contact sheet printing, and enlarging. With color, exposure depends on individual taste. Some photographers, particularly professionals who expect to have their pictures printed, prefer slight underexposure so there is color saturation. Other photographers might like a brighter or lighter photograph that could call for slight overexposure.

Creative exposure control is the ability to visualize the final photograph. Exposing for the highlights — the brightest part of a subject lit by the setting sun, for example — will make a very dramatic picture, with the background deeply underexposed. The same picture could be exposed for the shadow areas of the subject, and the picture would be brighter and more "friendly." A photograph of a beach or desert can be slightly overexposed so that the scene "simmers" with the heat of light. Such a picture is best taken with the sun overhead. A powerful picture showing lines, curves, and shadows can be taken by underexposing, and using the early morning or late afternoon sun to accentuate highlights and shadows.

Some photographers do not use exposure meters. They expose by experience. However, critical work may involve exposure control to one-third stop. This is very true with the higher-speed color films, which have less exposure latitude than the slower films. Exposure meters, for 99 percent of photographers, are essential instruments.

There are five types of meters — incident, reflected, flash, combination, and color. Incident meters have a white plastic dome mounted over the light cells and are used to read the light that illuminates the subject. The reading is taken from the subject toward the camera, or by holding the meter as if it were the subject of the photograph and pointing it toward the light source. Incident meters give readings that favor the highlights; they work well with color transparency films such as Kodachrome.

The Meterless Exposure System

A very reliable method for computing an exposure without a meter (and to check your meter) is an old formula: the correct exposure on a sunny day with the sun at your back is an f/16 aperture setting and the shutter speed over the film's ASA index. With Kodachrome 64, this means an average daylight exposure of f/16 at 1/60. With Ektachrome 200, the normal exposure would be 1/250 (the nearest speed) at f/16.

Then experience indicates what other exposures would be — open up one stop if the subject is backlighted and you want to see detail, open up two to three stops for a leaden, overcast day, or for taking pictures in open shade.

- Bright or hazy sun – f/16
- Sun on sand or snow – 1 stop less
- Side-lighted subject – 1 stop more
- Backlighted subject – 2 stops more Shutter Speed
- Cloudy bright – 2 stops more = Film ASA
- Heavy overcast – 3 stops more
- Open shade – 3 stops more

These meters have been used for years by cinema-photographers to measure the balance of key and fill-in lights and they are rapidly gaining in popularity with still photographers.

Reflected-light meters measure the brightness of light that bounces off the subject. These meters take readings of high light, low light, and between. All meters built into cameras are reflected meters. Hand-held reflected meters usually have a 30 degree acceptance angle, while most spot meters measure a 1-degree circle. Reflected-light meters are preferred by black and white photographers because they measure both high and low light, compute the exposure and, if necessary, the development time. Reflected meters are also valuable when the photographer wants an exposure based on a highlight — the horizon just after sunset, the reflection on a car's fender or the windows of a sky-scraper.

Flash meters read the light emitted by strobe or flashbulbs. The reading is taken from the subject while the meter is pointed toward the camera and the lights are set off. The meter calculates the correct exposure.

There are meters such as Gossen and Minolta that read incident light, reflected light, and flash. These latest models are examples of the state of the art.

Color meters read the color temperature and compute how to balance the color using filters.

Meters have three different types of light-sensitive cells — selenium, cadmium sulfide, and silicon photodiode. Selenium cells are used in meters that do not use batteries — the selenium powers the meters. This was the cell used in the famous Weston series of meters. Selenium meters are valuable on deserted islands and other places where batteries are scarce, and while they are quite sturdy, they should not be knocked around.

Cadmium sulfide cells, an improvement over selenium, are used in a few late-model cameras and in reflected meters. They are more sensitive, but they have a "memory" — they can be "struck" by too much light and then give a reading that is two stops

Exposure Guides

Pocket guides can be invaluable and there are a bunch of them. The best give a bit of everything — film code numbers, characteristics, speeds, reciprocity data, filter information. They also can give detailed data on exposure and dials or guides for normal and exotic situations.

- *Kodak Professional Photoguide* was prepared with the help of David Eisendrath, a New York photographer who is a walking photographic encyclopedia, and his information comes from testing, not from other books. The guide is invaluable for many reasons, but it includes eight pages on exposure, a gray card, gray scale, and color patches. It also has an existing-light dial that gives exposure information for such situations as photographing lightning, full moonlit landscapes, aerial displays of fireworks, color TV, and so on. The information would take several weeks of study to absorb.
- *Kodak Master Photoguide.* A hip-pocket book with a bunch of dials that tell you how to expose. With it you can get by without a meter.
- *Exposure Manual* (Dun and Wakefield, Fountain Press). Readable, informative, and compact.
- *The Professional Photographers Handbook* ($14.95 from Logan Design Group, 6101 Melrose Avenue, Los Angeles, CA 90038). A field guide filled with data.
- *ANSI Photographic Exposure Guide* (PH 2.7–1973, $7 from American National Standards Institute, 1430 Broadway, New York, NY 10018). A bore except when it explains how to photograph eclipses, rainbows, the northern lights, stars.

overexposed. They also can become "lazy" if kept in the dark too long. In both cases, the meters come back to normal after use.

Silicon photodiode cells (also called silicon blue cells) are the latest and most effective meter cells. They are extremely sensitive, respond quickly in conditions from very dark to very bright, and do not have "memory" as do the CdS cells. SPDs are

The Zone System of Exposure

Ansel Adams invented the Zone System (as described in his book *The Negative*; see section on publications, page 43). It is a system for exposing, developing, and printing black and white, and requires what Adams calls "previsualization."

The gray scale is broken into nine zones. Zone V is middle gray and represents the gray card with 18 percent reflection. Each zone above and below Zone V is equivalent to a total value that equals one f-stop. Photographers increase or decrease their exposure (and their development when using black and white) to render correctly the tones they want to produce in the print.

(Zone systemists spend more time thinking out which tone goes in what zone than in making the photograph. Edward Weston used an unconscious zone system. When he photographed sand, he increased the exposure several stops. Harry Callahan uses a thumb-to-the-wind zone system that works well for him.)

The system is based on the fact that black and white film has an exposure latitude of eight f-stops. Photographers learn to expose for the important tone and then, if these tones are weak or flat or too harsh, to increase development times to increase contrast, or to decrease development times to lessen contrast.

These are the tones represented by the Zone System:

Zone I. Just above total black. Hardly discernible.
Zone II. A faint texture in shadow detail.
Zone III. Detail in dark shadows — dark clothing, hair.
Zone IV. Stone walls, dark foliage, shadows in landscapes.
Zone V. The average middle gray with 18 percent reflectance — old barn board, green grass and leaves.
Zone VI. Concrete, snow in the shade, Caucasian skin.
Zone VII. Textured whites — snow that is side-lighted, light concrete.
Zone VIII. Whites with just a touch of texture — New England churches in bright sun, brightly lit snow.
Zone IX. Specular light with no texture — sun reflecting on water or on snow.

Color film, unlike black and white, has an exposure latitude of five f-stops — four less than black and white. Black and white, as a rule of thumb, is exposed for the shadows and developed for the highlights. Color film is exposed for the highlights. This is particularly true with transparency film, where overexposure can ruin the photograph. The Zone System works with color, if it is adapted to the exposure latitude of film and if the reflective values of color are taken into consideration.

A Color Zone Scale

All colors are not equal — some reflect more light than others and can cause incorrect exposure. The following chart, prepared by Pentax, shows the percent of reflectivity of seven colors, the IRE Index (see Pentax Digital Spotmeter, page 108), and the increase or decrease that should be made in exposure after a reading of that color is taken. The measurement of individual colors works best with a one-degree spot meter. Remember that all color may have incredible minute variations, which is why photographers bracket their exposures.

COLOR	REFLECTIVITY (%)	IRE INDEX NO.	EXPOSURE INCREASE/DECREASE
Red (bright red)	15–21	5	+1 f-stop
Orange	35–45	6–7	+1.5 f-stops
Yellow (dark yellow)	65–75	8	+2 f-stops
Green (dark leaf-green)	18–26	Standard Index	0 f-stop
Blue	15–21	5	+1 f-stop
Indigo	6–12	2–3	−⅔ f-stop
Purple	6–12	2–3	−⅔ f-stop

Underexposure heightens the color effect with transparency film by saturating the color. Drama and intensity can become more effective through underexposure, as can many scenes that are shot against the sun, particularly snow scenes. Most amateur photographers, according to professionals, overexpose their pictures one-half to one and a half stops. Most professionals underexpose one-third to one-half stop.

used in most in-camera meters and in all system meters (except the Gossen Luna-Pro, which is CdS).

Meters, regardless of what many photographers believe, cannot think. They measure all light to an average that equals a gray card reflecting 18 percent light. A gray card (available in camera stores and in exposure guidebooks such as *Kodak Professional Photoguide*) is equivalent in exposure value to weathered barn board, green grass, the trunks of beech trees, and northern blue sky. It is about one stop darker than normal Caucasian skin.

Exposure meters (except for color meters) are color-blind — they read tones. What this means is that the meter "averages" all light. Although incident meters give a slightly higher reading, they still bring the light down to the reflectance of the gray card. Reflected-light meters, either hand-held or in the camera, average light so that it matches the "tone" of the gray card. For instance, using black and white film, a metered-exposed photograph of snow will show it not as white, but with the tone of a grey card that reflects 18 percent of the light that hits it. A photograph of a black cat, taken with a metered exposure, will try to turn that cat from black to gray. This is basically the Zone System of photography and it proves that a photographer has to use his head to get the proper tones in the photograph. Snow should be exposed more than the meter says, opening up from one and a half to two stops with color transparency film, and up to four stops with black and white film. The black cat should be exposed less than the meter indicates, stopping down one or two stops.

The color photographer uses the meter to key the exposure against the predominant color in the photograph. Green grass and blue north sky will give a "straight" exposure, true, but a metered exposure of a yellow flower would be two stops underexposed while purple could be two-thirds of a stop underexposed. The difference is in the light reflectivity of colors. The professional photographer should know the sensitivity of the meter's cells to certain colors, and how film sees color.

Reflected-Light Meters

If you have an old *Weston* in working condition, hold on to it. They are fairly rugged and have easy-to-

Gossen Pilot 2 uses a selenium cell, so it does not need batteries

read dials that can be used for Zone System exposure reading. These meters also indicate the exposure range of color. They can be repaired by Empire Exposure Meter Service (see box, page 110).

Gossen Pilot 2 and *Sekonic* are inexpensive and serviceable and the Gossen can be converted to incident-light metering.

The Gossen Luna-Pro SBC (Silicon Blue Cells) and the *Gossen Luna-Pro CdS* are the workhorses of the reflected meters. They can be quickly converted to an incident meter with the flick of a finger, by sliding a dome over the meter's cell, but they work best as reflected meters. The Luna-Pro SBC and CdS are

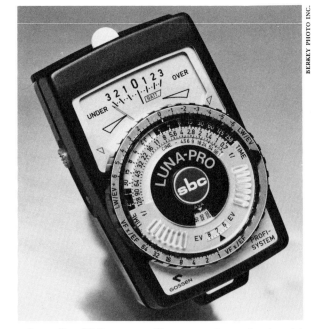

Gossen Luna-Pro SBC uses a nulling system that makes it quick and easy to deliberately under- or overexpose

Tips on Using Hand-Held Meters

Hand-held meters prevail in these days of in-camera metering because of the fear factor — photographers don't always believe their camera meters, or they feel the meter in the camera cannot give a correct reading for a subject that has difficult lighting. To get correct results, meter owners should follow these rules:

- Test the meters with your cameras, standardizing lenses, shutters, film (with the same emulsion number), and processing. Use the same system for all tests. Some photographers make tests using a gray card and color exposure scale (available from Kodak). Others include a face in the photograph to see how skin tones look. Outdoor photographers might use a gray scale in a scene. Take notes and analyze the results. Calibrate your meter to the results, or set the ASA index on the meter (or camera) to the indicated "corrected" index. Test shutters and mark on the back of the camera which speeds are off so you can make the correction.
- Always hold a hand meter in the same position for making measurements. Some meters will give different readings when held vertically or horizontally.
- Be careful of reflection when taking meter readings. Reflected meters, with their 30-degree angle of coverage, should be pointed slightly down when metering sunlit scenes to keep the sky from increasing the reading and causing underexposure. Be careful with spot meters when taking readings toward the sun. Flare could cause false readings.
- Learn to use substitutes to make readings. Green grass is a natural gray card. A meter reading off the back of a Caucasian's hand (the palm is often too light) indicates skin tones for faces and the highlights of a picture. Blacks' skin tones usually need one stop less exposure than the meter indicates.
- The faster emulsions in color transparencies have restricted exposure latitude. Take care. Conversely, black and white slow films have less latitude than the faster films. Underexposing transparency film is better than overexposing it, while overexposing color negatives and black and white film is better than not giving them enough exposure.
- If the meter does not work do the following:
 1. See if the batteries are in upside down.
 2. If they are not and the meter is still dead, replace the batteries.
 3. Use an eraser to clean the batteries and contact points.
 4. If the meter still does not work, you are about to support your repairman.
- Never trust any meter; bracket your exposures whenever possible, shooting over any underexposed shots according to what the meter says. Some photographers bracket one stop over and under and others bracket in half stops.
- On long exposures (one second or more), reciprocity (see page 150) may mean you need to increase exposure as much as 2½ stops. Check the reciprocity data on the film (use the *Kodak Professional Photoguide* or some other guide that lists all reciprocity data) and correct accordingly by changing the ASA index.

system meters — accessories include a spot attachment, fiber optic probe, devices that enable the meter to be used with enlargers and on microscopes. The Gossen Luna-Pro SBC uses a nulling system and can be easily set for three stops over- or underexposure, according to zero setting. The meter in reflected-light modes takes in an angle of 30 percent and when used as incident measures 180 degrees of light (as do all incident meters).

Gossen recently introduced two new meters. The *Gossen Luna-Pro F* is an incident, reflected, and flash meter (continuous light and flash meter, they call it). It is not as sensitive to low and high levels of light as the Luna-Pro SBC, but can cover almost any situation except very dark nights and above-tree-

What the Hell Is EV?

Most meters now have what is called an EV scale — the meter reading is given in terms of the EV scale. *EV* stands for *exposure value*. It is a measure that represents, on a film of a particular ASA index, all the variable shutter speeds and lens opening combinations that will give a correct exposure when the meter reads the light reflected from an 18 percent gray card. The EV scale is another way of expressing, for example, 1/30 at f/11, which, with ASA 100 film, is an EV of 12. 1/15 at f/16, 1/8 at f/22, 1/60 at f/8, and 1/125 at f/5.6 are all EV 12 with ASA 100 film. EV is a numerical guide of exposure equivalents and is easily translatable on meter guides to f-stops and shutter speeds. Meter sensitivity is often given in EV ranges at a particular ASA rating, either 100 or 25.

Gossen Luna-Lux has solid state readouts and, most valuable for black and white photographers, a Zone System scale

Small, accurate, and fast is the Pentax Digital Spotmeter

In photo taken through the meter's viewer, the spot can read only the white of the church, or the wood background, depending on where it is aimed and what part of the scene needs to be measured

line snow scenes. Having three meters in one is a saving in money, space, and time.

The *Gossen Luna-Lux*, unlike the previous Gossens, does not use a meter needle, but has a solid state readout of three light-emitting diodes (LEDs) in a nulling system to determine high, low, and average readouts. Most fascinating about this meter is that, although it does not read flash, it is an incident and reflected meter (with system attachments) that gives direct readouts of shutter speeds, apertures, exposure values (EV), and best of all, for critical black and white photographs, it has a full-sized Zone System dial — the first good meter to sport one of these since the demise of the Weston. There is also a memory recall for those who forget the previous reading. This meter should become the favorite for the field photographer who needs reflected readings.

Spot Meters

All spot meters measure reflected light and the best use SPD cells. Spot meters are invaluable in certain situations — for measuring light on a face at a distance (such as in a theater or nightclub), at sports events, and for measuring shadows and highlights at a distance. The spot meter is usually used to measure highlights and with long lenses. The meter, in these situations, can zero in on that portion of the scene that is most important and the basis of the exposure.

Pentax Digital Spotmeter is a small handful, quick to use and accurate. It does not have half the electronic abilities of the Minolta Auto Spot II Digital (see below), but that is one of its charms — the Pentax Spot is not complicated. It is also about half the price of the Minolta Digital. The Pentax Spot has an LED readout scale in the viewfinder with an EV scale sensitivity of one to nineteen. The photographer reads the number (two red dots light up to show one-third or two-thirds increments between EV numbers), then sets the dial on the lens barrel and reads out the exposure. What's best about the Pentax Spot is an IRE dial that acts as a color Zone System. The IRE (Institute of Radio Engineers)

In-Camera Meters

The new in-camera SPD digital readout meters are much more accurate than the generation of CdS coil and spring meters that just passed away. However, even these meters only read light; they do not evaluate it. Some rules:

- Know what area of the image the meter reads. Some are center weighted and are basically spot meters, while others may have two modes, spot and general. Memorize what area your in-camera meter covers.
- Use the compensation dial (your camera should have one) to increase or decrease automatic exposures where the important subject is not predominantly lighted. This is particularly true for backlit subjects, pictures taken in the shade, such as a face against a sky background, and in snow.
- Use the memory lock on the camera to make immediate automatic exposure corrections. This feature means the camera can be pointed at a subject and when the memory lock button is pushed, it "holds" the reading as the camera is moved to another subject (the exposure is "locked" as long as the photographer holds down the memory button). If an automatic camera is focused on a woman wearing a Day-Glo white dress and floppy hat, the picture would be underexposed. Point the camera at blue sky or grass, press the memory lock, move it back on target and, still holding the memory button, squeeze the trigger and hope for the best.
- Have the meter checked every so often at a camera shop.

MINOLTA CORP.

Minolta Auto Spot II Digital does just about everything except take the picture

scale was developed to compare signal voltages in radio communication, but is equally effective in comparing light energy levels. The IRE scale has ten values, or indexes. Index 10 represents 10 percent — "white level" — and is the brightest highlight that will be registered on color film. Index 1 equals 10 percent and represents the lowest level of shadow detail that will reproduce on color film. The numbers between indicate comparative brightness.

Between the IRE settings of 3 and 4 is the Standard Index, which represents a gray card or a surface that reflects 18 percent of the light hitting it. It is where the meter reading (in EVs) is first set.

What the IRE index represents are divisions of a linear gray scale that is broken into five f-stops, which is the exposure latitude of color film. The

scale can be used to set the exposure so the range of brightness is covered by this exposure, or it can be used to "correct" the meter. In a snow scene in flat light, for instance, the meter reading would not be set at the Standard Index (between 3 and 4) but at 10, which is the equivalent of snow. The Pentax instruction sheet gives IRE values for different colors, which should be copied and taped to the meter, or implanted in the photographer's brain.

Minolta Auto Spot II Digital is an unbelievable, computerized instrument. Like the Pentax Spot, it is a one-degree spot. The Minolta also gives an LED digital readout of EV numbers or f-stops in the viewfinder, but it is more sensitive than the Pentax Spot (1 to 22.5 EV as compared to 1 to 20 for the Pentax), and it gives readings in 1/10 increments, which is finer than any camera's f-stop dial can be set.

However, the genius of this meter is a liquid crystal display (LCD) scale on the side. The meter is basically an analog computer with digital readout. It is capable of storing two meter readings and displaying a third, and it has memory recall. Three keys on the side of the meter body are labeled S, A, and H. The S key, when pushed, tells the meter's computer to measure the low level, or shadow, reading. The H key, when pushed, calls up the exposure

for the highlight reading. The *A* key, when pushed, will give an average reading of the two measured spot readings. In addition, there is a dot array over an f-stop index printed above the LCD display. The dots appear above the f-stops indicated for each reading.

What all this means is that the meter can help keep the exposure within the exposure latitude of the film and, like Pentax's IRE scale, acts as a type of Zone System. People who like to push buttons should love this meter.

Incident Meters

Although the Gossen is deftly turned into an incident meter, photographers who favor incident readings usually opt for an honest-to-God incident meter. The best of the lot are the *Minolta Auto III* and the *Minolta Flash Meter III*. The Minolta Auto Meter III works on the same microcomputer principle as the Minolta Digital Spot, but it is primarily an incident meter (it can be converted, with attachments, to a reflected-light meter or a ten-degree spot meter). The Minolta Flash Meter III can also be turned into a ten-degree spot or a reflected meter, but it remains primarily an incident meter that is also a flash meter.

The Minolta Flash Meter III uses an LCD scale and a microcomputer, but there is no memory button or averaging system. An averaging system is most valuable with incident meters for reading artificial light, particularly in studio and motion picture systems, but it is not that important in the field for reading ambient light. This meter gives displays for ambient light (continuous light readings), for "cord" (synchronized flash metering using a synch cord), "non-C" (single-burst electronic flash without cord), and "multi" (non-synch multiple flash exposure metering).

The Minolta Flash Meter III is the hottest item on the market for the pro who wants a meter to do a bit of everything.

Color Meters

The *Minolta Color Meter II* is unique. It is a digital color meter that uses a microcomputer to give LCD

Martin Satloff, the Meter Man

For the past thirty years Martin Satloff and his small staff have been repairing meters in his mid-Manhattan shop (Empire Exposure Meter Service, 45 West Forty-fifth Street, New York, NY 10036). He repairs any kind of hand-held meter for an international clientele and his turn-around time for repair is one week.

Satloff, who also sells meters, is a flashpan of information on metering and meters:

- The best meters are the Pentax Spotmeter V and the Digital Spotmeter; the Minolta Auto-Spot II, Digital Spotmeter M, Flash Meter III, and Color Meter II; and the Gossen and Sekonic meters.
- The Japanese calibrate their meters to a different standard than the one used by the Americans and the Germans. The Japanese standardize their meters to 2865 K while the Americans and Germans use an ASA index that is standardized on 4700 K. "The Japanese meters," says Satloff, "give about one-third stop overexposure compared to American and German meters. The Japanese figure amateurs like a brighter transparency to show on their screens."
- Most meters in good working shape will read slightly differently, which is why meters should be tested or "mated" with the camera and film to be used.
- Meter cells are more sensitive to the red areas of the spectrum, so they overreact to that color and cause underexposure.
- Meters are calibrated in tungsten light conditions and are "averaged" to read tungsten and daylight. For critical work the meter should be tested in daylight and tungsten light conditions.

readouts. Three silicon photocells, filtered in the primary colors of red, green, and blue, are used to make green/red and blue/red readings. The readings are stored in a memory bank.

The way it works in practical use is incredible. A meter reading of the light source is taken (the meter works on the incident principle) and the photographer pushes the button. The response, displayed on an LCD readout, tells the user what filter to use in Mired (a form of correction filters) or in Kodak's Color Compensating series.

The meter can measure combinations of light (fluorescent and sunlight, tungsten and daylight and flash) and give the correct filtration, and it can be

Minolta Flash Meter III is an incident, reflected, and flash meter wrapped in one. It measures exposure in 1/10 increments.

Minolta Color Meter II is invaluable for the photographer who must produce color pictures from mixed light sources

set for 3200, 3400, and 5500 K films (that is, tungsten and daylight films). It is an incredibly compact meter — as small as it is expensive. It is an extremely valuable tool for photojournalists and annual report photographers who have to work in many different light situations in rapid sequence.

Flash: For Light Power

It was Gene Smith who, when asked what kind of light he used, replied that he used any light available — natural light, tungsten light, flash light. In the early days Smith used multiple flashbulb setups and carefully planned each shot. He had to, for carrying around cases of flashbulbs and changing them after every shot is a tedious job. Flashbulbs created discipline; photographers sat down and thought out their pictures before they fired off a bunch of No. 2s.

Smith was very subtle in his use of light. Some of his famous photographs — the death scene in the Spanish Village essay and Schweitzer studying by lamplight — appear to be images caught on the spur of the moment. Not so. Each of those photographs had the light level boosted by the use of strategically placed artificial lights. What Smith did was shoot for the highlights, using the "environmental" light, and then, with artificial light, he gave it an extra boost, particularly in the shadows. Smith was a creative photographer who knew how to use light to enhance a photograph. His approach is the ultimate aim of most photographers — to make the picture look natural.

Lighting baffles many photographers, but only in the studio, particularly with still lifes, does lighting become tricky. Studio photographers, through experience (trial and error and hundreds of Polaroid tests), develop their own lighting systems.

The problem most photographers hassle with is on-location photography — what to take and how to use it.

Large-Wattage Flash Units

These units are mostly used by photographers who shoot fashion and architecture with large-format cameras, although they may be used on an assignment to photograph cavernous interiors such as Saint Patrick's Cathedral or Buckingham Palace. These situations require lots of light, to fill nooks and crannies, and because small f-stops are needed to increase depth of field. Units such as Balcar, Elinachrome, and Ascor can whack out up to and over 6400 watt-seconds. These units are heavy and expensive, so photographers often rent them. Bal-

Flash Tubes

Many flash tubes are slightly blue and can cause a bluish tint in the picture. The tint is the result of ultraviolet light. Some flash tube manufacturers coat their tubes with a UV dye that neutralizes the tint. Others don't do anything to correct the cast. Photographers should check with manufacturers to see if their tubes are UV corrected. If there is a bluish cast, an 81 A or 81 B color balancing filter can correct the tint. Some photographers prefer to use an 81 C, which warms up flesh tones and gives everyone a pleasing tan.

car specializes in rentals and will do its best to ship units to far-flung photographers in need.

Medium-Powered Units

This type of flash falls in the 800 to 1000 watt-second range. Most popular is the Dynalite 804. The power pack is a lightweight at nine and a half pounds and works with up to four heads, which include modeling lights. The disadvantage of this unit is that the duration of the flash is 1/300, which is not fast enough for many action situations. Photographers then move to the Ascor 1000 watt-second unit, which has a 1/800 flash duration. These units operate on AC power.

Battery-Powered Units

These are preferred by photojournalists and those who cannot expect to use an external source of power. The qualities required are lightness, quick recharging, and versatility. There are four systems preferred by professionals.

Lumedyne is an American-made unit of 200 watt-seconds that, with a booster, can be increased to 400 watt-seconds. It has bare-bulb capacity (no reflector is used). Two heads can be used with the unit and light can be dialed down to one-quarter power. Modeling lights are available, as are several power sources, including high-voltage batteries and re-chargers. It takes six seconds for the unit to re-charge at full power, a drawback for those who like to work fast.

Norman makes a similar battery-operated unit of 200 watt-seconds and a special reflector that can triple the power. The unit has built-in modeling lights and is adjustable to 1/128 power with an accessory flash valve. The Norman recharges to full power in one and a half seconds. There is a complete line of accessories, which includes special reflectors.

Profilite Studio System is a unique modular outfit designed by Multiblitz. The basic kit consists of two 160-watt-second flash heads with modeling lights and built-in slaves, two reflectors, an umbrella, spare fuses, and a case. Accessories include a special-effects kit of spots, snoots, filters, and a diffusion

Lumedyne is a portable unit of 200 watts. Several can be stacked together for a maximum of 1200 watt-seconds.

Norman 200 B recycles 200 watt-seconds at 1.5 seconds, fastest in the industry. Unit is favorite of photojournalists.

Profilite Studio System is compact, has modeling lights, built-in slaves, and can be used with AC, nicads, or a 12-volt car battery

Remote Control Flash

Nothing is more damned by a hectically busy photographer than the connecting PC cord. They pull out of the synch connection. They break easily. The long ones are never long enough and they wrap themselves around light stands, tripod legs, and human feet. An alternative is a radio-remote control unit. The receiver fits onto the main flash, the transmitter slides into the hip pocket and is linked by a cord to the camera. The photographer is no longer tied to the lights and can move freely. Dynalite (408 Bloomfield Avenue, Montclair, NJ 07042) made a nifty remote-control unit but FCC regulations prohibited its manufacture because of the question of who can use what channels. A similar unit, though, is on the market, and it can be used to remotely set off flash and motorized cameras. It is the Hawk Radio Remote and lists for about $237. Larry Farrell of the Flash Clinic, 100 Fifth Avenue, New York, NY 10011, will be happy to sell you one.

screen that fits into the carrying case. Most important with this unit is not only its power, but the fact that it can be used with AC current, nicad battery pack, or with a twelve-volt battery (standard car battery). Accessories are available for these various

A Few Battery Facts

There are five types of disposable batteries used in photographic equipment: zinc-carbon, alkaline, mercury, silver oxide, and divalent silver oxide. In all types, better performance is achieved in higher-priced batteries *that are fresh.* How do you know fresh from stale? There is a code on the package, but it is changed periodically so consumers can't cheat and know what they're buying. But a good photo-store dealer knows (or ought to know) how to break the codes on the brands he sells. Also, a high-volume store with merchandise turnover is a good assurance of battery freshness.

- Keep batteries dated — either the date of purchase, if they are spares, or the date of installation.
- Refrigerate batteries when they are not in use for long periods. Seal them in plastic bags to keep moisture away. Allow batteries to warm up in the bags for two hours before using.
- Be careful not to overcharge nicads in hot weather. This can shorten battery life.
- Clean contacts with a dry cotton cloth and a soft eraser periodically between uses and before installing new batteries.
- Always carry spares.

Vivitar 283 and 285, used with special battery packs, are favored by professional photographers who travel light

options, including a cable that hooks up to the car battery.

Vivitar 283 and 285 units were designed for amateur use, yet they have become the favorite with professionals — even *National Geographic* staffers. The units are sturdy, and at about 75 watt-seconds, powerful for their tiny size. The basic flash units are part of a system that includes variable power control, which allows the flash output to be dialed down to 1/64 of full power, filter kits, external battery packs, a macro-flash sensor (automatic flash to eight inches), diffusers, slave cells, and so on.

Pros have been known to travel with six of these units and use them simultaneously. These lights are favored because they can be used with discrimination so as not to overpower the natural light. By using the control power at one-quarter or less, very low increments of light can be used for fill and for subtle highlights. As Bill Pierce mentioned, he uses

In-the-Field Flash Equipment Inventory — the Minimum

- AC unit with two flash heads, minimum of 800 watt-seconds

 or
- Battery units with two flash heads and a minimum of 200 watt-seconds

 or
- 283 or 285 Vivitars, at least four, with slaves, long cords, and external power packs

 plus
- Two folding soft light boxes or umbrellas
- Black and white folding reflectors (or a roll of aluminum foil to make your own)
- Light stands for each head — short, flat flash-handle brackets or plates (as made by Lowel Light) mounted with a small ball head. The brackets are handy to mount small flashguns on ceilings, balconies, whatever.
- Gaffer tape to secure light stands, wires on the floor, flash heads mounted on walls, wire connections, and so on.
- Extra PC cords, long and short, extension cords, and a transformer for foreign work.
- Polaroid back
- Flash meter

a small unit such as the Vivitar to increase the ambient light found in a fluorescent situation. He'll put a CC 30 Green filter over the flash head to turn it into simulated fluorescent light, then put a CC 30 Magenta filter on the lens. By dialing down the power of the flash, he can mix the lighting ratio to give a natural appearance. Fast lenses and fast films make these small units valuable for the photographer who has to watch his weight.

Naked Light

A few photographers prefer bare tube flash to umbrellas and soft light boxes. Bare tube flash gives a soft, omnidirectional light. Two or more units can light up a difficult situation, such as a horse barn or cider mill. They are the most compact of all types of light. Lumedyne and Norman units can be used as bare tube flash and a company called Enertec makes a system of bare tube flash heads that can be used with a variety of power packs. Architectural

photographers use them as pencil lights, to simulate light under a lampshade, to light a hidden hallway or a counter.

Tungsten Light Systems

Strobes are in favor for the majority of photographic jobs, because they are light, easy to use with batteries, and powerful. Tungsten light systems require heavy loads of electricity and are very hot. But they are preferred by professionals who shoot interiors, because they let you see what you are doing and can be controlled quickly, without making you go through Polaroid tests. The favorite system is a case containing five Lowell Totalites, barn doors, diffusers, and all the necessary accessories.

Automatic Flash, Flash Meters, and Polaroid Backs

Automatic flash, so popular with the amateur, is not well liked by the professional. The sensors work much as a meter does — they are balanced to give a normal "reading" based on middle gray. Like a meter, the sensors can be fooled and give over- and underexposure. They have worked well when the pictures are controlled, such as head shots taken inside, and for macro work. The dedicated flash,

Got an Electronic Problem?

There are a number of shops that specialize in repairing flashes. The best of them, however, also do custom work. Kusler Celestin, who is one of these wizards, operates Electro-Foto (920 Broadway, New York, NY 10010). He makes customized strobes and solves problems. He has made mixing boxes that will fire flashes in sequence, and special heads for diffusion. You want a picture of a balloon just as it bursts? Celestin solved the problem by rigging up a sound sensor that set off the strobe just as the balloon popped.

Armato Photo Repairs (87–31 Myrtle Avenue, Glendale, NY 11385) has customized flash brackets and improved the Vivitar 283 and 285. One device made by this service is a special battery pack that increases the 285's capacity to 200 full power flashes with a three-second recharge capability. They also convert these units to bare bulb capacity.

like those made by Nikon and Olympus, will be gaining more favor because readings are taken off the film plane. Still, a person in light clothes, photographed outside in pitch-black darkness, could confuse the meter and cause overexposure of the subject.

Any good photographer takes insurance — flash meters and Polaroid back — in the field with his flash units. The flash meters are very reliable instruments and the best ones are made by Gossen and Minolta. Polaroid backs are used to check exposure and lighting situations. There are Polaroid backs for medium-format cameras and there is now a practical 35 mm Polaroid back made by Marty Forscher of Professional Camera Repair, New York City.

Umbrellas and Soft Light Boxes

Umbrellas have been the favorite light diffuser for the professional. They soften the light, spread it over a larger area, and are easily taken down and packed. They can even be of benefit on a rainy day.

Umbrellas, though, are on their way out as the soft light boxes gain favor. Soft light boxes are tent-like structures that fit over the flash head. They vary in size and shape, from slim rectangles to circles. Until recently soft light boxes were unwieldy contraptions suitable only for studios and shoots populated with assistants. Now, however, there is a portable outfit designed by a Colorado photographer who borrowed ideas and materials from tent- and sailmakers. The system, called Illuminata, is made of spinnaker sailcloth, which is a plastic-impregnated rip-stop nylon that is very tough and has a

Gary Regester designed these lightweight collapsible soft box lights he calls Illuminata

high quality of luminescence — as any sailor knows. Fiberglass wands, the type used to erect dome tents, fit into the perimeters of the soft boxes, which are then strapped to the strobe housing. The boxes vary in size from 24 × 32 to 54 × 72 inches.

The soft box gives a very delicate and even light. The smaller the box, the higher the contrast of light. Best of all, the Illuminata fold down to a thin tube that is 27 inches long and weighs 14.5 ounces. Because of the slight weight, there are no supports needed between the light source and the diffuser. A few of the small units can create main and fill light, or be used as ring lights. The company makes square and circular soft boxes. The round soft box is perfect for portraiture, creating round catchlights in the eyes with no telltale strobe head reflections.

Illuminata are made by Chimera, P.O. Box 9, Silver Plume, CO 80476.

Accessories:
After the Fact

Ask any two photographers what gadgets and accessories they regularly carry in their bags and you will get two different lists of essential accessories. They will probably express disdain for the junk sold to amateurs in photo shops, but admit they are susceptible, too. For many photographers, accessories are the fun of it — trying them, testing and experimenting to produce a different result or find a better way. When an item is not available commercially, photographers create gadgets to do the job or adapt something from another area of interest.

Photojournalist Bill Pierce, for instance, carries a floppy, soft, old-fashioned shaving brush to gently clean lens surfaces as well as sweep off camera bodies. He also has a chamois cloth and lens tissue. Pierce likes to carry film and extra lenses on his body when on fast-moving assignments in places like Northern Ireland or at the Democratic National Convention. He has at least a dozen canvas belt pouches that are narrow and long enough to carry a 300 mm lens or have exposed film tossed into them without worry about it accidentally spilling out. He finds these pouches in army surplus or camping stores, and in recent years has used the Domke bag side pouch for belt-carrying. The best pouches are about 4 × 2, and 10 inches deep.

Other accessories in Pierce's bags are: a small tripod (Gitzo or Linhof), a small strobe with a 3 × 5 index card to use as a fill-flap, three or four 15-foot synch cords, a small light stand to hold the small strobe, and a 40-inch umbrella for bounce lighting. He has created an infrared triggering device for his strobe, too. All this accessory lighting equipment is designed for emergencies when available light isn't adequate, and he can throw in enough subtle light from a distance to do the job — like from the end of a monopod held high by an assistant.

How does he know when he has enough light? Pierce carries a Minolta Flash Meter III. He also carries a conventional incident meter and a small spot meter. Basic filters are a fluorescent and a polarizer. On occasion Pierce is willing to stoop to "the lowest form of photography" — the use of bizarre or weird filters and optical attachments to get dramatic results out of a boring subject.

For emergencies, Pierce has Gaffer tape, a set of screwdrivers and wrenches, a monstrous number of spare batteries, and a Leitz focusing target to test his range finders. Stuck in corners of his camera bags are notebooks and pencils, a small cassette tape recorder, extra eyeglasses, and a random set of keys and padlocks to secure equipment when necessary.

"I can't resist anything if it can make an interesting picture," admits Pierce as he scrounges through his locker naming the highlight items that are ready to go on an assignment or a trip. There's a complete traveling sound system with scanners and walkie-talkies, immense amounts of lighting equipment, as well as close-up gear with huge bellows attachments.

He's got clamps to hold lights and vise grips to hold cameras.

Those are Pierce's basic accessories. In addition, everything has a backup or a duplicate in case something doesn't function.

Now, what about Peter Miller? He carries a Leitz Tabletop tripod, a unipod, a clamp to hold a camera on a car or attach it to a tree, a C-clamp for a flashgun, and a small net to hold rocks to keep tripods steady. Miller uses an ear syringe to remove dust from lens surfaces and also has a chamois cloth for wiping. He carries silica gel to absorb moisture and, in addition to a small screwdriver set, has a Swiss army knife for major work. Along with numerous filters, Miller has a special wrench for removing them when they're stuck.

Miller has been known to carry a small insulated picnic cooler to hold film in warm climes; an emergency blanket for lying on or under, for placing camera gear on the ground, and to use as a reflector. He carries a tape measure, a level, and a small flashlight. Heavy-duty aluminum foil can be used for reflecting or for wrapping things, and plastic Ziploc bags are good for holding film or lenses to protect them from dust and moisture or prevent condensation. He usually has Kodak mailing labels and a batch of stamps to get film to the processor.

Has anything been forgotten? Janet Nelson adds a Sharpie pen for writing on film cassettes or any glossy surface, a compass to detect the direction of the sun's movement, model releases, and a magnifier light. Her repair kit contains (in addition to most of the items carried by Pierce and Miller) a soft eraser to clean battery contacts, lens cleaning fluid, rubber bands, pocket-size Dust-off, cotton swab sticks, and one Photo Wipe tissue.

Bags and Boxes

Halliburtons and Domkes are the two standard containers for carrying photographic gear, but there are others and there are variations, most of which are found in photo stores.

In the field of lightweight soft bags, Domke has set the pace with removable compartments, padding across the bottom, easy accessibility, and rugged construction. Bill Pierce has four of them, and takes at least two on every assignment. "On the job, I size up what I'm likely to need," he says, "fill up one bag and then tuck the second in an office or some safe-looking place while I work."

Nothing was completely suitable for carrying photographic gear on a field assignment until Jim Domke, a press photographer, created the Domke bag. Made of heavy cotton canvas and sewn to military standards, this bag has become the standard in the press corps. (Advertising even notes that the bag was "seen" on the "Lou Grant" show!)

The Domke bag lid flaps back to expose the entire inner compartment, which has dividers separating lenses and bodies. The compartment is removable, attaches to the bag on Velcro strips, and comes in several variations to fit different pieces of equipment. A webbed strap wraps all the way around the bottom of the bag for secure carrying. There is a pocket with Velcro closing flap on each end and two

HILARY MILLER

Lowe-Pro holds more than any other bag. It is beautifully made. Some traveling pros take a Lowe-Pro and Domke to carry all equipment, and use the Domke while shooting, the Lowe-Pro for storage.

DOMKE Examples of how four-compartment insert can be arranged to serve different equipment needs. Patented system.

2" heavy cotton web strap (with no-slip Naugahyde strip) goes entirely around bag

movable/removable attached insert padding optional

back pocket for maps

end pockets hold strobe for quick access or 20 rolls of 35mm film

exterior dimensions 7" x 15" x 9"

straps for monopod or umbrella

one-hand open/close spring clips

high density pad absorbs shocks

Domke bag, designed by a pro for a pro

pockets under the main flap, as well as a pocket in the top flap.

The Domke (6″W × 8½″H × 12″L) easily holds two bodies, six to eight lenses, and numerous extras. The top flap is held in place by Velcro, but also has two spring clips that snap into D-rings for more secure closing.

Why cotton duck in this age of plastic, nylon, and breathable fabrics? The cotton duck can be treated to be water repellant and moisture resistant, but no bag is completely waterproof, because seams can leak. But, when cotton gets wet, it swells — effectively sealing seams.

Domke also makes two very useful bags for the professional — the Sling bag, which can hold large tripods, umbrellas, and light stands, and a long lens bag for the 300 or 400 mm f/2.8 lenses, with camera and motor attached.

A number of bag designers have copied the Domke, but never quite matched it, while those who borrow and add innovations have been more successful.

Lowe-Pro makes a professional model (10″W ×

8½″H × 16″L) with side, back, and front pockets. The case can hold up to ten lenses, two motor-driven cameras, film, meters, and filters. It is beautifully made of Cordura.

The Tenba Pro-Pak has zip-open top flaps, two Velcro-closing front and side pockets. The interior can be fitted with padded dividers for individual needs. The lid stays in place with Velcro or a snap lock, and everything inside is easily accessible when the lid is open. Made of Cordura, it comes in several styles (the largest is 9½″W × 6″H × 16″L); all have webbed nonslip shoulder straps and stiff padded bottoms. Tenba also makes bags for tripods and light stands.

In hard cases, the metal Halliburtons — in nine different sizes and styles — have proved their ability to protect camera gear. The shell is prestressed aluminum alloy with rounded corners and a combination lock closing as well as two spring-loaded snap latches. The innards are dense foam that can be cut to individual specifications. There are eyelets on which to attach a shoulder strap, or you can buy folding carts made especially for the Halliburtons.

Cutting Foam

It's like Jell-O only messier, with little glips and bits that fly around and stick to fingers as you try to cut surgically. Foam can be cut out with a single-edge razor blade, but the results are usually far from precise.

A better way is to tape a piece of cardboard on the foam and mark the placement of equipment with a felt pen. Then, with someone holding the foam, cut out the patterns with a saber saw. Some prefer to place the foam in a freezer, where the cold hardens it and makes it easier to cut.

Cube foam liners are partially cut and easier to work with, although not as durable as the solid foam cores. Mark equipment placement with a chalk pencil (found in sewing stores) and use a sharp linoleum knife or single-edge razor blade to separate the cubes.

The only problem with the Halliburtons is that they *look* like Halliburtons — as every airport thief knows. In recent years the company has tried to disguise this identity with different finishes, but they are still vulnerable. Most traveling photographers slide the Halliburtons inside used suitcases purchased at Salvation Army stores. Some of the cheapest cloth bags in garish plaids fit nicely around the metal bags, leaving a little space in which to tuck other nonbreakable accessories to give a lumpy appearance.

The other box used by pros is the Vulcanized Fiber upright, long the standard for carrying Graflex cameras and film holders. They get scruffy, dented, and scratched, but remain practically indestructible. These boxes have steel frames, corner bumpers, metal loops for shoulder straps, and a handle on top. They come in five sizes (largest is 12½"W × 15"H × 26"L) and the interiors can be fitted with partitions according to individual specifications. They're not found in most photo stores, but can be ordered from Ikelheimer-Ernst, Inc., 601 West Twenty-sixth Street, New York, NY 10001.

The Best Vest

It's been described as "the best piece of photographic equipment I ever owned," it takes four hours to sew together, and more than 5000 of them

An overburdened photographer with a Quest Vest. The Vest is invaluable for carrying extra lenses and film.

are sold each year at $150 each. The Quest Vest is a working photographer's dream garment designed by a working photographer.

The vest has two large foam-lined and waterproof pockets with Velcro flap closers over the hips, two-zip flap pockets under the ribs, and two more zip pockets over the breasts. In back there is a giant pocket, and on the sides there are two large "dump" pockets for holding gear temporarily. The vest zips up the front, but most people wear it open with the cinch belt holding it comfortably in place. The vest itself is made of breathable nylon and comes in a brown and tan combination; small, medium, large, and extra-large sizes. Write to AMC-Sullivan Photo, 11 East Main Street, Bozeman, MT 59715.

Backpacks

Mountaineers, skiers, and hikers have long searched for the ideal way to carry camera gear safely, con-

veniently, and accessibly. Greg Lowe, a mountain cinematographer, needed an equipment backpack simply to survive, so after trying everything available, he designed his own. The Lowe-Pro Quantum II is the ultimate result and is indeed the ultimate for heavy-duty carrying.

Made of Cordura, the Quantum II has a solid piece of dense foam inside that can be cut to fit equipment as needed. The main compartment opens all the way around three sides, permitting quick and easy access. There are five zip pockets plus straps for a tripod. The padded shoulder and waist straps were adapted from systems used by mountaineers to carry heavy loads. The harness can be put inside, and a shoulder sling or carrying handle converts the Quantum II into a travel bag.

The Quantum II measures 22″H × 14″W × 9″D and has a smaller brother, the Quantum I, measuring 19″H × 12″W × 5″D. The "I" has fewer zip

Lowe-Pro camera backpacks use foam and can be carried as a backpack or over the shoulder with the backpack straps zipped up. Both cases fit under an airplane seat.

Mojo fanny pack is the best of that breed. When fully loaded, it is heavy and needs shoulder straps.

pockets, but otherwise is about the same. Omni side pockets can be attached to either backpack for increased capacity. Without these side pockets and with the foam liner removed and packed in a suitcase with other gear, the Quantum II holds up to eight bodies and eleven lenses. Carried on an airplane (smile nicely at the attendant), it fits under the seat.

Lowe-Pro makes a number of other pouches, cases, and packs — all of the same high-quality construction and design. For mail order, write to Firstlight Marketing, P.O. Box 3007, Eldorado Springs, CO 80025.

For a lighter load, most photographers opt for a fanny pack. The Photo Hipsac made by Mojo Systems is the best on the market. It's padded all around and has padded movable dividers inside as well as pockets and elastic loops on the lid for film containers and oddments. It can hold one body and three lenses and is still comfortable over the hips because of its very wide, padded belt. The Hipsac attaches to a Mojo Photo Backpack, creating a unique dual-purpose carrying system. The backpack is also padded, has numerous pockets and a wide zipper opening for accessibility. Both are available from AMC-Sullivan Photo, 11 East Main Street, Bozeman, MT 59715.

For overland situations, where a photographer is forced to carry his or her own gear, both the Domke and the Tenba bags have optional backpack harnesses. They're reasonably comfortable for short hikes, but no substitute for a good backpack.

Tripods

Three legs are better than two, especially for sharp pictures with great depth of field. For this the tripod was created and for this photographers suffer the grief of hauling them around.

For many years the standard by which other tripods were measured was the Leitz Tiltall. It is still available and still a precision-built piece of equipment. The head has adjustments that permit three-way movement — up and down, side to side, and panning — and it extends from 30 to 70 inches.

Today many photographers use variations of the Gitzo system of tripods, which encompasses more than eighty models in different styles, sizes, and

Tripod Tips

- Avoid using the center column, particularly with lightweight tripods.
- Lock up camera mirrors to avoid vibration with critical shots.
- For steadiness, hang a net filled with rocks from the center of the tripod or put rocks in a triangular accessory bag under the tripod.
- Hold your hand on tele lenses to dampen vibrations during long exposures.
- With extreme long lenses, attach a tripod to the lens (most have tripod sockets) and use a monopod to support the camera body.
- If you're working without a tripod, use an assistant or enlist a calm passerby for shoulder support during long exposures.

variations. Made of strong tubular steel, they have the weight and stability for high-performance work. They are exceptionally easy to use and have features like nonbinding rubber nuts for tightening leg extensions.

The Gitzo "Performance" line with spreading legs that permit extremely low positions as well as normal spread for high positions is most useful. Several fold to compact size for travel: the Weekend Compact Performance reduces to 14 inches, the Reporter Mode Performance to 17 inches, and Studex Compact Performance to 22 inches. A larger Gitzo for critical work and heavier cameras is the Pro Studex Giant/Rapid that folds to 32 inches.

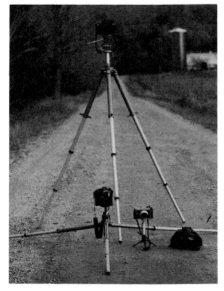

Tripods do more than their share to improve picture quality.

No. 1. Two Gitzos, one straight up, the other adjusted for machine-gun level, which the tripods were first designed for. Next to it is a Leitz Tabletop tripod with long ball head, and a bean bag.

*No. 2.
Two-camera platform helps to double up on shots that can't be repeated, or that need long exposures on two different formats*

*No. 3.
Gitzo with side arms and angled legs, all set up to photograph a cow pie*

*No. 5.
Long telephotos (here a 400 mm Leitz mounted on a Nikon) often need extra support. The tripod supports the lens, the monopod supports the camera body.*

*No. 4.
Center post is reversed, side arm attached, and camera can be adjusted for bird's-eye view of an extreme close-up*

*No. 6.
A monopod used normally. A foot wrapped around the monopod adds additional support. So does Gaffer-taping the monopod to a railing, tree, or chair.*

*No. 7.
A device called the Other Hand clamps onto posts, car doors, pipes, and so on*

The Invisible Tripod

The assignment is to photograph from a helicopter, or from a motorboat, or from a moving car, or it just calls for a slow shutter speed on a long lens. The pros use a Kenyon Gyro Stabilizer called the Universal KS 4 (good for cameras up to eight pounds; other sizes are available) to increase sharpness.

The stabilizer is a metal pod that is approximately 3 × 4½ inches, weighs 34 ounces, and fits to the tripod socket of the camera. Twin gyros rotate on crossed axes at 20,000 RPM so that yaw and pitch (vibrations) are drastically reduced. A gyro-stabilized camera can be safely held at exposures of one second.

Tests have shown that the gyroscope can, through its dampening process, double sharpness by eliminating camera shake. It is a very valuable instrument and used by too few photographers. The price, with a rechargeable power pack, is approximately $2000, and it is available only from the manufacturer, Ken-Lab, Inc., Old Lyme, CT 06371.

Gyro Stabilizer, mounted on the bottom of the camera, dampens vibrations and increases picture sharpness, even with low shutter speeds

The performance of any tripod, however, is all in its head. Ball-and-socket types permit that three-way movement — pan, tilt, and side tilt — for the most precise composition. The best ball-joint heads have one knob that loosens all the controls, while some good ones have two knobs, but three is one too many.

Leitz makes two sizes of ball-joint heads with a single knob control. The larger one is the more useful. Gitzo has a half-dozen ball heads with one or two control knobs. Notable are the Total/Sport Cremaillere 1 and the Reporter/Cremaillere 2. Gitzo also has a small friction ball head for very light cameras or small strobes. Bogen's Double Action Ball Joint head is a two-control model with a separate knob for panning. It also has a quick-release mount for fast changing of cameras.

The Bilora and Linhof Precision Tiltop 2 ball heads are large enough for heavy cameras or extreme telephoto lenses. Both have exceptionally smooth panning action. Linhof also makes a fluid head, like those used by movie photographers. These allow smooth rotation and 15 degrees of movement in any plane.

Monopods are practical and come in a variety of lengths when folded. They also come in handy as mugger buggers. Gitzo has ten models ranging from 14 inches (when folded) to 32 inches; all have wrist straps and one model, the Mono Studex Super, has an added shoulder or chest support.

Among the mini tripods, the Leitz 4½-inch Tabletop model is superior and is highly versatile when combined with the Leitz ball head. The Minolta TR-1 is sturdy and has a good head. Gitzo makes a Loisir Compact Luxe D that folds to 8 inches and weighs 12 ounces. Many manufacturers produce handgrip styles that are useful, but limited as far as critical work at slow shutter speeds is concerned. And Rowi has a number of pocket clamps that convert to tripod use, but again are light for really critical work. Bogen's Super Clamp, while not all that small, is handy extra support — provided you can find something to clamp it to in the right spot.

Supporting parts for the Gitzo tripod system can be adapted to other makes of tripods. Useful items include twin heads to hold two cameras, a triangle bag that fits a 15-×-15-×-15-inch space and holds accessories, and a platform level that fits between

Portable Seamless Support

On-location product shots can be greatly enhanced with a seamless background. A portable support for seamless comes in three foldable pieces and has attached tripod legs. One version extends to 8 feet, 4 inches, and 115 inches across, while another is 6 feet, 4 inches, and spans 67 inches. Either is available from Welt-Safe-Lock, Inc., 2400 West Eighth Lane, Hialeah, FL 33010.

the tripod and the head. There's also a service tray for several of the Gitzo models.

Remote Control

Sometimes it is best not to be behind the camera — for instance, when the camera is to record an explosion from a short distance, to show a moving car as it "runs over" the camera, to photograph a sports event or a woodchuck in front of his hole.

There are two basic types of remotes — those using a wire and those using radio waves or light beams. Wired remote can be done with very long cords, but usually it is accomplished with cords not longer than twenty-five feet. Remotes come in handy when the camera is mounted on a helmet as the photographer free-falls from an airplane or rides a bicycle. They are also handy when the camera is mounted just out of reach or when two or more cameras are fixed simultaneously. The remote cords are usually sold by the manufacturer and plug into the motor system.

Wireless remote control is usually accomplished through transmission of radio waves. A receiver attaches to the camera and the photographer carries the transmitter. Most units work within a half mile. Units using light signals are effective at several hundred feet. The more sophisticated units can fire single shots or bursts on several cameras, individually or simultaneously. These units are expensive and are made by camera manufacturers such as Canon, Contax, Nikon, Minolta, and Olympus. Much simpler units can be purchased from model airplane shops. Spiratone in New York offers a remote release system for under a hundred dollars.

Equipment Buying:
Comparison Saving

The most boring questions amateur photographers ask pros are: "Where do you buy your equipment?" "What did you pay?" "What should I buy?" To be truthful, most pros ask other pros the same questions, only they do it subtly.

If you know exactly what you want, the best prices, whether you are a professional, a beginner, or a nonphotographer buying a gift, are in the classified advertisements found in the back sections of *Modern Photography* and *Popular Photography* magazines. There are the advertisements from all the major mail-order photography stores, listing everything from Hasselblads and used Leica range finders to film, flash units, filters, and whatever else you may need. The prices are the best you will find in America without buying on the street.

Most photographic equipment is marked up 50 percent, although Hasselblads have a 33 percent markup and Sinar view cameras are 25 percent above wholesale (the costs of these two cameras are high and the small markup can still render a profit).

The large discount houses mark many of their items 10 percent above wholesale and sometimes less than that. Their profit is in volume and accessories, which creates a large amount of ready cash before the manufacturer's bill is due. Some discount houses put the money to work in certificates of deposit and others, particularly in New York, put this short-term money into precious stones and metals. Because some manufacturers' bills do not come due

for four months, the flow of cash is self-perpetuating and the interest earned allows the stores to shave prices to increase volume and increase cash income.

Say, for instance, you wish to buy a Nikkor 300 mm ED f/2.8. The list price, as quoted by Nikon, is $2849. Some retailer might quote you that list, and being a nice fellow, knock off 15 percent, to round out the price to $2422. Then he magnanimously knocks off the $22, to make it $2400 even, and you wait six weeks for him to order and receive the lens. A glance through the classified pages of both *Popular Photography* and *Modern Photography* reveals that not many companies list this lens. However, three companies have, all from New York City. One prices the lens at $1839.95, another at $1829.45, and a third at $1850.95. Two of the largest discount stores did not list the lens in their advertisements. Both stores were telephoned. Store A

Beware!

Some discount houses put together specials that include as many as twenty items, such as batteries, lens caps, straps, a flash, several lenses, lens cleaning tissue, a filter, and so on. What they are doing is selling accessories that sometimes come with the camera, plus they are throwing in some cheap flash units and off-brand lenses with, say, a very respectable camera body. If you buy such a package, you may have been suckered. What they may be selling you is one good apple decorated with a few lemons.

Some Leading Discount Camera Stores Specializing in Mail Order

New York City

Adorama
138 West Thirty-fourth Street
NY 10001
1 800 223-2500 (toll-free)

Cambridge Camera Exchange, Inc.
Seventh Avenue and Thirteenth
 Street
NY 10011
1 800 221-2253

Executive Photo and Supply Corp.
120 West Thirty-first Street
NY 10011
1 800 223-7323

47th Street Photo
67 West Forty-seventh Street
NY 10036
1 800 223-5661

Olden
1265 Broadway at Thirty-second
 Street
NY 10001
1 800 223-6312

Spiratone
130 West Thirty-first Street
NY 10001
1 800 221-9695 (ask for catalog)

Atlanta

Wolf Camera Supply
150 Fourteenth Street, NW
GA 30318
1 800 241-5518
(1 800 282-3883 in Georgia)
Stores in Charlotte, Nashville, Bir-
 mingham, and Jacksonville

Chicago

Helix
325 West Huron
Chicago, IL 60610
312 944-4400

Denver

Robert Waxman Camera
913 Fifteenth Street
Denver, CO 80202
1 800 525-6113

Los Angeles

Bel Air
1025 Westwood Boulevard
Los Angeles, CA 90024
1 213 208-5150

Olympic Camera
828 West Olympic Boulevard
Los Angeles, CA 90015
1 800 421-8588

said they did not have it in stock and Store B quoted a price of $1999. A second call was made to Store B to verify the price and a local number for the store, rather than the 800 number, was used.

"The price for the Nikkor 300 mm ED f/2.8 is $1999?" asked the writer.

"That's correct," replied the salesman.

"Store X is offering the same lens at $1829.45," the writer countered.

"Where you calling from?" asked Store B.

"Vermont," the writer said.

"Well, the pickup price, if you come to the store, is $1999. You ready to order by mail?" he inquired.

"No," answered the writer.

"Well, I can't give you a price," the salesman concluded.

Store B would have matched the price of Store X, once you pinned the salesman to the wall. If you had not comparison shopped, this particular salesman would have stuck you for almost $170 more than the lowest price.

Discount Houses

When shopping at the large discount houses there are several rules to follow. Comparison shop through the ads. Mail order by phone and have the purchase shipped out of state. The sales tax in New York City is 8 percent (on a 300 mm f/2.8, $148), and if it is shipped out of state, you don't pay that exorbitant tax. Know exactly what you want to purchase. The man on the end of the phone does not give advice; his job is to move merchandise as fast

Some Equipment Catalogs

Catalogs are not only a pleasant way to pass a Sunday afternoon, they are also good sources for hard-to-find equipment and handy odds and ends. The problem with some catalogs is that the dealers or distributors have the chutzpah to offend buyers by charging for the catalog from which they want to sell. In other words, they ask the buyers to pay for the advertising as well as the products they may buy. Beg, steal, or borrow, but avoid paying for catalogs.

Camera Discount Center, Inc.
89A Worth Street
New York, NY 10013

Edmund Scientific
101 East Gloucester Pike
Barrington, NJ 08007

47th Street Photo, Inc.
67 West Forty-seventh Street
New York, NY 10036

Garden Camera
345 Seventh Avenue
New York, NY 10001

Helix
325 West Huron Street
Chicago, IL 60610

Photographic Catalog
Ziff-Davis Publishing Company
One Park Avenue
New York, NY 10016

Porter's Photo Catalog
P.O. Box 628
Cedar Falls, IA 50613

Spiratone, Inc.
135–06 Northern Boulevard
Flushing, NY 11354

as possible. Above all, verify the price with the advertisement.

A word of caution. Most telephone mail orders are transacted by credit cards (some places will accept personal checks but prefer certified bank drafts). If the price of the item you want to purchase is high and over the card limit, the salesman will often write up the order on two cards, say VISA and MasterCard.

This writer ordered a lens by phone and credit card from a photo shop in New York City and was surprised, when he opened the shipment, to find two additional Nikkor lenses (value about $800) that he did not order. He called the shop and was told it was a mistake and to send the lenses back.

The problem was receiving credit for the $800 on a charge card, and it took repeated calls to straighten out with a letter to them and a carbon copy to the bank that honored the credit card. In this case the credit card was extended to the limit and was not usable for an important trip. A call to the credit card manager at the bank brought out the fact that other card holders had had the same trouble with the shop. It took approximately one month to have the credit card account credited with the $800 worth of equipment that was never ordered.

Unethical? Illegal? They are playing a psychological game. They hope you are larcenous by nature and will fantasize that you have just received two

lenses for zip. So you keep them, and when you receive your credit card statement listing the two lenses, you are too embarrassed not to pay. Their other line of thought is, after checking your credit line for the card you are using and finding you flush in credit, they figure you will keep the other lenses, once they are in your hands. Be careful with these long-distance transactions.

There are discount stores that will give you personal advice, although their prices may not be as low. It is often wise to pay a little more and strike up a friendship with a salesman. Olden Camera of

Shutterbug Ads

Probably the biggest bundle of confusing reading is this thick (over 100 pages) monthly tabloid advertising new and used equipment, materials, and artifacts of photography. In it there are some 2000 classified ads as well as an abundance of display ads. There is an attempt to categorize this profusion of selling, swapping, and horse-trading, but the net effect is boggling.

Obviously many of the more than 20,000 subscribers to *Shutterbug Ads* study this publication for serious kicks or are full-time traders. But if you're in the market to either buy or sell equipment, you can make deals through these pages or just comparison shop.

Shutterbug Ads is available for $8 a year third-class mail or $30 for first-class mail, from Patch Publishing Company, Inc., P.O. Box F, Titusville, FL 32780.

New York has a number of professionals on the staff who give straight advice. If they don't have what you want, they will locate it for you. They also have a repair shop in the store, a large rental service, a good offering of used equipment, and they even sponsor short courses on photography.

Camera Shops

Usually, though, the personal touch for professionals is found with smaller stores. Some can give very good prices, advice, a charge account if you need it or a few months' leeway if you make a large purchase. They will ship film and equipment to you the fastest way possible. A working professional always wants a store like that on tap. To find such a store in your region, call professional photographers and ask where they do their shopping.

Professional Camera Ltd. of White River Junction, Vermont, is typical of the professional stores found throughout the country. They serve Vermont and New Hampshire and Maine professional photographers and also sell to amateurs. They sell most 35 mm equipment at cost plus 10 percent, almost competitive with the big discount stores. The two owners, Jeremy Dickson and Ken Vieira, know their business well and keep their professional customers in touch with the latest developments.

Much of their expertise comes from conversations with technical representatives of various manufac-

Howard Copeland of Scott Camera

turers who visit their store. They read the trade magazines but also have feedback from the photographers they sell to.

They find that a comparatively low economy in the northern New England states means they sell more Olympus equipment, which they consider a good value for the money. Zooms sell well, particularly those that are less expensive and made by independents, such as Tokina or Kiron. They find that Minolta meters, even though they are expensive, are gaining in favor with photographers.

Scott Camera of Peekskill, New York, is typical of a store that caters mostly to amateurs, but willingly assists professionals with special problems or purchases. Howard Copeland, owner/manager of Scott's, admits he can't meet the prices on film that the New York City stores offer, but he often can match prices on equipment, provided the professional doesn't need the explanations and stroking that amateurs usually require.

While he doesn't stock some of the more exotic pieces of camera gear and accessories, he'll special-order anything and will hold hard-to-get items or new system parts for favored customers. Small stores like Scott's also often have accessories that you can't find in the mass market stores. And what they don't have they will order for you out of a shelf full of catalogs.

For processing, Scott's can get one-day service for Kodachrome and Ektachrome and will arrange for pickup and delivery. Used equipment is always repaired and guaranteed before it goes out, and you

Pro-Cam owners Jeremy Dickson (left) and Ken Vieira

Rules for Buying Used Equipment

- Don't sell your used equipment to camera stores. They will give you less than if you sold it direct. Shops put a heavier markup on used equipment than they do on the new equipment.
- Look for used equipment through mail-order discount houses (occasionally they offer specials on used equipment), and in classified ads in local papers, particularly those papers that have a photography section. Check the bulletin boards of camera repair shops. Get on the mailing lists of companies that specialize in used equipment, such as Foto-Care, 170 Fifth Avenue, New York, NY 10010, which periodically sends out a list of used equipment with extremely good buys. Subscribe to *Shutterbug Ads* (see box on page 128).
- If possible, have the equipment you plan to purchase checked by a camera repair shop. If this is not possible, run a few rolls of film through the camera to see if it is functioning properly.
- Be wary of equipment being hawked by a professional. If he is a photojournalist, ski photographer, or natural history specialist, the equipment could be worn out. Ask about the seller's life as a photographer. The best buys are usually from amateur equipment freaks who treat their cameras like golden fetishes and are constantly looking for something better.
- Make sure the equipment is compatible with the lenses or bodies you have.
- Keep current with used-equipment prices by checking camera stores. Good, retired twin-lens Rolleiflexes sell secondhand in camera stores for $400 and up. If you find one in good shape with a good lens for under $200, you have a buy. A Leica M-4, German-made, is a bloody steal at $500 (most go for $900–$1200). Some cameras, such as the Panon 120 panoramic camera (sometimes called Panox), have been out of circulation for years and are savored by professionals. If you find one, contact the authors of this book immediately!
- Haunt pawnshops, particularly those located in gambling towns like Reno, Las Vegas, Lake Tahoe, and Atlantic City, and pawnshops located near seaports and military bases. Cameras, firearms, old pocket watches, and jewelry are their best buys, and what the pawnbrokers know the least are cameras and lenses.

can be sure that items like batteries are fresh. Copeland has referred jobs to local photographers and gives advice about custom lab services. In fact, it's generally the personalized service and convenient location that make such smaller shops a good deal at a slightly higher cost.

Most professionals will deal with a specialty shop where they are known and can have a salesman look for good buys and special pieces of equipment that might be traded in. A good salesman can also put a good client on the top of the list, if the equipment is in short supply. But where there is time, and the item is expensive, you can save quite a bit by perusing the mail-order ads in *Pop Photo* and *Modern*.

Rent-a-Camera

Some professionals don't buy but rent some of their equipment. It is one approach to minimizing costs. A photographer may need certain items only in leap years, such as a 1000 mm lens, a 220-degree fish-eye, a Widelux panoramic camera, an 8 × 10 with special lenses, or a strobe outfit with 8000 watts.

Check with local professional photographers and camera repair shops to find out who rents. Olden of New York City has a large rental department, and so does Foto-Care, also of New York (for addresses see boxes on page 127 and above). Some outfits specialize in renting only flash equipment, and a few manufacturers rent their equipment.

The best deal, for professionals, is to borrow equipment at no cost from the manufacturer. You must prove your professionalism and with some manufacturers, such as Nikon, the photographer joins their professional association. Then you make a request for a certain item, give a date you want the equipment, and they will send you the cameras or lenses to use for a specified period. Most requests are for unusual items, such as the 15 mm for the Nikonos, perspective-control lenses, and large and fast telephotos. Some pros, if they have a rough job, borrow equipment from manufacturers to save wear and tear on their own equipment.

Equipment Repair:
Find the Finest

Nothing is more frustrating than to have a camera or piece of equipment break down just before a job. The question is, who can repair it quickly and how soon? Almost all manufacturers repair their own equipment. They often charge a leg and an arm if it is not under warranty (put one little dent on that camera and you may find the warranty is no longer valid) and it can take six weeks or longer to do the job. One professional sent his camera to the manufacturers for meter adjustment and was told by the repair department the price would be $150. He then sent it to Marty Forscher of Professional Camera Repair in New York City and the camera came out with a clean bill of health and a $40 bill. Another professional had his camera smashed by a horse and sent it in for repair. The distributor's repair service told him the camera was a total loss. Marty Forscher repaired it for $290.

The best way to find who can repair your camera is to go to photographers, the nearest newspaper, or call up wire service (AP or UPI) photographers and see who they use. There are a number of camera repairmen working in their homes in small cities. Often they are slow, because they are one-man shops. Sometimes they don't have the expertise or experience with specialized equipment or expensive cameras.

The finer repair shops are in the major cities and they can give rush service — with advance notice the work can be out in a day. The best list of camera repair shops is in the *Photography Market Place* by Fred W. McDarrah (R. R. Bowker Company, New York City), which has a section on camera repair and lists shops around the country. Many of the shops adapt equipment and some repair not only cameras and lenses but flash equipment and meters. The Havel Camera Service of San Antonio, Texas, so says this guide, repairs backs, cameras, enlargers, flash, lenses, lights, and meters, and will modify equipment to the customer's desire. The shop also custom-builds backs, cameras, enlargers, lenses, and so on. Other shops just do repair work and many of them are authorized warranty service centers for manufacturers. If they do the warranty repair work, they are reimbursed by the manufacturer.

The Top Repair Shop

The most respected camera shop in America is Professional Camera Repair (37 West Forty-seventh Street, New York 10036). It was started after World War II by Marty Forscher, who learned his trade while working with "the Steichen Unit" during the war, documenting the battles of the Pacific.

Forscher built his reputation through his ability to resolve problems by modifying existing equipment or building from scratch. He is also very good on the human element, bringing together a large work force with different skills and backgrounds

The Man Who Dropped His Camera Five Miles

Mark Meyer, on assignment for *Time,* was doing his job in the backseat of an F-4 Phantom jet, taking pictures of another F-4. He had just asked the pilot to do a roll over the F-4 being photographed so he could shoot straight down. Well, the roll didn't work because the power conked out and the planes collided. Adrenaline improves the reflexes, and there was a quick and successful eject all around; no one was hurt in the parachute falls to earth.

Meyer, being that type of photographer, was still holding on to his motorized Leicaflex when he ejected. The force of the second explosion separated the photographer from his seat and from his Leica. The Leica immediately took off on its own, and fell just over five miles to the California desert.

Eighteen months later a battered Leica was spotted in a Manchester, New Hampshire, store by a Leitz rep. He passed on the information to another Leitz rep, Dana Bodnar, who, thinking it might be Meyer's camera, did a bit of sleuthing along with Lief Ericksenn, a writer who eventually wrote the story up in *Camera 35.*

It was indeed Meyer's camera. A hiker had found the camera and, when the film was developed, the last frame showed a very close view of an F-4 Phantom. Unfortunately, the man who found the camera disappeared with the transparencies. (*Time* magazine is offering a $500 reward for their return.)

The startling fact is that the camera could have survived, if you wanted to pay the repair costs of $1260 for the camera, $357 for the lens, and $220 for the motor drive.

No one mentioned what it would cost to repair the two Marine F-4 Phantom jets. Both were totaled, at a cost of many millions, all for a photograph.

that result in a shop that can do good work quickly and professionally. Yet, Forscher will never turn down an amateur who brings or sends his equipment in, unless he feels the equipment is not worth repairing.

"There has been a ten-year gap between development of electronics and reliable equipment. Only recently have we had rugged electronic cameras. First is the Nikon F-3 and now Canon has one, and the new Pentax LX is very good. Unfortunately, manufacturers do not understand cameras because they are not photographers but engineers, and they design for other engineers, saying, can you top this?

"Almost all top-of-the-line cameras are good, but

you had better have a good mechanical backup for bad weather and bad assignments. The electronic cameras are more sensitive to moisture. Unfortunately the impurities in the water stay in the camera, and can play havoc with the electronics. It is wise to use a plastic bag to protect it in damp conditions.

"American photographers have a philosophic difference in the way they handle products compared to Asians and Europeans, who take care of their equipment. Americans have an attitude of planned expendability. Compare a New York taxi and a Tokyo taxi, both three to four years old. The Tokyo cabdriver keeps his car clean and neat and if it is dented, he has it fixed by the next morning. They seem to know, more than Americans, that a well-kept tool performs better.

"I know some guys who went into beachheads in World War II and spent six days in a foxhole and came back with their cameras looking new. But then other guys walk around the Washington Monument and their cameras look as if they were in a foxhole for six days. There are also pros who have equipment that is fifteen years old, but they drive a 1980 auto. Take an auto that has a hundred thousand miles on it. Would you want a camera like that, that you depend upon for your profession? Cameras should be traded in every three to five years.

"As the cameras become more complicated, and labor costs and overhead go up, so does the cost of repair. I know that 30 years ago it cost $16 to overhaul a shutter. Today it is $48 and a nickel candy bar is now 35 cents. A shop in New York cannot compete with the prices in Des Moines, but the New York repairman will work faster and solve more problems, because he handles such a variety. Now a technician makes $300 to $500 a week. While it used to be that the cost of repair was 10 to 25 percent of the camera cost, it is not unusual for the repair bill to be 30 to 50 percent of the original costs. A CLA (clean, lubricate, adjust) costs about $40. Take a Nikon body. It could take two hours to repair the body, one hour and fifteen minutes on the meter, and one hour on the lens. It adds up, and then what if you have to replace a piece of sophisticated circuitry?

"We help photographers in many other ways. We give them advice, find assistants' jobs, get rush jobs done quickly and airmailed out, if necessary. I figure we are only a day by air from any part of the

country. We also check used cameras that people are thinking of buying, and charge $8 to look over a body, $8 for a lens ($12 for a zoom), or $15 for both. I feel, if you are buying used, that it is better to buy a Saab or Volvo than a Datsun or Toyota."

Forscher is most famous for his modifications and creations. *Life* photographer George Silk came in with a photo-finish camera used for horse races. It was a cast-iron camera that weighed seventy-five pounds. The film was exposed as it wound at a set rate of speed past a slit. Such a camera can cause distortions and Silk wanted to use it to interpret sports events. Forscher finally made a slit camera, using a Victrola motor for evenness in the winding, and reduced the weight to twelve pounds. Silk tested it out on his kids in Halloween costumes and won an Art Director's Award for the resulting photo essay.

Forscher's ProBack fits on back of single lens reflex and gives two frames per Polaroid sheet

Marty Forscher's ProBack

Polaroid tests are important to the professional — to check lighting, camera position, exposure, and color balance. There are Polaroid backs for the large- and medium-format cameras but none for the 35 mm, unless you consider Nikon's Speed Magny, a very cumbersome and expensive camera within a camera. So photographers who work with 35 mm often take along a 2¼ Hasselblad with a Polaroid back to check their shots before shooting with a 35 mm camera.

For the past several years Marty Forscher has asked the major manufacturers to make a Polaroid back for 35 mm's. They never did, so Forscher solved the problem himself, creating the Marty Forscher ProBack. It is a de-

Picture was taken of author Miller as he photographed Forscher

tachable back that can be fitted, at present, to the Nikon F-2 and F-3 (or it can be adapted to most cameras that have a hinged, detachable back). It is a slim back that uses the camera's system to produce an image. However, it was not that easy to put together and Forscher solved the problem by using a state-of-the-art optic system.

The Marty Forscher ProBack makes two 24 × 36 mm color contact prints on one sheet of 3¼ × 4¼ Polaroid film, type 668, or any other type of Polaroid film that size. It can be ordered from Marty Forscher at Professional Camera Repair, 37 West Forty-seventh Street, New York, NY 10036.

Marty Forscher demonstrating his new 35 mm Polaroid back

Preventive Medicine for Cameras

Marty Forscher put together a list of preventive measures to avoid camera breakdown. The original list appeared in *Popular Photography*. A few of the ways Marty suggests to keep your camera healthy and your repair bills low:

- Keep batteries and the battery chamber clean. Use an eraser to clean all contacts.
- If the meter doesn't work after cleaning or replacing batteries, try to shock it into life by moving the shutter speed and f-stop dials back and forth at a fast rate. Moisture can seep into the meter and when it dries, it may leave a salt deposit, which can break a circuit. Working the dials can shake off the deposit.
- If the camera does not focus, put on the lens and set it at infinity. If the scene is out of focus, check the lens. If something is loose (rattles when shaken), the lens is guilty. If a different lens is put on the camera and the error remains, the problem is in the camera. The focusing glass could be out of place. It also could be that the camera has been dropped and there could be misalignment, particularly with the back of the camera. See if the camera focuses by putting on an 85 mm or a 105 mm lens and set it at infinity. If it is out of focus with these lenses, it is work for the camera shop. The worst place for a camera to land after it has been dropped is on the back or top, which can knock the pressure plate or viewing screen off kilter.
- To check shutter operation, open the back and while holding the camera to a light set off the shutter at all speeds from 1/60 on up. You should see the full frame. If you don't or you see a small slit, it means the shutter is sticking.

- You can use the same check for flash synchronization. Look through the open back (with the lens off) and fire the flash. You should see the full frame lit up. If the shutter is malfunctioning you will see part of the aperture or no light at all.
- If the flash synch won't work, it is probably because of moisture or corrosion from salt air. Use compressed air to dry, and clean contacts with an eraser.
- If the shutter sounds sluggish, set it off many times at different speeds to loosen it up. If it still is not working correctly, check it at 1/60 and 1/125 second. These speeds will often work while the higher ones won't.
- Electronic cameras are very susceptible to moisture. Protect them by covering with plastic bags. Screw on a lens hood from the outside, then cut a hole the diameter of the plastic covering the lens. Make another hole for the viewfinder and do the same with the screw-in glass protector or tape the bag to the camera. Be careful of condensation, particularly going from cold to hot. It can be very harmful to most cameras, particularly to electronic circuits. Cover the camera with a plastic bag, force out as much air as possible, and tie it shut before you go from cold to warm.
- If the camera is dropped in water and if there are circuit boards (the camera is electrical), there is little hope for survival, and almost none when the camera has been dropped in salt water. Mechanical cameras can be saved. If a camera is dropped in salt water, immediately transfer it to fresh water. Take off all movable parts and slosh it around for at least half an hour and change the water several times, to flush out all the salt. Use compressed air to blow out the water, but be careful of the shutter as it is flexible and can be blown out of position. Dry the camera in an oven at 120

Forscher and his staff made the first Polaroid back for the Hasselblad and only recently they made a detachable, two-shot Polaroid back for the Nikon. He sold thousands of soft release buttons, first invented by Leitz (his soft release button fell apart in very cold weather because the plastic came out of the collar due to expansion and contraction of the metal). As for elitism or whatever you want to call it, Forscher made an automatic bracketing exposure device that was hooked onto the lens of photographer Pete Turner's camera. An assistant followed

Turner around carrying a remote control to change the f-stop dial as Turner clicked away.

Forscher has also made a skydiving helmet, devices to enable people with injured or disabled hands to use cameras, a rig to hold a camera on a ski or a bobsled and withstand six G's, a busted arm bracket, and clips on the back of lenses to hold filters.

The shop is continually adapting brands of lenses to cameras they were not meant for. Unfortunately, manufacturers all make different mounts for their

degrees. Better yet, use a hair dryer. Some cameras have been saved by drying under a car heater.

- Use a half-inch paintbrush to clean a camera of dust and grit, then use a Q-Tip slightly moistened with lens-cleaning fluid to clean all the camera except the lens. Compressed air or an ear syringe is best to clean small crevices. Do not use canned air on a camera; the propellant may leave a residue, or it could cause condensation. Do not use compressed air on the shutters or mirror or viewfinder. It can damage the shutter and cause static, which creates more dust. Low-powered air, like that from an ear syringe, is okay. Use compressed air to keep the camera back clean from dust and film chips. Clean the pressure plate with a small amount of detergent and water to lessen static. Keep camera bags and cases clean — vacuum them.
- Tighten loose screws with a jeweler's screwdriver. Use a minuscule amount of clear nail polish under the screw head before tightening. A toothpick works well for this job. Continual traveling, particularly in airplanes, can loosen screws on cameras and lenses.
- Use silicone lubricant on the shaft of the rewind mechanism to remove stiffness. Stiffness could cause the film to rip during transport.
- Tighten flash connections by bending the center pin on the camera contact slightly off center. Then, with a small pliers, reduce the diameter of the rim of the PC cord.
- If a filter or lens shade is stuck on the camera, loosen it with some penetrating oil and tap it gently. There are wrenches specially made to remove stuck filters. Keep the threads in good shape, free of grit, and lubricate them very lightly. Never, in any application, use too much oil.

cameras and lenses, evidently to keep photographers buying their product. This makes it difficult to use a lens, say one made by Pentax, that may be better and less expensive than the comparable Nikkor, on a Nikon camera.

"If you have a special lens you want to put on another camera, it could cost $150 just to adapt it. To hook it up with the automatic diaphragm would cost $350 and it could cost $1000 total for also coupling it with the meter."

Forscher has adapted the 80–200 mm Nikkor zoom to a Leicaflex, the 17 mm Takumar to a Nikon, a number of lenses to Canons, the 250 mm and 500 mm Minolta mirrors to other cameras, the 400 mm Leitz to a Nikon, and the Canon 400-600-800 mm to a Nikon.

Some of the custom prices could work up a pretty good sweat, but obviously photographers think it is worth it.

Outside of ingenuity, the success of Professional Camera Repair is that Forscher spot-checks the work and requires a high grade of professionalism. Sometimes they make mistakes, but there remains that personal touch. "A society works best when each man is willing to give more than he gets," said Forscher. "You can't do a good job unless you feel responsible."

When Forscher is feeling irresponsible, you will find him bashing down the powder runs at Snowbird and Alta.

Marty Forscher's Lament for a Professional 35 mm Camera

In 1979 Forscher gave a speech at an Industrial Photographers' Seminar. In it he lamented the way cameras have deteriorated from strong, well-built mechanical "hockey pucks" to electronic folderols. Although there are breakthroughs on the horizon, of the twelve points Forscher would like to see built into what he calls the "Official Camera of the World of Professional Photography," only two have been adapted into cameras — built-in diopter correction in the Pentax LX and the Rollei 2000 F, as well as interchangeable backs for the revolutionary Rollei SL 2000 F.

. . . I believe it is fair to say that today the average consumer gets more for his photographic dollar than ever before. Cameras are becoming more and more sophisticated with the advent of each succeeding model. Highly developed manufacturing procedures have made it possible to produce cameras at relatively low cost. . . .

But what is good for the general public does not necessarily satisfy the needs of the professional photographer whose livelihood, reputation, and sometimes whose very life is on the line when he picks up a camera. It seems to me that the most essential ingredient of a photographic *tool* is that it be absolutely dependable under all shooting conditions. . . .

A Forscherism on Camerism

"Performance has been victimized by the photographic explosion of the sixties. With so many companies reaching out for supersophistication in design to attract the mass market, it was inevitable that economies would be sought in production methods to keep prices low and competitive. Stampings instead of machined parts, reduced thickness in critical areas, plastics in place of metal, even reduced tolerance controls in some cases. It is therefore understandable that the breakdown factor for equipment in the hands of professionals is much higher today than it was in the past."

Photography, particularly in 35 mm, is the only profession wherein the practitioners are forced to use equipment designed primarily for amateurs. The professional has no options beyond accepting the fragile, elegant toys with which he is being swamped!

In the past, at least, cameras earned their titles by performance in the field. Today, titles such as "official camera of the Olympics" are available in the open market to the highest bidder and bear little relationship to performance.

I am not opposed to the tremendous development in technology over the last ten years. In the professional world, assignments can be made easier in situations of rapidly changing light conditions, by the use of automatic cameras. There is no question that, relieved of the burden of making decisions about exposure, the photographer can devote his attention more completely to that which is happening before him. . . .

As I see the development of the camera industry over the last ten years, the manufacturer has recognized a market potential that can be measured in the millions. The objective seems to be to manufacture the most sophisticated camera at the lowest possible price — no one can argue with this objective, if the *target* is a mass, photographically uneducated market; but keeping costs down inevitably leads to compromises in manufacturing procedures, the net result of which is a lowering of quality standards. This may not be evident to the average user, but where does it leave the *heavy-duty* user? It is safe to say that the professional photographer puts *several hundred times* as much film through his camera in the course of a year as does the *average user*. It is equally safe to say that at least 80 percent of the visual images we see in advertising, photojournalism, and in commercial use are made on 35 mm. The common denominator among all cameras previously used professionally — the Graflex, the Rolleis, Contaxes, Leicas, the Nikon F — was rugged indestructability, or as I have been quoted as saying, they were built like "hockey pucks." . . . In a recent conversation with a designer for one of the leading camera manufacturers, I tried to get my message across by suggesting that they build professional cameras to the same standards as the medical instruments they also manufacture. It is one of the few times I can remember generating any real understanding. But, the reaction is one I have become accustomed to: "*No market!*"

I am sorry, I cannot accept this rationale; consider use by every newspaper, every magazine, all the wire services, all of industry, to say nothing of all the commercial studios and independent photographers plus all the serious amateurs who follow the professional's lead. I cannot believe that there is no profitable market. *If* there is no market, how do we explain photographers' willingness to spend $1200 for a Leica M4 body? *If* there is no market, why the rush to pay premium prices for used Nikon F bodies in good condition? And, *if* there is no market, why in Japan can you sell a Nikon SP for $1000??

I would not presume to dictate to the camera industry, but I would remind them that the vast market they now enjoy was in large measure generated by the very professional photographers they have forsaken. The manufacturer must decide whether he is in the tool business or the toy business. Obviously, there is nothing to preclude his being in both. High quality and high technology are not mutually exclusive.

Perhaps the most revealing experience a manufacturer could have would be to spend a week at the counter of Professional Camera Repair, where he would personally witness the frustration, the anxiety, and yes, the anger of those who have been victimized by mechanical and electronic failure. Then he would realize the inaccuracy of his advertised claims that his product is the answer to the professional's dreams, and that although he may sell a million cameras, he cannot satisfy his moral obligation to the professional community with mass market mediocrities. The camera industry has a debt to the professional

The Problem with Making Tests
(or why lenses should be calibrated in ⅓ f-click-stops)

Most lenses are calibrated in full f-stops. Most meters are calibrated in ⅓ f-stops. Kodak neutral density filters, put over the film to make Polaroid test film match the speed of the color film to be used for an original photograph, are calibrated in ⅓ stops. So your meter reads ⅓ under a full f-stop. Or your Polaroid tests show you should be ⅓ over a full f-stop. Then of course you should bracket your exposures in ⅓ f-stops.

But no, there are no lenses manufactured that are calibrated in ⅓ click f-stops. So what do all professional photographers do? They guess.

photographer that at present, in my judgment, is being ignored!

Inevitably we come to the question of the new generation of compact cameras. My gut reaction is that you minimize size and weight by reducing the safety factor, not necessarily in a direct ratio, but it seems to me there is a point beyond which you cannot go, without taking calculated risks. The issue was crystallized for me recently in a conversation with an older photographer who said that he loved the new, small-size cameras because they were so light but that he had to carry three bodies since he had experienced so many mechanical failures, remembered in sharp contrast to his World War II assignments, which he covered for *Stars and Stripes* with only one Leica body.

The concept of planned obsolescence has no place in the professional world. The burdens of our industry are heavy enough without the additional weight of anxiety caused by fear of camera failure. . . .

Eugene Smith, perhaps more than any other person, embodied the spirit and integrity of photojournalism and photography in general. Let the camera industry accept this challenge: the development of an instrument worthy of Gene Smith's memory.

If some manufacturer would like to compete for the title "Official Camera of the World of Professional Photography," here are a dozen features he should consider:

1. Accurate sprocket registration for multimedia use.
2. Accurate and complete viewfinder field coverage with a selection of varying grid sizes.
3. Auxiliary "pin register" back.
4. Counter frame control in rewind mode especially with motor.
5. Spirit level built into viewfinder — particularly for wide-angle lenses.
6. Elimination of PC outlets and design of a new connector system.
7. Interchangeable film magazines.
8. Signal in viewfinder to indicate nearing end of roll.
9. Automatic bracketing — either self-determined or programmed — up to two stops, plus or minus.
10. Auxiliary four-frame Polaroid revolving back.
11. Built-in diopter correction from +3 to −3.
12. Lens diaphragms calibrated in $\frac{1}{3}$ click stops.

Traveling: Avoiding Misadventures

As any veteran traveler will tell you, being there is fun, but getting there in these fast-paced days is a pain. It is doubly agonizing for the photographer. Not only does he or she have to get there, but the photographer and equipment must arrive at the same time. Once there he or she has to haul around the equipment, precious film must be protected, the job must be done, and then the equipment and film must be transported back to where it came from. Here are a few travel tips garnered from a number of professional traveling photographers who learned the hard way.

A Tip-Sheet for Traveling Photographers

- If you are going on assignment abroad, find a local person to meet you at the airport to help with customs, act as a guide, gofer, translator, chauffeur, and so on. Often students, young photographers, or housewives are better than professional guides.
- Figure the time element involved and plan for delays.
- Before leaving, check in with each consulate of the countries you plan to visit. This is particularly important where a bond is required for the equipment you bring in, or where film may be taxed as if it were to be sold, requiring that you pay a sales tax on each roll. (This happened to a *National Geographic* photographer when he entered Kenya. He ended up paying about fifteen dollars per roll.) Third World countries can be very difficult, as can the customs agents of Switzerland, France, and Canada. Find out about visa requirements, driver's licenses, and vaccinations.
- Buy an airline schedule guide so you can plan unexpected flights or film shipments. For domestic air travel, subscribe to the *Airline Guide*.
- Purchase airline tickets in advance, for an

India, Russia, and Canada

These three countries have special restrictions about bringing in professional camera equipment for work. India has a one-camera limit, but you can usually get around this by contacting the Indian consulate before leaving the United States. Russia has restrictions on cameras and film, which may also be circumvented.

Our neighbors to the north, however, can be much more difficult. They don't want anybody coming in to do a job that a Canadian citizen can do, and because equipment costs more in Canada, they are afraid U.S. citizens will sell their cameras when on a visit. If your work is intended to promote tourism in Canada or you are working for a Canada-based firm, get an official letter stating your job there and indicate that you are employed by the company.

Customs Customs

Before leaving the United States you should register all foreign-made photographic equipment in anticipation of your return through U.S. Customs. If you allow plenty of time you can do this at the customs office at the airport. Otherwise go to a district customs office. For information and addresses contact the Treasury Department, U.S. Customs Service, Washington, DC 20226.

While you need register equipment only once (keep the certificates with your passport), each new purchase should be registered. If you are rushed, the bill of sale will usually get you through without paying duty.

airport delay may cause a missed flight. If there are connecting flights, it is usually best to pick up your luggage at the connecting airport and transfer it yourself to the counter of the connecting airline. Otherwise, it could end up in Atlanta even if you are going to Bangkok.

- Locate a customs broker and make arrangements for shipping film or equipment, if necessary.
- Purchase shipping envelopes if you intend to air-express exposed film.
- Purchase insurance to pay for the expense of reshooting and make sure it is acceptable to charge the insurance to the client.
- Buy traveler's checks in the local currency.
- Make sure credit cards and your passport are up to date.
- Print model releases in other languages if necessary.
- Find where to rent photo equipment locally — particularly large strobes.
- Take only equipment needed to complete the assignment.
- Bring transformers and plug adapters when traveling to countries with different electrical systems.
- Bring twice as many camera bodies as needed because some are sure to break down.
- Use suitcases like those made by Samsonite and fit them with foam to hold cameras and equipment — disguising the fact that they hold camera equipment. John Lewis Stage prefers metal Halliburton cases, but knows

they are easily spotted and ripped off, so he packs the Halliburtons inside cheap suitcases. Harvey Lloyd designed a case 5½"H × 16"W × 22"L with movable dividers that slides under an airplane seat. It holds nine SLR bodies, each with a lens mounted on it, plus 300 mm f/4.5 and 180 mm f/2.8 lenses that fit vertically.

- If most of the camera equipment is going in the hold, be sure to carry one bag with a camera, several lenses, and twenty to forty rolls of film so you can shoot if all else is lost or delayed.
- Make sure the camera cases lock. If they are Halliburtons, program each combination lock with the same number. Use Gaffer tape to seal the suitcases.
- Pack your personal clothes separately so they are easily accessible. Bring clothes for dress occasions (a jacket and tie for men, a suit or dress for women) where you will be expected to look like the guests and participants even as you work. One photographer was kicked out of a party in the Palace Hotel in Saint Moritz. It didn't count that he was wearing a four-hundred-dollar Rive Gauche leather suit and silk turtleneck. He wasn't wearing a tie.
- To save space, take the film out of the square boxes and, with an indelible pen, mark the plastic canister tops with the film type. Pack the unexposed film with miscellaneous photographic gear you may be carrying — batteries, lens and camera cleaning and repair kit, roll of Gaffer tape (used for everything from repairing cameras to sticking strobes on walls to sealing shut the ripped crotch in your

How Much $ Is Enough?

Credit cards are the mainstay of any traveler, but particularly of photographers, who can have large unexpected expenses. Figure on spending about $200 a day and be prepared to cover that in cash, if necessary. In addition to at least two credit cards, carry $2000 to $5000 in travelers' checks with a portion in the local currency.

When you ask someone to sign a release or even take a casual photograph of a poor person, expect to pay them. John Stage smokes corncob pipes and carries several dozen extras as the ultimate Americana gift.

pants), filter kit, chamois cloth, lead bags for exposed film, small tripods, and so on.

- Carry a shoulder bag as a briefcase and fill it with tickets, traveler's checks, wallet, passport, eyeglasses, alarm clock, visiting cards, notebooks, address book, pens, pencils, tape recorder, customs papers, whatever.
- Be alert to the possibility of theft. Never look like a photographer except when actually taking photographs. Avoid hotels or motels with poor security. Chain camera cases to a radiator, put them under a bed or in the shower. Leave the bathroom light on and the water running.
- When working on the street, keep your equipment on your body or under the eye of an assistant. If you put down a bag, stick your foot through the strap. Carry additional traveler's checks and duplicate credit cards, and separate them from your wallet (a good hiding place is in a toilet kit).
- Don't *wear* cameras when going in and out of a hotel.
- Keep tabs on what film you shoot and where it was shot, and who was photographed, so you can caption it and key releases. Some photographers carry a small slate and photograph the slate with the first exposure of each roll. On the slate is written the date, location, and roll number. Keep caption notes in a diary or dictate them into a small tape recorder.
- Always separate different types of film you may use during the day. Also keep exposed film separate from unexposed film.
- Slow down. It is usually the Americans and the French who are impatient. Don't be bothered by delays. Always smile. Learn the local customs. Be very polite; the life you save may be your own. Early to bed and early to rise keeps a photographer healthy, wealthy, and happy with his take.

The Airport X-ray Problem

Although airport security precautions may prevent free trips to Libya or Cuba, they can also ruin a trip by fogging your film.

The Value of the ATA Carnet

The ATA ("Admission Temporaire / Temporary Admission") Carnet is a document that simplifies and streamlines the process of going through customs with commercial samples or professional equipment. As such, it can make life simpler for the international photographer.

The carnet is now valid in about thirty-five countries. It is basically a green folder containing customs documents for each country to be visited. In it is listed the equipment that is being brought into each country. Customs agents tear out a sheet when you enter and when you leave the country. The carnet is filled with official-looking stamps and different-colored papers and can be used not only to bring equipment into a country, but also when equipment is in transit through a country.

The carnet may be obtained from the Carnet Bureau, United States Council of the International Chamber of Commerce, 1212 Avenue of the Americas, New York, NY 10036, or their western office at 100 California Street, Suite 1100, San Francisco, CA 94111. On the application, the photographer lists all equipment and its value and sends to the Carnet Bureau a check in the amount of 40 percent of the merchandise's value. The check is either certified, an insurance bond, or a bank's letter of credit. The council can hold this bond or security for up to thirty months. The credit, or check, is refundable if the photographer doesn't go bananas and sell his equipment in some country and get caught at it.

The fee for the carnet is based on the value of the goods and is $50 for merchandise valued under $500, to $150 for merchandise valued at $20,000 and over.

Most airports have low-dosage X-ray machines, which, they say, will not harm film. This is not true. The effect of X rays is cumulative, so if exposed or unexposed film goes through a machine once the change may not be noticeable, but pass that same film through the machine several times and fog can build up or there may be a shift in the color of the film. A machine could also have stronger radiation than was intended. And high-speed film, such as Ektachrome 400, is much more susceptible to X rays than Kodachrome 25, and therefore needs more protection.

Because of these dangers, some people ship their exposed film with baggage. Most professional photographers do not do this, however, because it is an easy way to lose the results of a $10,000 shoot and

six weeks' work. Also, there are occasions when radioactive isotopes are shipped in the hold, and these are lethal to film stashed next to them.

One answer is to ship the film by air express and telex waybill numbers and flight information to the receiver. Be sure the film is packed in an envelope or carton that has printed on it, EXPOSED FILM! DO NOT X-RAY! RUSH!

Most people hand-carry their exposed film and ask the security personnel to personally inspect it, rather than send it through the X-ray machine. Usually security guards will do this, but sometimes they won't. The best protection, if the film does go through the X-ray machine, is a lead bag such as Film Shield, made by Sima Products in Chicago. The bag has a lead shield sealed in polyester and barium-impregnated polyethylene. The lead and the barium reflect X rays and thus protect the film. The bags are made in two sizes, one that holds up to twenty-two rolls of film and another that holds up to sixty rolls of film. The prices are $7.95 and $18.00.

The bags work. If the bag looks black on the X-ray screen, it is doing its job. If the security guard lets the bag through, without checking it, he is not doing his job. If you can see through the bag with the X-ray machine, the bag is not doing its job. This writer uses, for extra protection, two lead shield bags — one inside the other.

Some airports have such strong X-ray machines that the film would have to be sealed in about three inches of lead to protect it. Film Shield is distributed in forty countries and distributors keep track of airports with film-lethal X-ray machines. Sima Products continually updates the list and encloses it in every bag it sells. A typical list showed the following places where no film should go through X-ray security checks: British Airways in Great Britain, Cathay Pacific in Hong Kong, Philippine Airways in the Philippines, Singapore Airlines in Singapore, in Bahrain, and in the USSR, Heathrow Airport in Great Britain, and at all departure points for the Concorde. For an up-to-date list, call Sima Products in Chicago (312 286-2333).

Within the United States all requests for physical inspection of photographic material must be honored, according to the FAA. If you have any problems at airports, contact the FAA's man in Washington, James J. Given (202 655-4000).

Equipment to Take on Assignment

The minimum:
- Leica range finder
- 50 mm lens

(Perhaps the only professional to get away with the above was Cartier-Bresson.)

The minimum for a trek in Nepal:
- Three SLR bodies
- 20 or 24 mm lens
- short zoom lens (35–85 mm)
- long zoom lens (80–200 mm)

(God help you if a piece of equipment breaks down.)

The maximum for an assignment:
- Eight camera bodies with at least three of them mechanical
- The following lenses:

15 mm	55 mm
20 mm	105 mm
24 mm	180 mm
28 mm	300 mm
35 mm	500 mm

- Double extenders
- Backup lenses:
 35 mm
 105 mm
 80–200 mm zoom
- Filters
- Two reflected or incident meters (same model), one spot and one flash meter
- Six Vivitar 283 units with filters, power packs, slaves, long PC cords, light stands, umbrellas, Polaroid camera or back
- Tripod, unipod, small table tripod
- Special equipment, according to the assignment:
 Stabilizer for aerials
 Heavy-duty strobes for big interiors
 Special cameras (underwater, panoramic, view cameras if shooting architecture or still life)
- A strong assistant

A Photojournalist's Traveling Companions

Here's what Chuck Fishman carries when he leaves New York City for two or three months:

3 Canon SLRs
2 motor drives
7 to 9 lenses from 15 mm fish-eye to 400 mm telephoto
2 Leicas with a 35 mm and a 50 mm lens
2 small flash units with a small battery pack
Rechargeable battery packs for the motor drives
Lots of spare batteries
1 tripod (at least)
1 tabletop tripod
Several extension cables up to 20 feet long
2 light meters
60 rolls of Kodachrome 64
20 rolls of tungsten
10 to 15 rolls of Ektachrome 64
40 rolls of Ektachrome 400
40 rolls of Tri-X

In China with Eve Arnold

"What else did I need? If I could just blink my eye and get it on film that would satisfy me."

Eve Arnold produced a monumental book, *In China,* and vast coverage of China that appeared in major magazines throughout the world. It took her fifteen years to get permission to make two visits to China — February and March, and June, July, and August — in 1979 and she wasn't about to blow it with a profusion of equipment. In fact, her inventory was very much as usual.

"Normally I don't work with a light meter," she says. "I don't use anything extra: no motors, no tripod, no filters, no lights. I want to be open to any experience there is and that takes total concentration. With a motor drive, particularly, I think I might miss that split second when the important moment occurs.

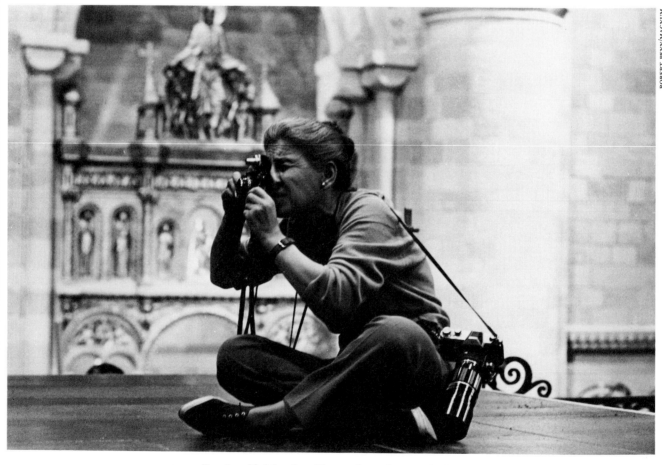

ROBERT PENN/MAGNUM

Eve Arnold doing her thing at Canterbury Cathedral

"Usually I work with two cameras on me and I like to work close up to people, to feel them, see them, smell them. If I haul all that stuff around, the camera ceases to be an extension of me and becomes a problem. The eyes stop seeing and get tired.

"For China I did make one change and that was to try a new body with automatic light metering. I thought I would be well advised to try it because I knew I would be moving very fast and be in unusual situations with great crowds of people and I wouldn't have a chance to bracket or anything. So on the first trip I took as one of my cameras a Nikon FE, and on the second trip I took all FEs."

A typical situation where these cameras came in handy was in a town called Wanxian. Most of the people had never seen a Western person and Arnold was the first Caucasian woman to sleep there since the revolution. Her arrival was a great event announced well in advance. As she walked through the village a small boy ran ahead shouting, "She's here! She's here!" The day was in her honor and crowds pushed and shoved to glimpse the photographer as the photographer tried to photograph the people.

"I like everything to be in motion, fluid and uncertain," says Arnold. "These automatic cameras are great for the unexpected things and I can switch to manual when I feel the light isn't right for the meter. I usually turn off the automatic mode outdoors, but they work particularly well in low-light situations and indoors they are great."

Eve Arnold's basic China equipment was four Nikon bodies and four Nikkor lenses — 35 mm, 55 mm, 105 mm, and 80–200 mm zoom. For film, she took 150 rolls on the first trip and 300 rolls on the second trip. "That meant I had to discipline myself to shoot just two to three rolls a day and not just shoot like crazy," she says. The bulk of her film was Kodachrome 64, but she also had some Ektachrome 400 and tungsten for indoor work.

Bags are every photographer's problem, says Arnold, so she designed a bag and had a friend make it up in leather. It was too soft, but she wrapped her cameras and lenses in foam to protect them. The bag has a pocket for passport and money and she also uses smaller leather bags on shoulder straps for daily shooting situations. At the end of each day she put exposed film and notes together in plastic bags and closed them with wire fasteners.

"If I have a small amount of equipment, people don't take me too seriously," she says. "I want the people to speak to me. It leaves me free."

4

SELECTING AND STORING FILMS AND PRINTS

Films
and Processing

Films are like people. Some of them are wide and expansive, others are frivolous, depressed, narrow-minded, sharp, clear and reasonable, romantic, or muddy-minded. Some color films are reminiscent of different images — a dull rainy day, New York City in August during a smog attack, trees lashed by a sharp west wind on a September afternoon.

Films can become very good friends and one always takes into consideration their idiosyncrasies, their color preferences, their dislikes for situations with too much contrast; how they shine with muted colors, bright colors, or how they can be adapted to other situations by using rose-colored glasses or other filters. Some films are schizophrenic, such as Infrared Ektachrome, and other films are boorish, narrow-minded conservatives, such as high-contrast copy films. Recorder 2475 is similar to someone too deep in booze or drugs to stay in control, but often sees through situations a bit more clearly than do more sober types.

The Best Color Photographers

Very few photographers have handled color with excitement. Too often they shoot pictures where the color dominates in such a way that it clashes with the viewer's taste or sensitivity. The ones who have contributed to the creation of taste and style in pure color photography are:

- The late Eliot Elisofon, a *Life* photographer who first worked with filters to enhance the psychological effects of the photograph.
- Ernst Haas, the leading color adventurer and explorer. He opened up color photography and showed how magical it can be. His color essays have been superb poetic images and his book *Creation* unveils a startling and perceptive sense of the magic of life, as seen in color. He puts color into a deeply aesthetic dimension.
- Gordon Parks works with the poet's eye. His images have muted, delicate color and deep moodiness. He was one of the first to combine images into a single picture that showed the potential of abstract color photography.
- Pete Turner's work is graphic, strong, and super-saturated in color. He combines this saturation with design, and the results are a battle between the emotions of color and the intellectual discipline of design.
- Eliot Porter sees color in nature that goes beyond the form of nature and becomes abstract. Some of his work can be compared, in the complexity of its simplicity, to Jackson Pollock's paintings.
- William Eggleston took the everyday use of garish color and turned it into super-sharp, brightly colored snapshots. However, his work as a photographer seems to ape the photorealist painters of a decade ago, who copied the commercial photographers of that era.

To know a film, black and white or color, means to live with it for a long while. Try it out in all situations, expose it to scenes it has not coped with, learn how it can be manipulated, and then see what develops. There's a lot to the relationship between film and photographer that is like an exciting, long-continuing affair, and much of it is magic.

Color

All photography is magic, and color especially, for it is an international language that can convey subtle ranges of emotion. Black and white photographs of war are graphic, startling, and can whack the viewer, but it was during the early part of Vietnam, when *Life* used Larry Burrows's color photographs of killing and destruction, that we became sickened by war — blotches of red smeared over bodies, intermingled with green foliage and brown mud. Burrows was sick of war; Vietnam was his last one, he said, before he was killed over there. There was no romanticism and glamour in his last photographs.

It was in the fifties that photographers began to use color poetically. Ernst Haas, one of a handful of photographers who understood how to convey the subtleties of color, published in *Life* essays on New York, Venice, and the Spanish bullfight. Haas abstracts images through color and his work is full of hope and wonder. Irving Penn conveyed the elegance of fashion through the subtleties of color.

The successful color photographers are subtle; their pictures are often variations on a single hue. They know intrinsically how color can work on our psyche. Pete Turner often produces images hued by the same part of the spectrum — shades of blue and black, or pinks and red — which he enhances through filters and film manipulation. Yet he will then break those rules that are the trademark of his photography. "There are no color theories," says Haas, "and no color formulas. If you arrive at a formula, go against it."

On a more mundane level, color reproduction is a part of our life. When television went color, out went the black and white magazine essays. Eventually, color overtook most pages of magazines; now even the small pictures on contents pages are in color. Ninety-nine percent of all assignments by professional photographers are in color.

Modern color photography is young. It became a feasible medium in 1935, when two musicians invented Kodachrome. Since then color has been studied, analyzed, and the psychologists have begun to understand the effect color has on the collective psyche. Men, for instance, prefer the color red, while women are more comfortable with blue, and children, as do primitive societies, have an affinity for saturated primary colors. According to one study, red "weighs" more than blue or yellow, so to the eye, the color red will anchor or dominate a picture. Most people feel comfortable with shades of green, blue, and magenta. Orange, yellow, and browns are disliked by many people.

Color can also be symbolic. Yellow, for instance, is a sacred color to the Brahmans of India. Yellow is also symbolic of wealth, of caution, and of cowardice. To some, New York is a city of yellow, oranges, and reds, a city of energy — yellow taxicabs, yellow police slickers, red and orange neon signs; many yellows and reds in the streets and in the skyscrapers. London is red and black, symbolic of royalty in the brilliant red uniforms, and of conservatism, as seen in black cabs, coats, and umbrel-

The Emotions of Color

Red: passion, love, hate, anger, danger, warmth
Orange: warmth, sensuality, energy, exuberance
Yellow: caution, wealth, happiness, health — also cowardice
Green: hope, freshness, peace
Blue: strength, power, eternity, contemplation
Purple: pomp, mysticism, sensitivity
Black: death, power, conservatism, mourning
White: purity, freedom, escape, salvation

Advertising gurus who have studied the effects of color say black and white ads pull better than four-color ads when introducing a new product. Mail-order ads are more effective when mixed with four-color pictures and copy.

Interior decorators say rooms decorated with warm colors (yellow and orange) are conducive to creativity, while coolly neutral colored walls help increase productivity for people doing routine jobs (typing, filing). Pink has a calming effect, but too much isolation in a pink room leads to violence. Black and red is the most sensual and arresting color combination. Yellowish green and brownish purple are, to most viewers, detestable colors.

las. Paris, on the other hand, is blue and gold; Venice reflects muted orange and blues; Las Vegas is saturated primary colors against black; and Zurich is best photographed with black and white film.

Color on Film

Color film will never record color exactly as we see. Sometimes it sees more than we do, sometimes less. There are so many variables in color film that a professional photographer, to have consistent results, must follow standard operating procedure if he or she expects the color and exposure to be uniform from roll to roll. Eastman Kodak, which makes the best film in the world, attempts to manufacture color film to a tolerance of one-half stop of the rated color speed in each emulsion number (film made at the same time). This means that there can be a difference of one stop between rolls with different emulsion numbers. Then, of course, Kodak is not perfect. One emulsion batch of Kodachrome 64 when tested revealed that it had to be rated at ASA 125, double its normal speed, and a batch of Ektachrome 64 ended up with a speed of ASA 35. Kodak attempts to keep colors within a range that can be corrected with a CC 10 filter, but that doesn't always happen.

Kodak lists these nine variables that can affect color balance and speeds:

1. Manufacturing variations among different emulsion numbers. Photographers should always buy film in batches with the same emulsion number and then make tests to find the speed and color balance that is correct for their film.

2. Adverse storage conditions before exposure. All film should be refrigerated at 50 degrees F or below to stabilize it. Moisture should be below 50 percent relative humidity. Above 60 RH the dampness begins to eat away packaging, and molds and fungi may grow on the film. Dehumidifiers or silica gel bags packed with the film can solve this problem. Roll film should be warmed up one and a half hours before use. Up to ten hours is needed for larger boxes of film.

3. Some illumination of incorrect or mixed color quality. Different color temperatures from what the film is designed for (outdoor film is designed to give correct color at 5500 K) will make the film bluer or

Kodak Is Not Perfect

The Great Yellow Father, as this huge chemical company is sometimes called, is a mixture of yin and yang. It makes the best film in the world, but at times it fiddles too much with it.

The first color film Kodak manufactured, Kodachrome, was supersaturated with warm colors and rich hues, a very sensual film. Photographers created their "style" based on these earthy colors.

When Kodachrome was replaced by Kodachrome II in the early sixties, some photographers went berserk. Ernst Haas, whose first color essays were shot on the old Kodachrome, bought up as many rolls of the original film as possible.

Kodachrome II didn't have the same sensuality. Still, Kodachrome II has the best saturation of any available film and more speed (ASA 25 versus ASA 10), and some photographers developed photographic styles around this film — for instance, shooting almost every picture with side- and backlighting. The colors became supersaturated and the shadows remained open while the highlights were not burned out.

Kodachrome II was replaced by Kodachrome 25 because the president of Kodak wanted a more natural film. His will prevailed and along with it Kodak released the new Kodachrome 64. Reportedly, these films were also ecologically cleaner in the processing.

However, the films were flat. Kodachrome 25 had lost much of its saturation. Highlights burned out and shadows blocked up. Afternoon light became muted, greens and blues dull. The only answer, at the time, was to change from shooting side-lit and backlit shots to more frontal lighting.

Kodachrome 64 turned faces bright pink and changed the colors of clothes. Professional photographers were up in arms. A group from the American Society of Magazine Photographers met with Kodak to resolve this problem and Kodak, ever-fearful behemoth, sent its lawyers rather than its technicians to attend the meeting.

Eventually, Kodak improved (slightly) the two Kodachromes, but they are still no match for the old Kodachromes. The president had his way, and the new Kodachromes developed the greenish tinge in the highlights. Not even the president of Kodak wanted that, but it is the professional photographer who has to use Kodachrome that pales against the original, zesty, sensual film developed by those two musicians. They should have left well enough alone.

yellowish. Certain deep colors take more exposure than normal. Mixed illumination (fluorescent light

and daylight, for instance) will change the color balance. Photographers solve this problem by testing and controlling the light, or by using a color meter and correcting the color balance with filters.

4. Differences in film sensitivity with changes in illumination level and exposure time. Very low light levels or low f-stops require long exposures. With most films, exposures metered at more than one second require additional exposure length, from one to three stops, and often a color compensating filter is needed to correct color shift. The correction is necessary because of what is called "reciprocity effect." Film manufacturers supply this information in books and pamphlets (such as the *Kodak Professional Photoguide*) or with the instruction paper packed with the film. Kodak, for instance, recommends that only Kodachrome 25 and Ektachrome 400 be used for exposure of 100 seconds or longer. The long exposure, with Ektachrome 400, calls for an increase of two and a half f-stops and the use of a CC 10 C filter, while Kodachrome 25 at 100 seconds needs a three-stop increase in exposure and a CC 20 B filter.

5. Variations in equipment. Each emulsion should be tested with the lenses, shutters, exposure meters, and flash units that will be used to expose the entire batch of film. Shutters can be fast or slow, particularly mechanical shutters at high speeds (both focal-plane and between-the-lenses shutters). Lenses can alter speed and color and, of course, meters and the way they are used may change the speed of the film. The photographer should test and find his or her personal ASA index and color balance for each emulsion number.

6. Adverse storage conditions between film exposure and processing. Film should be processed immediately after exposure — a delay of even one week can change the color balance. If it cannot be developed immediately, it should be wrapped carefully and refrigerated.

7. Uneven processing conditions. Wrong temperature, poor agitation, improper replenishment, can change the speed and color of the film. The very same procedure should be used each time the film is developed. Only one lab should be used and the photographer should check with the lab to find out the color balance of the processing. (There could be a shift to the yellow or green, which is correctable. A good lab manager would know that.) Pro-

cessing is so delicate that even a different type of water used to mix the chemicals can affect the color balance.

8. Nonstandard viewing conditions. Most professionals view film over a light box that is illuminated by a fluorescent tube rated at 5000 K with a Color Rendering Index of 90 or higher. There are three fluorescent tubes that meet the American National Standards Institute's criteria: MacBeth Prooflite, Duro-Test Optima 50, and General Electric Chroma 50.

9. Personal taste. Amateurs generally like a bright picture that, to professionals, would appear slightly overexposed. Many professionals underexpose one-half stop and prefer warm pictures, and so filtrate all lenses with a slight warming filter (equivalent to the 81A, but with more of a reddish tint to it). Every viewer will have a personal preference in tone and shade.

Favorite 35 mm Color Films

Most professionals become familiar with one or two films and use them for the majority of their work. There are times when certain other color films would be used — for high speed, grain, or color balance — but on the average photographers prefer the characteristics of their selected films.

Kodachrome 25 is the best film made. It has very good color balance, resolving power, sharpness, and granularity. It can be blown up 100 times and still be sharp. In fact, a portion of an Ernst Haas 35 mm Kodachrome was used to create one of the huge illuminated transparencies that Kodak displays in Grand Central Station in New York City.

Kodachrome 25 and Kodachrome 64 have the longest life of all films — a hundred years if kept in dark storage. (Ektachrome has a life expectancy of fifty years.)

Kodachrome 25 is slightly weak in blue, is vibrant and well saturated in reds and oranges. The film has the widest latitude of any color film and is best to use in very contrasty light, such as at high altitude, on the beach, and with snow scenes. It is also the favorite 35 mm film for use in making posters or murals because of its extreme sharpness.

Kodak manufactures Kodachrome 25 and Ko-

Professional versus Amateur

Most roll films that do not require refrigeration are meant to be projected through a 3200 K light source. Professional films, on the other hand, are meant to be viewed through a 5000 K source. All films, for the sake of standards, are viewed through a 5000 K source before being made into separations.

Does this mean that these films are balanced on the cold side, so that the 3200 K projection light warms them up? The answer is subjective, but a Kodachrome held under a 3000 K light takes on warmth and charm. Warm filters help amateur films when they are to be used for reproduction.

dachrome 64 as amateur films that are designed to "age" on the shelf. They estimate that an amateur photographer won't process a roll of film for one-half to two months. When the Kodachromes come off the manufacturing line they tend to be slightly green (about 5 to 10 CC), and in normal temperatures shift to the red or magenta within six months. The Kodachromes are very sensitive, thin films that are essentially black and white. Unlike those of any other films, the color dyes are added during a complicated development process, and it is for this reason that there is no home processing. However, this also makes these films extremely sharp and sensitive and means that all Kodachromes should be tested for speed and balance. Kodachrome 25 seems to have the least amount of variation in speed and color balance, although most professional photographers expose the film at ASA 32.

More and more professionals are switching to the Kodachromes from the Ektachromes, and because of this, manufacturers are making lenses with larger apertures so the Kodachromes can be exposed at higher shutter speeds. This is one of the reasons for the popularity of the 300 mm f/2.8 lens and the new fast medium telephotos in 85 mm, 105 mm, and 200 mm focal lengths.

Kodachrome 64 is the second-best film made. It is more contrasty than Kodachrome 25 and causes skin tones to be slightly pink, which some photographers love and some abhor. Blue sky tends to be slate blue and less saturated than the sky as recorded by the slower Kodachrome. The film performs very well with front lighting. Too much angular or back light and the film's contrast squeezes shut the dark areas.

Kodachrome 64 has a serious problem — also evident but to a lesser degree in Kodachrome 25 — and that is a fringing of green in the least-dense areas. It is particularly noticeable on the rims of clouds that are pure white, and on snow that is slightly overexposed. This is caused by the magenta curve, which is too sharp. Kodak has a major program under way to rectify this color aberration. Some Kodak technicians feel that once this fault is corrected, Kodachrome 64 should be processed to professional tolerances (which means it comes with technical data as to the emulsion speed and color balance and reciprocity factors, and that it should be refrigerated until used).

Ektachrome 64 is used mostly by medium- and large-format photographers. It comes, as do all the roll film Ektachromes except Extachrome 400, as professional or amateur film. As mentioned above, the professional film is packaged with technical data and should be refrigerated. The aim in manufacture of these films is that they should have the least possible variability, as viewed from a light table with a 5000 K light source.

The Ektachromes have very good greens and perform well with evenly balanced light, because the film does not have much contrast. Some photographers prefer Ektachromes when there is no direct

Valuable Books on Color Photography

Kodak Professional Photoguide. This book has just about everything one needs to know about using Kodak's color film.

Kodak Color Films (Number E-77). Facts on how color film is made, how it should be stored and preserved, comparisons of color film, information on filters, and data sheets on all Kodak color films. Kodak books are available from Eastman Kodak and large camera stores.

The Art of Color Photography, by John Hedgecoe (Alfred A. Knopf). A fine reference color and text book with photographs illustrating each topic and idea.

The Book of Color Photography, by Adrian Bailey and Adrian Holloway (Alfred A. Knopf). A very thorough book on color, film, filters, and how to use equipment and lighting to the best advantage. The chapters on film and the language of color are exceedingly good.

When You've Got a Problem

Kodak is there to help. At most of their seven regional marketing centers located in key cities throughout the United States, there is at least one person who has access to a basic library of general information about Kodak products as well as data on new products. When this reference person cannot answer questions or provide services, he or she can call on specialists with information about products or processes. If they can't provide an answer, they can get photographers to the source at Rochester, New York. A typical Kodak center receives between three hundred and four hundred calls per month.

Kodak's Regional Marketing Centers

Eastman Kodak Company
Midwestern Region
1901 West Twenty-second Street
Oak Brook, IL 60521
312 654-5300

Eastman Kodak Company
Eastern Region
1187 Ridge Road West
Rochester, NY 14650
716 254-1300

Eastman Kodak Company
New York City Region
1133 Avenue of the Americas
New York, NY 10036
212 930-8000

Eastman Kodak Company
Pacific Northern Region
3250 Van Ness Avenue
San Francisco, CA 94109
415 928-1300

Eastman Kodak Company
Pacific Southern Region
12100 Rivera Road
Whittier, CA 90606
213 945-1255

Eastman Kodak Company
Southeastern Region
1775 Commerce Drive, NW
Atlanta, GA 30318
404 351-6510

Eastman Kodak Company
Southwestern Region
6300 Cedar Springs Road
Dallas, TX 75235
214 351-3221

Professional Customer Service — The Source

Eastman Kodak Company
343 State Street
Rochester, NY 14650
716 724-2514

sunlight because of its luminous quality. All Ektachromes have a tendency to go blue, and outdoors many photographers shoot the film with a warming filter (81B) to cut this blue effect. Ektachrome 64 has very fine granularity, but not as fine as that of the Kodachromes.

What all the Ektachrome films have is higher fidelity in reproducing natural hues. They are the most neutral films, an important consideration for fashion photographers who must produce transparencies that are faithful to the hues and tones found in fabrics.

Ektachrome 200 has exceedingly fine grain for a fast film. It is sharp and has good color balance, but it requires very careful exposure, for it does not have much latitude. Professionals use it for sports and for low-light situations where they often push the film to 400, for they feel that this film pushed gives better results than Ektachrome 400. Pushing also increases contrast slightly, and photographers like the extra snap. The fast Ektachromes do not perform well under bright sunlight, because highlights tend to wash out.

Ektachrome 400 is grainy and a bit dull. There are problems with this film in the yellow dye layer, and yellows come out weak. It is used when photographers need to push a film to 800. (For best results, Ektachromes should be pushed only one stop.)

3M 640-T is the fastest film in the world and can be pushed two stops. It is a tungsten film and it is

grainy but it can produce an image where all other films fail.

Kodak has a strong lock on the American film market. Serious competition, if you call it that, comes from Fuji and Agfa. Fuji has crisp and pleasing yellows, greens, and whites. Agfa has more subtle bright tones, and is good with browns, blues, and greens. Skin tones look very natural with this film, as they do with Fuji. Both films have a rating of ASA 100 in their normal transparency film and are grainier than the Kodachromes and Ektachrome 64.

The favorite sheet film is Ektachrome 64 Professional, which is the standard for professional photographers.

For color negative work, Vericolor II Professional is used with large-format cameras, and so far Kodacolor II remains the best print film in terms of grain and gradation, in sunlight and shade.

Tips on Shooting Color

- Think in color. Take images where a particular color (or colors) dominate.
- The light of early morning and late afternoon produces the most saturated colors.
- Slight underexposure saturates transparencies with color, but slight overexposure is better with negative color film.
- Polarizers darken skies and help saturate colors, particularly of land- and seascapes, by removing reflections from grass, leaves, and water.
- Side-lit and backlit color is more dimensional than front-lit.
- Hazy days often give very deep saturation and the best color tones.
- The CC 30 Magenta filter is useful for shooting out of airplane windows, underwater at depths over ten feet, and under fluorescent light.
- Infrared Ektachrome turns very magenta when used without a filter.
- Dialed-down outdoor flash fill, such as that available with the Vivitar 283 and 285 units, can create subtle images when the camera is very close to the subject and can be used dramatically for key lights at sunset.

- Shade the lens from light sources; otherwise glare can soften the image (sometimes very effective). Sunshades and, better yet, compendiums solve this problem.
- Portraits look best under ambient light. Low-level-light portraiture can be most effective by muting tones. Psychology tests show that pupils dilate when focused on something pleasurable — sexual, bucolic, or whatever — and that people are more susceptible to other people who have this "openness" in the eyes. This facet is brought out in lower-level light situations.
- Know the exposure latitude of film, shoot within that framework, and base the exposure on the most important color feature. Expose for the highlights with transparency film, for the shadows with negative film.
- There is twenty minutes between sunset and darkness that is best for shooting "night" pictures such as cityscapes and country villages. There is enough light to give detail in shadows, produce deep blue in the sky, and record artificial light. Another way to achieve this effect is to make two exposures on the same film, one for the late sunset, another, taken after dark, for the artificial light.
- The best insurance for correct exposure is to bracket one-half to one stop.
- The higher the speed of the film, the higher the contrast and the lower the film's latitude.
- Don't project original slides. The heat can fade the dye. Make duplicates and use them for projection.
- When traveling abroad either:
 (1) Take tested film over, expose it, and airship it back for development by the lab that normally does your work.
 (2) Buy film over there, test it, and develop it with a local reputable processor. Kodak has labs in major countries. (Most reports rate American Kodachrome far superior to foreign-produced Kodachrome. English Kodachrome is brown. French Kodachrome is green.)
- High altitude can give a bluish, purplish cast to pictures when there is too much ultraviolet radiation. Use a UV filter.
- Color film is more sensitive to the far edge

of the red and infrared spectrum and will make some blues, as in flowers like morning glories, appear reddish. The color can be corrected by blue filtration.

Duping Slides

The process of duplicating slides can be used to improve the color balance, enlarge the original, create special effects such as double exposure, and copy "sandwiches" of one or more slides, while leaving the original for safekeeping. Black and white negatives can also be made from color transparencies.

Kodak Ektachrome Slide Duplicating Film is available as a tungsten or electronic flash film and has low contrast and fine grain. However, filtration is difficult and the basic filter pack must be worked out for the different types of film being copied.

Many photographers prefer to use Kodachrome for their duplicates because of its sharpness, saturated color, fine grain, and long life. However, Kodachrome when used as a duplicating film is very contrasty. The contrast can be brought down by using a neutral density filter, by prefogging the film, or by making a black and white negative highlight mask, which is sandwiched with the original and recopied.

Two portable duplicating machines have devices built into them to lower contrast. The Bowens Illumnitran uses a preflash system to fog the film. More critical, though, is the system used by the Dia Duplicator. This Swiss-made duplicator uses a twelve-stepped neutral density filter and a fiber optic that bypasses the lens and prefogs the film at the lens mount of the camera. Critical results with Kodachrome 25 are achieved by using a contrast control setting of about eight and exposing at about eleven when making a one-to-one dupe.

Facts about Color Labs

Eastman Kodak does a superior job developing Kodachrome and Ektachrome transparencies.

Most photographers use professional laboratories to have film developed and prints enlarged. Unfortunately, many color labs are more interested in

Dia-Duplicator uses fiber optics to pre-flash the film in the camera box

BOGEN PHOTO CORP.

making a profit than in producing a good print. A poor lab may:

- Not replenish chemicals automatically or regularly, so that the density and color balance can be off.
- Use outdated enlarging paper or cheaper brands that do not have good color fidelity, or may not make proper tests on the film, and not balance each new batch carefully.
- Offer a custom print while in actuality prints are being run off on an automatic enlarger that can make prints literally in seconds.
- Work in a sloppy environment, which, with little humidity or too much humidity, can affect cleanliness and color balance.

Some labs can become very greedy when they realize that machinery can compute the proper exposure and automatically produce finished enlargements with little handwork. The fact is that the retail cost for a finished 8 × 10 is usually up to $15.00, while the material costs for such a print may be no more than $1.25.

The success of a lab depends upon good equipment and a good manager's desire to do a good job. It can take some scouting to find this right combination. When a photographer does find a good lab, it becomes a marriage that will last for life unless the lab starts "cheating" on the photographer.

How to find a good lab:

1. Talk to the manager. Find out what processes

Prints by Laser Light

LaserColor Laboratories has a unique way of producing internegatives from transparencies by using laser beams. The beams "read" the color in the transparency, compute it, store the information, then release it to red, blue, and green laser beams that make an exposure on film. It is wondrously technical and takes about twenty seconds.

What is amazing about the system is that the internegative material is 70 mm Kodacolor II rather than 4 × 5 internegative material, which most labs use. There is no built-in contrast control — it produces very sharp, well color-balanced internegatives. The secret lies in the laser beams. They produce an internegative of uncanny sharpness and color saturation. It is so good that defects you might not notice in the original transparency can become a problem. Such was the case when one photographer had a LaserColor internegative made of a cauliflower shot against a black background. The white against black, during exposure, caused refraction within the film, making a very faint halo around the cauliflower. The LaserColor internegative enhanced this defect. The moral here is that the best LaserColor internegatives are made from perfectly exposed slides of very fine material (Kodachrome 25 and 64). The results appear almost better than the original.

LaserColor also has the capability to make color art prints, as opposed to normal, or "faithful," color reproductions. The LaserColor Art is basically a posterization process done within the computer before the internegative is made. This process needs to be used with sophisticated taste — too much of it, or the wrong colors, and the results are garish. The degree of posterization wanted can be judged by using a computer terminal. Write LaserColor for the nearest terminal or if you want one installed in your home: P.O. Box 8000, Fairfield Drive, West Palm Beach, FL 33407.

they use and what chemicals. A lab that uses Eastman Kodak products exclusively often has a good relationship with the tech rep of Kodak, who can advise on technical problems, color balancing, and so on.

2. Ask what type of equipment they use. Many professional labs prefer a "dip and dunk" processor for film rather than a continuous-feed cine-type processor. Dip and dunk is slower, very reliable and accurate in development. Ask about replenishment and, most important, whether they can give information on the color balance of their process. A good lab manager will tell you that the process is more to the yellow, blue, or green bias and let you know how much to correct with CC filters.

Ask about the mechanical difference in manufacturing of prints. Some labs have automatic-feed easels for enlargers while others use automatic enlargers that work with a roll paper so the print cannot be burned or dodged or played with during enlargement. A good lab will have an automatic enlarger for machine prints and regular enlargers, like the Chromega, for hand enlargements.

3. Send similar rolls shot at the same time with the same equipment to several labs and request machine prints. Analyze the results. Send the film back and ask for hand-enlarged prints, explaining the effect you want, then analyze those results. Check for color saturation, finish work, dust marks, and so on.

4. Find out what the lab specializes in. Often a specialty lab produces better results. A custom lab that specialized in processing Ektachrome would in most cases produce excellent work. So would a lab that specialized in Cibachrome prints or dye transfers. The labs that work for professional photographers in the large cities often turn out superb work — at superb prices.

5. Unless it is very well managed, a large laboratory can turn out too much work at too low a quality. Some of the best labs are located in small cities and operated by one or two people who are skilled enthusiasts and perfectionists, doing this work not only for their livelihood but also for personal satisfaction. At one small lab like this in Taos, New Mexico, the owner wants to know you personally so he can understand your style. A keen eye on consistency, however, is always called for.

Black and White Films

Although currently out of favor commercially, except with those who work for newspapers, black and white remains the favorite medium of the professional photographer. In fact, most professionals, when they shoot for themselves, use black and white. Something about black and white reaches into the soul and gives it a good squeeze.

Black and white, someone once said, is once removed from reality. It is more abstracted and eter-

Laboratories Processing *Kodak* Color Films
(Reprinted with permission of the Eastman Kodak Company, 1982)

Argentina

Kodak Argentina S.A.I.C.
Casilla de Correo Central 5621
Buenos Aires, Argentina

Australia

Kodak (Australasia) Pty. Ltd.
P.O. Box 4742
Melbourne, Victoria
Australia 3001

Kodak (Australasia) Pty. Ltd.
G.P.O. Box 46A
Adelaide, South Australia
Australia 5001

Kodak (Australasia) Pty. Ltd.
G.P.O. Box 260
Brisbane, Queensland
Australia 4006

Kodak (Australasia) Pty. Ltd.
P.O. Box M16
Sydney, New South Wales
Australia 2012

Kodak (Australasia) Pty. Ltd.
G.P.O. W2051
Perth, Western Australia
Australia 6001

Austria

Belgium

Kodak Ges.m.b.H.
Albert Schweitzer-Gasse 4
A-1148 Vienna, Austria

Kodak Ges.m.b.H.
Josef Mayburger Kai 114
Postfach 33, A-5021 Salzburg, Austria

N.V. Kodak S.A.
Steenstraat 20
1800 Koningslo-Vilvoorde, Belgium

Brazil

*Kodak Brasileira Comércio
e Indústria Ltda.*
Caixa Postal 849-zc-00
Rio de Janeiro, GB., Brazil

*Kodak Brasileira Comércio
e Indústria Ltda.*
Caixa Postal 225
São Paulo 01000, Brazil

*Kodak Brasileira Comércio
e Indústria Ltda.*
Caixa Postal 201
Recife, Pernambuco, Brazil

*Kodak Brasileira Comércio
e Indústria Ltda.*
Setor Comercial Lado Norte 103
Bloco C No. 6B
Brasilia 70.732, Brazil

*Kodak Brasileira Comércio
e Indústria Ltda.*
Caixa Postal 994
Pôrto Alegre, RS, Brazil

*Kodak Brasileira Comércio
e Indústria Ltda.*
Rua Padre Aspicuelta, 9
Largo dos Aflitos–Edif. Dom Pedro
40.000 Salvador, Bahia, Brazil

Canada

Kodak Processing Laboratory
Brampton, Ontario, Canada L6X 2M4

Kodak Processing Laboratory
P.O. Box 3700
Vancouver, British Columbia
Canada V6B 3Z2

Chile

Colombia

Kodak Chilena S.A.F.
Alonso Ovalle 1180
Casilla 2797
Santiago, Chile

Kodak Chilena S.A.F.
Colo-Colo 1182
Casilla 2717
Concepcion, Chile

Foto Interamericana de Colombia Ltd.
Avenida Eldorado 78-A-93
Apartado 3919
Bogotá, Colombia

Denmark

Kodak a.s.
Roskildevej 16
2620 Albertslund, Denmark

Kodak a.s.
Kodakvej 6
4220 Korsor, Denmark

Kodak a.s.
Brovej 17
8800 Viborg, Denmark

Finland

Kodak Oy
PL 758
00101 Helsinki 10, Finland

France

Kodak-Pathé
Rond-Point George Eastman
93270 Sevran, France

Kodak-Pathé
17, rue de Riviére
33007 Bordeaux Cédex, France

Kodak-Pathé
3, Bd de la Madeleine
06008 Nice Cédex, France

Kodak Pathé
130, av. de-Lattre-de-Tassigny
13273 Marseille Cédex 2, France

Kodak-Pathé
11, rue du Manoir de Servigné
35001 Rennes Cédex, France

Kodak Pathé
Zone Industrielle
71102 Chalon-sur-Saône, France

Germany, Federal Republic of

Kodak Farblabor
Postfach 369
7000 Stuttgart 60 (Wangen)
Germany

Great Britain

Kodak Limited
Colour Processing Division
P.O. Box 14
Hemel Hempstead
Hertfordshire, HP27EJ, England

Greece

Kodak (Near East) Inc.
P.O. Box 1253, Omonia
Athens, Greece

Hong Kong

Kodak (Far East) Limited
P.O. Box 48 General Post Office
Hong Kong

India

India Photographic Co. Ltd.
483, Veer Savarkar Marg
Bombay 400 025, India
(Send by registered post)

Italy

Kodak S.p.A.
Casella Postale 11057
20100 Milan, Italy

Kodak S.p.A.
Via Scorticabove, 151
00156 Rome, Italy

Kodak S.p.A.
Casella Postale 53
81025 Marcianise CE, Italy

Japan

Far East Laboratories, Ltd.
Namiki Building
No. 2-10, Ginza 3-chome
Chuo-ku, Tokyo 104, Japan

Far East Laboratories, Ltd.
14-1, Higashi Gotanda 2-chome
Shinagawa-ku, Tokyo 141, Japan

* Not Kodak Laboratories. These three laboratories do give credit for prepaid processing charges; however, additional charges may be incurred.

Laboratories Processing *Kodak* Color Films (Continued)

Kenya *Lebanon*

Kenfoto Limited *Kenfoto Limited* *Kodak (Near East) Inc.*
P.O. Box 18210, Funzi Road P.O. Box 90303, Meru Road P.O. Box 11-761
Nairobi, Kenya Mombasa, Kenya Beirut, Lebanon

Malaysia *Mexico* *Netherlands*

Komal Sendirian Berhad *Kodak Mexicana, S.A. de C.V.* *Kodak Nederland B.V.*
P.O. Box 628 Administracion de Correos 68 Fototechnisch Bedrijf
Kuala Lumpur 01-02, Malaysia Mexico 22 D.F., Mexico 04870 Treubstraat 11
 2288 EG Rijswijk (Z-H)
 Netherlands

New Zealand

Kodak New Zealand, Ltd. *Kodak New Zealand, Ltd.* *Kodak New Zealand, Ltd.*
P.O. Box 3003 P.O. Box 2198 P.O. Box 700
Wellington, New Zealand Auckland, New Zealand Christchurch, New Zealand

Norway *Panama* *Peru*

Kodak Norge A/S *Laboratorios Kodak Limitada* *Foto Interamericana de Peru, Ltd.*
Trollåsvn 6 Apartado 4591 Casilla 2557
1410 Kolbotn, Norway Panamá 5, República de Panamá Lima 100, Perú

Philippines

Kodak Philippines, Ltd. *Kodak Philippines, Ltd.* *Kodak Philippines, Ltd.*
P.O. Box 620 Dumoy, Davao City 9501 P.O. Box 450
Commercial Center Post Office Philippines Cebu City 6401, Philippines
Makati, Rizal 3117, Philippines

Portugal *Singapore, Republic of*

Kodak Portuguesa Limited *Kodak (Singapore) Pte. Limited*
Apartado 12 P.O. Box 687
Linda-a-Velha, Portugal Singapore 1

South Africa

Kodak (South Africa) (Pty.) Ltd. *Kodak (South Africa) (Pty.) Ltd.* *Kodak (South Africa) (Pty.) Ltd.*
Processing Laboratories P.O. Box 1863 P.O. Box 3296
102 Davies Street, Doornfontein Bloemfontein 9300, Port Elizabeth 6000,
Johannesburg 2001, Republic of South Africa Republic of South Africa
Republic of South Africa

South Africa (continued)

Kodak (South Africa) (Pty.) Ltd.
P.O. Box 735
Cape Town 8000,
Republic of South Africa

Kodak (South Africa) (Pty.) Ltd.
P.O. Box 1645
Durban, Republic of South Africa

Spain

Kodak S.A.
Apartado de Correos 130
Colmenar Viejo, Madrid, Spain

Kodak S.A.
Apartado de Correos 1438
Barcelona, Spain

Sweden

Kodak AB
S17585 Järfälla, Sweden

Kodak AB
Fack
S-43120 Mölndal, Sweden

Kodak AB
Brottkarrsvagen
S-436 00 Askim, Sweden

Switzerland

Kodak S.A.
Processing Laboratories
Case postale
CH-1001 Lausanne, Switzerland

Taiwan

Kodak (Far East) Ltd.
731 (K Bldg.), Wen Lin Road, Sec 1
Shih Lin, Taipei
Republic of China

Thailand

Kodak (Thailand) Ltd.
P.O. Box 2496, 71 Sub Rd.
Bangkok, Thailand

U.S.A.

Kodak Processing Laboratory
1017 North Las Palmas Avenue
Los Angeles, California 90038

Kodak Processing Laboratory
925 Page Mill Road
Palo Alto, California 94304

Kodak Processing Laboratory
4729 Miller Drive
Atlanta, Georgia 30341

Kodak Processing Laboratory
1065 Kapiolani Boulevard
Honolulu, Hawaii 96814

Kodak Processing Laboratory
1712 South Prairie Avenue
Chicago, Illinois 60616

Kodak Processing Laboratory, Inc.
1 Choke Cherry Road
Rockville, Maryland 20850

Kodak Processing Laboratory
16-31 Route 208
Fair Lawn, New Jersey 07410

Kodak Processing Laboratory
Building 65, Kodak Park
Rochester, New York 14650

Kodak Processing Laboratory
1100 East Main Cross Street
Findlay, Ohio 45840

Kodak Processing Laboratory
3131 Manor Way
Dallas, Texas 75235

Uruguay

Kodak Uruguaya, Ltd.
P.O. Box 806
Montevideo, Uruguay

Venezuela

Foto Interamericana de Venezuela, S.A.
Apartado 80658
Caracas 1080-A, Venezuela

Zimbabwe

Zimbabwe Photographic Company Ltd.
P.O. Box 2170
Salisbury, Zimbabwe

nal than the immediate and often garish aura that emanates from color. Black and white is much more calming to our emotions. Some images may be horrible, such as the pictures of Diane Arbus, Weegee, and the war photography of Eddie Adams and Don McCullin. Yet, we are much more able to live with these pictures mounted on a wall than we would be if they were done in color.

Black and white has tradition. It is a historical process, and it is a permanent process, for a black and white print can last for hundreds of years when archivally processed.

The world's most recognized photographers have given us images that are black and white and indelibly implanted in our memories — Weston, Adams, Evans, Arbus, Cartier-Bresson, Smith, Siskind, White, Strand, Frank, Klein, Erwitt, the snapshot twins Friedlander and Winogrand, Uelsmann, Caponigro, and Giacomelli. We can visualize their black and white efforts, but what color images come quickly to mind?

Black and white is a much more manipulative medium than color. It is also technically more difficult to master, for the total process is a continuation of technique, craft, and art from exposure

The Intellect and the Emotions

The quickest, most efficient means of communication is by the use of shapes: hieroglyphics, writing, cartoons, engineering drawing. Color often tells more, but in telling it also detracts from the main message. It's for this reason that painters like Goya and Picasso turned to black and white drawings to express their political passions and opinions.

A more dynamic, emotional impact comes from the use of color: paintings, clothing, decoration, advertising. Shapes may be diminished in the color surroundings, but people's response is generally more cheerful and direct. It's for this reason that bright, strong colors are used where people go to escape — in play parks and the gambling environment, for instance.

When viewing black and white objects, the person must extend him- or herself and work for comprehension. When viewing color, the person can be a passive receiver and let the object affect him or her. "Color produces an essentially emotional experience, whereas shape corresponds to intellectual control," said Rudolph Arnheim in *Art and Visual Perception.*

through development to the final print. A mistake along the way can completely alter what the photographer visualized through the camera. Conversely, mistakes can be minimized and elements of the picture emphasized through development and printing.

Black and white technique is too large a subject to cover in this book. There are fine books available on basic and advanced black and white photography by Ansel Adams, David Vestal, Henry Horenstein, Fred Picker, and others. A good book on manipulative darkroom techniques such as toning, adding color, and using special films for special effects is the *Darkroom Handbook* by Michael Langford (Alfred A. Knopf).

In recent years there has been a move to black and white photography sparked by the fine arts photographers who have moved up to view cameras to make their images of empty parking lots at night, clouds against an empty sky, and vacuous urban still lifes. Some, though, are still taking pictures of people trying to cope within this world and some black and white essays are creeping back into print, particularly in European publications. A few agents are asking their photographers to shoot in black and white because there is a continual need for those pictures for newspaper ads and textbooks. Black and white rates have traditionally been lower than those for color, but, ironically, it costs more to produce a black and white print than it does a color transparency. In a few years black and white rates should be comparable to those for color.

A few of the basics about black and white:

- Standardize procedures from exposure to print. Film exposure, film development, contacts, enlarging papers, and print development procedures should all be standardized. The photographer should know how to manipulate the film to lower contrast and how to double or triple the speed, as well as knowing what films are best for certain situations.
- The black and white specialist should know how to make a relatively flat print that will reproduce well on newsprint, and how to make an exhibition print that is printed for deep blacks, toned, and archivally mounted.
- The photographer who uses an outside lab knows its processes and the printer who will make the finished prints. The photographer

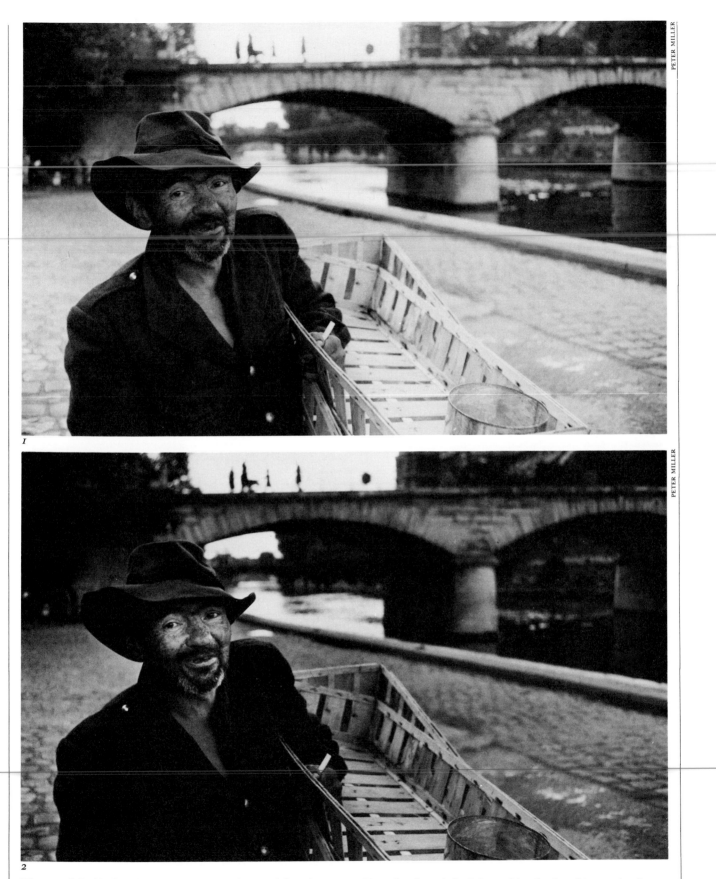

The art of the black and white print. No. 1 is a straight enlargement. No. 2 has been dodged, burned in, developed in two developers, and toned in selenium. In addition, ferricyanide was used to brighten the face.

PETER MILLER

PETER MILLER

adapts his or her exposure to the lab's specifications and collaborates with the printer so that a printing style develops that relates to the photographer's style.

Unfortunately, modern black and white materials do not have the deep blacks and subtle whites that were inherent in the enlarging papers of yesteryear. The film manufacturers have copied the candy manufacturers — they make a nice-looking and big package, but there is not much inside. In the case of films and paper, that means silver. Less silver means less gradation. In fact, fiber-based papers have almost disappeared as the weakly silvered resin-coated papers have become popular. These resin papers are great for speed work because they dry very quickly. However, they don't have the tonal range that fiber-based papers do. In fact, some of the resin-based papers don't even have decent whites. Manufacturers are correcting this by adding a whitening layer to the paper. The best papers today are fiber-based graded papers made by Agfa and Ilford, and some smaller companies that advertise silver-rich papers.

The favorite films are made by Kodak, Agfa, and Ilford. Ilford, which has made an effort to specialize in black and white with startling results, is becoming a leader in the field. It makes two fine enlarging papers, Ilfobrom and Galerie, and two very popular films, FP 4 (ASA 125) and HP 5 (ASA 400). Coupled with Ilford's new developer, IF 11 Plus, which has an additive to clean the sludge (something like STP), its films are giving superb performances. Kodak's Tri-X remains popular and is very versatile. Agfa has extra-fine gradation in its faster films. Ilford and Agfa have also made black and white chromogenic films, where the image is formed through dye couplers.

The serious black and white practitioner needs time and reflection and a darkroom to make prints that are suited to individual tastes. It is time-consuming, a very personal involvement, and extremely gratifying.

The Best in Black and White

Fast films. Kodak Tri-X and Ilford HP 5. Both have fine grain and great latitude. They work well in contrasty situations such as beach and snow scenes,

Leitz Focomat V35, the best of all 35 mm enlargers

and can be pushed in processing from ASA 400 to ASA 1600 and higher, although most pushing is to ASA 800 and 1200.

Slow films. Ilford FP 4, Kodak Plus-X and Panatomic-X. Both FP 4 and Kodak Plus-X have an ASA of 125. Panatomic X has an ASA of 32 and is extremely fine grained. All these films work well on cloudy days, as they have more contrast than the ASA 400 films. A good film for shooting snow scenes on dull days is Panatomic rated at ASA 64 (double its speed and give it increased development in Rodinal, and the scenes come out brilliantly).

Enlargers. Beseler 4 × 5 and the Leitz 35 mm Focomat. They are sturdy, versatile, expensive instruments.

Developers. Ilford ID 11 for a general all-purpose developer. Rodinal because of its extreme sharpness. Acufine for pushing one or two stops. HC 110 gives fine tonal gradation with Tri-X and is most valuable with medium- and large-format negatives.

Enlarging papers. Ilford Ilfobrom, a neutral paper with delicate tones. Galerie for its whites and blacks, and Agfa Portiga for a warm-toned paper. Brilliant is a newcomer that has delicate tones.

Enlarging developers. Many still prefer Dektol for cold-tone prints and Selectol Soft for warmer prints. Others prefer Ilfobrom developer. These developers can be altered by adding:
• Sodium carbonate to make the print colder
• Hydroquinone to increase print contrast

Diffusion versus Condenser Enlargers

Most enlargers come equipped as condenser-type heads. They have an enlarger bulb and two condensers that shove the light through the negative.

A condenser gives sharply defined images and high contrast. It can also bring out the grain in a picture, and any crud on the inside of the condenser, such as hair or specks of dust. A negative to be used with a condenser enlarger should be relatively thin.

A diffusion enlarger has a fluorescent tube mounted over an opalescent filter that diffuses the light through the negative to the lens. It is a soft light that does not emphasize grain or negative defects and gives very even light over the entire negative (a condenser light emphasizes the light in the center of the negative).

Some say that a diffusion enlarger is the only way to go. Karsh used a diffusion enlarger for the magnificent portraits he did of Schweitzer, Sibelius, and George Bernard Shaw. Ansel Adams uses the diffusion enlarger for his landscapes. They claim the light from a diffusion enlarger is softer and more luminescent, that highlights don't block up and tones are softly graded. They say never use a condenser enlarger.

They are wrong. There are times when a condenser can enhance a picture by increasing contrast. William Klein, who takes those marvelous street scenes that are so packed with information they read like a novel, emphasizes the street-wise urban scene with increased grain and contrast. The funkiness and gutsiness in his pictures is the result of creative use of the condenser enlarger. Most 35 mm photographs do appear better with the condenser enlarger because the condenser helps to build up contrast in big enlargements.

A few attributes:

- Diffusion enlargers work best with medium- and large-format negatives while condensers are better with 35 mm negatives.
- Emotionally, condenser-enlarged pictures have more guts and contrast, and work best for reportage or pictures that are enhanced by contrast.
- Diffusion enlargers lower contrast by one paper grade and tone down pictures made from contrasty negatives, such as snow and water scenes. The enlarger puts tone into highlights.
- Diffusion enlargers tend to soften the image and are favored by landscape and portrait photographers.

Most condenser enlargers can be easily converted to diffusion by the installation of an Aristo diffusion head, so that one enlarger can be used as condenser or diffusion. The best working situation would be to have two similar enlargers set up side by side, one diffusion and one condenser. Each would be used according to the "personality" of the photograph.

There is a problem where the fluorescent light from the diffusion head fluctuates. This is maddening when a number of prints are being made from the same negative, for this fluctuation causes unevenness in the prints. Paul Horowitz, a physics professor at Harvard, has developed a stabilizer that stops this fluctuation. The stabilizer plugs into the fluorescent head and stabilizes the light so that it is steady from exposure to exposure. This device also has a "dry-down knob" to compensate for the deeper tones a paper turns to when dried. If the print looks perfect when wet, turning the knob to minus five percent for the next print will automatically compensate for the dry-down effect.

The Horowitz-designed stabilizer also acts as a rheostat, so that too much light can be dialed down and the sharpest stop (f/8) on the enlarging lens can be used with long enough exposure times. The device, which is expensive (over $200), is available from Zone VI Studios, Inc., Newfane, VT 05345.

- Potassium bromide to make the print warmer and increase contrast
- Elon to reduce print contrast
- Benzotriazole to increase contrast and make the print colder

Most printers set up several trays for development — one with a strong stock developer, another with diluted developer, a third with a soft developer, and a fourth with water. The best developer of all is Beer's Developer, which was introduced by Ansel Adams in his first book. It is a two-part developer used in different strengths in three trays for normal, low, and high contrast. Mixing Dektol and Selectol Soft produces a Beer's type of developer.

Toning. Selenium is a wonder toner. It helps make the prints archival. It deepens tone and imparts an added dimension to the print, particularly with Ilfobrom. It removes a greenish cast and can tone to a very light, purplish hue that is pleasing. It deepens the tones of Galerie paper when the paper is left in solution for longer periods than normal (three minutes for Ilfobrom). To some photographers, a print isn't complete until it has been toned with selenium. Professional printers, however, use a number of

toners to increase the emotional content of the print.

Ansel Adams discovered that selenium toning of negatives can increase contrast without shortening the tonal range, particularly in the shadows, or increasing grain. The intensifier is used the same way it is for toning paper. Soak the negatives in water, then place them in a solution of two pounds of sodium thiosulfate per gallon of water and soak for three minutes, then place negatives in a tray filled with a mixture of one part Kodak Rapid Selenium Toner to two parts Hypo Cleaning Agent. Soak for up to five minutes, wash, and clear.

The New Wave of Chromogenic Black and White Films

Ilford and Agfa recently introduced two new films, Ilford XPI and Agfapan Vario-XL. They are a radical departure from the standard silver halide films. In normal black and white films, silver forms the image and hypo washes away the unexposed silver halide crystals. Chromogenic processes use silver halides that react with color couplers in development and produce a dye that forms the image. The more exposure, the more the development activates color couplers that release more dye. It is similar to processing color negatives. Ilford developed a two-process development and bleach fix (blix) for XPI.

Chromogenic film has a number of fascinating characteristics. The processing time and temperature remain constant, although the film can be exposed at ASA 200, 400, and 800 with superior results. Less gratifying results are obtainable at ASA 100 and ASA 1600.

There is very little grain, almost none when the film is exposed at ASA 200. The tonal range is long. Although negatives may be dense, there still is minimal grain. The film performs superbly in contrasty situations, although expect long printing times on the enlarger due to the density. There is not much advantage to using the film over ASA 800.

Although the film is grainless, it does not have edges as sharp as those of some of the older silver halide films. Sharp grain edges can create contrast, or snap. These new chromogenic films need to be carefully tested. So far they are startling the fine arts photographers, who are making enlargements from 35 mm that they did not think possible, in terms of gradation and grain. However, long exposure time and curling of the film are negative attributes of this negative film.

Facts You Might Not Know about Black and White

- The higher the speed of black and white film, the lower the contrast (just the reverse of color transparency film).
- Expose for the shadows, develop for the highlights (opposite of the method for chrome material).
- Overexpose and underdevelop to lower contrast. If the subject brightness range (as metered) is five stops, use normal development. If the brightness range is seven stops or more overexpose a stop and decrease development 20–30 percent.

Danger in the Darkroom

Photographers don't like to talk about it, but many of the old-timers who did their own darkroom work developed an inordinate number of nerve, eye, and breathing problems. Certainly the chemicals used in darkroom work are powerful agents and some are recognizably poisonous. Yet, most people absorbed in their craft are oblivious of the built-in dangers.

In his book *Artist Beware* (Watson-Guptill Publications, New York City), Michael McCann suggests using caution when preparing and handling stock solutions of some highly toxic chemicals, such as developers, acetic acid, and toners. It is important to wear gloves and goggles (to protect eyes from splashes) and to use a dust respirator when pouring powdered chemicals. As much as possible, avoid skin contact with chemicals and have good ventilation with at least ten changes of air per hour. People who have highly sensitive skin or are subject to allergies and asthma might do well to avoid darkrooms altogether.

Selenium toner has come under attack from the very same workers who want the rich blacks and archival benefits from this chemical. It is suspected of being dangerous when absorbed through the skin and mucous lining and may be carcinogenic to the thyroid and liver. They recommend wearing rubber gloves and using selenium in a well-ventilated area — like outdoors.

- Underexpose and overdevelop to raise contrast. Increase development by 50 percent, decrease exposure one stop. Tests should be made, using the meter, to standardize this procedure.
- Black and white, like color, film has reciprocity failure effects and needs longer exposures at one second or more. Check instruction sheets.
- Print softness may be due to a faulty enlarger — the easel is not even, or the negative carrier slot is at an angle. Use a level and grain scope to check out the sharpness at the center and edges on the easel.
- To increase print contrast, decrease the dilution of the developer; do the opposite to decrease contrast.
- Long print development times can extend tonal range and increase dimension by raising contrast. Be careful of fog.
- A K 2 filter renders scenes normal with panchromatic film. It creates a stronger tone of blue, more pleasing skin tone, and can be used to slow down high-speed film one stop.

Permanence
and Preservation

Considering that it all began in 1826 when Nicephore Niepce successfully exposed light-sensitive material and maintained an image, photography is not doing badly in keeping qualities. It's been estimated that black and white material properly processed and stored can have a life expectancy of three thousand years. And Kodak assures us that Kodachrome will last a hundred years, Ektachrome fifty years — at least.

The problem with such estimates and guesses is that they are based on absolutely optimum conditions in processing and storage. Until recent years, photographic materials were not as stable as they are today and few photographers maintained precise atmospheric conditions. Also, storage facilities and materials were not available; and in some cases procedures were actually more harmful than helpful. Who knew?

The American National Standards Institute (ANSI) made some attempts to establish controls, but often where they had the procedures, the tests were inadequate, and where they had the tests, the procedures were not consistent from one manufacturer to another. In recent years, with black and white prints selling for five-figure prices and transparencies achieving sales six to ten times over at high advertising rates, the concern about image permanence and preservation has mounted. Where we are headed in the race to maintain photographic images is a major concern of nearly everyone in the photographic industry.

A Man of Standards

It's hard to beat Kodak at any game in the photographic chemical business, but Ilford did just that in a daring move when they introduced Galerie paper in 1979. The company entered the photographic market with a high-quality, expensive paper product just when fiber-based papers seemed to be knuckling under to resin-coated materials. Galerie, with its high silver content that produces deep, rich blacks and a broad tonal range of grays, caught on with the purist crowd.

At that time, Peter Krause was president of Ilford, Inc., and when he retired a year later, after spending his entire career working for manufacturers of sensitized photographic materials, Krause continued to work with the American National Standards Institute in the development of standards for photographic materials and procedures. Specifically, he wants to help develop methods that can be widely used to assess the stability of photographic images — prints, negatives, and transparencies.

"What we need are standard testing procedures for dark and for light stability," he says. "We need

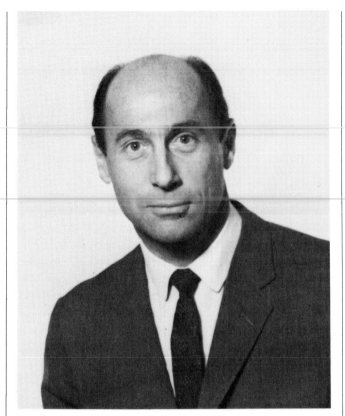

Preservationist Peter Krause

to answer the question: If I do this, how long is the print or transparency going to last?

"Transparencies are usually not projected or displayed for too long a time, but even in the dark some classes of dyes fade reasonably quickly. They might be oxidized or reduced, causing a degradation of the dyes resulting in reduced density and changed color balance — it's a very rare triplet where all the dyes fade at the same rate — or there may be a serious formation of stain. This latter problem tends to occur in the systems in which a dye image is generated during processing, like E-6 Ektachrome processing. In films of this type, residual color formers are left in the image layers, which in time can become colored, causing a stain. Where there is high image density you'll use most of the couplers to form the image dyes, but where there is little density, there will be more residual color formers that can discolor, usually becoming yellow.

"This condition is greatly reduced by low-temperature storage with low relative humidity. In fact, Kodak color films and prints are most stable when stored in a deep freezer. Usually a chemical reaction doubles for every ten degrees, so as you go down to zero degrees Fahrenheit, you get a substantial reduction in the rate of dark instability and therefore a commensurate improvement in the life expectancy.

"Clearly, if you have a valuable collection of slides, put them in the deep freezer in an opaque pouch. Make sure the moisture content is between 20 and 30 percent relative humidity when you place them in the pouch, turn the pouch opening several folds, and put polyester tape over the fold or heat-seal it. And, when you take them out, you'll have to let them warm up inside the pouch for twelve to twenty-four hours, depending on what the temperature differential is and how many slides are stored in the pouch."

For transparencies that do not warrant the deep-freeze treatment, Krause cautions that high humidity (above 50 percent) should be avoided, even when they are stored in normal room temperatures. They can be stored in polyester or polypropylene plastic sleeves in steel cabinets — never in wood cabinets, which may give off harmful acid fumes. (If the cabinets are painted, wait for eight to twelve weeks until the paint cures and ceases to give off fumes before storing slides.)

Krause says photographers should know the best applications for photographic materials for stability as they do for color rendition, speed, and other factors. For instance, Kodachrome is much more stable in the dark than Ektachrome, but Ektachrome lasts longer and is better for light display than Kodachrome. Duplicate transparency material, such as Ektachrome, is more appropriate for prolonged projection or light display.

Among print materials, Cibachromes do not require deep-freeze storage for stability, because their dyes will not change even if heated to 150 to 175 degrees, according to Krause. As long as the humidity is not high, the prints will not change. Dye transfers are also reasonably stable, but not as stable as Cibachromes.

Black and white prints also benefit from moderate temperatures, but high humidity is the real culprit in storage. "We know that a high temperature is inimical because that speeds up any chemical reaction," he says. "We know that high humidity is un-

desirable because it will tend to promote certain chemical reactions like oxidation and the growth of microorganisms. Then, especially with black and white prints, you also need to be concerned about industrial gases, because there are some, like hydrogen peroxide and ammonia fumes, that can cause fading, and others that cause deterioration or formation of stains."

Ilford's most startling black and white pronouncements, however, concern new, short-time recommendations for fixing and washing. Ilfobrom and Galerie and some Agfa papers require just thirty seconds of fixing in a fairly fresh solution and will then be washed adequately in ten minutes, with a ten-minute treatment in a washing aid solution between two five-minute washes.

"For black and white there are standard processing formulas and procedures, but we have an abnormal situation where there is no recommended limit for residual hypo content in black and white prints. We know how to test for residual hypo, but that doesn't tell you what are the permissible limits of concentration. With Galerie, Ilford selected an upper limit based on known technology and an extensive series of experiments and designed a pro-

The 47-Minute Advantage

The American National Standards Institute established a processing sequence that seemed reasonable for many years — until Ilford came along with a new one based on their chemistry. Here are the two sequences compared at 20 degrees C:

	ANSI	ILFORD (Galerie and Ilfobrom papers)
Development	1½–2 minutes	1½ minutes
Stop bath	10 seconds	(none)
Water rinse	(none)	5 seconds
Fixing I	5 minutes	30 seconds
Fixing II	5 minutes	(none)
First wash	30 minutes	5 minutes
Hypo eliminator	5 minutes	(none)
Ilford wash aid	(none)	10 minutes
Sodium sulfite 1% rinse	2 minutes	(none)
Final wash	20 minutes	5 minutes
Total time	69 minutes	22 minutes

Kodak's Fix

The two-bath fixing method is the recommended procedure from Kodak. Its experts say one to two minutes in each Rapid Fixing solution is economical (it saves on fixer) and produces a more complete fix of prints.

Unlike the Ilford system, the two-bath method allows some leeway in timing and the certainty that prints are thoroughly fixed. Underfixing, causing eventual deterioration and fading, is still a grievous error in processing.

cessing procedure to attain that limit in a relatively short processing sequence.

"With fiber-base papers, the major problem is the absorption of certain residual hypo complexes into the fibers. Once in there they are very hard to wash out and they can eventually interact with the image and cause stains. If you don't fix any more than is needed to get the job done, you can take the print out before these complexes have a chance to penetrate the paper fibers. With a fixer of the proper concentration and without a hardener, the fixing takes place in less than thirty seconds and the washing time needed is just ten minutes (plus ten minutes in a washing aid solution), as compared to sixty minutes when the fixing time is longer."

Longer fixing times might have come about, according to Krause, because the assumption was that people often used partially exhausted fixers and did not agitate properly. Furthermore, the two-bath fixing system, which is meant to overcome the problem of inadequate fixing, doubles the fixing time and essentially compounds the washing problem.

The quick fixing takes place in rapid (ammonium thiosulfate) fixers that have not been overused. With Galerie paper, the Ilford fixer provides sufficient fixing for up to forty 8 × 10 prints per liter — until there are four grams of silver in the fixing solution. The fixer must not be a low pH (acid) hardening type, which inhibits rapid washing.

Krause has particularly severe judgment on hypo eliminators containing hydrogen peroxide — Perma Wash is one — which attack the paper fibers as they transform residual hypo into sulfates. The preferred washing aid or clearing bath is a 2 percent solution of sodium sulfite containing a wetting agent, like the Ilfobrom Active Wash Aid. (This treatment is also recommended for film.) If for-

mulas for clearing agents are not on the containers, they usually can be obtained from the manufacturers.

"Fix as little as possible for fiber-base and all other papers," says Krause. "Why overfix? Eventually the fixer attacks the silver image, too. The old procedures are in need of overhauling and we are going in that direction. Kodak will probably come up with a new procedure, but it will be different."

In the next two to three years, Krause believes the ANSI committee will establish standardized procedures for assessing the stability of photographic images. "In the end, all the data that are published by different people should be comparable and you should be able to judge stability based on the same kind of tests. At the moment you can't be sure if somebody says, 'Mine will last this long,' how that was determined, whether you can accept it, and what validity it has. We are trying to develop test patterns that are meaningful and as simple as possible so a person or a laboratory can perform them. Furthermore, once we have the standards here, they probably will be adopted throughout the world because that's the way these things go. I think an international standard will come in time."

Keeping Color

There is little most of us can do about the processing of color transparency materials (of course, E-6 films can be home processed), but for sure, the manufacturers of a film have more interest in its permanence and quality than do outside labs. However, there is a great deal that photographers can do about maintaining color images once they are returned from the processor.

Before and after exposure, color negative and positive transparency materials are damaged by several conditions:

• Humidity. A relative humidity (RH) of 60 percent or higher for extended periods promotes the growth of molds and harmful bacteria that can actually eat gelatin and destroy emulsions.

• Temperature. Some professional films must be stored until processing in temperatures of from 0 to −10 degrees F, but most film supply needs to be protected from excessive heat,

Manufacturers' Word for It

Color life expectancy figures as officially stated by the manufacturers of film and paper were assembled by Martin Hershenson and published in *Modern Photography.* Here's the word on life span:

Color Life Expectancy

AGFA

Agfachrome films	50 years
Agfacolor negatives	20 years
Agfacolor paper prints	10 years

(The last figure depends greatly on storage and ambient lighting conditions)

CIBACHROME

Ilford tells us that a life expectancy of 100 years plus is a safe assumption for properly processed Cibachromes. This is based on room temperature in dark storage and 40 percent relative humidity.

EASTMAN KODAK

Kodachrome films	100 years plus
Ektachrome E-6 films	50 years plus
Ektacolor paper	10 years plus
Ektachrome 2203 paper	10 years plus
Ektaflex prints	10 years plus
Kodacolor II negatives	10 years plus
Vericolor negatives	10 years plus
Kodak Instant film	50 years plus

(All of the above is based on dark storage, such as an album at 75 degrees F and 40 percent relative humidity.)

FUJI

Fujichrome 100 and 400	45 to 90 years
Fujicolor F II 100 and 400	10 to 20 years
Fujichrome paper	10 to 20 years

(Above is based on dark storage at 77 degrees F and 40 percent relative humidity.)

which can alter the color rendition.

• Fumes and gases. A few of the damaging chemicals in the environment are: industrial gases, exhausts, paints, solvents, cleaners, mothballs, formaldehydes, chipboard, glues, mildew preventatives, foam-in-place insulation, fabric treatments such as permanent press and stain inhibitors, insecticides, and sulfides.

Even the transparency boxes are not recommended for long-term storage of chromes.

From the start, very valuable transparencies should be handled with great care to avoid finger-

Jay's Way

Storing over one million transparencies, many of which are used repeatedly for stock sales, has got to be a problem of particular dimensions. Jay Maisel and his chief archivist, Irv Hansen, solved it in a pragmatic manner. "Storing them in some exotic way that Kodak recommends is not practical for us," says Hansen. "We've got to take these pictures out to look at them. And we can't have an environment that's too cold or too dry for people to work in. So we settle."

How they settle is to file Maisel's million best transparencies in about three thousand Kodak carousel boxes salvaged from audiovisual houses or purchased directly from Kodak. Inside the boxes, slides are filed in rows of four separated by a quarter-inch foam core or cardboard strips. Everything is stored in a walk-in vault of about fifteen by twenty-five feet, and the temperature and humidity are controlled with the same type of instrumentation used by computer centers for their atmospheric conditions.

Just in case, several hundred super selects are duped, separated, and made into dye transfers that are filed elsewhere — completely decontrolled.

prints. Kodak recommends using a film cleaner to remove such impurities before storage. Originals should never be projected for more than half a minute and then only a few times in their lives. For prolonged projection, have inexpensive duplicates made, and for reproduction of an irreplaceable chrome, have an enlarged high-quality duplicate made.

Place 35 mm chromes in Kimac sleeves made of Kodapak and then into Kodak storage envelopes or polyethylene open-faced pages of twenty chromes. When placed in storage envelopes the chromes should be conditioned in an atmosphere with an RH of from 25 to 30 percent for at least one hour. Fold the edge of the envelope several times and seal with vinyl electrical tape or other waterproof tape. Place the sealed envelope in a freezer with a temperature of 0 degrees F (−18 degrees C). To get access to the transparencies, remove the envelope from the freezer and allow it to warm up for at least twelve hours to avoid condensation.

For transparencies of less value, room-temperature storage is acceptable, but avoid high humidity. Metal files and drawers are best for dark storage.

Most color prints are also best preserved in a frozen state — −18 degrees C (0 degrees F) — but the Cibachrome materials and dye transfers are stable enough to withstand normal room temperatures. Again, avoid high humidity. All types of prints are best stored in acid-free conditions, in either portfolio boxes or archival albums.

Kodak gives these examples of how heat and humidity affect prints made of their materials:

- The same degree of dye change occurring in a print stored in an album for 20 years at 75 degrees F is predicted to require 200 years at 45 degrees F and 2000 years at 14 degrees F.
- The same degree of dye change occurring in a print stored in an album for 20 years at 40 percent relative humidity is predicted to require about 40 years at 15 percent relative humidity.

Under display conditions, Kodak studies show that color dyes change most rapidly under ultraviolet radiation or blue light, and these are found in greatest amounts in sunlight and fluorescent lights. Tungsten light has the lowest content of ultraviolet and blue wavelengths. So for display of color prints, the lowest light level possible is recommended, along with tungsten illumination. Avoid sunlight or use an ultraviolet-absorbing filter over the print.

What to avoid for longevity of color materials is: excessive humidity or heat, polyvinyl chloride plastics (which includes most sleeves used for presentations), environmental contaminants, projection of originals, and surface contaminants including fingerprints. Keep them cool, dry, and clean.

Unfortunately, early transparency materials (particularly the E-processed Ektachromes) faded and changed color balance even in dark storage. Kodak as well as other processors are working on methods to restore these chromes to their original colors. Masking techniques have shown considerable success and are being improved rapidly.

Black and White Forever

The dangers to black and white negatives and prints comes from humidity, high temperature, high light levels, and contamination from chemicals and fumes. Dark storage in a relative humidity of 30 percent in a deep freezer in acid-free containers is the safest method of preserving black and white

Reading for Permanence

Method of Processing for Maximum Print Permanence, ANSI,*
 PH4.32-1974
*Practice for Storage of Processed Safety Photographic Film Other
 Than Microfilm,* ANSI, PH1.43-1979
*Requirements for Photographic Filing Enclosures for Storing
 Processed Photographic Films, Plates, and Paper,* ANSI,
 PH1.53-1978
*Specifications for Photographic Film for Archival Records Silver-
 Gelatin Type, on Cellulose Ester Base,* ANSI, PH1.28-1973
Storage and Care of Kodak Color Materials, Kodak Pamphlet
 No. E-30.

* American National Standards Institute, 1430 Broadway, New
York, NY 10018.

materials. Unfortunately, this is not practical for a large collection of negatives, let alone prints.

The photographer's creation is the negative, and it is essential — you can always make a new print. After careful processing, following the manufacturer's directions, long-term negative storage is easily accomplished, although it often requires some drastic changes in materials and habits. Conventions die hard.

To begin with, glassine envelopes are not good. Clear polyethylene sleeves are the safest way to store film. In a moist atmosphere, there may be slight ferrotyping on the emulsions caused by such storage sleeves, but at an RH of 30 percent this is not a problem. Negatives in the sleeves should then be stored in baked-enamel metal boxes or cabinets, or fiber boxes made of acid-free materials.

Black and white prints should never be stored in the cardboard boxes that photographic paper comes in. Such boxes release a variety of chemical substances that are damaging to silver images, including sulfur gases and peroxides. Prints, after thorough and proper processing, should be stored in acid-free boxes (like those from the Hollinger Corporation or Light Impressions) in the coolest, driest atmosphere possible. Interleaving with acid-free paper between prints also preserves surfaces, as does storage in polyethylene envelopes. Dry-mounting on an acid-free board or countermounting (mounting a print on an archivally fixed and washed piece of photographic paper of the same brand and

grade) is safe, but if it isn't essential, avoid this step, too. Overmatting is recommended with mounted prints.

These are the only safe materials to mix with photographic films and prints:

 aluminum
 cellulose acetate
 glass or porcelain
 metals coated with baked enamel
 100 percent rag content, acid-free paper or
 board
 polyethylene
 stainless steel

For long-term storage and permanence, any other materials should be avoided.

The Definitive Word — TK

Henry Wilhelm was mucking around in the humid and fungi-ridden jungles of South America on a Peace Corps assignment in the early sixties, when

MOMA's Way

The Museum of Modern Art in New York City was one of the first major collectors of photography, both for exhibition and for historic purposes. The museum's collection of black and white and color work totals more than twenty thousand prints and is extremely valuable, yet over the years even MOMA has made errors in storage, has changed, and is still learning, according to Susan Kismaric, associate curator in the Department of Photography.

All prints are matted and overmatted with acid-free rag board. Those that arrive unmounted are attached to the board with hinges made of Japanese tissue paper and a chemical paste, as opposed to an animal glue. Those that come mounted (presumably dry-mounted) are attached to the boards with clear acetate corners. The pictures are placed in sturdy wooden solander boxes that are lined with acid-free paper — a procedure that is currently being questioned. The boxes formerly were stored in rosewood cabinets, but are now placed on open baked-enamel metal library shelves. Of course, the total environment of the museum is temperature and humidity controlled.

Scholars and others with special interest in photography may look at prints by appointment, but they are carefully instructed in how to handle them. They must wash their hands first and then use only pencils while taking notes.

Relative Stability Characteristics of Common Color Print Materials

By Henry Wilhelm

© Copyright 1981 by Henry Wilhelm

No. 1 = Most Stable
No. 5 = Least Stable

Dark Keeping
1. Ilford Cibachrome Prints (glossy non-RC types only)*
 Kodak Dye Transfer Prints
2. Kodak Ektaflex PCT Prints
 Kodak Instant Color Film PR10 (Improved)
3. Kodak Ektacolor 74 RC and 78 RC Papers
 Kodak Kodacolor Prints (same as 74 RC and 78 RC)
 Kodak Ektachrome 2203 Paper
 Kodak Ektachrome RC Paper, Type 1993
 Kodak Instant Print Film PR10
 Polaroid Polacolor 2 Film**

* Cibachrome prints are available on two distinctly different supports; the high-gloss solid-white film base supports are recommended. The lower-cost semigloss (Pearl) RC versions should be avoided as they may be subject to surface cracking and loss of flexibility. Film base Cibachrome and Kodak Dye Transfer prints may be considered to be essentially permanent in dark keeping and should last considerably longer than 100 years under normal conditions without serious change. In dark keeping, these two materials are many times more stable than the other materials listed.

** The image dyes used in Polaroid Polacolor 2 Film are quite

4. Polaroid 600 High-Speed Color Film***
 Polaroid SX-70 Time-Zero Supercolor Film***
 Polaroid SX-70 Film***

Light Fading on Display
1. Ilford Cibachrome Prints (glossy non-RC types only)*
2. Kodak Ektaflex PCT Prints
 Kodak Dye Transfer Prints
 Kodak Ektacolor 74 RC and 78 RC Papers
 Kodak Kodacolor Prints (same as 74 RC and 78 RC)
 Kodak Ektachrome 2203 Paper
3. Polaroid SX-70 Film***
 Polaroid Polacolor 2 Film***
 Kodak Ektachrome RC Paper, Type 1993
4. Kodak Instant Color Film PR10 (Improved)
 Polaroid SX-70 Time-Zero Supercolor Film***
 Polaroid 600 High-Speed Color Film***
5. Kodak Instant Print Film PR10

stable in dark keeping; however, the prints are subject to objectionable yellow stain in dark keeping.

*** The image dyes used in Polaroid SX-70 and Polaroid 600 Films are quite stable in dark keeping. However, the prints are subject to serious yellow stain formation in dark keeping and under some conditions may develop large image cracks in either dark keeping or on display. The new magenta dye used in Polaroid SX-70 Time-Zero Supercolor Film and the recently released Polaroid 600 High-Speed Color Film is significantly less stable in light fading than the magenta dye used in previous types of SX-70 films. The stability characteristics listed for Polaroid 600 High-Speed Color Film are based on preliminary tests.

he noticed the deterioration and destruction of photographs — his own and others. Returning home, he founded East Street Gallery in Grinnell, Iowa, and began teaching photography and studying the problem of preservation of photographs.

It may seem like a long way from a degree in sociology to becoming one of the world's foremost experts on the preservation of photographic materials, but Wilhelm made that leap. He's a self-taught chemist (although he plans to return to college for a degree in that discipline) who has read practically everything published on the stability of photographs. Under the East Street imprint he published a fifty-cent booklet entitled "Procedures for Processing and Storing Black and White Photographs for Maximum Possible Permanence." If you own one, keep it; it's a collector's item.

Having mastered black and white permanence

and developed an effective print washer (because there wasn't anything that worked), Wilhelm moved on to color. Reading the literature available, he discovered that there simply wasn't much. So for a half-dozen years on borrowed money, Wilhelm put it all together. The result, "The History and Preservation of Contemporary Photographic Materials," is to be published (maybe) in 1982. For information, write to Preservation Publishing Company, Box 775, Grinnell, Iowa 50112.

Light Impressions, Light Impressions, Light Impressions

In 1968 Bill Edwards and Lionel Suntop were completing graduate work in visual communications at

the Visual Studies Workshop in Rochester, New York, when they perceived a need to help people find unusual photography books. They formed the Light Impressions mail-order company as a photo book distribution outlet, which they thought to run on the side while pursuing careers in art photography.

After five years they saw that photographers also needed archival products, some of which were available from scattered sources. So Edwards and Suntop added a couple of products to the Light Impressions catalog, beginning with linen tape and mat board.

Over the years, the business of making available products and books that are hard to find has expanded to a store, a warehouse, and an office. The operation employs about 35 people and publishes a catalog with a distribution of more than 250,000 copies each year. The Light Impressions business is equally divided between books — some of them published by the company — and archival products — some of them created for the company to its standards. Needless to say, Edwards and Suntop do very little picture taking these days.

"We have an archival picture-framing business that serves museums, corporations, and interior designers," says Edwards. "And when you put this framing business together with the photography supplies and the archival products, it works together as a unique supply source."

From this hands-on work as well as feedback from customers, Light Impressions has had products created to their stringent standards. These include items like Mylar negative and print sleeves, seamless envelopes in a variety of sizes, acid-free rag mat board with particular hardness and cutting properties, archival albums, portfolio boxes, museum cases, and storage cabinets. Each year new products are added.

The secret of the Light Impressions success is that no other supplier puts it all together and makes it available in a single, informative, no-nonsense catalog. The catalog is issued annually, while an updating service, for a ten-dollar lifetime fee, comes out three additional times each year.

Typical of the informative asides found in the Light Impressions catalog is this:

Suppliers for Keeps

Slide Storage:
- Eastman Kodak Company, 343 State Street, Rochester, NY 14650. Storage envelopes for processed film.
- Franklin Distributors Corporation, P.O. Box 320, Denville, NJ 07834. VPD slide pages made of polyethylene.
- Multiplex Display Fixture Company, 1559 Larkin Williams Road, Fenton, MO 63026. Slide storage and display cabinets.
- The Nega-File Company, Furlong, PA 18925. Slide pages made of polyethylene.
- Kimac Company, 478 Long Hill Road, Guilford, CT 06437. Polyethylene slide protectors.

Prints and Miscellaneous:
- The Archive, Box 128, Frenchtown, NJ 08825. Print and portfolio boxes.
- Archival Products, 300 North Quidnessett Road, North Kingston, RI 02852. Boxes, mailers, mat board, and carrying cases.
- The Hollinger Corporation, P.O. Box 6185, 3810 South Four Mile Run Drive, Arlington, VA 22206. Storage boxes, mounting board, acid-free envelopes, papers, and folders.
- Light Impressions Corporation, Box 3012, Rochester, NY 14614. Broad assortment of products for archival storage and protection, framing and mounting, plus tools for specialized work.
- Print File, Inc., Box 100, Schenectady, NY 12304. Polyethylene holders for negatives and transparencies, plus other storage products.
- Spink and Gaborc, Inc., 32 West Eighteenth Street, New York, NY 10011. Filing boxes and portfolios used by major museums.
- Talas, 104 Fifth Avenue, New York, NY 10011. Storage boxes and cases lined with acid-free paper, as well as other archival products.

What Is Polyester?
Polyester film is one of the best materials for archival storage of photographic film and prints. It is also recommended for encapsulation of valuable documents and other paper art by the Library of Congress Preservation and Research Office. The reason for this is that Mylar is one of the most stable and inert of the many different kinds of films now available and also the one least subject to variations in manufacture.

The type of polyester Light Impressions uses in our Polyester Folders is Dupont's Mylar, Type D and EB-11.

Type D characteristics: A super clear, bright, transpar-

ent, strong, tough dimensionally stable polyester film with outstanding surface characteristics.

Type EB-11 characteristics: A low gloss film with matte properties going completely through the film.

Polyester film is characterized by being exceptionally strong, durable, transparent and dimensionally stable. These are the same reasons it is used as the base in contemporary safety films in the photographic industry. They also meet government specifications (L-P-00670B-2, Protector, Document, and L-O-377B, Plastic Sheet and Strip Polyester) which require the polyester films to be entirely free of plasticizers, UV inhibitors, colored dyes, impregnants and surface coatings.

In tests conducted by the Library of Congress Preservation Research and Testing Office samples of film were exposed to accelerated aging conditions of 90 degrees C and 50 percent relative humidity and kept in the 100-degree-C dry oven for over sixty days. This may be interpreted as equivalent to several hundred years of natural aging. Examination of oven-aged samples showed little or no reduction in transparency, flexibility or brightness. The sample also retained good folding endurance, being superior in this respect to cellulose acetate or an alkaline paper.

5

EDITING YOUR WORK: MAKING CHOICES

The Art/Science of Picture Editing

One of the most difficult tasks any photographer has is editing his or her own pictures. This is true whether it's culling an assignment take, weeding out for a portfolio, selecting a series for a slide show, or choosing frames on contact sheets for black and white prints. In fact, editing is so difficult, some photographers eschew it altogether, preferring to let associates, representatives, or art directors do the job for them.

Editing is a very personal task. Some photographers do it in one fast pass through a take, while others return and review a selection several times. Some even make rough 5 × 7 prints before making a final selection for enlargements. The most important aspect of editing is to look for aesthetic and emotional impact rather than surface technical perfection.

Mastering the art of editing photographs takes time, concentration, and patience. To get into it, be prepared to spread the selection process over three or four sessions to narrow down the frames to a core of work.

The first session consists of a rough edit. With color transparencies, cull out the bad exposures and frames with obvious faults and defects in sharpness or composition. With black and white, make a selection rather than an elimination on the first pass. Mark any frames that interest you with a small red dot from a grease pencil.

The second session for color begins with projecting all the slides left after the first cut. Immediately after projection, run through the chromes again over a light box, eliminating those that you recall were not adequate. Then arrange them in some order — by subject, chronology, color, or whatever — that may lend itself to final presentation.

In the second black and white editing session, use the red dots to zero in on the frames that showed maximum impact. In this review, watch for technical problems, either defects such as poor exposure, or composition where cropping might be required. Mark the most promising frames from this examination with a squiggly line along the bottom.

The third editing review for either color or black and white is where the complexities of aesthetic choice begin to surface. Up to now judgment has been more a matter of gut impact than a comparison of frame with frame, a search for meanings, and a narrowing of visual experience. In this examination, color may be divided into "first selects" and "seconds," or backup chromes. Very few transparencies should remain after this session.

In the third look at contact sheets, use cropping arms to aid in judging how the final print might look. Run a squiggly box around frames that you are certain will print well and indicate cropping with straight lines.

Finally come back to the selection after you have let it rest for several days. Re-examine each photograph as though you had not seen it before. Do the

Tools for Editing

Black and white and color transparency editing require entirely different tools to do the job. In the first instance, you're looking at contact sheets that probably contain multiples of a scene with subtle differences and variations. Black and white negatives can be cropped to improve composition, and improperly exposed frames can usually be salvaged in the darkroom. With color slides, on the other hand, you may have a selection of frames from which to choose, but usually exposure — over- or under- — and sharpness are as significant determinants in selection as composition, subject matter, and impact.

Black and White Tools
- Red grease pencil — found in art supply stores
- Black L-shaped cropping arms — make them out of cardboard, each arm 2 inches long by 1 inch wide
- Flashlight with 5× magnifier — found in photo and art supply stores

Color Tools
Light box — make one out of translucent Plexiglas over ordinary light bulbs or fluorescent tubes. Or, buy a commercial fluorescent light fixture, an inexpensive slide viewer with a slanted plastic stepped-faced sheet over a light bulb, or a professional light box with 5000 K light tubes that are color-corrected for accurate viewing. The latter boxes are supplied by Macbeth and Multiplex, among other companies, and range in price from $75 to $200 and up, depending on size and construction features.

Magnifier or loupe — used to examine the sharpness of transparencies. The magnifier's price and quality run a parallel course. An inexpensive loupe, like that made by Agfa, magnifies eight times, but lacks sharpness. The Schneider-Kreuznach loupe magnifies four times and is critically sharp throughout the viewing area. Nikon has a loupe that magnifies seven times and is also extremely sharp. A loupe from C & L magnifies five times with a precise, wide viewing area and a transparent column. High-quality loupes like these three cost about $50 (as opposed to the Agfa for about $10), but they are well worth the money for critical judgment of transparencies.

Copyright stamp — each slide selected for final viewing or submission must carry the photographer's name, year-date, and copyright symbol (©). Such stamps should be no more than 1¾ inches long to fit on the transparency cardboard mount.

pictures stand alone? Are there any weaknesses in them? Do they work together? Have you achieved the maximum potential from each?

Arrange color transparencies in their logical sequence and project them for a final impact study. Remove any that are marginal or weak, and rerun them through the projector until you are satisfied with the series.

With black and white contacts, study each frame again, rethink the results and the printing techniques required. Where burning in is necessary, use slanted lines (///) to indicate "make darker." For dodging, mark the contact with circles (₀°₀) to indicate "make lighter."

Editing photographs is a demanding task, but it need not be an onerous one. It's important to begin each session with a fresh eye, keeping in mind that no selection process is final — you can go back and retrieve pictures cast aside earlier.

How about letting your friends, spouse, art directors, agents, and patrons participate in this intimate task? Elliott Erwitt said in the book *Contact: Theory* (Lustrum Press), "Contact sheets should be as private as a toothbrush and ought to be guarded as jealously as a mistress." (The same sentiment applies to a raw collection of unedited color transparencies.) "A dozen contact sheets tell far more about a photographer than a dozen 'good' pictures taken by that same photographer," continued Erwitt. "Two dozen contact sheets taken at random from various stories and carefully scrutinized would be equal to a complete [photographic] psychoanalysis of the photographer."

These photographers have edited one frame from each contact sheet. Can you guess which one it is? (Their selections follow the contact sheets.)

Andrea Alberts

This was a shooting for *Mademoiselle* magazine showing different ways to wear lace in summer. I used a mixture of sunlight and strobe for these black and white shots.

The girl had a beautiful tan, which looks good with the lace. I picked that picture because of the way the lace blouse is falling off her shoulder. Her face and hair look nice and the total effect is sexy.

Andrea Alberts

Andrea Alberts

Chuck Fishman

Chuck Fishman

I like the composition, too, with the white background and the wood floor.

Chuck Fishman

I made the picture of the cemetery caretaker in Poland while shooting what became the first take of an essay on Polish Jews. While being shown around the cemetery by the caretaker, I would occasionally follow him from a distance so as to view the situation from behind.

The lens used was a 105 mm. I was shooting very tight, trying not to waste film, and because I was there as a tourist I didn't want to attract much attention.

Jill Freedman

I was working on *Street Cops,* my book about New York City cops. There had been a chase and now they had the man. There was this feeling of confrontation that I wanted, and the frame I chose showed the tension of the moment. Plus, visually it was composed exactly to my liking. I especially loved the way all the eyes dovetailed. I thought it was the strongest frame of the sequence, both visually and emotionally.

Jill Freedman

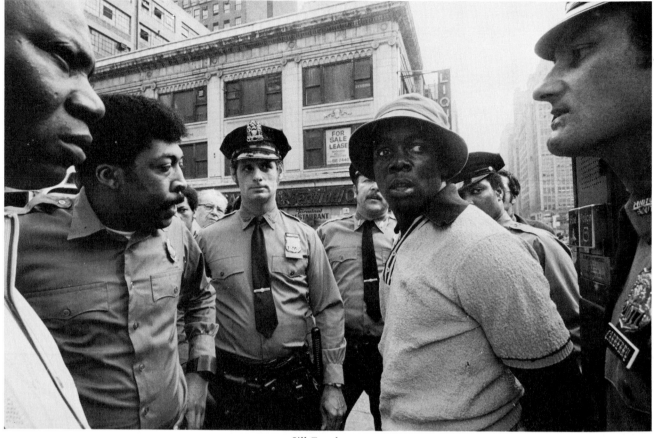

Jill Freedman

Larry Fried

I was working for Kraft Foods and was assigned to photograph Dean because he was appearing on 'Kraft's Television Playhouse.' It was Dean's first TV role and it brought him into prominence. Shortly after, Dean went to Hollywood. He was no Clark Gable, but rather was introspective and quiet and not into what we were doing. Actually, he acted like he was paid to be there.

The pictures were taken with a Rolleiflex and bounce strobe on Super XX film, the precursor to Tri-X. I shot so the photographs could be cropped vertically, horizontally, or for the head alone as edited. The Rollei has a slight wide-angle lens so you can't move too close or you cause distortion.

Whitney L. Lane

ASSIGNMENT: Cover photograph for *Families* magazine.
SUBJECT: Teenage virginity.
TIME: 3:00 P.M.
Kim, Dee, Jon, and Jennifer (models from Babes-in-the-Woods) arrived at the studio, followed by Norman Hotz, art director from *Families* magazine.

As the sequence of slides shows, we tried having the teenagers interact in different outside settings. Then we returned to the studio to do the "apple sequence," which became the cover shot and an inside spread. It was direct and simple.

7:00 P.M. End of photo session.

Thank you Norman and *Families* magazine.

Lawrence Fried

Lawrence Fried

Whitney Lane

Whitney Lane

Jack Manning

Jack Manning

Peter Miller

Peter Miller

Jack Manning

Choices are always personal and based on a somewhat curious mixture of the transcendental and pragmatic. The subject is my eight-year-old daughter, Sarah-Jeanne, in her first month of violin instruction.

Technical details:

 Camera — Contax model 137Q

 Lens — 100 mm Planar f/2

 Lighting — Single strobe unit three feet above
 and to the right of the subject

 Film — Tri-X

 Development — Versamat machine

 Paper — Kodak RC

Peter Miller

These photographs were taken near Pawlet, Vermont. I noticed the farmer as I drove down a back road. I stopped, made friends and asked him to pose.

I had not taken pictures for several months and felt I just couldn't "see" pictures. This was a breakout from that block. The first frames were much too stiff, too stereotyped. As I talked to the old man, he told me that he once owned all the land around him and he gestured with his hand. With a shrug, he said he had to sell it and now the buyer from New Jersey was probably going to kick him off the land. It was then that I realized the picture did not involve the trailer, but the land. The last frame on the roll was used to show him and the land he lived on, but no longer owned.

Brooks Veriwide camera, Tri X film, 1/125 at f/11.

Janet Nelson

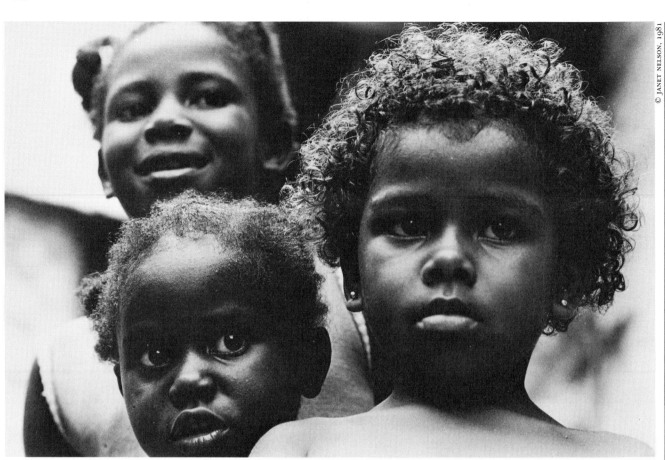

© JANET NELSON, 1981

Janet Nelson

Janet Nelson

I had walked around one of Rio's slums for the better part of a day without attracting much attention until I came to a source of running water. Suddenly there seemed to be children and teenagers in every direction. They would look at me for a moment, perhaps smile, and then quickly disappear in the maze of houses, doorways, streets, and rubbish. There was a poignancy about them that I wanted to capture, but none of the kids would stay long enough for me to try to communicate. Later when I examined the contact sheet I saw this picture of three young girls. They are not looking directly at me, but whatever attracts them brings out a look that is curious, yet wary. There is tension here.

Bill Pierce

The picture was taken at a funeral for a Northern Ireland hunger striker. Everybody is moved in such a situation by what happens to kids. This little girl was bored by what was going on and she was hanging on a gravestone. It seemed symbolic and so I waited for that expression. It took many frames until her face had the look that matched what was happening. From the contact sheet I picked that frame because she looked concerned, disturbed, and upset. It was not a strictly news picture, but it symbolized the event.

Bill Pierce

Bill Pierce

John Lewis Stage

© JOHN LEWIS STAGE, 1963

John Lewis Stage

John Lewis Stage

I made this photograph while doing a special issue of *Holiday* magazine on the Rocky Mountains. The editorial purpose of one of the portfolios was to portray the "timelessness" of mountain people by finding and photographing modern-day counterparts of the legendary characters who first explored and settled the Rockies — the trapper, miner, rancher, sod-buster, dance-hall girl, and so on.

When I met this twentieth-century priest in the New Mexico foothills, he seemed to have stepped right out of the past. I could imagine him as one of those original explorer-priests who, even before the Pilgrims landed at Plymouth Rock, had made the unbelievable trek overland from Mexico City to build a chain of missions as far north as Sante Fe and to claim what is now the Southwest for the Spanish Crown. And he, in fact, turned out to be a direct descendant of a military man who accompanied the clergy. So it was almost an automatic reaction for me to keep the adobe chapel small and lonely by moving back to emphasize the land, then trying to catch the priest in mid-stride. He was such a "natural" that the actual photography couldn't have taken more than eight to ten minutes. And the right frame almost popped off the contact sheet.

6

MARKETING PHOTOGRAPHY

Selling Yourself

How can you get a photographic assignment or an exhibit in a gallery? Quite simply, you sell skills, talent, ability, personality, identity, appearance, reliability, compatibility, unique vision — you sell you, the photographer. The difficulty with this task is that creative people often — in fact, usually — not only lack sales ability, but find selling anathema. They want to be discovered and rewarded for their huge talents.

It doesn't work that way.

Successful photographers continually sell themselves, albeit not in the Willy Loman sense of the word. Art directors, designers, assignment editors, gallery owners, and individual customers need photographers and the work that photographers produce. Selling yourself under these conditions is establishing a mutually beneficial relationship to create an advertisement, illustrate a product, cover a story, or show an artistic viewpoint.

Picture buyers are in effect the tastemakers for their particular medium. And just as it behooves photographers to know and understand the tastes of their potential clients, they must know and understand themselves and the professional requirements for establishing that mutually beneficial relationship — the sale.

Finding the Me

Who are you? That's the first question every photographer must answer before beginning to build a portfolio to sell his or her work. Art directors, assignment editors, picture buyers, gallery managers, all agree that they look primarily for some unique quality that sets one photographer's work apart from the hundreds of others' they see each year.

Finding that unique quality — the essential you — is not easy. Individual style is subjective and elusive; it's your way of seeing the world — the people, color, design, structure, tones, light, and dark. It's also the way you use lenses, the focal length and angles you select; it's the subjects you choose to photograph and the ones you ignore; it's the way you approach people, how you draw them out or let them reveal themselves; it's the moment you press the shutter, by preconception or by instinctive reaction. It's a recognizable image and a visual identity.

Beginning the Search

Finding your style is the most time-consuming and demanding part of creating a portfolio, or "book," as many art directors call it. Once you have it identified, the rest is an almost mechanical selection of pictures that reflect that style.

The search starts with a look inside yourself: what you are, what you like (love), and what you're inclined toward. This is not simply selecting recurring images or subjects, but a real attempt to find what you like to do best. Be open and flexible and alert to the fact that the essential you may be the last item or the least-explored topic in your repertoire.

One difficulty in finding your unique point of view is that it may be a private thing that you must now share, exposing your innermost self to criticism, or even ridicule — damaging the vulnerable ego. But once you have the confidence to reveal this individual side of yourself, it will be with you and be basic to all the photographs you take from that point on. Your individual style will show through, no matter what the subject matter.

If you don't believe in the efficacy of individual style, take a look at the work of the top photographers who interest you. No matter what the subject matter, there is something that carries through every one of their pictures (at least the *best* images of their representative work). This style or individuality is more than just gimmicks — although gimmicks will sustain you, and may even get you assignments or shows for a while; it's evidence of a sustained visual sensibility that shows that you are doing more than just taking pictures.

Getting Help

Many photographers have never seen a portfolio prepared by another photographer. How can you know what attracts buyers? What format to use? How many pictures to show? How to group pictures? Any picture buyer will tell you, there is no formula. They see everything from a few slides to massive exhibits, and if the quality is there, they remember, assign, and buy.

Obviously, there are better ways of presenting photographs or tear sheets or ideas, just as there are better photographs, tear sheets, or ideas to present. It comes back to that conundrum: How do you identify quality?

Help is available in the form of consultants who will assist you in the search for your individual style, even help you edit your work, and then encourage your efforts to assemble a portfolio in an appropriate format. Like any consultant, these people charge a hefty fee — about $50 an hour — for such personalized guidance. But you may also find this kind of help in adult education courses at local colleges and art schools, where the hourly rate is considerably less. In such a group setting you will also learn that other people have similar problems and are willing to share ideas about presentations. Eight to ten weeks of courses like these usually run $100 to $150 for one two-hour session per week.

Elaine Sorel is one counselor/instructor who gives both private consultations and group sessions in New York City to creative people of all persuasions. Her classes, which she likes to title "How to Be Your Own Best Seller," often include actors, dancers, painters, and poets as well as photographers. In the beginning sessions all the participants outline where they are in their career and where they want to go or how they want to change. "Just verbalizing these things helps people see what's inside themselves," Sorel says. "I am open to admitting fear and sharing anxieties and that helps others identify their problems and individual qualities." Sorel says that many creative people are self-destructive, setting themselves up for failure or rejection of their work by sloppy or inadequate presentations. In successive sessions, her clients gradually assemble a body of work that reflects themselves or what they want to do. From that point they create an imaginative presentation from which to sell their individual style. Her sessions also emphasize what it takes to be a good business person, how to develop business relationships, and self-promotion. "The object is to develop careers, not just to get jobs," she says.

While the content and structure may differ, workshops or classes like these often help photographers, both neophytes and experienced pros, to focus themselves and to acquire the discipline for change or advancement. In short, to take risks.

Selecting a Specialization

Once you decide who you are and where you want to go, you must identify the market or markets that you want to sell or promote to. If your interest is annual report photography, write to a dozen or so major corporations and ask for copies of their annual reports. If you want to work for magazines, select six to ten that carry photographs and articles that interest and stimulate you. If you want to do studio advertising work, select some advertisements that fall within the realm of your abilities, equipment, and facilities. If you want to have an exhibit of your work, visit galleries and see what general categories of work they are showing and what they

Portfolio Advisers

Friendly art directors who work with photographs will usually find time to help a struggling photographer — for a fee. If they're good, such help is well worth the cost. Some photographer's representatives can also be hired for consultation. Whoever you go to for help, whatever their expertise, check the person's credentials, type and length of experience, and talk with other photographers who have hired the consultant.

Three consultants who have helped photographers in New York City are:

Henrietta Brackman
415 East Fifty-second Street
New York, NY 10022

Susan Eyre
292 Marlborough Road
Brooklyn, NY 11226

Elaine Sorel
640 West End Avenue
New York, NY 10024

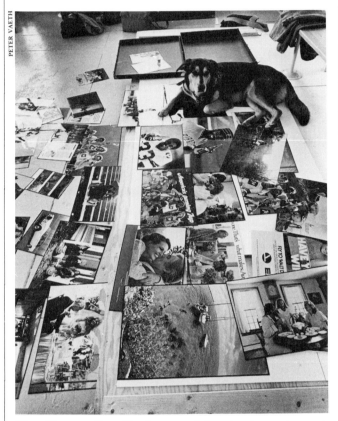

Photoillustrator Peter Vaeth uses work from previous assignments to sell himself

will show in the near future to get a sense of their direction.

These investigations are a further step in the process of identifying the essential you as a photographer. You are now focusing on a specialized field. If you've been kidding yourself up to this time — romanticizing about the kind of photographer you'd like to be rather than recognizing what you actually are — it will be revealed in harsh terms. The subject matter (or several subject matters) and the technique of your work must parallel those of the mar-

ket you have selected. If you like shelter magazines, you had better have pictures of houses and interiors. If you want to do executive portraits, you had better have posed photographs of people in artificial-light settings. If you want to do fashion, you'll need a series showing people in situations and poses that you have directed. If you are into sports, your action shots must capture the peak moment and spirit of the sports event.

For many beginning photographers, this may be a cruel exposure of an underdeveloped approach or lack of opportunity to fine-tune specializations. The secret is to start somewhere, but to start. Obviously you can begin with less prestigious publications of the type selected as a goal, or work for a photographer who is already in the specialty selected.

Another possibility is the self-assignment. Find a story, an idea, a topic, a product, a person, or a group to photograph for a specific market objective (that is, a magazine, advertisement, annual report, gallery, and so on). Carry out the assignment as if you were being paid the top fee in the field, and when it's finished judge the results. Are they good enough to appear in that publication or to be shown on those walls? Be honest in critiquing the work and if it isn't good enough, start over again.

In finding your photographic specialization, don't be afraid to call on other fields where you have expertise or professional knowledge in hobbies, sports, special interests and activities. Your authoritative knowledge and inside information in another field might reveal aspects of the subject that no one else has ever seen. Begin with simple studies and gradually apply more sophisticated technical approaches to your picture taking. You'll need to balance your expertise in subject X against the pro's

expertise in photography. You may come out a winner. Then, you can include these pictures in a portfolio selling your knowledge and photographic abilities.

Selecting the Photographs

Be ruthless. Edit, weed out, update, select, reject, refine. Never be content. Don't be sentimental. Avoid clichés. Never show sunsets, nudes, or flowers.

Aim to astonish your viewers.

With those caveats, spread your photographs out for an examination: chromes on a light box, prints on the floor. Start with an impulse selection of two hundred of your best pictures. Look at them, really look, concentrate. Then go away from this intense study and do something completely different — sleep, eat, play golf, have sex — so that you can return to this evaluation of your work with a fresh(er) eye. If you have friends whose judgment you trust, get a second opinion; but don't stop there, get a third, fourth, and fifth. A consensus of such outside judgments will help you recognize your strengths so that you can take still another fresh look at this body of work and winnow it down to eighty chromes (for a slide carousel) or twenty to thirty prints.

"In the beginning, when you have very little published material, you've got to be able to put together at least eighty dynamic slides," says Lisl Dennis, a photographer who specializes in travel. "If you can't do that, don't bother."

For actual presentations of your color transparencies, a carousel may not be appropriate or even what the art director or picture buyer wants to look at — and thirty or forty slides is probably a more agreeable number to deal with — so don't feel locked into any particular format. This selection process is a starting point. You may also be able to put together a second tray or group of knockout pictures to use as backup material and for substitutions. Each time you show your material to an art director, buyer, or gallery owner, see what photographs they respond to, even ask them which ones grab them. By a process of elimination, you can further refine your selected bests by removing any

pictures that seem weak or uninspired and adding others that have more promise.

It shouldn't need to be said, but many art directors complain of being shown pictures that are exposed incorrectly, that are out of focus, or that lack depth of field where it is needed. The moral is: never include in your portfolio any photograph that needs an explanation or an apology for being less than technically perfect.

Organizing Your Portfolio

If selecting pictures for a portfolio is difficult, the process of arranging them for presentation is overwhelming for many photographers. They agonize over it, discuss it, debate it, and finally come up with a philosophy for organizing their work — by color, subject, variety, size, topic, design, style, people, action, scenics, whatever.

Such ardor isn't entirely wasted, but according to picture buyers, it may not be necessary. They like photographs to be in some order, but more important, they should be easy to go through, they should be neat, and they should show variety and versatility.

For this reason, some photographers prepare a half-dozen carousels or boxes of their best work — standard trays of the major themes that they shoot — and pull together a selection from them according to the market they are trying to reach on a particular visit.

Shorty Wilcox specializes in industrial, agricultural, sports, and travel pictures and maintains collections under each major category. If he's going for an annual report, he'll select from the industrial and agricultural trays shots of people, for instance, according to their function: executives in formal portrait settings, office personnel working together, laborers at their jobs indoors and outdoors. Then, he includes a grouping of indoor environments and outdoor architectural views, with some scenery and close-up details to vary the focal length and perspective for the viewers. Finally, he adds some pure design shots: smokestacks, abstractions, reflections, graphics, even dirt or shadows or unidentifiable objects.

"The important thing is to show what you want

to sell and what you want to be," says Wilcox. "The tray must show my eye and my design feeling as well as the fact that I can do many different kinds of pictures."

Your versatility as well as originality of style can be shown in one overall theme or in two or three types of subjects, themes, or assignments grouped together. You might also show black and white and color work in one portfolio — as long as the market that you're going for uses both mediums. But remember, even though the photographs are grouped according to some logic or order, each image must be strong enough to stand alone. Each one is a beginning and an end in itself.

Presenting Prints

People are accustomed to reading material about eighteen inches from their eyes, and this is also about the ideal distance for viewing 8 × 10 prints. Sizes up to 11 × 14 can be managed, but the viewer will need space in which to back away from the picture.

Besides telling you the maximum size to present to publication picture buyers, these dimensions should also give you a hint about what format works. If you use a loose-leaf notebook — the zipper-closing type with vinyl sheets inside — keep your prints small enough to work within reading distance. If you mount prints that can be held at arm's length, you can go up to 11 × 14 — but no more.

While a notebook portfolio is easy to carry around and flip through, acetate sheets diminish the impact of a truly beautiful print that has deep blacks and subtle gray tones; the sheets also tend to reflect light, making it difficult to see the print as a whole. Mounted prints of any size are more intimate and stronger, but they can be very heavy to haul. The best alternative is to countermount prints — that is, dry-mount a fixed and washed sheet of the same printing paper on the reverse side of the print itself — and carry them in a box or folder. To prevent damage in handling, wax the face of the print with an auto paste wax that contains no solvents (Blue Coral is one brand).

For portfolio presentations to galleries, size is almost irrelevant — if you can carry it there, they'll look at it. But showing a body of work that's coherent is important. Gallery people also like to see a short biography of your photographic career with the portfolio.

In either case — for publication or exhibition — twenty to thirty black and white prints is usually enough to show what you can do with a camera. It's also all an individual can absorb at one sitting.

Showing Chromes

Some photo buyers do, some photo buyers don't — look at color transparencies projected. "The problem is we don't always have a machine handy," explains one art director, "and in some offices the blinds don't come down that easily, because there aren't any."

The answer is simple: call in advance and find out if the buyer has a projector for a carousel or if he/she prefers to see pictures on a light box. If the room you must show in isn't dark enough, move the projector closer to the wall.

While a projected presentation is most desirable because it shows your pictures individually for maximum impact, it simply isn't always possible. Another efficient and widely used method of presentation is pages or sheets of vinyl or acetate to hold transparencies. The most familiar type holds twenty 35 mm slides, but sheets are also available to hold $2\frac{1}{4} \times 2\frac{1}{4}$ up to 8 × 10 film. Many photographers who do advertising and commercial work like to show their pictures in a more isolated and elegant manner. Black mat boards with die-cut openings of various sizes give color transparencies more breathing space. The 11 × 14 boards come with twenty-two different openings for film ranging from 35 mm through $2\frac{1}{4} \times 2\frac{1}{4}$ up to $7\frac{1}{2} \times 9\frac{1}{2}$. The transparency in a protective sleeve is taped to the back of one board and another board is taped to the first, creating a black sandwich around a colorful filling.

Submitting Tear Sheets

Showing copies of your published material is one of the most convincing ways to prove you can take

Getting Laminated

Laminating tear sheets and expensive prints not only protects them during a presentation, it makes them look important. Finding laminators who understand the value of photographs and reproductions is not easy in most cities, but two sources in New York City have experience with these materials.

Mr. Laminate Corporation (7802 Twentieth Avenue, Brooklyn, NY 11214) offers three thicknesses of plastic lamination: 20 mm, 30 mm, and "photo." The heavier grades are obviously more durable, but also more expensive to mail. In the photo weight, the price for an 8-×-10-inch lamination with a clear border is $4.15; for 11 × 14 inches, it's $5.65; and for 16 × 20 inches, it's $15.60. Add $.35 for a black or white border.

Laminal (11-42 Forty-sixth Road, Long Island City, NY 11101) charges about $5.00 for an 8 × 10, $7.00 for an 11 × 14, and $10.00 for 16-×-20-inch 30-mm laminations. But Laminal will discuss discounts for a dozen or more pieces. They do not charge for black borders and, in fact, recommend them for printed material where there is bleed-through from the reverse side of the page. These laminations come in glossy or satin surfaces.

photographs. This method of portfolio presentation is preferred and used exclusively by many photographers who are well-established and content with the direction of their work and career. It does, however, have several inherent drawbacks:

1. Once out of the owner's hands, tear sheets, covers, magazines, even books, tend to disappear, never to be seen again.
2. It shows what you have done, what you are doing, but not what you *can* do. This can be particularly limiting for a new photographer whose published efforts thus far may be routine and pedestrian.
3. Published material is often cropped or laid out in ways that do not enhance the photographs. A poor layout (or any layout) can destroy the integrity of a good photograph.

Yet, published material is impressive, it does influence picture buyers, it reassures them that somebody else bet on you. One photographer maintains: "Clients are really impressed by covers — of anything, on anything!"

Fortunately, there are some methods of dealing with the inherent problems of submitting tear sheets. First, never leave your portfolio with an art director, picture buyer, assignment editor, or gallery manager. Easier said than done, for many of these people are adamant about leaving portfolios for private viewing, or overnight for after-hours study, or they are in distant cities, necessitating mailing your portfolio. It's not one hundred percent, but usually if tear sheets are impressively packaged, the viewer–potential client will respect them enough (or at least respect the packaging) to return them intact.

Presentation methods for tear sheets range from leather-bound, zippered ring binders to Kodachrome copies of published material projected in a slide show. One of the most effective and protective techniques is laminating printed pages in plastic. Another is having C-prints made of published work. Even putting tear sheets in plastic sleeves is preferable to submitting them raw. In any case, it's wise to accumulate as many duplicate copies of your published work as possible. Ask magazine editors, publishers, or designers if you can buy extra copies for future use.

For photographers who want to show more experimental work or self-assignments or groups of pictures of their desired specialization, mundane tear sheets can be a hindrance. "Put them in the back of your book," advises Tim Short, art director at McCann Erickson Advertising Agency. "Tear sheets say, 'Look, I've been published,' so they're good in that respect. We know you paid the rent with this junk if you include it at the end."

That advice also applies in cases where the layouts don't do justice to the photographs. If the original pictures are outstanding, show them in your carousel or your sheets of transparencies and let the reproductions fade away. Usually they won't hurt; sometimes they help.

Neatness Counts

Photography is, after all, a precision task and the photographer's portfolio reflects the way he goes about that work. It is his calling card. If it is neat, orderly, and organized, it reassures the potential client that this person approaches a job in the same manner.

Specific Markets

While the above advice is applicable to almost any situation in which a photographer is trying to sell him- or herself, most markets have specific requirements as well. Here's advice from picture buyers representing the major photographic markets.

Magazines. Content is what magazine art directors look for first: unusual angles, different points of view. They want some evidence that the photographer can get involved in the assignment and *observe* rather than just *see* the subject. Technical skill is vital, as in a sense of spontaneity, fun, and action. Biggest mistake of most newcomers is not becoming familiar with the magazine before showing a portfolio.

Advertising agencies. These art directors are looking for an identifiable hook or style that is memorable. (Where have I heard that before?) Your work should show that you have your own ideas, but your personality should reflect a willingness to execute others' ideas, too. Biggest mistake is talking about slides and explaining what's in them. This disturbs the AD's concentration on your work. (Many photographer's representatives warn against leaving portfolios of transparencies overnight at agencies. One New York City rep says: "Portfolios that sleep overnight at agencies can have babies. Slides are removed and quick C-prints made for reference.")

Annual reports. Picture buyers at design firms doing annual reports are interested first of all in a photographer's technical proficiency: how well he or she handles difficult lighting situations, deals with fluorescent light, shows the product, handles people, composes pictures, selects lenses, and creates abstract designs. Passing that test, the annual report photographer must have the poise and presence to get along with people and create a good impression. Biggest mistake is not showing industrial-corporate photographs in a portfolio. This field pays high rates and the buyers won't take risks.

Newspapers. Diversity is important to get newspaper assignments. Picture editors like to see a series on a story that shows the photographer's editing ability. Some will ask you to bring a contact sheet to get an idea of how you crop, select lenses, understand exposure, and how well you cover an event, situation, or personality. What these editors don't want to see is art photography, although they appreciate fine prints and an interesting presentation.

Galleries. Besides unique imagery and individual vision, gallery owners and managers look for evidence of conviction and commitment that shows the photographer is a mature artist. Some galleries prefer portfolios made up of pictures on a related theme, while others will look at anything that shows what the individual is all about. All want to see a body of exhibition work. What you cannot expect from a gallery review is a critique of your work. Some will suggest other galleries that are appropriate for your style and some will invite you back in six months to see if your progress qualifies you for an exhibit.

Presenting Yourself

One of the features that attracts many people to professional photography is the seeming casualness and informality of the work. A photographer is, after all, an on-site worker and performer. Yet art directors, picture buyers, and assignment editors consistently mention appearance and personality as very important factors in hiring a photographer for a job.

"A guy has to be neat and presentable," says Chuck Queener, art director for *Ski* magazine. "After all, he or she represents the magazine when they're on assignment. Personality counts a great deal, too. They've got to have the ability to work with people. They can't have an 'artistic temperament' or be prima donnas with personal problems that get in the way. Doing a photography assignment often means traveling to a place, working long hours and working late. A sense of humor helps — and it shows in the pictures."

Unlike photographing for fun or for oneself, photographing on an assignment is often frustrating. "A common problem [in corporate photography] is that the thing you are sent to shoot doesn't exist," according to one top annual report photographer. "Or, I find the stuff that is supposed to be shot cannot be done. There is just no way to shoot it. In these cases I make a list of alternative shots and pick the one or two that I consider best before I call the client to check it out."

Being pleasant, sincerely pleasant, is critical in

Sales Sources

Names and addresses are the keys to successful self-promotion and there are numerous sources for these. Telephone directories, particularly those for large cities, are prime sources. The directories listed here are also invaluable. You'll find most of them in business libraries in large cities or in those connected with universities. Or ask a librarian for help in locating them in regional or state interconnected systems.

Audiovisual Market Place (R. R. Bowker). Lists over 16,000 firms and individuals including production companies, producers, distributors, and others in this field.

Ayer Directory of Publications (Ayer Press). Lists magazines and newspapers geographically with addresses, editors' names, circulation data, and subject matter. Magazines are cross-referenced according to subject.

Business Publications Rates and Data (Standard Rate and Data Service). Lists more than 3000 trade journals and technical publications. Descriptions of editorial focus and names of editors given.

Consumer Magazine and Farm Publications Rates and Data (Standard Rate and Data Service). Lists more than 1000 publications with descriptions of editorial profiles and names of personnel. Cross-referenced according to subject and geographic location.

Directory of Corporate Communications (J. R. O'Dwyer Company). Lists over 2000 business public-relations departments with size of company and personnel. Also arranged by product and region of the country.

Directory of Public Relations Firms (J. R. O'Dwyer Company). List of more than 1000 public-relations firms throughout the United States. Arranged geographically with size, accounts, and personnel provided.

Directory to Art Buyers (Art Director's Index). Lists advertising agencies and corporations with amount of annual billing, personnel, and products. Divided regionally.

Literary Market Place (R. R. Bowker). List of book publishers with descriptions of areas of interest and names of personnel. Books also classified by subject. Technical and support services also listed.

Magazine Industry Market Place (R. R. Bowker). Lists close to 25,000 periodicals, agents, and distributors along with other information about the magazine industry.

Million Dollar Directory (Dun and Bradstreet). Three volumes. Lists 150,000 corporations in the United States arranged alphabetically and cross-referenced by state and city. Addresses and chief corporate officers by title are provided, along with products and industry types.

Photographer's Market (Writer's Digest Books). List and description of businesses and publications that buy photographs. Addresses, fees, requirements, and personnel names are provided. Also, articles with tips by professional photographers.

Photography Market Place, by Fred W. McDarrah (R. R. Bowker). List of publications, corporations, and media buyers of photographs. Also lists equipment sources and custom labs, services such as model agencies and package express, organizations and reference books. Addresses, telephone numbers, and key personnel are given.

Standard and Poor's Register of Corporations, Directors and Executives (Standard and Poor's Corporation). Volume I lists 40,000 of the largest corporations in the United States with addresses, top executives, and goods produced. Cross-referenced by state.

Standard Directory of Advertisers (National Register Publishing Company). Lists more than 17,000 corporations with annual sales volume, media usage, key management personnel, ad agency, and budget. Indexed by name, product trade name, type of product, and geographical area.

Standard Directory of Advertising Agencies (National Register Publishing Company). Lists agencies with names of key personnel, clients, annual billing, with breakdown by medium. Arranged alphabetically with a geographical index.

Stock Photo and Assignment Source Book, by Fred W. McDarrah (R. R. Bowker). Lists news agencies and stock photo houses around the world, plus businesses and associations that use photographs.

Thomas' Register of American Manufacturers (Thomas Publishing Company). Lists manufacturers alphabetically and by product type. Information provided varies according to company submission.

Ulrich's International Periodicals Directory (R. R. Bowker). Lists worldwide publications grouped by subject and then arranged alphabetically. Gives address, publication data, and description of the periodical in the language of the country in which it is published.

Working Press of the Nation (National Research Bureau). A five-volume set: *Newspaper Directory*, arranged according to metropolitan areas, includes supplements and syndicates; *Magazine Directory* of consumer and trade publications, cross-referenced by subject; *TV and Radio Directory*, by metro areas, including networks and programs by subject; *Feature Writer and Photographer Directory* of free-lancers according to specialty; *Internal Publications*, arranged alphabetically and indexed by industry and editorial material requested. All carry names of key personnel and other vital data.

getting assignments. Successful photographers say, "Jobs come from friends." And art directors say, "The vibes you get are part of a presentation." In other words, being a professional photographer demands being professional in appearance and in demeanor.

In art photography, on the other hand, appearance and personality mean nothing, according to top gallery operators. Being pleasant probably helps, but one need not be outgoing or ingratiating. "An artist is all alone anyway," says Marcuse Pfeifer, owner/manager of the Pfeifer Gallery in New York City. "I'm not interested in the dress-up part of it. The only thing I'm looking for is a quality in their work that says something about art. The special vision of that individual."

Making a Pitch

Telephone in advance to make an appointment. This is more than simple courtesy; it also puts your potential client in an agreeable frame of mind. When calling for the appointment, you have an opportunity to ask how the picture buyer wants to see photographs, if a slide projector is available, and if there are any particular subjects, themes, or topics he or she wants to see.

Be on time. In fact, plan to arrive earlier than your scheduled appointment so that unexpected hazards like traffic, stuck elevators, or wrong directions won't cause you to be late. If you are late or have to cancel your appointment, be sure the reason is justifiable and convincing. (Forget about dying aunts, even when true.)

In a way, an interview with a picture buyer is like a job interview — except there may not be a specific assignment in the immediate future. The impact of your portfolio and the effectiveness of your follow-up should keep your name and ability vividly in the buyer's memory. Your objective during the interview is to speak with confidence about yourself, your abilities and goals. Your communication on these points must be precise and thorough. You can't assume that the buyer understands; you must explain.

"The photographer's ability to listen and ask questions is most important," says Sheldon Seidler, head of his own annual report design firm. "Most assignments don't work out because of miscommunication, not [lack of] talent. This ability is a learned experience as well as a personality trait."

During your introductory interview you can ask

Presentations by Mail

Whether you mail one-of-a-kind, original Kodachromes, black and white prints, or tear sheets with a cover letter, there are certain safety procedures and formalities to follow. Assuming you want your material back, take these precautions:

1. Stamp your name and address on each print, chrome, or other submission as well as on all correspondence.

2. Enclose a self-addressed stamped envelope (SASE) of the same size as the one you use for mailing.

3. Put the proper amount of postage on the SASE to cover the return of your material.

Unfortunately, even if you follow these three important steps, your photographs can be lost or damaged in shipping or mailing. Using protective cardboard around the photographs helps (use two pieces and wrap them with two rubber bands, criss-crossed from corner to corner). Carousels and large quantities of prints should be shipped in a sturdy box. Stamp all envelopes or boxes with PHOTOGRAPHS, DO NOT BEND warnings.

Finally, if your pictures are extremely valuable (that is, irreplaceable original transparencies or artwork), insure them in transit. Most delivery and courier services will insure items only up to $500 or $1000, but precedent set by legal action has placed a value of $1500 on a single original transparency. This is a basic fee that has been upheld in subsequent cases, but such awards may depend on the photograph or work of art and the photographer's or artist's reputation.

By sending valuable photographs by registered mail, however, you can insure them for $25,000 for a fee of $11.10 plus $.25 per additional $1000 up to one million dollars, and get a return receipt. Using this method, you must pack the material very well and seal all exposed edges with paper tape to ensure safe handling. This method is often used by photographers when sending assignment photographs to a client, but for blind submissions or for portfolio queries, it may not be acceptable.

Without insurance, for peace of mind you can enclose a stamped and addressed postcard with a query about the safety of your pictures. The recipient signs and mails the card to acknowledge receipt.

questions about the buyer's needs and then interpret what he or she wants in terms of your work. Try to find some points about your background that distinguish you from other photographers, who are, after all, your competitors.

Portfolio Viewing

Whenever and wherever it comes up in an interview, treat your portfolio presentation as a sacred event. As with any sacred event, that calls for silence. Don't speak unless spoken to. Don't explain technical details, locations, reasons for taking pictures, or aesthetic aspects.

"I hate to listen to a running dialogue while trying to get into what I am looking at in a folio," says Sheldon Seidler, "unless I ask for some explanations."

Simply said: shut up when showing your portfolio.

Self-Promotion

Many photographers give picture buyers a card, brochure, poster, or promotion sheet with examples of their photographs. Others send such promotion pieces or a print from their portfolio shortly after visiting the potential client. Still other photographers maintain that such self-promotion is too limiting and may fix a too-rigid image of a category of work in the client's mind.

"I regard the 'sheet' as a calling card or mini portfolio of my work," says Whitney Lane, a successful illustrative photographer. "The photographs I choose to show on the sheet are representative of what I do — people, still life, and industrial — and they're visually arresting. We're in a visual business so you have to provide something memorable when you leave. It's mandatory."

Promotion sheets like the one Lane describes are usually overruns from commercial directories in which photographers buy pages to advertise their services. The directories are then either distributed or sold to the photo buyers. Space rates in these books range from $1500 to $4000 per color page, but the overrun of 1000 to 1500 sheets is included in the price or can be purchased for a small fee.

Many photographers maintain that two or three jobs obtained from being in such directories more than pay for the space, and the overrun sheets save them printing promotion material on their own. Art directors, however, often say the directories are only useful as "swipes" where they get ideas. "There's too much to look at in them," says one art director. "It's like looking at a type book, except that you can't make a reliable selection knowing what you'll get like you can with type."

A card with a single image that represents your

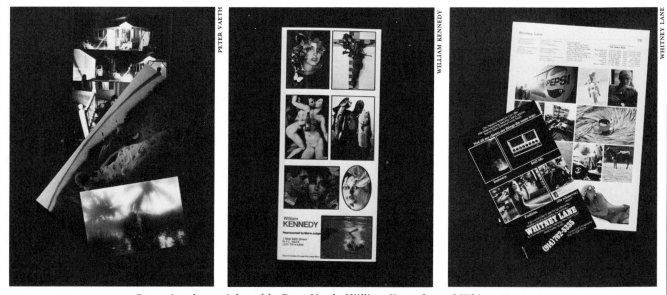

Promotional material used by Peter Vaeth, William Kennedy, and Whitney Lane

work is another self-promotion technique. A small size — 4 × 5 or 5 × 7 inches — and stiff stock make cards handy to file and refer to and allows them to be used as easy and inexpensive mailing pieces. The cost for 3000 cards printed on both sides is about $60 for black and white and $200 for four-color. You also need to add typesetting and layout, but the cost of several promotional mailings is still lower than the price of one page in a directory. Sending cards every three or four months is an effective reminder, and with a different photograph each time, you can present various facets of your work.

Posters are another promotion technique used by some photographers. If the images are dramatic and appealing enough, posters may actually be posted in an art director's office. On the other hand, they may be rolled up and buried in a corner. Posters are a risky all-or-nothing promotion technique.

Brochures and booklets are gaining favor as self-promotion methods. For one thing, they lend themselves to words in which a photographer can describe his or her fields of work or approaches and list previous assignments and clients. Another advantage is that photographs can be displayed more effectively as a single image across a spread or on an individual fold of a brochure. But brochures or booklets tend to be very costly.

"My twenty-four-page, four-color book cost $14,000," says Shorty Wilcox. "But it was important for me because I wanted to make a statement about where I had been and how I think about a wide range of things. It's effective and memorable in showing my capabilities."

The simplest and least expensive type of promotion is the all-word approach. Lisl Dennis supplies a short biography (eight typewritten lines), a listing of magazine and newspaper credits, names of corporate clients, and professional associations to which she belongs. Many photographers send out periodic lists of subjects, places, and people photographs they have available. These techniques are particularly appropriate for magazines where you have made a contact with an assignment editor or photo buyer.

Gallery owners usually want a short biography as a reminder of your presentation. These should include education, previous exhibitions, projects you are currently working on, and what you are interested in pursuing in the future.

Using Directories

In the past decade, photographers have increasingly turned to specialized directories to reach potential buyers of photographs. Printed on slick paper in rich four color or deep-toned black and white, directories are expensive, but provide exposure to more markets than any individual photographer could possibly reach.

The four major directories have different formats and differing personalities, but they often overlap in extra reference features and services to photographer/advertisees. To some extent they also appeal to slightly different audiences. For these reasons, some photographers switch directories every year.

The Creative Black Book has been bringing photographers' advertising messages to buyers since 1970 and currently reaches about 22,000 buyers in the United States and foreign countries for free, plus another 12,000 people who buy it at $35 a copy. The *Black Book* is actually a two-volume set. One book contains the promotional photographs and sales messages submitted by the photographers and is divided into regional sections. The second volume contains lists of sources that are of value to photographers — retouchers and model agencies, for example — and some that are of less interest to photographers, such as type houses, illustrators, and printers.

Many photographers buy two facing pages in the *Creative Black Book*, which gives them an advantage in exhibiting their wares. They also tend to show many smaller photographs rather than one or two large ones, and present them in a great variety of layout patterns, bleed and nonbleed. To catch the eye in this mix, you need very powerful images.

The *Black Book*'s size is 5 × 10 inches and rates start at close to $4000 for a color page. The 500 or more advertisers in the *Black Book* get 2000 free overruns of their color pages. These are a convenient size and are printed on thick stock for durability and easy mailing.

For a copy of the *Creative Black Book* or a rate sheet for the next edition, write to Friendly Publications, Inc., 401 Park Avenue South, New York, NY 10016.

The *American Showcase*, with a larger page size and book binding, is easy to view, which may be why it

tends to attract more advertising and illustration photographers. They generally show fewer and larger pictures. This plus the larger format and white background give the *Showcase* an elegant appearance. Some photographers print a short text along with their pictures, describing their specialties and accomplishments. Scattered through the book are essays on various topics of interest to people in the graphics side of advertising. The *Showcase* also carries advertising pages of illustrators and graphic designers. It is distributed free to more than 13,000 agency art directors and creative people, and sold in bookstores to another 11,000 people.

The *Showcase* page size is 9¼ × 11¾, but the picture area is restricted to 8⁹⁄₁₆ × 9 inches and bleeds are not permitted. Price per color page starts at about $2000, but includes 2000 free reprints of the ad pages as well as an option to have the publisher do mailings for a fee or supply 2000 mailing labels of picture buyers for $200. The cover price is $30 by mail order or from book and art supply stores. The *Showcase* carries about 250 advertisers in its 350 pages.

For more information, write to American Showcase, 724 Fifth Avenue, New York, NY 10019.

The *Art Directors' Index to Photographers* not only has a large format, it is a large book — in its entirety. The *Index,* published in Switzerland, includes photographers from around the world. The full, hardcover book with text in English, French, and German is over 700 pages with more than 600 pages in four color. Advertisers are grouped by country so that national or continental editions (for example, the American Section) can be soft-bound and sold at lower cover prices.

The *Index*'s format is large, but photographers tend to show a collection of their work resulting in pages of smaller pictures. Many photographers buy two facing pages, and single-page displays are surrounded by white space, giving the *Index* a cohesive look. About 100 photographers appear in the American *Index.*

Page size of the *Index* is 8³⁄₁₆ × 12³⁄₈, but allowable picture area is 7⁵⁄₁₆ × 9¼ — bleeds are not permitted. Base page rate for four color is $3675, which includes a free mailing of 1000 tear sheets to potential buyers. Advertisers also receive a discount toward the purchase of the *Art Directors' Index to Picture Buyers* (25 percent off the $250 price), with listings of major advertising agencies and Fortune 500 corporations (names and titles of key personnel are provided). The American edition is distributed free to more than 10,000 picture buyers and the entire international edition has a press run of about 15,000. Cover price of the American Section is $22; the international edition is $85.

For copies of the *Index* or information about advertising, contact Art Directors' Index, 415 West Superior, Chicago, IL 60610.

The newest directory is the *ASMP Book,* published by the American Society of Magazine Photographers for members' advertising and promotional efforts. Most photographers in the *Book* take single-page ads, which tend to compete with each other across the page gutters. Also, more editorial photographers advertise in the *Book* than in the other directories, which gives it a mixed-bag appearance.

The *Book* is thick, with close to 500 pages of photographers' ads divided by region of the country. Members of ASMP are listed, but not all of them advertise in the *Book.*

Page size for the spiral-bound *Book* is 7 × 9½ inches and the cost is $1250 per color page. About 12,000 copies of the *Book* are sent to photo buyers without charge. It is also available at some book and photography stores in New York City. Photographers who advertise are provided with 1500 tear sheets of their pages free.

For information about joining ASMP and advertising in the *Book* or buying a copy, contact American Society of Magazine Photographers, 205 Lexington Avenue, New York, NY 10016.

The Photographer as Salesman

Whitney Lane walks twenty-five feet to work. He has a studio in an old barn just that distance from the back door of his house in Ossining, New York, an exurban village near New York City. Inside, the barn is white and spacious with tear sheets of his work on one wall, Polaroids of models' faces on another, all intermixed with framed awards from art directors' organizations.

Lane has been a photographer for about twelve years, specializing in industrial, fashion, and travel assignments, with occasional ventures into still life work. While those are his specializations, one of the

Whitney Lane, the photographer-salesman

keys to Lane's success is his gentle ability to work with people. He convinces people — usually professional models — to react to him, to each other, to their environment.

Obviously, some of this personal goodwill is used by Lane in selling himself.

"I spend about one day a week in self-promotion, ranging from stuffing envelopes with mailers to preparing portfolios for presentation, to making calls, to follow-up mailings and looking for new prospects," he says. "Usually I'll send a mailer out first and then follow up with a phone call for an appointment. It takes me about fifty minutes to get to New York City by train, but I also see clients in the suburbs, in Westchester and Connecticut. All that time for promotion figures into my overhead, too. I'd say promotion amounts to 5 or 10 percent of my gross — depending on the year.

"During an actual presentation of my portfolio, what I try *not* to do is to give a running commentary on every slide or piece I'm showing. I think it's important that the art director devote his full attention to looking at the images. The strongest thing you can do is put some terrific images in front of a client — they speak for themselves or they don't."

Lane gets his mailers from overruns of ads he has placed in either the *Art Directors' Index* or *American Showcase* over the past six years. He estimates that he has sixty images from those sources alone that he can place in front of an art director.

"These books are good dollar value for a couple of reasons," says Lane. "First, you have an ad that is being circulated all over the United States and the world — I've had sales in Europe and South Africa based on pictures in those books — so you're getting a lot of exposure. Second, I get a minimum of a thousand runoff sheets that I can use as calling cards when I see a client. I use them as mailings or leave them when I see an art director.

"It's hard to measure the results of this kind of advertising, either from stock sales or actual assignments, but I'm sure it's paid for itself several times over. All it takes is two or three good assignments. It's the combination of the tear sheets and the ads that brings in new work.

"The *Art Directors' Index* has been very productive for me. I think the *Black Book* is outrageously priced, but the *ASMP Book* is a darn good buy. When I figure the cost of one of these ads, I include my production costs — I usually give them a photo mechanical — which adds another $800 to $900. The total is a substantial amount of money.

"The problem with the books is that they are becoming supersaturated. They have been good, but an art director can become overwhelmed and confused by so many powerful images. I think we have to consider alternative ways of presenting our work."

Before becoming a full-time photographer, Lane was an art director at several advertising agencies, and his training was a college major in advertising design with a minor in photography. This background contributes to Lane's particularly effective portfolio presentations.

"I show more samples than I probably should," he admits. "But I try to limit it to about twenty laminated tear sheets and C-prints. I have them all done in 11 × 14-inch format, which holds a double-page spread of the smaller magazine size or a single page of larger size and also fits nicely into a Samsonite attaché case. Each laminated page costs about nine dollars and I have about fifty of various topics."

Marketing West of the Hudson

Regionally there are directories that are far less expensive than most of the national promotional books. The circulation of these books is also smaller and the free reprints of ad pages consist of about half the number offered by the nationals. If you live in these regions, they offer good deals:

Chicago Creative Directory	*Creative Directory of the Sun Belt*	*The Workbook*
333 North Michigan Avenue, Suite 311	1103 South Shephard Drive	Scott and Daughters, Publishing
	Houston, TX 77019	1545 Wilcox #204
Chicago, IL 60603		Los Angeles, CA 90028

When Lane opens one of his three attaché cases, the first page is a blank sheet of colored paper with his large business card on it. The tear sheets, laminated with black or white backgrounds, are carefully arranged for presentation, and each one is backed with felt Contact paper to prevent it from scratching its neighbor.

"Organizing a portfolio is like designing a magazine," he says. "You open with the strongest sample in front. Then you might follow with more complex shots. If I'm showing some big face shots, I try not to have a lot of those grouped together. The pacing of the presentation is according to design with variety. I choose to isolate rather than group samples. Each sample should be strong, but the end sample should be particularly strong.

"I have one portfolio that shows fashion and beauty, another for industrial accounts, and one for travel, but they often overlap, too. Then, I try to throw in something that surprises the client, that hints that I do more than just one type of photography. I think if you understand your tools, your equipment, you can photograph a range of things. Sometimes if you restrict your showing too much you get typecast in a certain direction.

"Once I was showing a carousel to a strictly industrial client — I thought. He saw that I had more chromes at the end of the carousel and he asked to see them even though they were mostly fashion shots. From that I got a job for another account that he worked on."

Lane keeps updating his portfolio as new work is published. Three or four weeks after a job, he contacts the art director for several reprints or engraver's proofs of the ads or layouts. He has a stock of sheets in case something happens to one of his portfolios or for duplicate presentations.

Even though he uses the laminated tear sheets as his primary portfolio format, Lane believes that projected chromes are the best presentation, but they take more time and are difficult to set up — finding a room and a projector. To augment the tear sheets, he carries one sheet of twenty unpublished transparencies — "Pictures that are very special to me, that I like to do and I'm working on" — and changes these from client to client, too.

"Art directors, particularly those in New York City, are deluged with photographers," he says. "Their time is valuable, so you have to keep the presentation of a portfolio compact.

"What I usually do is see what's on the art director's walls to get a clue as to what he's about, what he's working on, and what he likes. From this I get an idea of helping him solve his problems — and photography and design are just that: solving problems and trying to move a product with words and design and strong images."

Selling Your Photographs

Photographers, farmers, and widget manufacturers have similar problems in that they all have to move their product to the market, and then sell it. A photographer knows he has to eat, sleep, and buy film, and not always in that order.

Most fledgling photographers believe they sell photographs to the local newspaper, a magazine such as *Geo*, a public relations firm, a large company such as Coca-Cola or an advertising firm that represents such companies. They do not. They sell to a picture buyer — a creative director for an advertising firm, an art director for a magazine, perhaps a photo editor or a photo researcher. Basically, a photographer is dealing with a person whose profession is to look at photographs all day and buy those he or she likes, or what he or she thinks the client might like. As such, these buyers wield power and influence.

It is a very good idea for photographers to move around and talk to these buyers, but here's the problem: a photographer must keep shooting — producing — to live. If the production line is shut down and everyone in the factory goes to a sales meeting, what will the photographer sell?

There are a number of ways to sell photographs. The worst way is to put them in an envelope and mail them to some magazine with a stamped, self-addressed return envelope. That's like entering a lottery and the photographer may never see the photographs again. It is much better to query first,

and then get the rejection slip without all that packaging, filling out of return receipts, and traveling to the post office to pay too much for the service.

The most efficient way to sell photographs is through a photographers' agent. An agent makes a living by selling a number of photographers' photographs. There are three basic types of agents: a photographer's representative who acts as a personal salesman, an agent who specializes in assignments, and an agent (stock house) who sells the one-time use of single stock photographs. A number of photographers use all three types of agents, and also sell themselves.

Photo Representatives

These are portfolio luggers and their job is to land assignments. They live in the market areas — Chicago, New York, Los Angeles, Paris, London — but you can find them in other cities or wherever there are enough photograph buyers to give them commissions to live on.

The photographers who need a rep do not have the time to sell, do not have the inclination (or are terrible salespersons), or live out of town. A rep knows all the clients and makes calls, showing the portfolio and finding out the requirements of the buyer. Usually one rep will represent a few illustrators and photographers who have different special-

ties — still life, fashion, location, or annual reports. Besides securing assignments they can do the billing, promotion, and more or less provide the photographer with a security blanket. For this they take a 25 percent commission, and reps with photographers who bill in the high figures can make small fortunes.

Photographers, claim the reps, never understand their job and neither do the buyers. A good photo rep tries to balance the needs of the photographer and the client. He or she walks a tightrope. If the photographer is good, and the rep is good, the two can generate a lot of income. A poor rep may not sell well and/or may create enemies.

A photographer needs to know the rep well — his or her background, reputation, and drive to sell. The rep needs to know the photographer's taste, style, availability, and professional ability, for a rep knows better than anyone that if the photographer turns in one lousy assignment, the buyer will be looking for other photographers and reps.

A number of photographers use a relative as a rep — husband, wife, friend. It often works out well and the commission stays in the same household. (This is a much better arrangement than to have one mate learn photography from the other. What happens then, in most cases, is that the two compete against each other, followed by the inevitable breakup.)

A rep needs to know how to present a portfolio, whom to present it to, how to sell, how to guarantee the rights the photographer is selling, what expenses are required (such as travel time, assistant and stylist, weather standbys, and including cash advances if necessary) and how to put them on paper and secure prompt payment.

Photographers are constantly looking for reps, particularly those photographers who live in Aspen, Colorado, Hanover, New Hampshire, or other out-of-the-way places. They are too far away to see clients and market their own photographs. A rep will often prefer the photographer who has the biggest billing, so he or she earns a bigger income. This means that reps prefer advertising or commercial photographers to those who sell to magazines. (Whom would you prefer to represent? The photographer who does journalism for a maximum of $350 per day, or a still photographer who can bill out $5000 a day?) A rep prefers in-town photographers because the client can visit the studio and put in his or her two cents. On the other hand, a few out-of-town photographers with different specialties can give the rep a wider variety of skills to snatch an assignment. You do not find many underwater specialists or outdoor sports specialists living in the big cities.

The best way to find a photo rep is to write to SPAR (Society of Photographers and Artists Representatives), P.O. Box 845, FDR Station, New York, NY 10150. At last count, SPAR had 225 members, 60 on the West Coast, 65 in Chicago, the rest in New York, with a new chapter starting in Atlanta. To join SPAR, a photo rep needs to have attended seven orientation meetings, presented references, and carried talent (photographers) for six months. In other words, members of SPAR are, or at least should be, quite professional. They have a list of members that outlines their specialties and whom they work for, and they will sell it to anyone for $8.10. They also publish a newsletter for their members and for $5.00 you can place a classified ad stating your need. Hopefully, some rep might call. One word of advice — don't ever get a rep if you can't make that rep and yourself enough cash. If you are starting out, you have to let that rep know you are a good investment for the future.

Assignment Agencies

There are two types of agencies. Those that sell or rent the use of single pictures are called stock houses. They often do not sell assignments. Assignment agencies do just that — they sell assignments for photographers who work with them and they also sell stock from past assignments.

Assignment agencies carry on the tradition of the old *Life* and *Look*. They work with staff and stringer photographers who are among the best in the world and they continue to do journalism, selling photographs to magazines from Buenos Aires to Johannesburg. They also secure assignments for annual reports, for advertising, and for books. It is difficult to obtain a staff position with an assignment agency; they deal with superb photographers who have creative ideas and a thorough knowledge of travel, airline schedules, and how to ship film to meet deadlines. Some agencies, such as Magnum and Contact,

Chapnick's Last Tape

Popular Photography magazine has put together a number of cassettes on photography, everything from equipment to galleries, free-lancing, and, yes, one cassette called *How to Use a Photo Agency*, by Howard Chapnick. It is good. The price is $9.95 and Chapnick's tape is #23002. Send your money and the number to Popular Photography Cassettes, P.O. Box 278, Pratt Station, Brooklyn, NY 11205.

Howard Chapnick, dean of photojournalists and the force behind Black Star

are cooperative — the photographers own the agency and new members are elected in. Other agencies, such as Black Star and Liaison, have staff photographers and stringers in most major cities in the world.

Black Star. This remains one of the oldest photojournalistic agencies in existence. Its president, Howard Chapnick, is the dean of photojournalists and of all photographers who must communicate in a broader sense than through a page of advertising in *Cosmopolitan*. Chapnick has more enthusiasm and

love for a good photograph than do most photographers. He is also the photographers' collective conscience, and he is articulate in what he has to say to photographers who wish to work on assignment through his or any other agency.

Photojournalism dates back to the 1920s in Germany, when sequencing of photographs was developed by Kurt S. Safranski and Kurt Korff in *Die Berliner Illustrierte* and *Die Dame*, two leading publications of the Ullstein publishing empire. Dr. Erich Salomon was candidly photographing statesmen in deliberation and off-guard moments at the League of Nations and young Alfred Eisenstaedt was sent to Saint Moritz to photograph snow and came back with one of the first photo essays.

Black Star's founders, Ernest Mayer and Kurt Kornfeld, as well as Pix Incorporated's Leon Daniel and Franz Furst, were among the first of the German émigré picture agents to see the value of selling photographic stories. Forced to leave Germany by Hitler's oppression of the Jews and political opponents, Kornfeld and Mayer started Black Star in London and then came to the United States in 1936, coincidental with the birth of *Life* and *Look*. Wilson Hicks, *Life*'s brilliant and difficult photo editor (his out-of-print book, *Words and Pictures*, is a classic on photography, words, and layout), picked up agency-related photographers such as Philippe Halsman, Fritz Goro, and Eisenstaedt, and hired away several Black Star photographers.

Through the years, Black Star has developed into a multiservice agency. It sells to special publications, to newsmagazines, newspapers, to industry for company publications, annual reports and brochures, to the U.S. government, advertising agencies, audiovisual producers, and publishers of books, posters, and calendars. "We are a supermarket of photography," says Chapnick. "We are an umbrella for energetic, creative people." Black Star also sells art or graphics for office decoration. It is the representative for the distribution of picture material produced by *Stern*, the German magazine, and Sipa, a French news and feature photo agency. In addition to securing assignments for photographers, the agency maintains a stock file from past assignments and contributions from photographers all over the world. The library now contains more than one million images. Thirty percent of the agency sales are generated from Black Star files. "Stock photography

is a potential gold mine for residual sales of a photographer's material," Chapnick affirms.

Black Star has a staff of twenty-six, nine of whom work in the stock library. Salesmen are constantly on the phone and making personal visits to create new clients. They are trained salesmen. "One of them used to buy and sell rabbit skins," says Chapnick.

There are fifteen staff photographers who receive a weekly draw against their earnings. Those who have been on staff for a number of years may receive a better percentage arrangement on sales of their material. Sixty percent of the assignment rate goes to the photographer doing the assignment. The photographer receives 50 percent of any stock sale. Distribution to foreign countries is split fifty-fifty between agency and photographer on the net received from abroad. Black Star, as do most agents, has subagents in foreign countries who take between 25 and 35 percent commission on sales they generate. Costs of making prints or duplicate color transparencies for distribution in foreign countries are split fifty-fifty between the photographer and the agency. A Black Star photographer can make from $15,000 to $100,000 annually, depending upon his energy, drive, creativity, technical proficiency, ideas, and initiative.

Black Star also has 150 stringers, photographers who work part time for the agency in most major cities of the world. They do not receive a draw, but receive comparable fees on the assignments they cover. (When *Life* and *Look* were in their glory, Black Star had a staff of twenty-five, larger than the staff of *Life* magazine. At that time, Black Star specialized in photojournalism exclusively.)

Photojournalism based on the news and the background of the news is covered by several photographers who have an interest in that particular kind of work. Black Star knows that it cannot compete with AP or UPI for spot news coverage. Consequently, the agency works primarily with magazines that take a more reflective look at the news.

Feature assignments are often based on ideas presented by the photographer or Black Star in behalf of the photographer to specific magazines. Fred Ward, Black Star's Washington, D.C., based staff photographer, did a most definitive piece on the subject of diamonds for *National Geographic* magazine. Black Star ultimately sold it to magazines

around the world. Other feature stories related to the development of robots, the brain, DNA and genetic engineering, and Tibet were equally successful in distribution worldwide.

Chapnick has been extremely adept at nurturing young photographers and nursing his staff. "An agent," he says, "is a sounding board for photographers and their problems, a financial counselor and backer, a marriage counselor, psychiatrist, psychologist, casting director, equipment carrier, and camera-carrying assistant."

Chapnick also fine-tunes portfolios for the image the photographers want to project — whether tilted toward advertising photography, annual report photography, or photojournalism. He urges them to mix in photographs that show the photographer's ability to shoot well-lit portraits or to use multiple strobe lighting. "I'll look at any portfolio or see any photographer in the hope of finding a new creative talent. If you are in the creative business, you cannot afford to close your doors to prospective new talents," he says.

"Of the hundred thousand estimated students of photography currently in universities and colleges, few make it as free-lancers. It doesn't take four years of photographic education to become a photographer. To survive and be successful, a photographer needs intelligence and the ability to use his or her brain.

"Photographers also need commitment, passion, and dedication. They need to learn how to express themselves in words as well as photographs. They must know how to take notes and accurately caption material. They need to make judgments about stories — whether they are viable and salable editorial ideas, whether they are international in scope or limited to a regional audience. Above all, they must learn how to query editors and write thoughtful proposals for stories. They need facts, background material, and carefully developed research. Ideas are the lifeblood of the industry.

"It is unbelievable that there are so many photographers without any technical grounding or technical proficiency. An assignment photographer should be the master of his equipment and be able to control artificial light as well as photograph with natural light. I am constantly amazed at the number of unprofessional people in a field that requires a high degree of professionalism. Magazines are using

photographers who know about focusing a camera, but have little idea about exposure, the requirement of tilts and swings in large-format photography, and so forth. In the old days when photographers were using the ground glass for composition and preconception, they were forced into greater visual discipline.

"Many photographers now use their cameras like machine guns. There is a need for greater intellectual discipline when photographing. John Launois, on one of his most successful stories for *National Geographic*, photographed the Tasaday Stone Age people in the Philippines and shot only forty rolls of film on a one-month assignment. It was a tight, well-conceived shooting, but provided *National Geographic* and the magazines of the world with an exciting story and outstanding photographs.

"Too many young photographers are swayed by the emphasis in the universities on art photography. The rhetoric about photography in the fine arts field is overblown. They are influenced by the collection of photographs curated by John Szarkowski, photography curator at the Museum of Modern Art, whose 'Mirrors and Windows' exhibition and book glorified empty, vacuous photography in lieu of content.

"Still photography has a great future, even if the electronic media will eventually completely supplant newspapers and magazines. Still photographs isolate the moments — the memorable moments. Who can forget the screaming, napalmed child of Vietnam or Gene Smith's photograph of the mother and child at Minamata, or the pictures of the recent assassination attempt on President Reagan? We remember only a few pages of Gene Smith's photographs in *Life* of Dr. Albert Schweitzer, but his exhibitions included some 150 photographs. Television could adapt those photographs and make a lively, dynamic, still animation presentation in a seven-to-eight-minute show.

"Our job as agents is not only to sell photographs, but to inspire photographers to do better work, more imaginative work replete with storytelling content. To inspire them to be more curious and more critical. Many times our client may be satisfied with a completed assignment, but we find the material less than satisfactory. We consider it our responsibility to constructively criticize the work and inspire the photographer to a better job the next time out.

Ideas That Sell

If you were a working photographer and you needed projects that would sell internationally, what would they be?

A few ideas:

- What will happen when a major earthquake hits California? What can be photographed before it happens that would be prime photographic material after it happens?
- Mexico is experiencing inflation, extreme wealth through oil, yet has heavy poverty. What can be photographed that would show the turmoil this country is experiencing?
- What are the leading diseases in the world? Who are the leading scientists or centers combating these diseases? What are the breakthroughs?
- Who are the nouveau riche in the new oil boom in America? What are their backgrounds and what are they doing with their new wealth? How is it affecting their lives?
- Famine is threatening several sectors of the world, yet American farms, through their technology, could prevent this famine. What is the new technology in growing crops and in animal husbandry?
- The world looks at America as a land of crime and violence. What measures are being taken to prevent this rise in crime? What is the source of most crime?
- What happens to the old people in America?

A free-lance photographer, no matter who he or she is and what his or her past performance record might be, is no better than the last assignment. That's the one the client will remember."

Liaison is primarily a news agency with its roots in Paris with Gamma Presse, its European counterpart and big sister. It is run by Michel Bernard and Jennifer Coley. Their contacts with Gamma are very important. Located in Paris, Gamma edits and prints photographs for the world press. Gamma sends out sets of news photographs to ten or twelve times as many countries and markets as exist in North America, so they sell much, much more.

On a fast-breaking story, Liaison will send a news take to Paris. Within twenty-four hours (less if they use the Concorde) that take is back in New York, printed, copied, and captioned. Every black and white photograph selected is printed simultaneously

Michel Bernard and Jennifer Coley live high-tension lives when there is a major newsbreak

in multiples and the caption is mimeographed on the back in French and English. In a few hours, Liaison can blanket the world with a story.

Liaison staff photographers work on a draw against commission of 50 percent. Liaison, like Black Star, has stringers and contributors from South Korea to Chicago. Although it is primarily a news agency, it also does features and personalities.

"We consider a news event," says Coley, "as a sociological textbook. There is also a time element in news. If there is a riot in South Korea, it is news that week, not the next week. We provide a place to store photographs and sell them for immediate impact. We also do stock sales in black and white and color, although color is becoming predominant.

"Photographers rarely know the value of a photograph or the value of time. One photograph at the right time could be worth $150,000, but it could sell for $15 or for $75. It is our job to set the value."

Liaison has 25 staff photographers and about 125 stringers in the United States. Photographers with five to six years of stock photography to lean on can make $50,000 to $60,000 a year. There is a Hollywood photographer who works on personalities and makes about $10,000 a month. Some are news photographers who specialize in other endeavors. One does medical stories as a sideline, another is good with portraits of businessmen. Yet, most of their work is in news.

Liaison also assures that they have credentials for the best photographic locations. It paid $1000 for a bleacher position for one of its photographers to cover President Reagan's inauguration. The money went to the Inaugural Committee. Liaison also bought the exclusive rights to the wedding of tennis star Bjorn Borg, who did not want a crowd of photographers around and who is also a very shrewd businessman. Bernard believes it may be the first time that anyone sold the film rights to his own wedding.

"Our job," says Bernard, "as an international agency, is to have an understanding of time and

markets, of airplane flights and magazine deadlines. It allows the photographer to be concerned about taking photographs and shipping the film to us as fast as possible — and nothing else."

"A photographer needs to have a sense of quality and commitment," Coley adds, "but as a professional he or she must be able to think. Photojournalists know how to react, shoot the right exposure, and, so very important, to move the pictures. In many cases, this business is built on risk and the photographer takes the risk in every situation.

"We rely on the initiative of our photographers. If a war breaks, our photographers just go, and if they have time, give us a ring that they are on the way. The professional photographer gets into many hot situations, but often gets away with it. It is the young ones who don't take responsibility for themselves or their work. They start as photographers, then they become journalists and news photographers.

"During trouble, the first photographers can go

where the action is before the incident becomes organized, roadblocks are set up, and passes issued. When the Russians moved into Afghanistan, François Lochon, one of Gamma's photographers living in Paris, went into Kabul on the first flight. As the plane landed, he photographed the buildup in Russian military equipment at Kabul airport. He then went through customs and hired a cab to drive him through the streets. From the cab, he photographed tanks and Russian soldiers. He spent six hours in town and was out on the return flight.

"His were the first photographs of the Russian invasion. They were sold to all the major newsmagazines in the world. Lochon is one of our best, with a good nose for news and a finely tuned sense of airplane schedules and deadlines. For this six hours of work the agency grossed $200,000, of which half went to Lochon."

Many spot news photographs come from amateurs. The first pictures of the Tenerife disaster, when two 747s collided, came from a tourist who

Gamma's François Lochon, here photographing Khaddafi, is often several steps ahead of the competition

Getting the Most out of a News Situation

If you happen to luck out and shoot a news happening — a UFO landing in New Mexico and strange things getting out and rustling a steer, President Reagan falling off a horse (a similar photograph of Jackie Kennedy going headfirst over her mount made a small fortune in the early sixties), or an airplane smacking into one of New York's Trade Towers — call, do not write, one of the following agencies. They are the best and could make you a bundle if you get the image to them quickly:

Black Star (Howard Chapnick)
450 Park Avenue South
New York City
212 679-3288

Woodfin Camp, Inc. (Woody Camp)
415 Madison Avenue
New York City
212 355-1855

Sygma Photo News (Elaine Laffont)
225 West Fifty-seventh Street
New York City
212 765-1820

Liaison Agency, Inc. (Michel Bernard, Jennifer Coley)
150 East Fifty-eighth Street
New York City
212 888-7272

called up Paris with Instamatic pictures of the collision.

A photographer called Liaison from California. He had seen a train hitting a car and photographed it in color and black and white. He went to Associated Press, who told him they usually pay $35, but in this case they offered the photographer $50. Bernard, who had already seen the photograph on the wire service, told him to go back to AP and ask for the return of the color. AP didn't want to give it up, but did so, and a few hours later Bernard had sold the color for $2500.

Coley tracked down an amateur photographer who had photographed a commercial airliner going down in San Diego. This photograph sold for $30,000. A staffer heard of a child who could exist only in a bubble support unit in a hospital. He spent seven hours photographing the child and earned nearly $20,000.

"Most photographers have no idea about how photographs are handled," says Bernard. "We have to sell a photograph four times before it begins to make money. We edit, mark it, log it, catalog it, show it to the client, sell it, airmail it, and bill it. Sometimes our photographers never see their work.

"We baby-sit photographers, call attention to technical problems, wire them money, or pay the mortgage if some fellow is stuck in Dar es Salaam. We try to encourage photographers."

"Unfortunately, some just can't think for them-

selves or generate ideas," says Coley. "We have to tell them everything, what to do and when to do it, and we don't want photographers like that. We are not encouraging new photographers right now, but we are finding out that all our photographers specialize. Harry Mattison, for instance, covers Latin and South America. He knows the language, the politics, and identifies with the people. He has contacts and is recognized as an expert for work in that part of the world. Other new photographers growing into this field should realize the importance of understanding the languages and the background of the areas they may have to cover in depth. A photographer must think. We edit his thoughts and package his photographs and find him clients to work for."

Contact Press Images. Within the industry, Robert Pledge is recognized as one of the most astute editorial directors of the new-wave photo agencies. He was raised in England and Paris and holds a number of degrees in linguistics, anthropology, and sociology. His specialty is Africa and he learned two West African languages — Fulani and Mandingo. He worked as a reporter and editor in Paris, specializing in Third World affairs. His first field assignment with photographers found them illegally entering Chad, a landlocked African country south of Libya. They were ambushed, put in jail, and finally expelled several weeks later.

"We lost a VW minibus, a Land Rover, and equip-

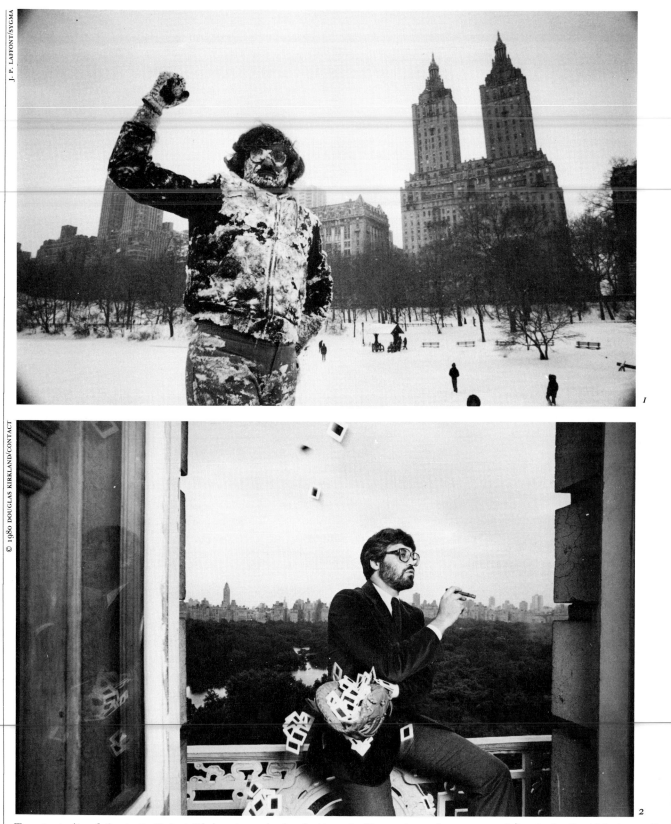

Two portraits of Contact's Robert Pledge, two schools of approach. No. 1 shows the au naturel *"grab shot," which drops all pretensions. No. 2, a set-up photo, shows Pledge as the sophisticated, picture-deluged photo agent*

You Can't Take It

The First Amendment to the Constitution gives you the right to take any photographs you want — almost. There are specific laws that prohibit photography in certain places and of certain things.

U.S. military installations that contain secret equipment or facilities are off limits for photographs. How do you know which installations? There is usually a sign or notice, but if in doubt, ask.

Theatrical shows, concerts, or ballets may be copyrighted, in which case you cannot photograph. Again, there is usually a sign or a notice in the program. Even when they are not copyrighted, union rules usually prohibit photography during a performance.

Museums that are privately owned may prohibit picture taking. Even public museums that have exhibits of work on loan can prohibit photography of that work.

Public places sometimes prohibit photography on a tripod because members of the public may trip on the tripod.

Courtrooms are still off limits, but some states are easing up on this regulation.

Money or postage stamps cannot be legally photographed in color — just in case somebody might try to counterfeit stamps or currency.

ment: a total then of $25,000. But we managed to get the film out. We eventually sold enough to recoup our expenses." One of the photographers was the legendary Raymond Depardon, who had formed Gamma and now is with Magnum. The other was Gilles Caron, who was killed in Cambodia shortly after. It was the time that Pledge spent in jail with these two photographers that interested him in photography. He worked as an editor with *Zoom*, the European photography magazine, then in 1973 with Gamma in New York as their bureau chief. He started Contact in 1976 with prizewinning photographer David Burnett.

Contact is a small cooperative agency; six photographers own the agency together with Robert Pledge, and there are six contributing photographers. In addition to Burnett, there is veteran Douglas Kirkland, who began his career at *Look* and the original *Life*, Alon Reininger, Rick Smolan, Gianfranco Gorgoni, and Dilip Mehta. Contributing photographers include Annie Leibovitz, whose specialty has been rock stars and who produces most of *Rolling Stone*'s covers.

Contact specializes in selling its photographers' work internationally to agents throughout Europe, and sells directly to South America, Japan, Australia, and the United States. It also maintains a stock house of its photographers' material.

"We are small," says Pledge, "and we intend to stay small. We split sales with our photographers, but, of course, they own the business. We do little commercial work; most is editorial photography — features and photojournalism.

"We are different from Sygma or Gamma in that they mostly cover wars, news, and hot spots. We try to go beyond the news; we featurize it."

What is so interesting about Contact is the strategic thinking and planning to find hot spots in the world before they erupt, and to seed them with photographers. Pledge reads all the major papers — the London *Economist, Le Monde,* the *Financial Times.* Foreign affairs publications provide more information on the Third World and the Middle East than American publications do. Pledge also reads periodicals that specialize in news of Central and South America. His insight led him to place photographers in South Africa four months before the Soweto riots, in Iran six months before the American Embassy takeover, and in Nicaragua and San Salvador seven months before those countries erupted. Contact photographers are now covering all of Central America, and particularly Cuba, Jamaica, and Mexico. (One photographer spent six months in Guatemala just learning the language.) In addition to the particular assignment, they shoot stock photographs — the geography, native people — but they also shoot photographs of the military, government leaders, the police, unions, industry, and transportation. When, and if, the area becomes the focus of news, they have the "background" photographs ready to distribute. When the photographers go back to the country, they have contacts and know their way around.

Contact photographers have been shooting heavily with their motor drives so that instead of making dupes on a fast-breaking story, they can send originals. In the office they break the take into sets. The first set, the best, is kept in New York. The second set is sent to France. The rest of the photos are split among the most important agents. Meanwhile, dupes of the first set are made and sent out to other agents.

Contact has to work on features because of its geographical location in New York.

"Paris is the ideal location for a photojournalism agency," Pledge explains. "It is halfway between Washington and Moscow, and it is close to Africa and the Middle East. This means a Paris-based agency can cover these areas quickly, and distribute pictures throughout Europe in a few hours after

You Can't Use It

Photographs of current events require no releases, nor do pictures that are to be used for educational purposes or for documentation of events or situations.

What do require releases are pictures of people or places that are being used for the purposes of trade or advertising — otherwise, that's invasion of privacy. This doesn't mean that people who are incidentally in the background or public buildings that provide a setting need to be released. However, it's always best to get a release whenever you can for either news or trade/advertising. Do you need to pay to make the release legitimate? No, just be sure the subject is of legal age.

Publishing or displaying photographs that may cause a person to be an object of ridicule, contempt, or hatred — in other words, ruin his or her reputation — is cause for libel action. To be sure your pictures cannot be used in this manner, caption every print or transparency that might be published.

A recent suit in New York City, known as the Arrington Case, may change all the above. A "street photograph" of a black was used for the cover of the *New York Times Magazine*. There was no release and the subject of the cover, Clarence Arrington, incensed not by the cover but by what he considered an insulting article, sued the *New York Times*, the photographer, and the photographer's agency, Contact Press Images. A decision by the New York State Court of Appeals found that the *New York Times* was not liable, but that the photographer and his agent were, since they made the photograph and sold it for commercial gain. Everyone is furious with the decision except the *New York Times*. If the ruling stands it means, in New York State, that any photograph sold for profit needs written consent of the people photographed. Thus, the files of most news agencies become worthless — the photographs of Robert Frank, Cartier-Bresson, or Ruth Orkin could not be sold in New York State unless there were releases. It would mean the death of photojournalism and the birth of reconstructed news photographs, acted out by models. That used to be called yellow journalism.

receipt of the materials. When the news was in Iran, the planes always delivered to Paris. While the Parisian agencies were distributing their stories a few hours later, our film was still on the plane to New York and we could end up three days behind them. For us to compete, the story must break early in the week so we can meet the same deadlines.

"There is another reason that Europe is so good. The TV there is state-controlled and there are not as many stations. The advertising is controlled stringently. This is healthy for the magazines and for photojournalism. A photojournalist cannot exist by selling only to the American market.

"In the United States, television has the advantage. So we do our research and in-depth photojournalism to compete. America, of course, is a gold mine of stories; the rest of the world is fascinated with America, and they cannot get enough material from us — ethnic stories, the new technologies, energy movements and life-styles, economic trends and issues. We are also close to Central America and Mexico, developing nations that capture the world's attention."

Contact's very first story, in 1976, started out as a disaster. For the U.S. Bicentennial, Pledge and Burnett decided to do a "Cowboy" story. "What is more American to Europe," asks Pledge, "than Coke, Cadillacs, and Cowboys?"

They found out about a cattle drive in southern Arizona and Burnett spent four weeks photographing it, with cowboys ranging in age from nineteen to eighty-one.

"It was an amazing story and beautifully photographed, and we were amazed that nobody bought it. We spent $4500 just on expenses and we couldn't sell it. We were stunned.

"Then, about seven months later an Italian magazine bought it and paid miserably, but did a cover and ran twenty-five pages. Another Italian magazine saw that take and did a twelve-page story. Then a French magazine picked it up, then Air France's in-flight magazine, *Atlas*, published it also. And so on — Germany, Japan, Switzerland.

"Within a year we had recouped our expenses. Then there were reprints in the United States, in a photo magazine and in *American Heritage*. More sales followed in Europe and Ralph Lauren picked up four of the shots for TV and advertising in print media. Four years later, that story made as much as

Duping

Most photographers hate to part with their original slides, so they "dupe" their slides, that is, copy them the same size onto another transparency. Many send them to professional labs to be duplicated, but the prices and quality vary. Many photographers make their own dupes, using a bellows and slide holder or a machine made specifically for duping.

Dupes are usually made with Kodak's Ektachrome Duplicating Film, daylight (#5071) or tungsten (#7071). The film has a softer gradation than regular film so it doesn't build up contrast during the duping process. However, for stock purposes, the best dupes are done on Kodachrome because of its fine grain, color, and longevity. But Kodachrome is also difficult to dupe with because it can quickly build up contrast in the duping process, making highlights burn out and shadows darken. This can be controlled by masking — making a black and white, same-size negative that is exposed and developed for the highlights and then sandwiched with the original transparency, which is then duped. This is costly and time-consuming.

The best way to control contrast is by pre-exposing the film to be used for duping to a slight gray card to build up a density base, then re-exposing the film to the transparency to be duped. There are also machines that have contrast control, such as the Bowens Illumitran and Dia Duplicator.

Duping slides also allows for correction or enhancement of the original color through filters. One landscape photographer who used to shoot in 8 × 10 now uses 35 mm Kodachrome 25, then dupes that onto 4 × 5 Ektachrome, which he sends to his agent and other buyers. By using Kodachrome he cuts down on film costs, and, he believes, the larger format helps to sell landscapes. He loses very little detail in duping up to 4 × 5 from Kodachrome 25.

it did in the first three years. Those photographs will be selling as stock twenty years from now because there will always be a need for good cowboy pictures. After the story is used, the stock file becomes a trust fund for us and the photographers."

Contact is also good at logistics. During the Pope's round-the-world trip in 1981, Contact worked with *Time* magazine and four photographers. They set up all the necessary credentials and leapfrogged photographers from Rome to Ireland to the United States. "Our photographers always were ahead of the Pope by twenty-four hours. They had their cre-

dentials in hand and had found the better locations to shoot from. Part of the take was processed and distributed from London, the rest in the United States was processed by *Time* and then sent out to other countries. Ten publications ran those photographs, with coverage ranging from two-page spreads to eight pages." Pledge was pleased that although *Time* had forty photographers on tap, Contact's four photographers provided one-third of the photographs that *Time* published.

Technology of distribution of photography bothers Pledge. He is experimenting with a Midwest firm on producing microfiches of 20 to 60 transparencies made with laser beams that are good enough to make separations from. For filing purposes, there is a microfiche of about 4 × 6 inches that holds 635 slides. The same firm can produce separations within 24 hours.

As office work expands, Contact photographers help with editing. They also, by editing, learn to discipline their shooting so there is not as much wastage and office work, and, very important to the photographer, there is less film to carry on assignment.

"It's a very big problem for photographers that they have to take huge amounts of film and five or six cameras. Carrying thirty-five to forty pounds of equipment hurts shoulder and back muscles, twists the spine, and then the knees go. Health is a very big problem for photographers. We want to use lighter cameras, but the new, smaller Canons and Nikons are not sturdy; they break, melt, and fall to pieces. If they are electronic, they are more vulnerable to breakdown. Many have switched to the Canon, but we would like all our photographers to use the same equipment. The office bought a Nikkor 1000 mm for the space shuttle and we have a Canon 600 mm — equipment not normally used on assignment. However, the major problem is to lighten the photographer's cameras and load. Instead of shooting 400 rolls, we would like to cut it to 250 rolls, or 125, by narrowing the shooting down to one pertinent situation."

A Contact photographer's income is hard to figure. As so many traveling photographers know, their tax write-offs are enormous. Pledge figures they can net $25,000 to $80,000 a year. If they have a large stock file that is selling for them, they make much more. Contact's top photographers could take

a year off to work on a personal project and live for that year on their stock earnings.

Pledge feels there is room in this field of photojournalists if the photographer is committed. He feels many move toward the commercial end; annual reports and advertising photography are where a photographer's income can be many times higher than a photojournalist's.

"Beginning photographers need an idea of what they want to do. By their nature, photographers do not like offices. They are against bureaucracy. Many of the young see photography as a glamorous business. They don't want to pursue an education but they have fair intelligence. They have hands, eyes, legs, and want to work on their own. Photography is the answer, they think.

"It is best for the young to go out and shoot on speculation in their own area. Shoot as if someone was going to publish it, not as fine art, but as a usable newspaper or magazine article. Edit the take, caption it, stamp it with your name and address, and copyright it. Be professional. Then go show it.

Assignments made this way and placed in your portfolio will show agencies how you shoot, and how much drive and energy you have will appear through the photographs. One of Contact's leading photographers, Alon Reininger, grabbed me at a photographic opening and asked me for work. He kept shooting experiments and showing them to me until I gave him assignments. He is now one of our leading photographers."

Stock Agencies

Stock agencies are nothing more than libraries that rent the use of photographs they have collected from photographers. They most often sell one-time rights to a photograph, for a fee that varies for color from $150 to $5000, the price depending upon use (the low end is for editorial use in a book, the high price is for national advertising). The agency takes a 50 percent commission for this service and submits

What You Need to Set Up Your Own Stock Business

- A few years of shooting good transparencies on a specialized subject.
- A bunch of filing cabinets.
- Someone to caption, stamp, file, answer the phone, send out requests, do promotion, billing, and retrieving of lost or damaged transparencies (each is valued up to $1500).
- A light box about two by four feet. One of the better manufactured boxes is the Macbeth Prooflight 5000. You can also make your own, using neutrally filtrated Plexiglas and G.E. Chroma 50 fluorescent tubes, which are closest to 5000 K, the color temperature at which chromes are viewed by photographers, buyers, and engravers.
- A very good loupe, such as the Schneider. It allows you to see quickly the color quality and sharpness of the transparency.
- A copyright stamp with your name and address.
- A delivery memo that basically gives the right for someone to look at the slides. It states what was sent and what is charged for research and holding fees. The value of the transparencies is also stated — in case they are lost or damaged.
- A billing memo, which states the conditions of the sale — what rights are sold, what the price is, any

discounts if the purchaser buys multiples or pays within ten days, and so on.
- A postage scale and return receipts. Every photograph is shipped out insured with return receipt. Without that return receipt, you can never prove that a potential buyer actually received the transparencies.
- Promotional literature to send out to potential buyers so that they will know to call you when they have photographic requests that fit your specialty.
- A mailing list of photo buyers — magazines, newspapers, design houses, advertising agencies, book publishers, poster makers, calendar and greeting card firms, and yes, stock agencies. You build up buyers, through reference books that list magazine buyers, advertising agencies, design houses, public-relations firms, book publishers. A good place to start is with reference books in a large library.
- Letterheads, cards, a telephone, and enough money to support a large bill if you are not located in the same region as most of the buyers.

A working photographer (one who is constantly on assignments) can expect to make 30–50 percent of his or her income from stock. In some cases, photographers shoot only for stock. To be successful you may have eight to ten requests a week and billing of at least $800 to pay overhead and yourself.

a quarterly statement and a check to the photographer.

There are some agencies that have black and white and color in their libraries. (Black and white has traditionally sold for less than color, but this policy, if the agencies have their way, will change. Black and white photographs cost more to produce than color transparencies, and they are more expensive to catalog and file.) There are general agencies that handle thousands of photographers and slides on every subject, and there are specialist agencies that might do most of their business in categories such as nature, science, or sports, or work with a limited number of photographers.

Clients are buying more and more from stock houses, because they realize it is the fastest and least expensive way to purchase photographs. More photographers are sending their photographs to stock houses, discovering that even with the agency's commission taken out, they are generating an income that they normally wouldn't have.

Some photographers prefer to sell their own stock. Most of the successful ones specialize in a certain subject and picture buyers know their names and specialties. Jill Krementz, for instance, specializes in authors, Walter Chandoha in cats, dogs, and vegetables. There are specialists in outdoor sports, in regional scenes, in Americana. Photographers who maintain their own stock have to have help and a good sense of business and organization; the cataloging, mailing, promotion, and paperwork are phenomenal. Most photographers find it more feasible to take photographs and have someone else do the stock selling. If they do set up their own stock system, they use a member of the family to do the office work or they hire help.

Selling stock is a little bit like gambling — you never know who wants to buy what and when. But the more photographs that are in stock, the better the chance for a sale. What sells are photographs that are recognized, that have a track record; one sale generates another. And also, unbelievably, what sells the most are clichés — couples having fun, gorgeous landscapes, sailboats in the setting sun, kids eating ice cream, the Eiffel Tower, the New York City skyline at night, New England pocket villages and lakes and mountains. Historical moments also sell well, such as Little Rock integration and the tragedy of Kent State. The photograph can

Hard Core Selling Ideas

Rohn Engh lives in Wisconsin and for twenty years has been selling photographs by mail. He publishes *Photoletter*, a newsletter about photographic markets and how to sell to them. More important, he's compiled his own experiences, information, and know-how as well as some clear thinking and writing into a book on the subject, *Sell and Re-Sell Your Photos* (Writer's Digest Books, Cincinnati, Ohio).

Engh is no romanticist, he's not into art photography, and he doesn't eschew the word *copy*. If it's been sold, it's salable — again. He's big on formulas and charts and lists and examples, but somehow it's not sticky or cloying. Much of his information and advice is aimed at the beginner going for the low end of the market. But he's a realist and he knows what the market will bear.

be twenty times as valuable if there is a release of all recognizable people, animals (no, the dog doesn't sign the release, the owner does), and even houses.

Stock photographers who work through agencies can net up to $30,000 a year. Those who sell their stock direct can double that if they are organized and prolific. In a lifetime a photographer can gross $250,000 to $750,000 from stock sales — so claims John Lewis Stage, who sells photographs himself and through an agency.

Agencies usually want photographers to sign exclusive contracts. Although there should be a relationship of trust between the photographer and the agency, the contracts agencies offer photographers are usually not healthy for the photographer. Some of the contracts are punitive in their restrictions for exclusivity and may make it almost impossible for the photographer to retrieve photographs that have been submitted for stock. There is usually no protection against bankruptcy or for audits. The best contracts are those written after a session of give-and-take between photographer and agency, or better yet, follow the guidelines of a contract prepared by the American Society of Magazine Photographers.

Many photographers prefer to use several agencies, one in New York, another in Chicago, and a third in Los Angeles. Others will use one main agency, but send certain subjects to agents that specialize — in science or nature, for instance. All pho-

tographers must caption their transparencies accurately and stamp them with their copyright. (Some photographers use Roman numerals for the date, figuring most buyers won't be able to read the numbers, and thus "date" the photograph.) An *NR, R,* or *RA* in red ink in the upper right-hand corner of the mount indicates No Release, Release, or Release Available. Photographers keep all releases, keyed to the photograph, and supply a copy when requested by a buyer or the stock house.

Some photographers are very reluctant to part with original photographs and make duplicate slides to send to agents. The dupes must be superb — not drugstore copies but of reproduction grade. Others shoot the duplicates in the camera (the easiest way). One photographer who specializes in travel shoots his photographs with a 6 × 7 Pentax making twelve to fifteen shots of each important scene. Eleven of those go to stock houses in nine countries (he has done his research well and visited each one). The

Ethics in Selling Stock

- Don't sell stock below the minimum standards, such as the ASMP pricing guide. Don't sell below the net your agent charges.
- Keep a publishing record for each transparency. A perfume company would probably not want to buy a photograph to use as an ad in a particular magazine, and then find, on the opposite page, the same photograph being used in a feminine deodorant ad.
- Don't send near dupes to different stock houses in the same region. It is not wise to have several agents trying to sell the same transparency to the same buyer, or to companies that compete against each other.
- Caption all photographs accurately. False information could cause a lawsuit or cost someone a job, and possibly destroy your sales.
- Be very careful about released photographs. A released photograph means a model release *has* been signed and is in your file. If a release is available but not signed — mark it *release available*.
- Get to know your agency personally so you understand each other.
- An agent and a photographer's rep should communicate about sales, so there is no conflict between the two, and with the photographer they represent.

extras he keeps in his file. His method, which he began a few years ago, now grosses him close to $100,000 per year.

Filing of slides is too often the downfall of a photographer. Without a good filing system, nothing is retrievable, and if the photographer is at all messy, he or she should immediately edit and caption and stamp the takes, and send them to the agent to file.

Some photographers file their chromes and prints in color-coded boxes (yellow for cities, blue for country, red for children, and so on). Most, however, use the 8 × 10 heavy-duty plastic photo pages that hold twenty mounted 35 mm or twelve 2¼-inch slides. Some agents prefer photo pages that are clear on both sides, instead of clear on one, frosted on the other. The reason is that sometimes twenty slides in a plastic page are color photocopied for filing or for buyers in a hurry, and only those pages clear on both sides work with these machines.

Once the slides are inserted in order — verticals together, horizontals together, one subject per page — they are filed in regular business files by subject matter. Often subject matter is cross-indexed and the system can be complicated. This is one reason why stock houses have so many librarians at work, and why they keep 50 percent of every sale. Photographers send their submissions to stock houses in these pages. The stock house editor looks over the page with a loupe and pulls the slides for the files or marks the ones selected with a red grease pencil on the plastic envelope and returns the take to the photographer, who then stamps and captions each selected transparency and returns them for the permanent stock files.

Photo Researchers. The agencies that win the most respect from photographers are those that treat them decently and send them regular checks, each one (hopefully) bigger than the one before. Photo Researchers of New York City is such an agency. President Jane Kinne explains how it works.

"We do some assignments, but the large percentage of our work is selling one-time use to the information markets — textbooks, encyclopedias, filmstrips, wall charts," she says. "Since the early sixties we have made a conscious decision to shape our files toward this expanding market.

"We handle color and black and white as we feel that black and white has a stronger impact. Many good photographers have been driven out of the

Photo Researchers' Jane Kinne urges photographers to do their mental homework

market in the last five years because of loss of black and white sales and the cost in producing a black and white print is five to six times that of a color transparency. Payment is too low for black and white, but it will take two to three years to raise the payment of black and white to the level of color.

"We handle about 3500 photographers and some estates (it is complex to value transparencies for an estate, as they are worthless until they are sold, and may never be sold). Many of these photographers are specialists, such as a doctor who shoots influenza strains through a scanning electron microscope or a microbiologist who shoots DNA. There are broad-spectrum photographers who will make $30,000 to $35,000 from stock sales. Some shoot natural history — birds, insects, mammals. Travel photographers will shoot from Asia to the Caribbean. Most of our best photographers do self-made assignments between their commercial assignments, and they often follow our suggestions on what to photograph. We have a need for photographs on social issues — water and energy, state education, comparative cul-

tures in life-style, recreation, and religion. We are looking for a photographer who has a knowledge of psychology. If a photographer would sit down and read five leading psychology books he could make a list of photographic situations and we could sell and resell those pictures.

"What a photographer needs is brains — brains behind the eyes, to know what is important to photograph so it is marketable. Having specialized knowledge in a certain field can expand his or her business 20 to 30 percent. Most are technically good, but all would do better to invest in a self-assignment rather than buying more equipment. We tell photographers what we need for our files and they come back and ask what to shoot. They don't listen. Photographers should go to the library and look at encyclopedias and see what they use. They should scan dozens of magazines and look at year-end issues for the leading photographs.

"Travel should always be photographed, and never pass up a cliché. Try and put the human element in each photograph. America is underphotographed and there is a tremendous need for pictures of this country and its people. About one-third of photographers don't believe the camera can be turned vertical. They obviously don't look at the printed page, and finding good cover material is hell.

"For a photographer to make $10,000 a year means he or she needs a very large file with us. If photographers shoot and organize their files and follow the instructions we give them, they should make 30 to 35 percent of their total income from stock agencies. Unfortunately, only about a dozen do that. What they do best is combine aesthetics with information.

"We do not accept every photographer and actually we turn down a large number of photographers. We sometimes contact photographers whose work we have seen in books, magazines, or galleries. We do wish there were more women selling stock. Not 20 percent of the total we represent are women, possibly because roving around with a lot of equipment is a rugged business and, in the past, women were frightened of their ability in certain technical areas. Women have always been good at photographing children and child development, and we always need those photographs.

"Naturally, Photo Researchers believes that pho-

tographers would do better having an agent sell their photographs rather than doing it themselves. We know we can get better prices. Mobil, for instance, may pay $150 to $200 for a filmstrip, but $5000 for a national ad. Also, agencies do handle bulk sales, and give a 20 percent discount on a sale of 3000 to 4000 pictures. Few photographers could provide either the number or variety of photographs wanted. Most of those requests come from the book market, which is about 75 percent of Photo Researchers' business."

Kinne also complains about the time-consuming job of sending out and retrieving photographs, and she feels that the only photographers who can sell stock well by themselves have a specialty and a staff. Photo Researchers uses a computer for billing and issuing sales reports and to log photographs in and out to customers. Kinne also believes that video terminals will be in use soon. If a customer wanted to look at all photographs of Park Avenue between Fiftieth and Forty-second streets in New York City, he or she could view them on the video screen and make selections. The main drawback to the system is in adding new material and eliminating old.

Photo Researchers requests accurate captions that are typed on labels, then applied to the mount of the transparency. It wants model release information marked on the slide. It prefers Kodachrome because of its high resolution, color, grain, and longevity. The agency has in its natural history department a chrome that shows a fight between a beaver and a coyote, a very unusual situation. It was shot

The ideal stock photo — a cliché shot of lower Manhattan. It will sell many times.

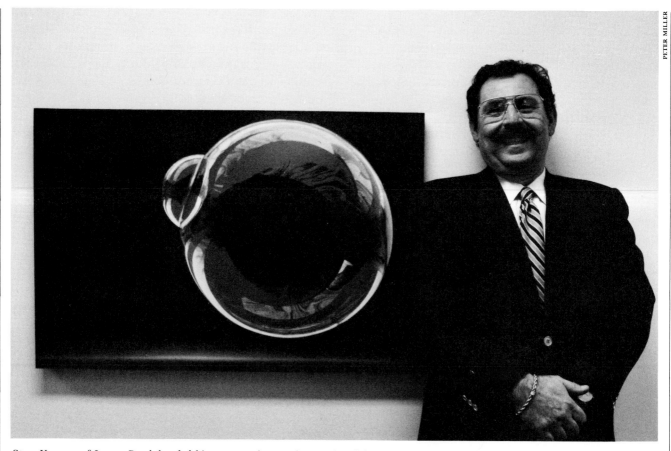

PETER MILLER

Stan Kanney of Image Bank has led his company into an international force as a photo stock house. Here he poses next to a photo by Pete Turner, one of Image Bank's photographers.

several decades ago on Kodachrome and is completely unfaded and has been sold many times. Staffers are constantly returning to photographers transparencies that have faded into brown and magenta or are so old that styles in dress have changed. Most of the returns have been on Ektachrome E-3 and E-4 film.

Photo Researchers has close ties with other stock houses in Paris and Tokyo, and warns photographers not to send original photographs abroad as the risk is high that they will be lost.

Photo Researchers is now building up its black and white file, looking for update of cities, government situations, and schools. It wants 8 × 10 black and white prints, double weight, printed flush on glossy paper dried matte. It doesn't like resin-coated paper as well because of the loss of contrast.

This agency makes five-year contracts with its photographers and it wants an exclusive contract. (A photographer, though, should work out his or her own contract.) Kinne suggests that photogra-

phers spend a day with the agency and get to know the personnel and the system. Some photographers have a feel for one agency over another, a small agency over a big one, and should pick an agency accordingly.

Image Bank is a unique stock house that does not even call itself that. The Image Bank says it "fills photographic requirements." The agency was the first to specialize in selling photographs for commercial rather than for editorial use. It was also the first to license its business and now has twenty offices in fourteen countries. The president of Image Bank is Stanley Kanney, a blunt-talking former commercial diver, a salesman of factories, former manager of another stock house, and a man facile with figures. He has a unique way of looking at selling photographs on the international market.

"There are two thousand photo agencies in the world that first started in the late twenties and early thirties with the main purpose of selling to magazines — the photographs were used to educate and

inform, rather than to have the image prompt a person to buy a shampoo or travel to Russia.

"Image Bank edits photographs to sell for commercial use — photographs sold for commercial use sell at from five to fifty times the price of those for editorial use. Our concept is to represent only the best photographers. About a hundred photographers a week have been applying to us, but few of them meet our technical and artistic requirements.

"We take only world-class photographers. We edit down to the very best and we submit only the very best to art directors. They are confident our material is usable and we charge more because of our top quality.

"Our customers are actually our photographers. We sell for them. Unfortunately most photo agencies are not run by business people, but usually by former photographers or editors.

"Too many photographers are peddlers, selling photographs here and there. Continuous peddling takes away from the artist. An old pro may go and sell his pictures to some creative director. That creative director is giving out checks and in the power position is even doing the bidding for you. Do you think Michelangelo would have bid for the *Pietà*? Photographers are confronted with this worldwide — they are being bottom-lined. What is a photographer? A salesman who takes pictures, or a photographer who knows how to market himself? What is his entity? A photographer must see himself as an entity, not to make an image for himself, but to make a career for himself.

"We believe that some of our photographers, within five years, will be shooting only to place stock in Image Bank. It takes a year and a half of work before stock can start selling for you. One French photographer shoots only stock for a living. He spent a month in the West shooting rodeos, a month in Chicago, a month in New York, a month on each project he selected. We sell his photographs, he

Jeanne Upbin of Image Bank runs the staff that selects the images that the clients buy

How to Find a Stock House

Stock houses are located in the major cities of the world and in this country are concentrated in New York, Chicago, and Los Angeles. The best way to secure a stock house is to compile a list from the Yellow Pages, call them up, make appointments, show your work, and see if there is any interest.

Photographers should be very interested in the stock house's ethics. The best way to check on stock houses is through references. Find out who are some of the photographers who use the agency and ask their opinions of the agency or any other agencies you know of.

One group that is trying to upgrade the practices of stock houses and to promote their businesses is the Picture Agency Council, 60 East Forty-second Street, New York, NY 10165. Listed below are members and their addresses.

Picture Agency Council of America

After-Image
6855 Santa Monica Boulevard
Suite 402
Los Angeles, CA 90038
213 467-6033
Contact: Ellen Henderson

Animals Animals
203 West Eighty-first Street
New York, NY 10024
212 580-9595
Contact: Nancy Henderson

Peter Arnold, Inc.
1500 Broadway
New York, NY 10036
212 840-6928
Contact: Peter Arnold

The Bettmann Archive, Inc.
136 East Fifty-seventh Street
New York, NY 10022
212 758-0362
Contact: Melvin Gray

Black Star
450 Park Avenue South
New York, NY 10016
212 679-3288
Contact: Ben Chapnick

Camerique
1701 Skippack Pike
Box 175
Bluebell, PA 19422
215 272-7649
Contact: Orville Johnson

Woodfin Camp and Associates, Inc.
415 Madison Avenue
New York, NY 10017
212 355-1855
Contact: Woodfin Camp

Bruce Coleman, Inc.
381 Fifth Avenue
New York, NY 10016
212 683-5227
Contact: Norman Owen Tomalin

Dewys, Inc.
200 Madison Avenue
New York, NY 10016
212 986-3190
Contact: Leo Dewys

Earth Scenes
203 West Eighty-first Street
New York, NY 10024
212 580-9595
Contact: Eve Kloepper

Editorial Photocolor Archives, Inc.
342 Madison Avenue
New York, NY 10017
212 697-1136
Contact: Ted Feder

Frederic Lewis
15 West Thirty-eighth Street
New York, NY 10018
212 921-2850
Contact: David Perton
 Irwin Perton

shoots them. What we are doing is saving his time.

"Photography is an international language. The top market requirements are the same in Paris and London and we intend to implement those same standards around the world. We have franchised our business on four continents and have five offices in North America with their own files. We do the major editing here in New York and educate photographers to shoot for stock, thus distributing originals to all our offices. We also give them internal support so that all of our systems of filing and selling are homogeneous. The franchises guarantee a volume in dollars to their relative market area (50 per-cent of any sale made by the New York office goes to the photographer, but only 30 percent of any sale made by a franchised office goes to the photographer — 30 percent goes to Image Bank in New York, and 40 percent to the franchise that originated the sale). I travel 100,000 miles a year to find new markets and understand selling problems in foreign countries, and heads of our departments meet regularly with executives of franchises. We also are developing assignments for our photographers and spend $200,000 a year on legal fees, suing for lost chromes, unlicensed use, or nonpayment.

"We are looking toward the future. We expect

Freelance Photographers Guild
251 Park Avenue South
New York, NY 10003
212 777-4210
Contact: Arthur Brackman

Globe Photos, Inc.
404 Park Avenue South
New York, NY 10016
212 689-1340
Contact: Gary Phillips

Grant Heilman
Box 317
Lititz, PA 17543
717 626-0296
Contact: Deborah Schoon

Image Bank
633 Third Avenue
New York, NY 10017
212 953-0303
Contact: S. Geiger

Liaison Agency, Inc.
150 East Fifty-eighth Street
New York, NY 10022
212 355-7310
Contact: Jennifer Coley

Life Picture Service
Time-Life Building #28-58
Rockefeller Center
New York, NY 10020
212 841-4800
Contact: Marthe Smith

Phelps Agency
32 Peachtree Street, NW
Suite 1614
Atlanta, GA 30303
404 524-1234
Contact: Kattie Phelps

Photography for Industry
850 Seventh Avenue
New York, NY 10019
212 757-9255
Contact: Charles Rotkin

Photo Media Ltd.
105 East Nineteenth Street
New York, NY 10003
212 677-8630
Contact: Walter Hayum

Photo Researchers, Inc.
60 East Fifty-sixth Street
New York, NY 10022
212 758-3420
Contact: Jane Kinne

Picture Group, Inc.
5 Steeple Street
Providence, RI 02903
401 273-5473
Contact: Don Abood

Plessner International
95 Madison Avenue
New York, NY 10016
212 686-2444
Contact: Al Weiss

H. Armstrong Roberts
4203 Locust Street
Philadelphia, PA 19104
215 386-6300
Contact: Bob Roberts

420 Lexington Avenue
New York, NY 10170
212 682-6626
Contact: Roberta Groves

Shostal Associates, Inc.
60 East Forty-second Street
New York, NY 10017
212 687-0696
Contact: Joe Barnell

Sports Illustrated
Time-Life Building, Room 1919
Rockefeller Center
New York, NY 10020
212 841-3663
Contact: Nancy Kirkland

Tom Stack and Associates
3350 Cortina Drive
Colorado Springs, CO 80918
303 599-9441
Contact: Tom Stack

Stock Boston, Inc.
739 Boylston Street
Boston, MA 02116
617 266-2573
Contact: Mike Mazzaschi

Transworld Feature Syndicate
142 West Forty-fourth Street
New York, NY 10036
212 986-1505
Contact: Elsa Zion

that eventually all of our stock transparencies will be housed in one lab and represented on video disks. Buyers around the world who want a particular image will punch it up on their terminals, using satellite communications, and they will use a number at the lab that will then make the separation, masks, dupes, or whatever. The transparency will never leave the building.

"Buyers will have to be trained for this new system. An art director envisions a picture and sends an assistant to the library to find it. The problem here is that we have to have a common language to retrieve the right pictures. For instance, a guy says

he wants a picture of a golf ball just about to enter the cup. What he really wants is a picture of anticipation. What he is doing is finding a way to visually communicate.

"The international market also helps us with clients who want large orders. We now have an arrangement to market 10,000 photographs for a German publishing firm, but say TWA needs 60 transparencies for a brochure. We have 58 in our files the art director likes. The other two must be photographed, one in London and one in Paris. The art director can hire one of our photographers who lives in Paris and one who lives in London to com-

plete the request. Such an assignment is inexpensive, but some of our assignments have sold for a high fee. One week's shooting brought in $30,000."

Jeanne Upbin is director of photographic services at Image Bank. She and her staff have the most critical job in an agency — editing, filing, and distribution of slides to customers and to Image Bank offices throughout the world. They also know what sells. Image Bank primarily supplies pictures to clients who are selling products, ideas, and travel. Here are Upbin's tips for stock photographers who wish to sell their work internationally:

- Leave space in the image for copy or a product. Shoot horizontals and verticals, close-ups and distance shots. Vary the placement of the image within the frame so that copy could be put to the left, right, or above the image.

- Use Kodachrome film, either 25 or 64 ASA. It is sharp, has good color and longevity, and reproduces on the printed page very well. Image Bank prefers 35 mm slides, although they also file larger transparencies.

- If the subject appears very salable (a couple on a beach, the Eiffel Tower, the New York City skyline at dusk, a geothermal plant), shoot forty photos of the same subject so they can be distributed as originals. If there is only one shot, it can be duped for distribution, but that means time and money. Originals go immediately into the files and out to the client.

- Because of Image Bank's international market, photographers should consider shooting models who can pass as European, American, or even Latin American. A photograph of a jogging couple, for instance, would be more salable with plain T-shirts rather than T-shirts that advertise a product or that show words in English.

- Releases are of the utmost importance, and releases apply to more than people — to homes, private planes, race cars, boats, and antique automobiles.

- Be aware of trends in fashion, business, occupations, and industry. Energy photographs are very important now, as are health subjects, particularly older couples participating in active sports. When a city skyline changes, new photographs are needed. The top of the Chrysler building in New York has been relit and so it must be shot at twilight and at night. Image Bank's international offices are having a number of requests for photographs that show rural America.

- Image Bank now has over two million images and over two thousand subject categories in the New York library, so a very broad range of photographs are needed. It is always looking for creative, strong photographers, and believes that in the present market, it is better for a younger photographer to specialize and develop a strong style. As the photographer matures he or she can expand the subject range according to what sells.

Image Bank spends heavily to market itself and its photographers. It produced an award-winning audiovisual show, which is shown to clients internationally. It printed a color catalog of transparencies (the photographers paid half the printing cost, Image Bank the rest), which was sent to all clients. It has a large selling staff and close communications between the franchised offices and New York to coordinate complex sales. Some photographers feel that stock houses will become more important as assignment expenses increase, causing more clients to shop for their needs in stock houses. Image Bank, banking on quality and a pricing structure that is top-of-the-line, hopes to have an international lock on this market.

The Business
of Photography

Deep inside the photographic psyche is a fundamental guilt about money. Photography, we seem to be saying to ourselves, is an enjoyable occupation; its roots for many lie in the pleasant realm of avocation. To further compound this guilt, photography has in recent years entered the rarefied climes of "art."

How, then, can one justify being paid for such an occupation? Isn't it downright crass to associate lucre with this kind of work? Who can ask for money to take photographs?

An old sage once said, there are three reasons to work: profit, profit, and profit.

The fact is, what you are selling is not a photograph or a series of photographs, but your time, talent, know-how, and the risk of being in this business — which includes overhead costs and competing with other photographers. Any photographer can discount his or her price — and thereby discount the value of his or her creativity, thinking, and self-worth — and get a job. Unfortunately, too many photographers do cut their rates in order to get visibility, a prestigious credit line, or a large display of their work.

"Talent is the last to know the value of its worth," said Barbara Gordon, president of the Society of Photographers' and Artists' Representatives, at an ASMP seminar on negotiating assignments. "You have to take a stand and not be afraid to take it. If you take it, he takes it, she takes it . . . we will raise the standards for the rest of the people who won't take a stand."

Unfortunately, clients, the buyers of photography, are only too aware of the vulnerability of photographers and other creative people. They know that for every photographer who stands up for his or her needs, rights, and dignity, there are another dozen hungry (real or perceived hunger) photographers out there who will do the job for less. This is a risky business and each time a photographer cuts rates, he or she increases the risk and the hazards of being in it.

"If you were put on the payroll and given profit sharing, a pension, social security, unemployment insurance, workmen's compensation, and so on, it would cost the client one hell of a lot," according to Gordon. "The fact is that you maintain this operation yearly at your expense and for the two or three days a year that the client takes advantage of it. It is only fair that they pay a premium rate for it. There is nothing wrong with asking your just due."

Getting Your Worth

"We have a budget."

Fair enough. Everyone has a budget, including picture buyers and picture takers. But those four words do not mandate that items within a budget are inflexible or unalterable.

The technique of bending and changing budgets, rates, and prices is called negotiating. "The core of all negotiation is psychological," says Burt Glinn, past president of the American Society of Magazine Photographers. "You have to be willing to lose work in order to get work on a negotiated basis. Otherwise you are simply accepting terms."

Effective negotiation is based on all parties knowing what they need and want, and all having some willingness to adapt and give in order to achieve those ends. For the photographer, then, the first step is knowing his or her worth for a specific time span, effort, or achievement. This is a calculated amount that can have some margins and profit segments built in. The amount is, of course, also predicated on the established rates and fees being paid to other photographers — and this information is easily acquired and factored into your basic monetary requirements.

Unless you have an agent or a rep selling your photographic services, the actual negotiations are usually a face-to-face confrontation. But don't get the idea that negotiating is armed warfare or a hostile exchange. It should be a friendly trading of data and ideas for which you need to be mentally and physically ready, with facts and a good night's sleep.

Negotiating Tactics

"If you are at the bargaining table, you belong there, you are equals and you should not feel inadequate," said Philip Cowan, a New York attorney who represents photographers in various negotiations, at an ASMP seminar on negotiating fees. His statement supports the obvious conclusion that you must be convinced of your worth, know what you need to do a job, and feel that you deserve what you are asking for. The most difficult thing to get in any negotiation is something that you feel you don't really deserve.

To reach a mind-set of absolute conviction about your worth, there a number of steps to follow in preparation for negotiation and a number of procedures to use during the negotiation itself. These tactics have a chronological order, but they also overlap, are subject to change, and often need to be repeated during the negotiation process.

Know what you are after. Begin by calculating your

Travel Time and Rain Days

When you're traveling, you're not taking pictures. You are not working! But at the very minimum you should receive half of the basic day rate for time spent getting to the shooting site. Many photographers advise getting full day rates for lower-paying assignments such as editorial work.

The same billing procedures apply to work canceled because of weather conditions unless the client notifies the photographer at least two days in advance. Even with forty-eight hours' notice, many photographers bill at half the basic day rate for the job. In any case, all expenses and costs should be paid by the client.

expenses, overhead, salary, and a margin for error. With this you'll know what you need to be paid for the work to be profitable. If it's a job that requires an estimate of expenses to be covered by the client, be sure you have all the facts required. At the ASMP negotiating seminar, Joe Toto, a leading advertising and illustration photographer, said that it often takes him two days to do an estimate. "I am very cautious about expenses because this has to do with my overhead," he said. "My secretary and I learn as much as we can about the job and plan it out before doing an estimate. . . . The photographer should explain to the client the expenses involved, and if they line up logically for the job, the art buyer will be free to choose a photographer on talent and not on who bills for what incidentals."

Part of the estimating process is figuring the time required to do the job, to prepare to do the job, and to finish the job with editing and a presentation. Time calculations can be based on fee guidelines resulting from surveys conducted by the American Society of Magazine Photographers. (You may obtain a free copy of "Assigning Photography: The Basic Considerations" by writing ASMP, 205 Lexington Avenue, New York, NY 10016.)

For this step — knowing what you are after — to be successful, you must present a fair price and legitimate expenses. But you must also be prepared to turn the job down; to take a walk. "I strongly believe you have to take a stand," said Jay Maisel, noted annual report and documentary photographer, at the ASMP negotiating seminar. "[You must] say what you want and if you don't get it, you walk

away clean. That's important. You never get what you don't ask for. You have to be willing to walk away from the deal. You can't say, 'My fee is X,' and then say, 'But it's negotiable.'"

Learn what the client wants and expects. In preliminary discussions by phone or when making an appointment to discuss details of the assignment, don't be afraid to ask questions about the job. What does the client want to achieve from these pictures? What will they be used for? Are any secondary uses planned? How long does the client estimate the job will take? Is there a deadline on the job?

Your investigation into the client's real and perceived needs doesn't stop there. Ask other people who have worked with this client how pliable the client is and on what points he or she will give. Some photographers share such information, but you may also ask illustrators and writers, former employees, or people in other departments of the company about the client's areas of concession. It's important, however, when talking with the client, to never reveal how much you know or that you know anything from these outside sources.

You may also get budget and fee statistics before entering negotiations. For advertising jobs, you can get advertising budgets of corporate accounts from the "Red Book" (*Standard Directory of Advertising Agencies*, published by the National Register Publishing Company). For other jobs, such as annual reports and editorial work, you can ask over the phone what the client's regular rates are — and even determine whether a negotiating session is worthwhile.

Establish your expertise early. Whatever got you in the door — your portfolio, a promotion piece, an ad in a directory, or a personal reference — can be utilized to enhance your position as an expert and a talent during the actual negotiations. You should build on these credentials and add other achieve-

Reshooting

In a first letter to a client, one photographer's rep establishes an understanding about reshooting: ". . . if [the photographer] fails to execute the assignment through some error on his part, he will reshoot it charging only expenses. However, if the client changes the assignment after it has been completed or fails to make crucial arrangements, then the resulting reshoot will be treated as a new assignment and fees plus expenses will be billed."

ments or selling points to those that the client knows about. Brag, but nicely.

Once your credentials are clearly established in the client's mind, explain the ways that your particular skills can meet his or her needs. It's during this phase that you'll need to ask knowledgeable questions as well as educate the client about how you operate. "Most [clients] underestimate the time involved for a good job," said Peter Paz, a top New York corporate photographer, at the ASMP seminar on negotiating. "It's out of ignorance. You must educate the client as to what the job requires."

Essential to creating an aura of expertise is having a professional attitude and style in your presentation and discussion. As one photographer put it: if you want to stay hungry, look hungry. Put more positively, you have to believe in yourself.

Don't rush the negotiating process. Let time be on your side by not revealing that you have a deadline. If the client indicates that there is a time limit, use this deadline to your advantage. Observe and listen to the client's explanations and point of view about the job, ask questions to fill in blanks, and be very thorough in gaining an understanding of the client's needs.

Be equally thorough in stating what you want and need in order to do the job properly. Be persistent in giving step-by-step explanations of your method of operating, assuming that the client knows nothing at all about the way you work. "Make the client feel it is abnormal to do anything different," advised Paz. Have something in your demands that you are willing to give up — in other words, overstate your requirements so that you can concede a point as the client gives a point.

During this stage in the negotiations, you can let time be your ally by appearing to be unrushed. Hang in and keep explaining your position and needs. But throughout, never regard the client as an opponent. Treat him or her with respect and expect the same kind of dignified treatment in return.

Close the negotiations on your terms. If you're close to an agreement and you know that negotiations must soon end, then present your ultimatum and final concession. At that point you must be prepared to walk away without getting the job if your needs are not met.

Once you get the assignment, you can bring up

Join

That there is strength in numbers is without question. And photographers, like every other group of people in America, are joiners — of camera clubs, trade associations, and commiserating societies.

Trade associations for people who free-lance or those who own their own businesses are very useful. They can supply educational information, file legal briefs as amici curiae (friends of the court), conduct surveys of members, negotiate with groups of clients, set standards and codes of ethics, hold seminars and clinics, get group insurance programs, and act as sounding boards and meeting places for friends in similar circumstances.

The principal associations for professional photographers in the United States are:

American Society of Magazine Photographers (ASMP) 205 Lexington Avenue New York, NY 10016	National Press Photographers Association (NPPA) Box 1146 Durham, NC 27702	Professional Photographers of America (PP of A) P.O. Box 7197 Chicago, IL 60680

ASMP general membership is open to photographers earning 50 percent or more of their income from work in the communications media, including advertising, corporate industrial, editorial, fashion, book, audiovisual, television, and film. Those who do not fulfill this qualification can apply for associate membership, but must apply for general membership within 36 months. There are more than 2600 members nationwide.

Benefits from ASMP membership include a newsletter (*The Bulletin*), group insurance plans, seminars and workshops, listing in a membership directory, and group discount rates on some services. Headquarters is in New York City, but the organization has 20 chapters in major cities throughout the country. Membership dues are from $125 to $250 for general members, based on annual gross income, and $75 for associate members. There is a $75 application fee for associates; $125 to $250 for general members.

NPPA membership is open to full-time working newspaper, magazine, television, and newsreel photographers, but also includes free-lance photographers, photo editors, photographic manufacturers' reps, industrial photographers, and photojournalism teachers. The organization is divided into 11 geographical regions that administer programs and information for members. Throughout the United States and Canada there are more than 6300 members.

Members receive a monthly magazine (*News Photographer*), regional newsletters, photo courses at reduced fees, group insurance policies, and opportunities to compete for prizes and recognition in nationwide picture competitions. There are 20 chapters in cities across the country. Membership dues are $40 a year.

PP of A membership is open to commercial, portrait, and industrial photographers, but includes various degrees of activity in these fields, as well as photography teachers, students, and people in manufacturing and distribution of photographic products. Worldwide there are more than 15,000 members.

Membership benefits include a subscription to *The Professional Photographer,* and opportunities to attend the Winona School of Photography at reduced rates, take off-campus courses, get technical and business advice, apply for group insurance, and receive promotional kits. The organization also runs a merit and degree program offering Honorary Master, Master of Photography, Photographic Craftsman, and Photographic Specialist certificates. There are 212 chapters in the United States and other countries, including Japan, France, Mexico, England, and Israel. Membership fees range from $20 for students to $130 for professional active members to $165 for sustaining national members (commercial interests).

In addition to these organizations, there are numerous specialized photographers' groups, such as those involving architectural, wedding, educational, evidential, biological, and underwater photography. There are also numerous industry groups, like those for photo marketers, studio suppliers, and photographic equipment repairmen. For a full listing of organizations consult *Photography Market Place,* by Fred W. McDarrah (R. R. Bowker), or *The Business of Photography,* by Robert M. Cavallo and Stuart Kahan (Crown Publishers, New York). If you can't find it, form it.

sensitive or difficult points to be finalized. These points should not be fundamental to the job itself, but may cover issues like hiring an assistant or fees for travel time. You are more likely to get what you want at the end of the negotiating session after the basic agreement has been made, because the client has invested so much time and effort in reaching that point. Again, perseverance pays off.

The final step in striking the deal is to get it in writing. You might ask for an assignment letter or write one yourself and send it to the client for a signature. Better yet, create a form or a contract that includes all the elements of assignment agreements. Clients, particularly in advertising, are accustomed to seeing this form and will sign for what you have agreed upon. Be sure to also get an advance (usually one-third of the job price) before you leave with the contract. If the client balks at this, be suspicious. In fact, a payment schedule — such as one-third up front, one-third on delivery, and one-third when accepted — should be understood and part of the agreement.

Pricing Yourself

The going rates for assignment photography are determined by several factors in several different ways: (1) the photographer's reputation and/or experience; (2) the use to be made of the photographs, including the frequency or circulation of the media; (3) what the client can get versus what the photographer demands.

The economy appears to be locked into double-digit inflation, yet too often photographers' rates are static. Some magazine editors sheepishly admit that they haven't raised rates in twelve years, yet they are able to continue because there is a stable of photographers who will work for less and less.

Over the years, photographers have struggled to set standard rates or at least strong guidelines to determine fair pay for their work. The American Society of Magazine Photographers, which was formed in 1944, spearheaded efforts to establish rates by publishing suggested fees. In 1973 the organization published *Professional Business Practices in Photography*, with information on how to protect copyrights and get written contracts, as well as a list of suggested rates. Revised in 1979 and again in 1982, the *Business Practices* is the standard reference for photographers as well as picture buyers. Sadly, it is not always followed.

An article on photographic rates in *Folio* magazine (December 1980), a publication for magazine management, had this to say: "Most photography directors, editors and design consultants contacted . . . said they think ASMP rates are generally too high.

Women Do It, Too

In a profession dominated by men, women need support. That's the prime reason for the existence of a group called Professional Women Photographers. P.W.P. grew out of two photographic events by and for women: an exhibit of photographs during the International Women's Year in 1975 and the publication of a book, *Women Photograph Men*, in 1978.

The women who participated in these events decided to form a group in 1978 and since that time membership in P.W.P. has grown to more than three hundred. Those located in New York City meet monthly to hear speakers (women and men), share information, and provide encouragement.

A number of the most acclaimed women photographers belong to the group and there is a growing interest from women outside the New York City area. P.W.P. publishes a monthly tabloid covering meetings and other women's photographic news. Headquarters for the organization is Photographics Unlimited, 43 West Twenty-second Street, New York, NY 10010.

'When we arrange photography for one of our magazine clients, we usually pay photographers 50 percent or 75 percent of the guideline rates listed by ASMP for the particular type of assignment,' says one design consultant. 'But top photographers, of course, command top rates. And even in other cases,

Don't Join

Don't join any organization that promises moneymaking opportunities within a set number of days. Such hard-sell outfits purport to deliver inside tips and the true secrets of selling photographs. What they actually tell the gullible is that you need to work hard at researching markets, keep records of submissions, and take good pictures to make money. (If you were doing those things, you wouldn't have time to join such organizations and read their hype.)

Legitimate organizations of professional photographers have standards for admission and offer common goals for the group. Phony organizations can be spotted by their aggrandizing names and offers to help members increase intangibles, like creativity. What you get is a rehash of stale ideas from photo magazines.

You're better off to read this book.

Assignment Photography Fee Ranges

	NATIONAL ADVERTISING	TRADE ADVERTISING
Spread in color	$2000 to $3500	$1000 to $2500
Spread in black and white	$1500 to $3000	$2000 to $2500
Single page color	$1500 to $3000	$750 to $2000
Single page black and white	$1000 to $2500	$750 to $2000
Billboards	$1500 to $3000	$1000 to 42500
Stills for TV commercial	$1000 to $2500	
Products and packages	$1000 to $2500	

DAY RATES — GUARANTEE AGAINST USE

Reportage in general	$350 to $700+
Reportage under 2 hours	$250 to $350+
Illustration	$350 to $1400+
General documentary	$350 to $700+

CORPORATE/INDUSTRIAL DAY RATES

Annual reports	$600 to $1300+
Brochures	$400 to $1200+
Filmstrips	$400 to $900+
House organs	$400 to $700+
Trade slide shows	$400 to $900+

you have to be open to negotiation, depending on the particular assignment.'"

What this reflects, of course, is the supply and demand equation: too many photographers for the amount of work available. If photographer A won't do the assignment for the fee offered, photographer B will.

What's the answer? Let your conscience be your guide and get to know rates charged by other photographers as revealed in surveys taken by ASMP.

Figuring Overhead

Overhead might refer to your roof, but if you're a smart photographer you know that it refers to all those expenses not directly related to the cost of performing any particular job. The trouble is, most photographers count only the obvious in estimating costs and then they figure on the lowest dollar amount possible.

Richard Weisgrau, a successful Philadelphia photographer, wrote the following account in the *ASMP Bulletin* of how he calculates overhead:

What's in a Picture?
by Richard Weisgrau

On a recent visit with an art director, I had the unusual experience of hearing an agency client somewhat forcefully ask the account executive for an explanation of the high cost of the photography. Basically, he could not understand how a single photograph could cost $1750.

This experience started a defensive reaction on my

Photographers' Write-offs

Photographers, who among other services sell stock, can have a very advantageous deduction for the IRS. Where your ideas come from — magazines, books, newspapers, and other people over drinks or dinner — is tax deductible. Anywhere you travel and take photographs that are for sale can be tax deductible. Your camera equipment is depreciated on a schedule. Your film and processing are very legitimate expenses, as is repair. Your studio and office are legitimate expenses. If you incorporate, your company can supply you with a corporate car and an expense account, pay your medical fees, insurance, and so on. See your accountant for details of allowable deductions and expenses.

part, and soon I began to wonder what response I would give if that very question were asked of me.

Back at the studio, I pulled out a quarterly statement and after some thought about what the average $1750 billing translates into in terms of work, I broke it down to see just how it related to the overall operation. The job accounted for .48 percent of the total billing of the studio. Based upon that percentage, I am allowed 1.2 working days in studio without going into the red. A certain capacity is required for this. Let's look at the breakdown of this fee in relationship to the overall studio operating statement:

DESCRIPTION OF COSTS:	AMOUNT:	PERCENT:
TOTAL SALE	$1750.00	100
Production salaries	287.00	16.4
Supplies and props	152.25	8.7
Outside services	91.00	5.2
Film and processing	145.25	8.3
Models	183.75	10.5
Payroll taxes	49.00	2.8
Auto and travel	52.50	3.0
Promotion	52.50	3.0
Bank charges	3.50	.2
Camera repair	5.25	.3
Professional dues	3.50	.2
Depreciation	8.75	.5
Utilities	12.25	.7
Benefits	1.75	.1
Freight	14.00	.8
Insurance	26.25	1.4
Interest	8.75	.5
Legal and audit	8.75	.5
License and permit	10.50	.6
Office expense	14.00	.8
Office salaries	122.50	7.0
Rent	56.00	3.2
Telephone	10.50	.6
Officer's salary	183.75	10.5
Sales commission	175.00	10.0
Total costs	$1678.25	95.8
Before-tax profit	$ 71.75	4.2

And all these figures hold true if you can do the job in the allotted 1.2 working days.

This started my thought processes. All one has to do is reduce any of the percentages, in substantial amounts, and he can produce work at a lower cost than anyone else; in other words, you can corner the market. So, I created a Utopia on paper and found that I could do the photograph for half the price. Of course, it meant that I would be working out of my apartment with no staff and dependent on outsiders for all the required services, plus the fact that the job would only take about five or six days depending upon the reliability of my suppliers. Naturally, this would start after I was able to find and lease enough floor space to do the shoot. That's Utopia.

What's in a picture? Rent, insurance, salaries, taxes, film, interest, supplies, models, and a few other aesthetic elements.

All of this thought and research completed, my phone rang. It was someone for whom I had just done a color shot. The person wanted to know why a $1500 picture had to be held up to the light to see it.
(*Reprinted from the ASMP Bulletin*)

Estimating Costs

Studio photographers are usually the only ones who have to account for their expenses up front and that's because they have heavy costs to execute a job: sets to make; models to cast; hairdressers, makeup people, and other specialists to hire; props to rent or buy; as well as the usual overhead and operating costs to cover. There is a growing tendency in these bottom-line times for corporate and even editorial assignment buyers to ask for estimates of expenses on larger shoots. That practice is okay as long as you follow carefully established procedures that any good business person needs to use:

1. Be sure the client agrees in advance to a fee-plus-billable-expenses deal. (Usually wedding and commercial portrait photographers work on a flat-fee basis with extra charges for prints beyond a set number.)

2. Cover every conceivable expense in your estimate, but be sure the client understands that unforeseen costs can come up and that these should be covered, too.

3. Charge a markup or service fee on expenses. This means that when purchasing items like film and paper, you can add 10 to 25 percent, as is the practice in TV and film work.

4. Be sure to include your time for making the estimate.

5. Be scrupulous in keeping records, receipts, and documents to prove expenditures. Have a file folder or envelope to hold bills for each client; near your business phone have a book to record the last

four digits of long-distance calls with the client's name or initials; keep a diary to record time spent organizing, estimating, and planning jobs, to be sure you are calculating your salary or profits properly.

Pricing Your Stock

Generally, doing your own stock sales is a losing proposition. The time, the paperwork, the follow-up hassle, and worry are not worth the rewards — unless you have a specialization that is unique and for which you are well-known. Then it pays to sell stock.

If you fall into that category, or are simply so renowned that buyers come to you for stock sales, your individual sales should start at $500 and go up. In other words, *they should equal the cost of going out and making the photograph on assignment.* Another way of looking at profitable stock sales is that you should sell between $800 and $1000 per week, have a full-time assistant dealing strictly with your stock photos and a huge well-organized library.

Because most photographers can't meet either of those criteria, they use stock houses or agencies to sell pictures. Stock agents may deal in the exotic and high-priced work of name photographers or they may sell the bread-and-butter pictures of less-established photographers. The latter type of agent can deal with the routine requests that net from $75 to $100 per use particularly if they are selling quantities of pictures for a publisher of textbooks or encyclopedias.

The fact is, though, many photographers do sell their own stock, make a few bucks, and enjoy seeing their work published. In that case, you should charge a research or service fee of from $50 to $100 that is applicable against the purchase of the photographs. You should also charge a holding fee of $1 per item per day after 14 days. These conditions must be set up front and maintained by all photographers who sell stock.

You might ask, what's the point of being so sticky about pictures that are just lying around in my files anyway? These answers came from photographers at an ASMP seminar on stock photography:

John Lewis Stage: "If you don't keep your stock prices up, you won't have any assignment work."

Scott Heist: ". . . the research fee will guarantee

Shooting Seconds, Similars, and Dupes

You probably thought that motor drives were designed for shooting fast action and sports. Wrong! Motor drives are for shooting duplicates (incidentally, this is the quickest, cheapest, and most accurate way to make duplicates). Some photographers shoot dupes of bracketed shots — two stops in either direction — and they don't stop at one dupe, but may go for five or six of notable or momentous situations.

The point is, duplicates or close seconds (similars) of situations that are in flux are valuable for additional uses as well as for your portfolio and future distribution. Most clients expect the photographer to edit the take and provide them with the best. Occasionally art directors will ask for a shot with greater saturation or a slightly different angle, but normally a vertical and a horizontal of a setting or a few variations are all they want.

the payment of your staff person if you have enough stock requests coming in. It can pay, or maybe you'll just break even on it."

Jay Maisel: "I charge $50 minimum service fee and $100 for someone who doesn't buy and is constantly using us for reference material. This discourages browsing."

Peter B. Kaplan: "I don't allow clients to hold photographs beyond 21 days. If they do, they are charged $10 per photograph per week."

Scott Heist: "Stock photos are our residuals, and they are important to us because our residuals are our future security. It is incumbent upon us to make those residuals work for us in our best interests. We're the only ones who can do that."

And, from a stock agency, Al Forsythe, who runs Design Photographers International, had this to say at the ASMP stock photography seminar: "Photographs are not apples and oranges, they are individual creations that must be priced individually. Are you going to stand up for a price you believe is right when it's based on the value of the picture you're selling, or are you going to give it away? You've got to be willing to say to yourself that you might lose the sale. It's $1000 and you may really need that $1000, but if you're thinking of it in that way, you'll always lose. . . . If you've got a unique picture, stand up and get the price it's worth."

The sample rates given here are a compilation

Stock Photography Fee Ranges

CONSUMER MAGAZINE ADVERTISING	Quarter Page	Full Page
National Circulation		
Under 500,000	$425	$850
500,000–1,000,000	$600	$1200
1,000,000–3,000,000	$750	$1500
Over 3,000,000	$1250	$2500
Regional Circulation		
Under 250,000	$400	$800
250,000–500,000	$500	$1000
500,000–1,000,000	$600	$1200
Over 3,000,000	$750	$1500
Local Circulation		
Under 100,000	$350	$700
100,000–500,000	$425	$850
Over 500,000	$500	$1000

BROCHURES AND CATALOGS	Quarter Page	Full Page
Press Run		
Under 20,000	$175	$350
20,000–50,000	$200	$400
50,000–100,000	$225	$450
100,000–250,000	$275	$525
250,000–500,000	$325	$625
500,000–1,000,000	$375	$750
1,000,000 and over	$450	$875

DAILY NEWSPAPERS	Quarter Page	Full Page
Circulation		
Under 250,000	$165	$275
Over 250,000	$255	$425

CORPORATE/INDUSTRIAL	Quarter Page	Full Page
Circulation		
Under 10,000	$250	$400
10,000–20,000	$300	$500
20,000–50,000	$315	$525
50,000–100,000	$325	$550
100,000–250,000	$375	$600
250,000–500,000	$425	$700
500,000–1,000,000	$500	$800
1,000,000 and over	$550	$900

POSTERS		
Press Run–U.S. Distribution		
Under 10,000	$350	to $525
10,000–100,000	$500	to $725
Over 100,000	$650	to $950

MAGAZINES	Quarter Page	Full Page
Circulation		
Under 250,000	$180	$300
250,000–500,000	$210	$350
500,000–1,000,000	$255	$350
1,000,000–3,000,000	$330	$550
3,000,000 and over	$405	$675

SUNDAY SUPPLEMENTS	Quarter Page	Full Page
Circulation		
Under 1,000,000	$225	$375
1,000,000–3,000,000	$300	$500
3,000,000 and over	$360	$600

that ASMP derived from surveying its members. They are based on *one* usage in a U.S. publication. For additional suggested rates, refer to the ASMP 1982 edition of *Professional Business Practices in Photography*.

The Paper Trail

Whatever you do, get it in writing — that goes for any photographic transaction. A survey of professional photographers revealed that collection of fees was one of the top three problems they encounter. (Just slightly ahead were "fees too low" and "inflation" as major problems.)

"Many photographers fail to understand that they are in a business and should treat it as a business," says Stuart Kahan, executive director of ASMP. "A number of them are not resolving basic issues up front when they are called for an assignment. They should outline what they are being hired for and solidify the terms of the assignment or transaction on paper: you are hired to do this, you are to be paid X dollars, you are to be paid at certain time periods, the client has X rights to what is produced, the photographer has X rights and gets a credit line with a copyright, or not. That's the bare bones of it. It needs to be written out at the beginning rather than wait for later when misunderstandings can come up."

Business Aids

High-tech times call for high-tech helpers: forms, records, and rubber stamps. Such systems keep you organized and move work along faster. Here are sources of business materials that are especially good for photographers:

New England Business Service, Inc.
500 Main Street
Groton, MA 01471

This company prints all kinds of business forms from bills and statements with "carbonless" copies to envelopes and letterheads. All can be imprinted with your name, address, and telephone number in the company's typefaces. They also produce two photography contracts, one for studio and one for wedding jobs. Very professional and businesslike.

Day-Timers
Allentown, PA 18001

One of the many companies creating effective business diaries, Day-Timers has diaries with some features appropriate for photographers. In addition to the usual appointment spaces, these books have daily time records, expense records, and a long-range project planning section. There are several pocket sizes as well as desk versions.

Jackson Marking Products
Brownsville Road
Mount Vernon, IL 62864

The one rubber stamp essential for all photographers is a copyright mark with his or her name and the year-date. This company makes personalized copyright stamps to order as well as some standards that are useful for photographers, such as: "Photographs — Do Not Bend," "Date and File Number," "For one use only, additional rights available," and so on. Some of their stamps are gimmicky or cute, but there are many useful ready-made types, too.

Executive ScanCard Systems
6480 Busch Boulevard
Columbus, OH 43229

This is a device to track projects and monitor their progress. It consists of a loose-leaf-size holder with 64 pockets for $3\frac{1}{4}$-×-$3\frac{1}{4}$-inch cards. The cards come with three-color coded stripes that are visible along with the top half-inch of the card. A supply of 500 ScanCards comes with the holder. The Executive ScanCard device comes in three sizes.

Clearly, a written agreement is easier to enforce than an oral agreement and, if it's simple yet detailed enough, it avoids confusion about what is to be done, who gets what, when, where, and how.

Photographic agreements that should be in writing fall into three major categories: (1) assignment contracts, (2) stock photography transactions, and (3) model releases. No single set of forms covers all situations or all photographers. What *is* important for all photographers in the business of making money at photography is to create a trail of paper recording, confirming, and acknowledging any agreements that have been made.

Following are sample forms from several sources. Using forms that include the elements put forth here can create precedents that benefit all photographers as clients become accustomed to signing such agreements.

NEGATIVE #_____
DATE _____
LOCATION _____
SUBJECT:

ALL REPRODUCTION RIGHTS to this photograph are reserved except as specified in writing.

NOT FOR REPRODUCTION
WITHOUT PERMISSION

**PHOTOGRAPHS
DO NOT BEND**

ALL MATERIALS
MUST BE RETURNED.

ONE REPRODUCTION ONLY
All other rights reserved
PLEASE CREDIT PHOTO TO:

FOR PRIVATE USE ONLY
NOT FOR REPRODUCTION
NOR PUBLIC DISPLAY

© Copyright 19__

Photograph may NOT be reproduced in any form without permission and without an adjacent credit line.

ONE - TIME REPRODUCTION
RIGHTS ONLY. ALL OTHER
RIGHTS RESERVED.

MODEL RELEASE
AVAILABLE

DO NOT X-RAY EXPOSED PHOTOGRAPHIC FILM

COPYRIGHTED PHOTOGRAPH
THIS PHOTOGRAPH IS NOT TO BE REPRODUCED, TELEVISED, OR COPIED IN ANY FORM WITHOUT WRITTEN PERMISSION.

Janet Nelson
All rights reserved

Frame no.
Negative no.

Contents--Exposed Film
HANDLE WITH CARE! DO NOT CRUSH!

©JANET NELSON 1981

JACKSON RUBBER STAMP CO.

(REPRINTED COURTESY OF THE AMERICAN SOCIETY OF MAGAZINE PHOTOGRAPHERS)

Assignment Confirmation/ Estimate/Invoice Form

FROM:	TO:	
		Date:
		Subject:
		Purchase Order No:
		Client:
		A.D./Editor
		Shooting Date(s)
		Our Job No:
		☐ Assignment Confirmation
		☐ Job Estimate
		☐ Invoice

Expenses

ASSISTANTS
CASTING
 Fee/Labor
 Film
 Transportation

FILM & PROCESSING
 Black & White
 Color
 Polaroid
 Prints

GROUND TRANSPORTATION
 Cabs
 Car Rentals &/or Mileage
 Other

INSURANCE
 Liability
 Other

LOCATION SEARCH
 Fee
 Labor
 Film
 Transportation

LOCATION/STUDIO RENTAL
MESENGERS & TRUCKING
 Local
 Long Distance

SETS/PROPS/WARDROBE
 Set Design Fee
 Food
 Materials
 Props
 Set Construction
 Set Strike
 Surfaces
 Wardrobe
 Other

SPECIAL EQUIPMENT
SPECIALIST ASSISTANCE
 Electrician
 Hairdresser
 Home Economist
 Make-up Artist
 Stylist
 Other

TALENT
 Adults
 Children
 Extras
 Animals

TRAVEL
 Air Fares
 Meals
 Hotels
 Overweight Baggage

MISCELLANEOUS
 Gratuities
 Shoot Meals
 Toll Telephone
 Other

EXPENSE TOTAL

Photography Fee(s) & Totals

PRINCIPLE PHOTOGRAPHY (BASIC FEE) $
($_____ per day or photograph, if applicable)

DESCRIPTION

SPACE &/OR USE RATE (IF HIGHER)
($_____ per page: $_____ per cover: $_____ per photo)
TRAVEL &/OR PREP DAYS (at $_____ per day)
PRODUCT OR SUBSIDIARY PHOTOGRAPHY
($_____ per photograph)
POSTPONEMENT/CANCELLATION/RESHOOT
(_____ % of orig. fee)
WEATHER DAYS (at $_____ per day)

TOTAL FEE(S)
TOTAL EXPENSES (see 1st column)
FEE PLUS EXPENSES

SALES TAX (if applicable)

TOTAL

ADVANCE

BALANCE DUE

MEDIA USAGE

ADVERTISING		EDITORIAL/JOURNALISM	
Animatic	☐	Book Jacket	☐
Billboard	☐	Consumer Magazine	☐
Brochure	☐	Encyclopedia	☐
Catalog	☐	Film Strip	☐
Consumer Magazine	☐	Newspaper	☐
Newspaper	☐	Sunday Supplement	☐
Packaging	☐	Television	☐
Point of purchase	☐	Text Book	☐
Television	☐	Trade Book	☐
Trade Magazine	☐	Trade Magazine	☐
Other	☐	Other	☐

CORPORATE/INDUSTRIAL		PROMOTION & MISC.	
Album Cover	☐	Booklet	☐
Annual Report	☐	Brochure	☐
Brochure	☐	Calendar	☐
Film Strip	☐	Card	☐
House Organ	☐	Poster	☐
Trade Slide Show	☐	Press Kit	☐
Other	☐	Other	☐

Subject to all Terms on Reverse Side—Which Apply in All Cases Unless Objected to in Writing by the Sooner of the First Shooting Day or Ten Calendar Days. Usage Limited to Reproduction Rights Specified

Client Signature: _____

(REPRINTED COURTESY OF THE AMERICAN SOCIETY OF MAGAZINE PHOTOGRAPHERS)

Terms and Conditions

(a) "Photographer" hereafter refers to (insert name). Except where outright purchase is specified, all photographs and rights not expressly granted on reverse side remain the exclusive property of Photographer. All editorial use limited to one time in the edition and volume contemplated for this assignment. In all cases additional usage by client requires additional compensation and permission for use to be negotiated with Photographer.

(b) Absent outright purchase, client assumes insurer's liability to (1) indemnify Photographer for loss, damage, or misuse of any photograph(s)and (2) return all photographs prepaid and fully insured, safe and undamaged by bonded messenger, air freight or registered mail, within 30 days of publication. In any event, client agrees to return all unpublished material to Photographer in the above manner, and supply Photographer with two free copies of uses appearing in print.

(c) Reimbursement for loss or damage shall be determined by a photograph's market value or, in the absence of that due to lack of prior use, then its intrinsic value.

(d) Adjacent credit line for Photographer must accompany editorial use, or invoice fee shall be doubled. Absent outright purchase, client will provide copyright protection on any use and assign same to Photographer immediately upon request, without charge.

(e) Photographer has supplied or will supply specifically requested releases on photographs requiring same for use. Client will indemnify Photographer against all claims and expenses due to uses for which no release was requested in writing. Photographer's liability for all claims shall not, in any event, exceed the fee paid under this invoice.

(f) Time is of the essence for receipt of payment and return of photographs. Grant of right of usage is conditioned on payment. Payment required within 30 days of invoice; 1½% per month service charge on unpaid balance is applied thereafter. Adjustment of amount, or terms, must be requested within 10 days of invoice receipt. All expense estimates subject to normal trade variance of 10%.

(g) Client may not assign or transfer this agreement. Only the specified terms, hereby incorporating Article 2 of the Uniform Commercial Code, are binding. No waiver is binding unless set forth in writing. Nonetheless, invoice may reflect, and client is bounded by, oral authorizations for fees or expenses which could not be confirmed in writing due to immediate proximity of shooting.

(h) Any dispute regarding this agreement, including its validity, interpretation, performance, or breach, shall be arbitrated in (Photographer's City and State) under rules of the American Arbitration Association and the laws of (State of Arbitration). Judgment on the Arbitration award may be entered in the highest Federal or State Court having jurisdiction. Any dispute involving $1000 or less may be submitted, without arbitration, to any Court having jurisdiction thereof. Client shall pay all arbitration and court costs, reasonable Attorneys' fees plus legal interest on any award or judgement.

(i) Additional Specifications: (to be filled in as applicable)
Placement (cover, inside, etc. _____).
Size (½ page, 1 page double page, etc. _____).
Time limit on use _____ Use outside U.S. (if any) _____.
Copyright Credit Line is required in the following form: © 19___ (insert photographer's name).

(j) Client agrees that the above terms are made pursuant to Article 2 of the Uniform Commercial Code and agrees to be bound by same, including specifically clause (h) above to arbitrate disputes.

(k) Weather postponements and cancellations 48 hours prior to shooting, will be billed at ½ fee. Thereafter, full fee will be charged. All expenses, costs and charges shall be paid in full by the agency.

(l) Days put on hold at client or agency request and not cancelled within 24 hours will be billed at full fee. All expenses, costs and charges shall be paid in full by the agency.

(m) All cancellations after confirmation and, or booking a shooting date will be billed at ½ fee if cancellation is prior to 48 hours before shooting date, and full fee if cancelled less than 48 hours before shooting date. All expenses, costs and charges shall be paid in full by the agency.

(n) If same photograph that is cancelled is rescheduled for a later date, full fee will be charged for the actual shooting.

(o) The cost of all charges or deviations from the original layout or job description must be approved by the art director, art buyer or agency representative.

(p) The agency is responsible for sending an authorized representative to the shooting. If no representative is present, the agency must accept the photographers judgement as to the execution of the photograph.

(q) When shootings are booked on a day basis, the day rate shall apply to any consecutive 8 hour period. Any further time will be paid for on a pro-rated basis. All additional expenses (rentals, talent assistants, etc.) due to extended time shall be paid in full by the agency.

Delivery Memo

FROM:	TO:	
		Date:
		Subject:
		Purchase Order No:
		Client:
		A.D./Editor
		Our Job No:

Enclosed please find:

Set No. & Subject:	Format:	35	2¼	4×5	5×7	8×10	11×14	Contacts

Total Black & White	Total Color

Kindly check count and acknowledge by signing and returning one copy. Count shall be considered accurate and quality deemed satisfactory for reproduction if said copy is not immediately received by return mail with all exceptions duly noted

Terms of delivery:

1. After 14 days the following holding fees are charged until return: $5.00 per week per color transparency and $1.00 per week per print.

2. Submission is for examination only. Photographs may not be reproduced, copied, projected, or used in any way without (a) express written permission on our invoice stating the rights granted and the terms thereof, and (b) payment of said invoice. The reasonable and stipulated fee for any other usage shall be two times our normal fee for such usage.

3. Submission is conditioned on return of all delivered items safely, undamaged and in the condition delivered. Recipient assumes insurer's liability, not bailee's, for such return prepaid and fully insured by bonded messenger, air freight or registered mail. Recipient assumes full liability for its employees, agents, assigns, messengers and freelance researchers for any loss, damage or misuse of the photographs.

4. Reimbursement for loss or damage shall be determined by photograph's value which recipient agrees shall be not less than a reasonable minimum of $1,500.00 for each transparency and $ for each print.

5. Objection to above terms must be made in writing within ten (10) days of this Memo's receipt. Holding materials constitutes acceptance of above terms which incorporate hereby Article 2 of the Uniform Commercial Code, and the Copyright Act of 1976.

6. Any dispute in connection with this Memo including its validity, interpretation, performance or breach shall be arbitrated in (photographer's City and State) pursuant to rules of the American Arbitration Association and the laws of (State of Arbitration) Judgment on the Arbitration award may be entered on the highest Federal or State Court having jurisdiction. Any dispute involving $1500 or less may be submitted, without arbitration, to any Court having jurisdiction thereof. Recipient shall pay all arbitration and Court costs, reasonable Attorneys' fees plus legal interest on any award or judgment.

7. Recipient agrees that the above terms are made pursuant to Article 2 of the Uniform Commercial Code and agrees to be bound by same, including specifically the above clause 6 to arbitrate disputes.

Acknowledged and accepted _____

(REPRINTED COURTESY OF THE AMERICAN SOCIETY OF MAGAZINE PHOTOGRAPHERS)

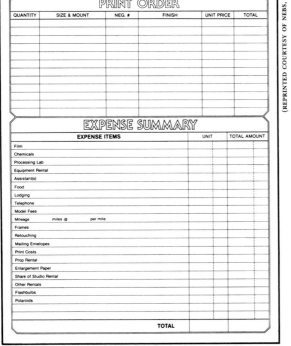

What's It Worth?

To you maybe a lot, but to someone else who loses or abuses your photograph, maybe not much. The question of the worth of a picture or pictures revolves around a test of reasonable value. It is up to the photographer to place such a value on his or her pictures that go out for examination or purchase.

Although some submission contracts stipulate that a reasonable value is $1500 for a transparency and $75 to $150 for a print, in fact, if this price is unrealistic as far as the earning power of the work is concerned, it may not be a collectible amount. A more accurate test of the worth of photographs involves the track record in stock sales of the photographer and, perhaps, the photograph(s) in question. Another point is, what would it cost to reshoot the pictures, if they could be reshot? Also, if other pictures were taken at the same time, do similars exist that could take the place of the picture in question?

There is no simple, clear-cut test of a photograph's worth, but it may pay the photographer to overvalue rather than undervalue his or her creations.

Assignment Confirmation/Estimate/Invoice. This form can be used for any or all of the three functions in its title. Make it out in duplicate or triplicate. Send the client two copies, one to be signed and returned to you before the assignment begins. The expense estimates are subject to variations of 10 percent, or you may simply state that "all expenses are to be paid or reimbursed by the client." Note that you are required to insert your name in several places on the "Terms and Conditions." This is to assure that in cases where there is a dispute, the arbitration will take place in your home state.

Photography Contract and Wedding Photography Contract. These two forms are available imprinted with your name and address from the New England Business Service. They come in sets of three copies and can be ordered in small quantities. On the back of the third copy is a print order form and an expense summary.

Stock Photo Delivery Memo. Forms like these should be used whenever someone asks to examine photographs for possible purchase. It's important to give a brief description of the photographs submitted along with a reasonable statement of value in case they are lost or damaged. Fill out three or four of these forms with each submission of photographs. Keep one copy in your logging-out file, send two to the client (one to be signed and returned to you), and keep one in a "tickler" file to send to the client just prior to the fourteen-day examination period termination date. With such advance warning he or she can't complain about the holding fees. Again, you'll need to insert your name and other data in the "Terms and Conditions."

Stock Picture Delivery/Invoice. When the client has selected photographs and agreed to buy them, this form gives him or her permission to use the material, at the same time it acts as an invoice for billing. Use the company or publication name and address after "To" and fill in all of the data on the right side. Check the appropriate media usage, describe the photographs, and note the agreed-upon fee. Two copies of this form are adequate, but three allow for a follow-up billing.

Releases. While it is always desirable to get a model release, it is not always possible to do so for editorial usage. However, model releases, including those on private property, are essential for advertising and promotional usage. It's best to get releases at the

time you take the photographs and mark the pictures to indicate that releases are available.

A release for adults that covers a broad range of usage is technically preferable to a simplified adult release, which is usually directed toward professional models. However, a long release is often a difficult document to get signed. A release for minors must be signed by a parent or guardian and may be subject to state or local laws covering child labor. The property release is needed when you use buildings as background for advertising or promotional photography.

Other releases can be bought in most camera stores. The short forms come in 3 × 5 card size and are extremely handy to carry in a camera bag. The longer forms cover both adult and minor release situations.

Burt Glinn has won disputes with the following release: "I hereby for good consideration [usually $1] grant permission to [your name] to publish the photographs taken of me on [the date and place] for editorial, advertising, or commercial purposes. [Subject's signature.]"

He advises you to have witnesses sign the release, too.

What Do You Sell When You Sell a Photograph?

Most often you sell one-time rights for North America. That means that the buyer has the use of the image for one time and one purpose, such as for a cover of a magazine. The buyer does not have the use of the photograph for any other purpose. After use, the photograph — the transparency, usually — is returned to the seller, who may sell it again.

There are different rates for broader distribution. One-time world rights in one language is two times the basic fee. Use in each additional language is the basic fee plus 25 percent. One-time rights in five languages is the basic fee plus 100 percent. One-time world rights in all languages is the basic fee plus 200 percent.

Some buyers may want the exclusive use of the photograph, lifetime rights for any purpose, and then only the buyer has the right to use that photograph.

"To give up rights on your photographs is like giving up the skin from your eyeballs," said Cartier-Bresson. Charge accordingly.

Adult Release

In consideration of my engagement as a model, and for other good and valuable consideration herein acknowledged as received, upon the terms hereinafter stated, I hereby grant _____, his legal representatives and assigns, those for whom _____ is acting, and those acting with his authority and permission, the absolute right and permission to copyright and use, re-use and publish, and republish photographic portraits or pictures of me or in which I may be included, in whole or in part, or composite or distorted in character or form, without restriction as to changes or alterations, from time to time, in conjunction with my own or a fictitious name, or reproductions thereof in color or otherwise made through any media at his studios or elsewhere for art, advertising, trade, or any other purpose whatsoever.

I also consent to the use of any printed matter in conjunction therewith.

I hereby waive any right that I may have to inspect or approve the finished product or products or the advertising copy or printed matter that may be used in connection therewith or the use to which it may be applied.

I hereby release, discharge and agree to save harmless _____ his legal representatives or assigns, and all persons acting under his permission or authority or those for whom he is acting, from any liability by virtue of any blurring, distortion, alteration, optical illusion, or use in composite form, whether intentional or otherwise, that may occur or be produced in the taking of said picture or in any subsequent processing thereof, as well as any publication thereof even though it may subject me to ridicule, scandal, reproach, scorn and indignity.

I hereby warrant that I am of full age and have every right to contract in my own name in the above regard. I state further that I have read the above authorization, release and agreement, prior to its execution, and that I am fully familiar with the contents thereof.

Dated: _____

(Address)

(Witness)

Simplified Adult Release

Dated:

For valuable consideration received, I hereby give _____ the absolute and irrevocable right and permission, with respect to the photographs that he has taken of me or in which I may be included with others:

(a) To copyright the same in his own name or any other name that he may choose.

(b) To use, re-use, publish and re-publish the same in whole or in part, individually or in conjunction with other photographs, in any medium and for any purpose whatsoever, including (but not by way of limitation) illustration, promotion and advertising and trade, and

(c) To use my name in connection therewith if he so chooses.

I hereby release and discharge _____ from any and all claims and demands arising out of or in connection with the use of the photographs, including any and all claims for libel.

This authorization and release shall also enure to the benefit of the legal representatives, licensees and assigns of _____ as well as, the person(s) for whom he took the photographs.

I am over the age of twenty-one. I have read the foregoing and fully understand the contents thereof.

Witnessed by:

Minor Release

In consideration of the engagement as a model of the minor named below, and for other good and valuable consideration herein acknowledged as received, upon the terms hereinafter stated, I hereby grant _____, his legal representatives and assigns, those for whom _____ is acting, and those acting with his authority and permission, the absolute right and permisssion to copyright and use, re-use and publish, and republish photographic portraits or pictures of the minor or in which the minor may be included, in whole or in part, or composite or distorted in character or form, without restriction as to changes or alterations from time to time, in conjunction with the minor's own or a fictitious name, or reproductions thereof in color or otherwise made through any media at his studios or elsewhere for art, advertising, trade, or any other purpose whatsoever.

I also consent to the use of any printed matter in conjunction therewith.

I hereby waive any right that I or the minor may have to inspect or approve the finished product or products or the advertising copy or printed matter that may be used in connection therewith or the use to which it may be applied.

I hereby release, discharge and agree to save harmless _____, his legal representatives or assigns, and all persons acting under his permission or authority or those for whom he is acting, from any liability by virtue of any blurring, distortion, alteration, optical illusion, or use in composite form, whether intentional or otherwise, that may occur or be produced in the taking of said picture or in any subsequent processing thereof, as well as any publication thereof even though it may subject the minor to ridicule, scandal, reproach, scorn and indignity.

I hereby warrant that I am of full age and have every right to contract for the minor in the above regard. I state further that I have read the above authorization, release and agreement, prior to its execution, and that I am fully familiar with the contents thereof.

Dated: _____

_____ _____
(Minor's Name) (Father) (Mother) (Guardian)

_____ _____
(Minor's Address) (Address)

(Witness)

Property Release

For good and valuable consideration herein acknowledged as received, the undersigned being the legal owner of, or having the right to permit the taking and use of photographs of certain property designated as _____ does grant to _____, his agents or assigns, the full rights to use such photographs and copyright same, in advertising, trade or for any purpose.

I also consent to the use of any printed matter in conjunction therewith.

I hereby waive any right that I may have to inspect or approve the finished product or products or the advertising copy or printed matter that may be used in connection therewith or the use to which it may be applied.

I hereby release, discharge and agree to save harmless, _____, his legal representatives or assigns, and all persons acting under his permission or authority or those for whom he is acting, from any liability by virtue of any blurring, distortion, alteration, optical illusion, or use in composite form, whether intentional or otherwise, that may occur or be produced in the taking of said picture or in any subsequent processing thereof, as well as any publication thereof even though it may subject me to ridicule, scandal, reproach, scorn and indignity.

I hereby warrant that I am of full age and have every right to contract in my own name in the above regard. I state further that I have read the above authorization, release and agreement, prior to its execution, and that I am fully familiar with the contents thereof.

Dated: _____

_____ _____
Witness

(Address)

How to Collect

It's not easy, but deadbeat accounts can be forced to pay. Kenneth Pepper, a New York attorney who specializes in claims and commercial law and coauthor of *Your Check Is in the Mail* (Warner Publishing), gives this advice about chasing payments.

"The first step," Pepper says, "even before you submit a bill, is to have some sort of written contract or at least a purchase order or a letter from the client outlining the job. That letter or purchase order should be signed by someone in authority. If the client refuses to commit him- or herself to a letter or purchase order or contract, then the photographer should be suspicious of the client's intentions or willingness to pay. If you can't get a document, you act at your own risk.

"Even with major corporations, the client may be well-intentioned, but the person who ordered the work may have left or been fired. Those kinds of clients are so big that no one remembers the order. Getting something in writing is a good idea no matter what the client's size.

"If you haven't got a written document, it then becomes your word against the other person's, which is the weakest sort of proof. If you can't get something in writing from the client, it is good practice for a photographer to send a letter to the client. Something like, 'Thank you for this job. I understand I am to deliver this, how much I am to be paid, including expenses, when paid, what rights selling.'

"Whether you have something in writing or nothing in writing, if the client doesn't pay, call him up and try and find out what the problem on payment is. It could be cash flow, they could be unscrupulous or going out of business. Try to work with the client, negotiate partial payments, make the best deal for yourself. Maybe there's a quality problem. The reason they are not paying may be that they are unhappy with the work. Then you should be prepared to analyze it while you are on the phone and make an accommodation — knock off a third.

"If they send you a check for half the amount and it says, 'Payment in full,' no problem, you just cross it out and drop the check in the bank. You can write on it, 'Partial payment only,' or anything you want. Then endorse and deposit it.

"If a client doesn't pay, it doesn't hurt to put

yourself on record in writing and send out a letter. But I would also try to get him or her on the phone. If you can't do that, then you have to think of other steps.

"If a client doesn't want to speak to you or you can't negotiate payment, then your alternative is to start suit. One option is to go to the small-claims court if the amount is under $1500 in New York State. Other jurisdictions have other rules. It's a simple procedure: you go to the clerk of the court where the client is located, you pay a small fee, explain the problem, the clerk fills out the summons or complaint, the court mails it out to the person and gives you a date to show up in court, usually in the evening. Then you present the case in front of the judge or an arbitrator at that time.

A Letter of Demand

Bill Owens is a man who believes in doing it himself — even collecting money. In his very wise and informative book, *Publishing Your Photo Book,* Owens has this to say about getting money that's due you:

A letter of demand is your final letter before taking legal action. This letter is to give the reader final notice, that if action isn't taken about your problem (usually money they owe you), you will take them to court. The tone of the letter should be firm and businesslike. The letter should be brief and to the point. Because the letter is an emotional issue it will take you anywhere from one day to three months to write . . . depending on how angry you are! Insulting the individual or personal attacks do not help your case. It is best to stick to the facts!

A letter of demand should contain the following information:

1. A statement of the facts showing how your agreement has been broken.
2. References to previous attempts to solve the problem.
3. A statement (again) of your demands with Xerox copies of receipts or any other items necessary to prove your case.
4. Finally, the letter should have "cc" (carbon copy) to all individuals involved, including the name of a lawyer.

This letter should be typed and mailed by certified mail, return receipt requested. And, you should keep a Xerox of the letter for your files.

If no action is taken (give them two weeks) then go see your lawyer or take them to small-claims court.

Making Small Claims

In most states an individual can sue for up to $1000 in small-claims court, where a lawyer is not needed. What is needed is time because the court action itself is slow and tedious and opponents have a way of delaying things — particularly if they come with a lawyer.

Small-claims action begins with filling in the blanks of a form — a more difficult task than it appears to be. Fortunately, most small-claims court clerks are adept at this and willing to help, and in some city courts paralegals or legal assistants are available to help. Before you go to court to file a claim, have this information ready: who you are suing (with names and addresses and correct spelling), how much you are claiming, and why you are suing. The fee for filing a claim is usually about $5.

An excellent source of information on small-claims court action and many other legal topics is HALT, Suite 319, 201 Massachusetts Avenue, NE, Washington, DC 20002. A membership fee of $15 includes five *Citizens Legal Manuals* on a variety of topics ranging from small-claims courts to bankruptcy, using a law library to small business incorporation.

"Sometimes trade associations have arbitration procedures. If the client is responsible enough to go to arbitration and have some knowledgeable, impartial arbitrator work it out for you, that's another possible step.

"If the amount is over $1500 you can still sue. You can handle a claim in the upper court yourself. It's difficult, but the clerk's office will help you in filing the suit. I would recommend that you refer the matter to an attorney who specializes in the collection of commercial accounts. It wouldn't cost a photographer much to do that because most collection matters are handled on a contingency fee basis, which means the attorney's fee is a percentage of what he recovers for you. If nothing is recovered then the attorney doesn't get anything. The amount is usually from 25 to 40 percent. If it's a large claim it could be less than 25 percent; if it's a small claim it could be more than 40 percent. The only thing you would be stuck for are out-of-pocket disbursements, which you'd be responsible for whether or not the attorney collected for you. That would be about $50.

"Rather than use a collection agency, I prefer to see people go to a collection attorney. The reason

WILLIAMSON LAW BOOK CO.

☐ AFFIDAVIT OF SERVICE ON INDIVIDUAL(S)
State of New York, County of SS.:

being duly sworn, deposes and says, that he resides at

and that on the_____day of_____, 19_____,

at No. he served the within Notice on the defendant(s) therein

named, by delivering to and leaving a true copy of each thereof with said defendant(s) personally; deponent knew the said person(s) so served as aforesaid to be the same person(s) mentioned and described in said notice as the defendant(s) therein; deponent is over eighteen years of age and not a party to this action.

☐ AFFIDAVIT OF SERVICE ON A CORPORATION
State of New York, County of SS.:

being duly sworn, deposes and says, that he resides at

and that on the_____day of_____, 19_____,

at No. , he served the within Notice on

a Corporation, the defendant therein named by delivering to and leaving a true copy of each

thereof personally with an officer of

said corporation, to wit, its deponent knew said corporation so served as aforesaid to be the same corporation mentioned and described in said notice as the defendant therein, and knew said

to be an officer thereof at that time; deponent is over eighteen years of age and not a party to this action.

☐ I asked the defendant whether defendant was in active military service of the United States or the State of New York in any capacity whatever. Defendant told me defendant was not. Defendant wore ordinary civilian clothes and no military uniform. The source of my information and the grounds of my belief are the conversations and observations as narrated.
Upon information and belief I aver that the defendant is not in the military service of New York State or of the United States as that term is defined in either the State or in the Federal statutes.

☐ The person so served was male/female

Color of skin_____

Hair color_____

Approximate age_____

Sworn to me this_____day of_____19_____

Approximate weight_____Pounds

Approximate height_____ft._____in.

Notary Public · Justice

STATE OF NEW YORK
County
Court
of
PLAINTIFF
against
DEFENDANT
NOTICE TO DEFENDANT
SMALL CLAIMS COURT
Filed this
day
of
19
Judge·Justice

WILLIAMSON LAW BOOK CO.

NOTICE TO DEFENDANT
SMALL CLAIMS COURT Form No. SC-1 Williamson Law Book Co., Rochester, N.Y. 14609

State of New York

_____ COURT _____ COUNTY

_____ OF SMALL CLAIMS PART No._____

NOTICE TO DEFENDANT:

To :_____

TAKE NOTICE THAT_____ PLAINTIFF,

asks judgment in this court against you for $_____ together with costs,

upon the following claim:

In agreement with which the Plaintiff hereby signs and demands Judgment.

Plaintiff Signature and Address

There will be a hearing before the Court upon this claim on _____

at _____ o'clock, _____.M., in the Small Claims Part of this Court, held at

_____. YOU MUST APPEAR to present your defense, or to present any claim that you may have against the other party at the hearing described above. **IF YOU DO NOT APPEAR IN PERSON OR BY AN ATTORNEY, JUDGMENT WILL BE ENTERED AGAINST YOU, EVEN THOUGH YOU MAY HAVE A DEFENSE.** If your defense or counterclaim is supported by witnesses, account books, receipts or other documents, you must bring them to the hearing.
If you admit the claim but desire time to pay, you must appear personally on the day set for the hearing, state to the court that you require time to pay and show your reason for same.

Dated:_____ 19_____

Justice - Court Clerk

NOTE: If you desire a jury trial, you must, before the day set for the hearing, file with the justice or clerk of the court a written demand for a trial by jury. You must also pay to the justice or clerk a jury fee of $6.00 and file an undertaking in the sum of $50.00 or deposit such sum in cash to secure the payment of costs that may be awarded against you. You will also be required to make an affidavit specifying the issues of fact which you desire to have tried by jury stating that such trial is desired and demanded in good faith.

Under the law, the court may award $25.00 additional costs to the plaintiff if a jury trial is demanded by you and a decision is rendered against you.

Adjourn to _____, 19_____ _____, 19_____ _____, 19_____

BRING THIS NOTICE WITH YOU.

is that a collection agency has no more power than you do. All they can do is write and call, which you can do yourself, but some people pay when they get a dunning letter from a collection agency. If yours is a small claim, it usually doesn't get the attention that it should from the agency. The information goes on a computer and the computer spits out a series of collection letters that go out to the debtor every two weeks or so. They may not get any human contact. If the agency can't collect, they usually refer it out to an attorney they have.

"So the point is, why not eliminate that six, eight, ten weeks of letter writing and give it right to an attorney? Then you have peace of mind knowing that you have a higher standard of care than you can get from a collection agency. Also, an attorney has the power to start suit. He or she might send out a letter and if there is no response, the attorney could start suit in a week or ten days.

"The most important thing is to protect yourself in the beginning rather than worry about collecting in the end. You must try to formalize your dealings by having something in writing — even a letter that you send back to the client. Or draw up an order form with the date, time, what is required, how much, and get the client to sign it.

"After all, most business is done in writing."

January 1, 1978: Copyright at the Moment of Creation

The copyright system came into effect in the United States in 1790 when Thomas Jefferson was secretary of state and in charge of administering it. Since then, the law has been altered several times; the most recent change became effective on January 1, 1978. On that date, photographers and other creative people acquired first-class citizenship. That's when the moment of creation and the act of copyright became one. Even as a latent image in silver

The Krementz Ultimatum

"I send all pictures out with two stamps on the back," said portrait photographer Jill Krementz at an ASMP seminar on stock photography. "The first stamp says, 'Photo ©,' and has space for the date, has my name, address, and phone number, and says, 'Not to be reproduced without permission or without adjacent credit line.' The second stamp says, 'This photograph cannot be copied, televised or reproduced without the expressed and written permission of the photographer.'"

halides, the picture is yours to keep, to lend, or to give away, for your lifetime plus fifty years.

Before January 1, 1978, a client who hired a photographer owned the copyright unless there was an agreement to the contrary. No longer. Now, the photographer owns the copyright unless there is an agreement to the contrary. The old law revolved around the concept of "work for hire" and many publishers, advertising agencies, and photo buyers have tried to maintain that advantage by asking photographers (and other creative workers) to sign their rights away on contracts and check endorsements.

Under the new copyright, when you negotiate an assignment, you transfer one-time reproduction rights to the client (unless otherwise stipulated) and confirm that on an assignment confirmation form or some other contract agreement. It's advisable to reconfirm whatever rights you sell on your invoice or bill to the client, too.

With stock photography, be sure the client understands (put it in writing) that the submission of photographs does not grant the right to reproduce or use the pictures in any way — merely to look. A delivery memo should state this, and the invoice or bill for the sale of photographs should then include a description of whatever rights you are licensing the buyer to use.

As creator of a work, you should also ask for a proper copyright notice to accompany your photograph. This is: (1) the letter *c* inside a circle, (2) your name, (3) the year the work was created (or for unpublished work that dates from before 1978, the year 1978). If your photographs were published before the new copyright law took effect, you must have as part of your copyright notice on them the year of first publication. It is best to request adjacent copyright notice when you negotiate the job and make it a standard condition of the sale of the work.

Usually advertisers will not grant requests for copyright notices adjacent to printed photographs. In this case you can register your copyright of photographs. Get an application from the Copyright Office (Library of Congress, Washington, DC 20559), fill it out and mail it with ten dollars and a copy (print, slide, duplicate slide, or Xerox) of the work being registered to the Copyright Office. It is then assuredly yours.

Insurance

Photographers need the same kind of insurance that any other self-employed person needs — life, hospitalization, major medical, disability income, automobile, liability, and a few other specialties — but they need more. Specifically, you should be covering your equipment, your workplace, and perhaps your luck on a shooting assignment.

A camera floater protects against loss or damage to your equipment and usually pays for replacement less depreciation. To use it effectively, you should insure each piece of equipment individually and keep records of all your gear, including serial numbers and descriptions. This type of policy usually protects you anywhere in the world and applies to new equipment for a month or six weeks after purchase, but before you have had an opportunity to insure it individually. Incidental accessories and

Do-It-Yourself Censorship

Many photograph buyers request that photographers sign a "work-for-hire" agreement. Often it is a separate statement or is part of the purchase-order agreement, and sometimes it is printed on the back of a check. Signing a work-for-hire agreement means you are signing away virtually all rights to your photograph — resale rights, foreign rights, and if the magazine uses the photograph in the wrong context, you could be sued.

To solve this problem take a black felt-tip pen and cross out all offending phrases. Basically, all you are selling is one-time rights unless there has been a previous agreement. These miniature work-for-hire contracts are a publisher's way to circumvent the United States copyright law.

Weather Window Forecasts

Sunshine, blue skies, red sunsets, and golden light are the elements that make outdoor commercial photography successful. No one wants to show rain and gloom in an annual report or bleak travel shots on a magazine cover. Obviously, weather prediction is essential for expensive photographic assignments.

Universal Marine, Inc., was created to provide weather forecasting for industrial clients, but now makes its services available to photographers through ASMP, although nonmembers may also join. The company's Weather Window forecast can include extended outlooks for any time period in any area of the world, specific site forecasts, "Best Time" forecasts selecting the day or days for a planned shoot, "Best Place" forecasts selecting the location with the required conditions, and continuous verbal briefings before and during the shooting period. This service costs $15 a year plus fees for each forecast. Short-term forecasts for a specific location cost $25; longer-range forecasts to select a specific place or time for a shooting cost $75 to $125; and support services for extended shooting assignments cost $100 and up per week.

Communication is by WATS lines, telex, and TWX, and Universal Marine will call you if and when weather changes unexpectedly.

Claimed accuracy rate is 95 percent.

small items can be insured to 10 percent of the total policy amount.

If you live in a high-crime area where regular commercial insurance is not available, the federal government has a policy that goes to $10,000. For information contact Federal Crime Insurance, P.O. Box 41033, Washington, DC 20014.

Your studio and its contents can be covered against fire, theft, and malicious mischief. Usually there is a deductible on this type of policy.

Your luck on the job is also insurable, but only through ASMP. That organization instituted a policy, called Photo Pac, that covers a photographer's equipment (just like the floater), props, sets, and wardrobe; extra expenses caused by delays due to accidents; property damage liability against a third party's property; and negative/film faulty stock, camera, and processing coverage for reshoots (but this does not cover photographer error). The minimum premium for this policy is $1000 and it goes up based on the photographer's billable expenses.

Who needs a Photo Pac policy? Those photographers who do jobs where their expenses equal or exceed their fees, those who quote a single price for a job that combines fees and expenses, and those who deal with clients who tend to want or need reshoots.

A View from the Top

The sign on the door says RING PERSISTENTLY please.

This is the home of Burt Glinn, one of an envied group of photographers who have reached an eminent position in this rarefied business: he is a much-in-demand corporate / annual report / advertising

More Words on the Subject

There is much, much more to say about the business and legal aspects of photography, and fortunately there are many experts willing to say it. Here's a list of some books and publications that can provide you with greater detail and source material for further study.

The Business of Photography, by Robert M. Cavallo and Stuart Kahan (Crown Publishers, New York City)

Copyright Basics — Circular R1 (free from the Copyright Office, Library of Congress, Washington, DC 20059)

The Copyright Book, by William S. Strong (MIT Press, Cambridge, Massachusetts)

The Freelance Photographer's Handbook, by Fredrik D. Bodin (Van Nostrand Reinhold, New York City)

How to Survive in the Freelance Jungle, by Barbara and Elliott Gordon (Executive Communications, New York City)

Photography: What's the Law?, by Robert M. Cavallo and Stuart Kahan (Crown Publishers, New York City)

Professional Business Practices in Photography, a compilation by the American Society of Magazine Photographers (ASMP, New York City)

Selling Your Photography, by Arie Kopelman and Tad Crawford (St. Martin's Press, New York City)

Small Claims Court, by Chip Greenwood, Lenny Heymann, and Lauren Shea (Halt, Inc., Washington, DC)

Stock Photography, by Ellis Herwig (Amphoto/Watson-Guptill, New York City)

*Sue the B*st*rds*, by Douglas Matthews (Arbor House, New York City)

You Can Sell Your Photos, by Henry Scanlon (Harper and Row, New York City)

The ever-peripatetic and charming Burt Glinn

and magazine (when the assignment is exciting enough to him) photographer. He's a member of Magnum Agency and a former president of ASMP. Glinn at fifty-seven has spent his entire working career shooting pictures from news to documentary to travel to illustration to industrial. He charges $1500 to $2000 a day and has more requests for his time than he can handle. He is an unqualified success.

"It's the best way to earn a living," says Glinn in an ebullient mood. "I'm not that enormously successful — I've always worried about money, I'm always on the edge. But, it's a good life and there's excitement in it, though I'm sure if the assignments weren't coming, I'd want to jump off a bridge."

Glinn and his wife live in a spacious, well-appointed apartment overlooking New York's Central Park. He has a small office there stocked with gadgets. He shares another apartment in the neighborhood with his best friend, photographer Elliott Er-

witt. There Glinn has facilities for editing and storing his massive stock of pictures taken over the past thirty years.

"One thing that's hard for photographers to know is what their own cost of living is," says Glinn. "People are amazed when they hear charges like $1000 a day. Well, does the photographer have an agent? If so, the photographer is really getting $750 a day. How many days a year does he or she work? How much support does he or she need to do that work? I didn't need a secretary until two years ago, but now I have all that mail to answer. I have a full-time assistant. A photographer has to know what kind of insurance to carry and what that costs. What are your phone bills and what are all the things that make your business function?

"Sometimes people fail in photography because they misidentify where their strong points are and they take on the wrong assignments. For instance, I am not a fashion photographer. If people ask me to do things where someone else can do it better — fashion, still lifes, 8 × 10 view camera stuff — I give them a whole list of people who can do it better. I'm a 35 mm photographer and work in a certain way."

As an annual report photographer, which he has been since the late 1960s, Glinn credits himself on two points: his ability to be pleasant and cordial with almost everybody he works with and his ability to organize a shooting before he goes out the door. Typically he might contract to do twenty days of shooting for an annual report, but because he can get all the details arranged beforehand, Glinn may do the shooting in fourteen days and will charge his client accordingly. It is this honest treatment, he says, that brings him repeat business year after year.

"It's a matter of perspective. To be successful you have to have a lot of confidence in yourself to be able to charge what you want and need. You have to know how good you are, how well you satisfy the needs of the market you're serving.

"It's amazing how resistant to inflation the prices of photography are. Take advertising. For a major ad shooting I hardly get any more now than I got in 1950 because the market changed — the advertisers went to television, so print advertising was not as valuable. I would like to see us keep pace with inflation.

"Sometimes you hear the argument, 'That's not in my budget.' There are so many people out there taking pictures now that you have to give the clients the impression that you're almost indispensable. One of the things that makes you indispensable is your ability to organize.

"You're dealing with your own integrity, too. I'm tough on my clients in charging them a lot, but I feel I have to give them their money's worth. The worst thing, though, is to be pretentious about it. This is commercial work. It isn't the Sistine Chapel we're doing. It is the application of skills for commercial purposes."

Glinn recognizes that photographers now breaking in have a tougher time than he did when he started in the 1950s. There weren't so many people taking pictures in those days, but everybody aspired to be a staff photographer for *Life*. Glinn worked for *Life* as an assistant for ten months ("The only salaried job I ever had," he says), but thinks he was lucky they didn't offer him a staff job. He had been with Magnum for five years by the time the offer came, and he could turn it down.

Where Has All the Glamour Gone?

"In the early sixties I did entire issues of *Holiday* magazine," says Burt Glinn. "That was probably my most valuable training. They didn't give very much direction and they didn't give me a text piece. Their only instructions were to take a few snaps of a place like Russia. Of course, if you'd worked for *Holiday*, you knew what their parameters were and you knew what they were interested in, but they didn't hand me a list of contacts or people to see — I was on my own and that was very good training.

"Today nobody could afford to do what *Holiday* did in those days. I guess *National Geographic* does, but they give more limited display — thirty-four or thirty-six pages.

"Do you realize I did an entire issue on Japan? In 1960, I was able to travel to Japan twice: in the fall and in the spring. I spent a total of twelve weeks there. Now, I probably couldn't afford to take that much time, but for those twelve weeks and two trips I couldn't go to Japan and stay twelve days on expenses today.

"Magazines had a lot more money than they have today and the stories cost a lot less to do. They paid me page rates, but who cared? I had all my expenses paid. I had all the pictures in that issue. It was a terrific opportunity. I did a book and I still sell those pictures today."

"The new photographer today has a problem in getting that first assignment. The first step is to get some clients, to get something to show, to get established.

"But the other big problem is to recognize what you're doing when you negotiate. If you cannot afford not to get the assignment, then you're not negotiating. On the other hand, if you can put yourself in the position where it would be nice to have the assignment, but you can live without it, then you can set the standards you need to have.

"In the final analysis, the business of photography really derives from what kind of photographer you are and what kind of picture you do. Being a successful photographer is finding out who you are and how you can make yourself function in the world that you've chosen. And, strangely enough, that's the most important part about learning how to take pictures well. You always have to take *your* pictures, not somebody else's. You've got to know who you are."

Glinn and his wife went to China on a nonassignment trip that cost him over $10,000. He shot more than 250 rolls of film, and says he will have to sell $20,000 worth of pictures over the next four years to pay for the trip. Even so, he maintains it was a sound investment in making contacts and getting ideas for stories that he can do in the future.

"Eve Arnold was the first one to really do China," he says. "She gave up two years of her life to do that and took a big risk, because she could have gotten nothing out of it. What she did was put together her own syndicate. Eve always worked for the *Sunday Times* [London]. They couldn't pay her enough for the entire China project, but they gave her something to get started. And Knopf gave her an advance on a book. Then the job turned out to be so terrific that she was able to sell it to *Life*, *Paris-Match*, and *Stern*. If you have a project that you have faith in, then you can go off and do it.

"In fact, you ought to do things in photography for yourself. You ought to do some things because you like the pictures, because you look at them and maybe get a print made to hang on the wall.

"Somebody once asked Elliott Erwitt what he likes to do best in photography. He said: 'I like to take pictures and I particularly like to take pictures I like.'"

Getting Published

by Michael O'Connor

Most successful professional photographers know how to win advertising and editorial assignments, get prints hung on gallery or museum walls, and sell their stock photos. But few photographers know about one of the very best showcases and outlets for their work: photography books.

Probably the biggest benefit of a book is reputation. A book is a sign of recognition, a sign someone thinks your work is good enough to publish for posterity. Unlike magazines, newspapers, and advertising campaigns, books have an element of permanence. They don't tend to be thrown out along with the leftovers from last night's dinner, or used under the kitty litter. Books are kept in the collections of libraries, sold for years by museums and bookstores, and cited as examples by teachers to generations of student photographers.

A second benefit is financial. While very few photographers have become rich off the sales of a single book, many a photography career has picked up as a result. A book is the ultimate promotional piece. It can be seen and admired by untold potential clients across the world. It can also be included as an impressive element in portfolios and presentations.

Most books don't take new shootings and additional expenses on the part of the photographer. The photographs usually come from stock or file photographs. Whatever income there is, is most likely generated from past work. And since books tend to sell for years, the checks keep arriving unannounced for a long period of time.

There are two ways to publish a book of photographs: you can publish yourself, or you can have a professional publishing house do it for you. Each way has its advantages and disadvantages.

The biggest advantage of publishing your own book is that you have maximum control over the presentation and marketing of your work. You also make all of the profits after expenses. The disadvantage is that you alone have to bear all the costs and headaches.

Publishing any type of book is expensive, and illustrated books (in this case a book of photographs) are the most expensive, much more so than a novel or a book of poetry. The reason is reproduction. In order to get good-quality reproduction you have to pay for (or make) custom prints, pay for good paper, good halftones or separations, a good printer, and a good binder. For the best presentation of your work you probably also should pay for a good designer and a good writer. And then you have to pay to store the finished books someplace, and to ship them to the buyers or stores.

Five thousand copies of a decent quality, black and white, medium-sized paperback containing some eighty images costs around $30,000. A similar book in color costs more than twice that amount.

Michael O'Connor

Books about Books

How to Get Happily Published, by Judith Appelbaum and Nancy Evans (Harper and Row, New York City). This book covers everything from how to write to techniques for promoting books. In between there's a wealth of valuable dope on contracts with publishers, production, and spin-offs to magazines.

Photography Between Covers, by Thomas Dugan (Light Impressions, Rochester, New York). This is a collection of interviews with photographers who felt a passionate need to see their images published in book form. Individual opinions are refreshing and, at times, controversial.

The Publish-It-Yourself Handbook, edited by Bill Henderson (Pushcart Press, Yonkers, New York). Subtitled *Literary Tradition and How-to,* this anthology of articles by both well-known and obscure authors is inspiring for anyone attempting a book. Here are twenty-five case histories of people who did it without commercial assistance.

Publish Your Photo Book, by Bill Owens (Bill Owens, Livermore, California). The basic reference book for photographic self-publishing. Owens reveals all he has learned in publishing his own books and lets the reader profit from his mistakes. Chock-full of valuable information and sources for more.

The Self-Publishing Manual, by Dan Poynter (Parachuting Publications, Santa Barbara, California). A quickie course in how to write, print, and publish a book, followed by detailed information on marketing. There are dozens of ideas on announcing books, promotion, advertising, distribution, and finding buyers.

Better reproduction, hard covers, a larger format, more pages, or more copies obviously costs more, though not necessarily proportionately more.

It is quite possible to produce a book for less, but lower bills mean lower quality. And since the prime reason to publish a book is to show the quality of your photographs, a cheaply produced book can defeat the whole purpose. Better not to do a book at all than to do one that makes your images look bad.

The headaches of publishing your own book don't stop here. If you write the text or captions (assuming there are some), you'll slave for hours in probably unknown territory. If you design the book you'll also work and worry hard. If you supervise the production you'll have to check and correct the halftones or separations, pick the paper, printer, binder, and possibly the warehouse by the seat of your pants. Should you decide to save costs by storing and shipping the finished books yourself, you'll trip over the cartons and have to pack and ship every book personally.

But the biggest headache is selling the books. The easiest, and most practical, way is to convince a professional distributor to handle it. However, that will mean giving up a share of the profits, and if you can convince a distributor to sell it for you, you can probably convince a publisher to publish it for you. If you sell the book yourself you'll have to make a sales pitch to hundreds (if not thousands) of individuals and bookstores. You may have to prepare and send promotional or direct-mail pieces. You'll have to make sure the orders are filled promptly, and get there in good condition. And, needless to say, you'll have to bill the buyers, and make sure they pay.

Publishing your own book can be interesting and fulfilling, but realize up front exactly what you are getting yourself into. It takes endless hours that could probably be used far more profitably shooting, or drumming up clients and assignments. Unfortunately, you don't always have a choice. It may be your only option if you have been turned down by all the possible publishers and are still determined to go through with it. Be forewarned, however, that when several publishers turn you down it is probably because your work just isn't salable. Remember, they're the experts in this market.

Bookmaking Mechanics

Advertising Agency and Studio Skills, by Tom Cardamone (Watson-Guptill Publications, New York City). Starting at ground zero, here are the techniques and what they mean for putting together any kind of printed material. How to scale prints, do paste-ups, handle type, and lots of other tricks are covered in this book.

Printing It, by Clifford Burke (Wingbow Press, Berkeley, California). Here are the basic mechanics of how a book is printed and what needs to be done before it gets on press. Creative and useful ideas for the self-publisher, whether of books or brochures.

Production for the Graphic Designer, by James Craig (Watson-Guptill Publications, New York City). The numerous illustrations, charts, and samples of how printed material is produced make this book a valuable text for learning this aspect of publishing. Topics covered are typesetting, printing, paper, inks, impositions, folding, and binding. Impressive glossary.

The advantages of publishing with a professional publisher are numerous. For starters, they will bear the high costs, most of the headaches, and supply much-needed expertise gained over many years of publishing many different books. The reproduction quality will be watched by people who have done it hundreds of times and know how to evaluate separations and talk to printers. The sales will be handled by a force of professional salespeople who personally know the bookstore buyers. Your book will have access to domestic and foreign markets, book clubs, and magazines you probably never knew existed. The publisher may also have promotional and direct-mail setups you could never personally pay for yourself.

The disadvantage of doing your book with a commercial publisher is that you lose some control and profits. In order to secure a large investment the best way possible, the publisher will want control over the product. Almost always this will mean complete authority over the packaging, distribution, and budget of the book (though your advice may be sought, and listened to). Finally, in order for it to be worthwhile to touch the project at all, much less to invest capital, the publisher will also want a high share of the profits.

So, what do you do? If you decide you want to publish yourself, you should read the books, kits, and articles telling you how to do it, pump friends in the publishing industry and elsewhere for additional advice and suggestions, and get to work. If you decide you want to work with a publisher, you should look for one that is right for your project.

The best way to start looking for a publisher is to look at books. Go into your favorite bookstore and examine the books they carry. Look for one that is similar in feel, content, and quality to what you want. Look at the price. Study the content. Be honest in evaluating the photographs. Are yours as good or better? Is the subject matter as commercial? If the book you have in mind was on the shelf next to the one you're studying, which one would a person in Cleveland buy?

Once you've found that similar book, and still think yours is better, look at other books by the same publisher. See if that book is really representative of the type of book they do. All publishers have an image, a market position, a publishing program.

Basically there are two types of photography books, and two types of publishers. The first is books *of* photographs; images for their own sake. The second type is books *about* photography; books designed to teach the reader something. Of course there are many variations and combinations of these

Trends in Books

"The photo essay book is on the decline, partly because of the crap that's been published and partly because of the costs of publishing." So says a leading book publisher.

From the selling side of the business, Harvey S. Zucker, who, with his partner, Gene E. Bouner, operates A Photographer's Place bookstore and mail-order house in New York City, says the big, traditional names in art photography just roll on and on. "Adams-Weston-Strand; Adams-Weston-Strand — they sell constantly. Other books by name photographers hit peaks and valleys and there's a trend toward higher-priced photography books. But, Adams-Weston-Strand go on and on."

Technical books have always sold well and are getting better in quality and reproduction. Even specialized and esoteric topics can sell 5000 to 10,000 copies a year.

What isn't selling is photojournalism and unknown names. If your name isn't Adams, Weston, or Strand, the advice is: do your own introspective number only if you have a very large family of willing buyers.

Postpublication Tactics

If you have a big-name publisher or one that specializes in photographic books, you have to trust that they will get your tome in the bookstores. Beyond that there are things you can do to get your book bought.

1. Buy (or ask your publisher to buy) Bill Owens's Media List of more than 2000 names and addresses of people concerned with photographic books. These include book buyers, reviewers, galleries, stores, and organizations. Contact: Working Press, Box 687, Livermore, CA 94550. The Media List costs $175.

2. Be sure the two photographic book clubs, Photography Book Society and Popular Photography Book Club, get copies of and press releases about your book. They can buy up to 14,000 copies for their subscribers.

3. Send copies of your book with a cover letter and press release to the editors of the main photographic magazines: *Popular Photography, Modern Photography, Camera 35, Petersen's Photographic, Camera Arts, American Photographer, Creative Camera* (England), *Printletter* and *Camera* (both Switzerland), and *Asahi Camera* (Japan). If it's a book of photographs, Bill Owens advises sending ten prints from the book to each of the editors. Ask that the prints be returned (they usually are) and send them to another group of reviewers.

4. Be sure the book is sent to other magazines, newspaper reviewers (names on Owens's Media List), and to newsletters that go to photographers.

5. Send a brochure or press release or book to people in the business of photographic education. This includes high school teachers (list from *Petersen's Photographic*), workshop, trade school, and college instructors (rosters from the Society for Photographic Education, Box 1651, FDR Station, New York, NY 10022).

Owens says it is a long process to get reviewed and to sell a book, but you have to keep at it because photographic books are reviewed only once or twice a year in some publications. Some of the hottest-seeming opportunities don't bear fruit (he was interviewed on the "Today Show" and in the *Book-of-the-Month Club News*, but it didn't help). But the simple act of carrying a half-dozen books under your arm to a bookstore may get local publicity or an autographing session that does sell your book.

The author and the editor have the greatest interest in the success of the project, while the publishing house deals with many (from 15 to over 1000, depending on the size of the house) books each year and necessarily views yours as one of many. It's up to the author to feed information to the publisher through the editor to help sell the book. Go over ideas for promotion with him or her and be sure that copies of the book get to everyone you think is important.

two types. And there are also books with a large number of photographs illustrating a nonphotographic topic, such as interior design or wildlife.

If you see that the book you have in mind fits the program of a particular publisher, search that house's books for specific themes, as well as for the address. Often the editor (or editors) is credited on the copyright page, in the acknowledgments, in the back, or elsewhere in the book. As with magazines, newspapers, and advertising agencies, it is crucial to talk directly to the right person, and not a receptionist or secretary. The right person is not necessarily the top person, though. The very top person in a commercial publishing house is often a businessman or administrator who keeps track of budgets and evaluates the ideas proposed by senior or acquisitions editors, but does not personally initiate many projects.

Once you know who to contact, send the person a package explaining yourself and your book. The ideal package (from the editor's point of view) contains a cover letter, an outline of the book, a proposed format, an analysis of the market, examples of your work, and tear sheets of material you have had published or that has been published about you.

Let the editor have at least two weeks to mull over and discuss your proposal. Then, if you haven't heard anything, call him or her and ask permission to come in with your complete portfolio to discuss your idea.

What you should do from then on is complicated by many factors, but in closing I will make two extremely generalized recommendations.

The first is that you should jump on almost any offer from a reputable publisher. Industry-wide there are dozens of photography books offered for every one published. You may never get another chance.

However, there are two important qualifications to the preceding paragraph. First, don't do the book for the royalties. Only do it if it is worth it for the money up front, the advance against your royalties.

Contracts, Royalties, and Advances

For this you need a lawyer or an agent from the beginning of negotiations and you need one who understands photographic books, which differ markedly from text books. Some of the unique problems are: submission and safe return of photographs, use of the images for promotion or advertising, the photographer's input in the design of the book, and the quality of the printing. ASMP has a very well conceived photography contract in the *Professional Business Practices in Photography* book.

There's no standard royalty agreement — you can negotiate what you can get. However it's set up, be sure the royalties are based on suggested retail or catalog retail price, not net receipts or wholesale price, which is significantly less than the retail price.

For your first venture into publishing, you'll probably be working at something less than the minimum wage — advances range from $2000 to $5000 or less.

Remember that your photographs are coming from your files, and thus relatively expense- and effort-free. Your book may turn out to be a monster, and you may make a good deal on the royalties, but the odds are against it. Photography books are a very specialized market, and there simply are not enough people buying them for many of the hundreds published each year to earn sizable royalties. Instead, pretend you are doing the book for a flat fee (the advance), and look to the career and very-long-term monetary gains discussed earlier.

Second, make sure the publisher you say yes to is a good one. A bad book can hurt your reputation (though it's got to be pretty bad). After all, your name is on the cover.

The second generalized recommendation is that you get a lawyer, and know why you got one. You don't need a lawyer to protect your interests so much as you do to know what you are getting into. If you're signed by a reputable publisher you are about as safe as you will ever be, but you need to understand your and the publisher's responsibilities and commitments fully at the outset. Not knowing can create a good deal of friction and bad feeling later on, and conceivably destroy your book.

Having your work published anywhere is an exciting experience. But having a book published can truly be one of the proudest moments of a photographer's career. Just remember, where publishing is concerned, your best assurance of success is self-education.

Michael O'Connor is a senior editor with Amphoto books, a division of Billboard Publications. This article was published in New York Photo District News. Copyright © 1981, Michael O'Connor.

7

GETTING
INTO
GALLERIES

Photography as an Art Form

The proliferation of "photographers in the fine arts" is somewhat akin to the production of rabbits — the country is overrun by photographers carrying portfolios. They are young, often graduates with a degree in photography appreciation, and they usually ape their teachers, who ape *their* teachers.

Photography as an art form has grown so rapidly there are very few curators, gallery owners, or critics who can winnow the seeds of this proliferating overgrowth. One of the problems is that photography

Collector's Word for It

You could have grown rich over the past decade by purchasing the right photographs and holding them as the values went up and up. This is also known as collecting, and the right photographs are identified and labeled in a lavish and thorough book, *The Photograph Collector's Guide,* by Lee D. Witkin and Barbara London (New York Graphic Society).

This book effectively puts the stamp "Art" on photographs. The photographers listed in the "Compendium" chapter thereby gain credibility and, no doubt, their work increases in value.

The book also provides a chronology and a glossary for collectors and gives tips on the care and restoration of photographs. Of great value for artists is a chapter listing museums, galleries, and exhibition spaces throughout the world.

This book is a "must" for the beginning collector.

as an art form — pictures to hang in a gallery or on a wall — is very young. Another is that gallery owners and curators have a perspective that often does not give space or recognition to the growth or direction of photography. Buyers pay too much or too little for certain pictures. The auction and gallery action has jacked up prices to an extraordinary extent. A prime example is Ansel Adams's "Moonrise," a print that has sold for $22,000, which some people see as a big-buck investment. To those people, it is valuable no longer for its content, but for its price tag.

The other problem is photographers themselves. Many are young and their photography needs to grow. Most photographers don't come into their own until their mid-thirties. It takes a long time for the artist as a young person to mature into a photographer who can put together six to ten pictures that reflect a spark of vision and creativity — photographs that literally scream out the essence that is within the maker.

And alas, too many youngsters, a little wet behind the ears, with an MFA that cost about $20,000 in their hands, leave academia with technical expertise, a lot of transferred theory, and little knowledge about life or living. They think they are instant fine arts photographers. As these new photographers strive for recognition, they attempt to shock through the use of different media. Their work is

too often minimal; they seem afraid to show faces, people, or the abrasive facts of reality.

Sometimes, they are more interested in the camera or the technique than in the final product. What good is a picture made with an 8 × 10 Deardorff equipped with a Schneider lens, transferred onto a homemade platinum paper, when the photograph has nothing to say?

Most experts in the art field agree: there are too many photographers, and the work, while technically good, doesn't say much. Yet a few art critics feel photography is a rich medium and is developing, through trial and error, into an art with extraordinary resonance. Here are what a few experts have to say about the art field.

The Museum of Modern Art, New York City

Peter Galassi is an assistant curator who put together the exhibition "Before Photography: Painting and the Inventions of Photography," which toured throughout the United States. His theory was intellectually stimulating — that the style and content of art before photography, evolved toward the invention of photography.

The Museum of Modern Art remains the foremost influence on the direction of photography today, much to the pleasure or dismay of various members of the photo-art field, depending upon what camp they fall into. The protagonist here, MOMA's curator John Szarkowski, is a former commercial photographer. He has put together two important shows, "Looking at Photographs" and "Mirrors and Windows." He helped to discover and anoint the photorealist snapshot shooter David Eggleston, and was the force behind the museum's stunning three-part Atget show. Szarkowski and MOMA are looked on as traditionalists in the uptown gallery sense of that word. Their position as leaders in the photo-art world is treacherous and surrounded by obstacles. Peter Galassi remains a scout for his boss.

"We have two collections," says Galassi. "One is the Museum Collection, which contains works that have been approved for acquisition by the department's Trustee Committee. This collection includes approximately 15,000 pictures. The other is the De-

Where to Show Your Stuff

Never turn down an opportunity to exhibit your photographs when you are starting out in the art field. Accept invitations to group shows in churches, rural art centers, corporate lobbies — anywhere to get the experience of showing. You'll acquire skills in framing and hanging pictures and get a sense of what looks best in exhibiting photographs.

When you feel you have an important body of work to show a larger world, approach smaller galleries that specialize in photographs. If you get a show, be sure to alert reviewers by sending press releases announcing the opening party. Keep your clippings (assuming they are favorable) and try moving up to larger, well-known galleries.

Galleries and exhibition spaces come and go, but you can find a reasonably up-to-date listing in *Photographer's Market*, published by Writer's Digest Books, Cincinnati, Ohio. This listing gives lots of tips on how to submit photographs, how often exhibits change, on sales commission policies, and generally on how the photo-show business works.

partmental Collection (the 'study collection'), consisting of other works, including prints of primarily historical interest, which may or may not be of exhibition quality. We also maintain a reference library and a biographical archive on individual photographers. Anyone with a serious interest in any of this material may make an appointment to see it.

"All five members of the curatorial staff look at photographers' portfolios every Thursday. Occasionally — but rarely — we buy pictures from these viewing sessions. But our main purpose in the sessions is to try to keep aware of changing ideas and interests expressed in current work. Thus we are very grateful to photographers who take the trouble to show us their pictures.

"If the pictures are too large to be portable we are of course glad to look at slides. We also make an effort to visit the studios of photographers whose work is large.

"In addition to the weekly viewing sessions, we try to keep up by visiting galleries (each of us has an afternoon off each week for this purpose) and by reading, by traveling, by talking with photographers.

"It is unimportant whether the prints are matted. Nor do we reject out of hand prints that might pose

preservation problems. We are, for example, currently investigating the best way to preserve Type C color prints, of which we have already collected a number.

"It is not our mission to influence what happens in photography but to collect the best of what *has* happened. We hope also that the collection will trace the development of photography as an art. Thus, if presented with two pictures that are equally good,

Nikon

Deep in the heart of Rockefeller Center in New York City is Nikon House, an elegant showcase for products of the same name. Visitors can examine any piece of equipment made by Nikon as well as have it explained by experts. They may have their own equipment checked (but not repaired) by Japanese technicians, and they can attend free seminars dealing with photography and Nikon equipment.

The most splendid freebie of this domain is a small gallery that has monthly shows of works by professional photographers. A typical exhibit has thirty to forty prints in color or black and white on any subject or style or theme — within reasonable taste. The selection process for mounting a show at Nikon House begins with AC&R Public Relations, where Lois Mann screens portfolios. In slides or prints she looks for high-quality work that is technically perfect and well produced. She prefers a group of pictures that have a theme or some relationship to one another, but each photograph must be able to stand by itself and be of interest. The group of pictures must not have been previously exhibited in the New York area.

The photographers who get through Mann's screening then have their portfolios sent to Nikon House, where more eyes examine them and make a selection. While the selection process is based on merit and aesthetics, it is also based on the photographer's financial situation. Photographs must be printed, mounted, matted, framed, and shipped — an expensive outlay that the photographer makes. Beyond that, the photographer must pay for an opening reception, which is a minimum of about $500 for a simple wine and cheese spread, but can be an elegant buffet if he or she chooses.

What does Nikon provide? The place, the personnel to put on the show and man it during the month's exhibit, and the promotion and publicity through AC&R Public Relations.

A Nikon House exhibit brings some prestige, some assignments, some sales of pictures. It's also an ego booster. And you don't have to prove you use Nikon equipment.

Alex Coleman

we will be more interested in the one that seems to have indicated a new direction in the art.

"In our collecting, then, and in our exhibitions, we try to respond to the best and most original in photography. We also try to make sense of things. Thus our exhibitions are intended to be critical, not only in the sense that they show works of high quality, but also in the sense that they contribute to our understanding of photography. Because the exhibitions each represent a point of view, they will tend to provoke criticism. This situation is presumably productive.

"When the museum was founded 50 years ago, it was one of the very few places where photography was shown. Now other museums — and many galleries — also show photography. As a result there is less reason for our exhibition program to be comprehensive; we are much freer to concentrate on the pictures and issues that seem most important to us.

"When the expanded museum opens in 1983, we will have a new, larger gallery for our permanent historical exhibition and for recent acquisitions. We also hope to make these galleries more flexible so that exhibits may be changed more frequently than they have been in the past."

Foto Gallery, New York City

Alex Coleman established this gallery seven years ago. She has a passion for photography, particularly contemporary experimental photography. Her gallery is in SoHo and it reflects the vigor and dyna-

mism of some of the younger photographers. She first exhibited a number of now well-known photographers who have since prospered and moved uptown.

"I don't always show what I like, but I try to show all work that I consider to have merit," says Coleman. "Personally, I don't like street photography, but if it is well done I am likely to appreciate it and to show it. I like work that is substantial and involving and for which mere scanning isn't enough. Such work takes time and effort. I like experimental, surreal, and altered images.

"I work in contemporary photography and often take in totally unknown photographers. Sometimes the establishment is not receptive to new photographers. This prevents the medium from growing and evolving.

"This is not to say that I do not hang classical work. Recently I gave a show of landscapes using the calotype process. It contained images reminiscent of the last century.

"Sometimes I look at up to fifteen portfolios a day. I see quality going down; there are too many in the field. There was a time when there were many new photographers, each with a totally new way of seeing, such as Jerry Uelsmann and Les Krims. They and others, in order to survive, took jobs as teachers and lecturers and taught thirty students at a time. Their students went out and taught photography in universities and colleges and produced another batch of unseasoned photographers who in turn became teachers. They are inbred. All art is not exciting and having too many people in the field waters it down. It takes at least six years for a photographer to put a show together. I recently talked to students at the School of Visual Arts and told them that they must spend many years at their art in order to develop a personal visual expression. They should seek independence from the influence of teachers and try to work within. Their portfolios are often so varied that they lack cohesion and an independent outlook. I see a lot of bad work and only a few bright spots. Then it is like fresh water in the face to see good work.

"Some think that I deal with the 'California style,' but in fact much of the work comes from New York. I am dedicating my strength to altered images, but have not given up on two-dimensional black and white photography.

"Most of the work I see is experimental, painted, multiple images or collages. I observe that the size of prints keeps going up. In the fifties it was 8 × 10, then it moved to 11 × 14 and 16 × 20 and now print size is 20 × 24 and larger.

"Many buyers worry about how many prints will be made of an image. Much of the new work, painted images for instance, is one of a kind and would be very hard to duplicate. Most are done in black and white and then colored but I see and show many color prints.

"I take a 40 percent commission. The lowest a picture sells for is about $75 and the highest was $750 for a hand-colored print. Most of my photographers are in their early twenties to mid-thirties."

Marcuse Pfeifer Gallery, New York City

Marcuse Pfeifer has an intensity of feeling for photographers and photographs. Her latest coup was the first showing of portraits by Timothy Greenfield-Sanders. She has exhibited photographers who are young and not yet known as well as more mature artists who somehow have been overlooked. She gave Lilo Raymond her first show in 1977 after the photographer had been working for sixteen years and was still unrecognized.

"It doesn't matter who a picture is by or what the subject matter is as long as it communicates something," says Pfeifer. "Many people think photography is an easy and exciting career and although it

Marcuse Pfeifer

One Camera–One Lens Theory

Photojournalists and their nemeses, the editors and art directors, begat the proliferation of camera bodies and lenses with which photographers drape themselves. In their search for unique page designs they used extreme wide angles, fish-eyes, zooms, medium and long telephotos, and cameras such as the Widelux Panoramics and Hulcher sequence.

Yet, in the art field, the work that typifies the style of a photographer is often work produced with one camera and one lens. Atget, Nadar, and Sullivan appeared to have taken their pictures with a one-camera–one-lens setup. The work of Diane Arbus and Lisette Model has the composition and point of view often associated with the $2\frac{1}{4} \times 2\frac{1}{4}$ twin lens reflex. Cartier-Bresson's work, as mentioned previously, is the result of his eye and gut working with a 50 mm lens mounted on a Leica. Large-camera photographers such as Edward Weston, Harry Callahan, and Ansel Adams (in his early days) used several lenses but their nature photographs have the clarity and perspective that is effectively dictated by the large-format camera.

Which brings up the interesting point. Is a photographer's style dictated by the camera and lens he or she uses, or is the style the result of selecting a particular lens and format? Is the reason many photojournalists do not hang well in a gallery due to the fact that their photographs are made with many different focal lengths and their work is often too varied to be comfortable on gallery walls? Do the most successful art photographers work best from a one-camera–one-lens perspective?

can be exciting it is mistaken to think it is easy. It's not an easy career either as an artist or as a commercial photographer or photojournalist. It's true that anyone can be a photographer if that only means someone who takes pictures, but not everyone can make a living at it.

"A young person thinks the last five images he or she took are always the best ones. It's too simple that way. I'm interested in seeing work that goes back a couple of years. It shows where the current work comes from and perhaps where the work is going. A good photographer needs passion, determination, and certainly a point of view. Most photographs have no reason to exist. Especially what is being made today. An artist must be a good editor, knowing what to throw out and what to keep. I want to see about fifty to a hundred photographs that

cover a period of time longer than the last six months or year.

"People think if they have one subject, like fifty different gas stations, it will have some meaning. The meaning has to be there first and then the subject matter follows. There should be something beyond the subject matter; there has to be passion in the work. I see too much technically good work that is not otherwise interesting. Competence is not enough. The technique must be the means to the end, not the end in itself.

"Many younger photographers support themselves by working in printing labs. There's also room for careers in restoration if there is a strong interest in chemistry and technology. There is a great need for this and the need will only become greater as there are more collectors. It takes a knowledge of printing and chemistry as well as a knowledge of paper restoration. The paper restorers who exist today are not versed in the chemistry of photography and many are not willing to learn. More photographers can find a living in the field that can give them an income so they can pursue their art.

"I see many trends in photography, and they fluctuate. Now large-format cameras are in style, up to 11×14. It is interesting because there is so much more information in a contact print than in an enlargement. But enlargements are also a current trend as well as self-sensitized paper. Photographers seem attracted to earlier processes because some of these have much more range of tone than the commercially available papers offer.

"I also see trends through influence. I begin to recognize students from the various schools — New Mexico or the Rhode Island School of Design or whatever. It is necessary for a student to rid him- or herself of the school influence before being able to grow as an artist.

"Although there is more color around I still don't handle very much of it because it's unstable. Type C prints crack and peel and/or fade in five to seven years. Dye transfers also fade, but it takes them longer. Cibachrome is the most stable, but it's too plastic-looking.

"Most galleries have chosen some sort of cubbyhole — the kind of work they prefer showing and promoting. That gallery's stable reflects the tastes of the owner or director. An artist looking for a gallery should be aware of the differences between

the galleries and not waste time on the ones showing work incompatible with his or her own.

"I have found that some photographs look best in books and some work well hanging in frames. Cartier-Bresson, who is certainly the best of the photojournalists, looks best to me in books. His photographs are made to be reproduced. Work such as that of Larry Clark or Eugene Smith seems to me to have more meaning in a book, or at least in portfolio form, which is essentially a kind of book. Many photographers, like Winogrand and Friedlander, work so that it's not one single image that is important, but rather a whole body of work that carries meaning. Then there are other photographers who work like jewelers so that each image stands by itself, on its own. Most of the work I handle is in this latter category.

"I began as a collector while working for another gallery. That was ten or eleven years ago when photograph collecting was the province of a very few people and institutions. Now there are many more people involved. Younger people are buying now just because they love the medium and particular images. The passion for collecting can be stronger even than the passion for making pictures. That is what collecting should be about, rather than about investment."

The Photograph Gallery, New York City

Photograph Gallery opened in February 1981 with two exhibitions of the work of W. Eugene Smith, whose estate the gallery had purchased the previous July. The director, Courtia Worth, was formerly with the Witkin Gallery, as was Bruce Cratsley, the associate director. Although the gallery has since gone out of business, the comments of Bruce Cratsley are appropriate to the way most gallery directors review portfolios and classify photography.

"There are so many photographers with quite good work wanting to exhibit that the galleries must impose barriers," says Cratsley. "We are trying to run a business and we have a very high overhead. We are not a graduate school or a museum, and cannot take as much time as we would like, looking at and commenting on portfolios. A recommendation is very helpful. If a photographer calls me, it

Courtia Worth (left) with Bruce Cratsley (right) in the Photograph Gallery

can be two or three weeks before an appointment can be set up. I try to make special allowances for photographers from out of town.

"I will see up to two portfolios a day and out of that, one or two a month interest me and there is maybe one a month the gallery might wish to become more involved with. Some photographers never do make it in New York, but do quite well selling prints in other parts of the country. They go to art fairs and some make a living in this way. It oftens helps for photographers to exhibit in regional galleries to build up a following and to have their work published in the photography magazines such as *Popular Photography*, *Modern Photography*, *Camera Arts*, *American Photographer*, and so on.

"Generally, people in their twenties or thirties have not yet become nationally or internationally known. The better-known photographers seem to be in their forties and older. The really young we may want to watch for a while. It helps to see work several times before coming to any firm decision about its value to our gallery. There are many things that affect my feeling — it is many different qualities in the picture that makes you say, 'I love this thing!'

"In the last ten years the number of photography-school graduates, many with MFAs in photography, has increased tremendously, though I am not sure this education is necessarily that helpful to a camera artist. An academic tradition in photography, or whatever, can be very inhibiting and create a lot of imitation. I feel that the best photographs are made with the same kind of inspiration that affects the painter or the poet: the work has little to do with fashion or with money. That may come later.

Resources

Art photography can be a lonely profession/hobby/business — like running a marathon footrace in reverse. Diagonally across the country, in Boston and Los Angeles, organizations have been created to provide inspiration and sustenance to photographers. Both groups are supported by membership fees and public and private grants, and in both, much of the work is done by volunteers. Both can be emulated in other cities where there is an active and vital population of photographers.

The *Photographic Resource Center* in Boston was founded in 1976 by Chris Enos, a photographer who sensed the need of photographers for communication and space. After two years' existence in her loft apartment, the PRC found a home on the campus of Boston University and is currently seeking funding for permanent quarters.

Most members of PRC are located in the Boston area, although a broader New England contingent is growing. The backbone of the PRC is information in the form of a monthly newsletter with a calendar of photographic events, gallery listings, exhibitions in progress, lectures, workshops, new publications, news, and advertising. *Views* is PRC's quarterly publication with more in-depth reviews, essays, and reproductions from current gallery shows. The third information component of the PRC is its extensive library of books and periodicals on photography.

The PRC also sponsors a lecture series, films, and workshops conducted by well-known photographers. All of this has generated an active social calendar for PRC members, as well as exhibitions, portfolio review sessions, and informal discussion groups.

Funding for the PRC comes from groups like the National Endowment for the Arts, the Massachusetts Council on the Arts, CETA, the Polaroid Foundation, Bell and Howell, and other photographic corporations.

The *Los Angeles Center for Photographic Studies* started in 1974 and now has over five hundred members, mostly living in or near Los Angeles. The LACPS has a place, a gallery, where exhibitions of members' and nonmembers' photographs are mounted. It is also the place where lectures and workshops are conducted and where a library of photographic books and publications is located.

The LACPS published a monthly newsletter, which evolved into a bimonthly slick magazine called *Obscura*, with critical articles, interviews, book reviews, and reproductions of photographs. Each month, LACPS publishes a calendar of local photographic events, gallery information, competitions, and workshops, as well as brief news. This organization has also published some high-quality catalogs of its gallery exhibitions.

LACPS is supported by membership dues and patron donations entitling supporters to a series of original prints made by local photographers. It has also received funding from the National Endowment for the Arts, the California Arts Council, the Los Angeles Municipal Department, and the Security Pacific Bank.

For more information about these two organizations:

Photographic Resource Center
1019 Commonwealth Avenue
Boston, MA 02215

Los Angeles Center for Photo-
 graphic Studies
814 South Spring Street
Los Angeles, CA 90014

"I generally like to see twenty to thirty images in a portfolio, and all should be good and of equal strength. Often there are two or three good images and the rest are weaker, or there will be such diversity that the impression is very amateurish. It would be better for the photographer to wait and build a strong, cohesive portfolio. It can take a decade or an afternoon; this varies among creative personalities. A portfolio unified in style and content does make a much greater impression.

"Some make limited-edition portfolios, as low an edition as five, but most editions are in the twenty to seventy-five print range. Portfolios work best with sought-after photographers, as there is a fine selection and the per-print price is lower. I think a young photographer is better off working on a single-print basis. A print made and signed by the photographer is important, and if it's a limited edition, this must be carefully marked and careful records kept as the edition sells out.

"We generally take a commission of forty to fifty percent. The average price for a young photographer's work is $150 to $350.

"It used to be that the New York galleries were

feeding shows to the rest of the country, but now there is quite a healthy flow around the country and to and from Canada and Europe. There is a lot of exciting work going on in so many places. Some say there is an East Coast style and a West Coast style, but I don't see that as being clearly defined in any way. The same is true of various 'schools,' such as documentary, marked images, and so forth. I think a lot of the divisions are breaking down. Art is cyclical. The successful photographer, who has something to express and communicate, needs to work from a strong personal vision, and just as important is integrity. Good art is eternal; if not appreciated in one generation, it may be in another. History has set so many examples of this for us. Some artists will always work in near obscurity, like Atget. It is good to remember that only a few in any generation will be tops in their field."

The Odyssey of an Artist

Timothy Greenfield-Sanders is a twenty-nine-year-old photographer whose star is quickly ascending in the photo-art field. He had his first New York show in 1981, which then traveled throughout the country, and he is working on two more shows. He is a portrait photographer who works with an 11 × 14 camera that is three-quarters of a century old. He now lives in New York City in a charming converted rectory that holds his wife, children, studio, and darkroom. In a way, his life is as slow-paced and solidly directed as his old camera and the portraits he produces with it.

"It is an absolute miracle to get into a gallery," says Greenfield-Sanders. "I had no idea how lucky I am. There are about 20 photograph galleries in New York and 150 people might have one-person shows each year. How many photographers are there in New York alone? Maybe 10,000?

"I have a BA in art history from Columbia and went to graduate film school there before I switched to the American Film Institute, where I received an MFA. I lived in Hollywood and made films. I like documentaries, but ended up making Hollywood narrative films and the more I made, the more I didn't like it. I am trained to operate a 35 mm Panavision camera, but working with forty to fifty people is not creative, it is more like factory work.

Timothy Greenfield-Sanders

"When I was filming I also shot still portraits of people working on the film, directors, producers, and actors, and I enjoyed it very much. I used 35 mm Nikons, then went to a Hasselblad and worked my way up.

"A photographer friend of mine, Ira Resnick, had this six-foot-tall Fulmer and Schwing 11 × 14 camera sitting in his living room. It was made in 1905 for copy work and portraits, and I bought it by trading a bookcase, rocker, and adding fifty dollars. It was fitted with a soft-focus, 18-inch Wollensak Verito f/4 lens. It has about a finger length of focus when stopped down to f/11, but I learned to take portraits with it, using strobe light I boxed and bounced. Eventually, I worked out a system that looked natural.

"It takes about ten minutes to take one portrait. The person I photograph has to stand almost motionless for that time period. During this time the subject usually becomes more meditative, more intense, and there is an interesting feeling; it becomes a portrait of the person, not a snapshot." Greenfield-Sanders shoots no more than five sheets of film per subject ($2.50 a sheet) and develops them by hand, ten at a time.

"I moved back to New York from Hollywood, with my family and new camera, and we were lucky enough to find a rectory for sale on the Lower East Side. I set up my studio on the ground floor and began free-lancing to make a living, doing jobs such as portraits for the *SoHo News* and working as a still

photographer on movies being shot in the New York area.

"During this time I was interested in photographing the avant-garde abstract artists of the fifties who formed 'The Club' — Motherwell, de Kooning, Sanders, Vincente, Mitchell, Resnick." Greenfield-Sanders enticed forty of the original group to pose in his studio for his seventy-five-year-old camera. The portraits, as 11 × 14 contacts, have a startling timeless quality to them, a perspective of age, history, and directness, reminiscent of Nadar's work. "The camera's lens has a certain quality and I have a certain style. I like to photograph older people and all these people were very important who evolved one of the most original and influential movements of art in the twentieth century.

"I had an idea in the back of my head that someday I would have a show of the material, but I hadn't really thought about it until I photographed the poet Mark Strand. He saw six of my big portraits and immediately used my phone to call a friend of his, Marcuse Pfeifer, and told her that she must see these portraits of the Abstract Expressionists for a possible show in her Madison Avenue gallery.

"The show opened March 21 and traveled to nine museums. The photographs sold at $400 each and were bought by museums in several countries, and by private collectors. Right now I am earning fifty-fifty: commercial work and through the galleries. I would like to do more gallery work. My house is the key. I don't need a lot of money to pay for a studio and this house almost pays for itself. I have my big camera downstairs and my life has slowed down. The camera makes it that way.

"I now have another series to do on critics in art, film, literature, food, dance, and so forth, and I am going to do a series on photographers. Van der Zee is my first subject."

Hidden in Greenfield-Sanders's basement is a 20 × 24 process camera. He will move up in size when he gets bored with 11 × 14 contact prints.

A Manifesto for Art Photography

by Bill Jay

Following are excerpts of a lecture given by Bill Jay at the Newport Art Gallery, Newport, Gwent (Wales), under the aegis of the Documentary Photography Course at Gwent College of Higher Education. Jay, associate professor of art history at Arizona State University, was, before leaving Wales for the United States in 1972, a significant catalyst in the resurgence of photographic fine art and published the fine magazine Album.

I have a strong feeling that European photographers have appropriated the myth of the Western hero and share its ideals with the Americans. Photography in the United States seems so wide open in its possibilities, so daring in its enterprises, so free in its potentials, and so heroic in its achievements. And it is true that a good deal of photographic activity in America has reached a status and public acceptance that is the envy of photographers in other countries. The achievements, and there have been many, have been hard-won by committed individuals in the Western mold.

But the costs have been high.

Most of the problems inherent in American photography stem from exactly the same source that has provided so many assets: the acceptance of photography as fine art.

Prod any beginning student carrying a camera on any American campus and the response will be "I am an artist." I had always thought the term "artist" was like a distinguished award bestowed by the individual's peers after a lifetime of struggle with a medium. It seemed scandalously arrogant if not downright stupid for the student to proclaim himself an artist, particularly as he was having trouble loading a camera.

So, no longer is the student striving with photography as a long-term goal for the revealing and communicating of a personal life-attitude; he is proclaiming a present state of mind. In declaring "I am an artist," the person is its meaning. And the meaning of the word *artist* carries with it an immense number of connotations that are manifested in living style, speech patterns, appearance of images, and career goals. When a young American photographer states "I am an artist," the implications of the words have no reference to history, to a thousand-year tradition of value-seeking and -sharing, to a striving transcendent view of life. They are here-and-now adoptions, grabbed in passing from a ragbag of notions and fallacious assumptions about what an artist is and does. Of course, they can be as quickly jettisoned as they are adopted. A student sees no discrepancy in being an artist one week and a business major the next. Being an artist is tuning into one TV channel: if it is not instantly rewarding, amusing, or profitable, then it is simple enough to instantly switch channels.

I am not being facetious. The young photographer's notions of what is worth doing are drawn from the immediate cultural *zeitgeist*. And since the

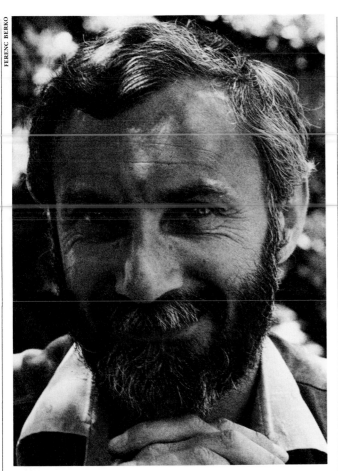

FERENC BERKO

Bill Jay

culture (not only in America, but in all Western societies) is sick, so are the arts, and that includes photography. When the culture promotes banality under the guise of significance, anxiety as a sales aid, and instant gratification in place of striving toward long-term goals, then human values are lost. And without values art itself is lost.

Much of contemporary American photography is concerned with petty subjectivity, the glorification of the banal, the lauding of the trivia of everydayness, and for these reasons is lifeless and meaningless.

This is the central point. The failure of contemporary photography is a failure of the human spirit. The photographer is defeated, swamped with trivia, and merely a passive reflector of cultural norms. Petty personal problems are the compositions of his or her concerns and therefore the real subject of his or her imagery. When life fails, the effectiveness of the photographer's art also fails.

I have no objection to photography being employed as a fine arts medium. I do object to the limits or parameters of the photographic medium being defined by art notions alone. If the spectrum of photography is as long and as broad as the room, the art of photography occupies a space as small as this chair. Yet students are encouraged to believe that this small area defines the medium.

More devastating, they are led to believe that other areas of photography, such as photojournalism, portraiture, landscape, and other professional pursuits, are less valid, important, serious, or significant. Again, I would emphasize that this attitude is implied by neglect of nonart aspects of the medium rather than by any open antagonism. It is useless to point out that most of the masters of art photography whom the students revere (Brandt, Atget, Evans, and many others) were primarily professional photographers.

Art and Criticism

One of the most serious abuses of the art-attitude in American photography is the obfuscation of ideas, issues, and meanings. The meaning (and I presume there is one) is so encoded with complexity piled upon sheer perversity that no viewer has any hope of understanding it. If the viewer is audacious enough to ask for clues as an aid in decoding, the "artist" is affronted, as if everyone must be desperately interested in and minutely aware of every tiny tinkle in his or her mental machinery. I am convinced that the work that does not communicate has nothing to say and that there is, therefore, no meaning to be derived from a picture that might be stylistically brilliant but is intellectually dead.

Much critical writing not only reflects this obtuseness but feeds it with the correct veneer of art-jargon, which sustains the photographer for another spurt of nonsense, which is then lauded by the critic, which is gobbled up by the artist's ego, which is then . . . and so on, *ad absurdum*.

I have a file full of photogobbledygook culled from the pages of photographic and art journals. The sheer quantity of quotes attests to the fact that verbal perversity is spreading through the medium like a cancer in the body photographic.

A good example of this type of *post-factum* justi-

fication for photographers occurred in the last graduate reviews of the university where I teach. A student had driven into the desert with a large format camera and had brought back about six prints of trash half-buried in sand. This was his fifteen-week production, and looked as if it had been (and probably was) shot in an afternoon. The pictures were indescribably boring. The other photography faculty members could not think of anything to say — until the student was asked, "What do they mean?" His brow furrowed in seriousness as he said, "Well, you see, they are explorations of ritual in charged spaces." At this, the faculty members perked up. This sort of language they could deal with.

I play a game at lectures and critiques — it is called, collect clichés. A few of the more common of the species picked up in the past few months include the following justifications for uniformly boring, bad photographs:

"I'm exploring the edges of the frame."

"I'm opposing the tyranny of the rectangle." (For any picture not rectangular.)

"It's about time and space." (What is not?)

"I'm redefining light." (Indeed!)

"I'm working with the tension between time/space /light/edges of the frame/form/content/process, etc." (Pick any two to complete the sentence.)

"You don't understand — it is a meta-paradigm." (*Meta-*, in front of anything, is big right now.)

"I feel an empathy with that line."

It is very important for young photographers to learn these acceptable phrases in order to be fully paid-up members of the art-photography fraternity. It often seems to me that the prime purpose of education is to teach this language, because it will elevate any piece of mediocrity into Art.

Art and Money

A major result of photography entering the Temple of Fine Art is that the money changers are there and waiting. There is no way that this, in itself, can be argued as unseemly or unjust. It is about time that photographers were adequately rewarded for what they do best. But the old adage "The laborer is worthy of his hire" can also be read as "The hire should be in proportion to the worth of the laborer." As we all know, that is not necessarily true in art

photography. The rewards — by which I mean gallery sales, museum exhibitions, grants, and so on — are not necessarily for the best or the most productive.

Only a generation ago, very few markets existed for a photographer's personal work, especially if it had aspirations to art as opposed to social functionalism. In this context, the photographers themselves, by a consensus of opinion, slowly recognized the individuals who deserved reputations. The appreciation of their peers may not have been very useful (as someone said, "You can't eat praises"), but at least it led to the likelihood that the right individuals were marked out for special attention. It also meant that these reputations did not spring into the medium full-blown; there was a natural, long-term growth and a "paying of dues," in the sense that a consistently high standard of work had to be maintained over many years, before the individual received recognition.

This is not true any longer. Today, the tastemakers in art photography have switched from the photographers themselves to the gallery directors. This is unfortunate in several respects: (1) the gallery director is usually someone who has entered the medium from a fine arts background, and therefore expects photographs to look like work in another medium; (2) the gallery is in business to make money and therefore the criterion of selection is based more on sales appeal than on merit; (3) the photographer who wishes to sell his or her work is under enormous pressure to make prints that conform to the current selling trends and to the notions of what an art photograph should look like; (4) because "differentness" is a sales asset, there is a rapid turnover of name-photographers and a bewilderingly large number of short-lived stylistic bandwagons.

I do not know a single gallery director or museum curator who is a renowned photographer. In addition, time after time, I have heard a gallery director say to a photographer: "It's fine work but unsalable."

I am not suggesting that art galleries show only fine but unsalable photographs. I am suggesting that because money is the criterion of selection we should understand that galleries can never be the arbiters of merit or makers of reputations. Yet that is precisely what has happened in the United States:

the galleries have taken, or been given, the major role in determining quality. That is what is so alarming.

Unfortunately, galleries are so often flattered by sycophantic hustlers that they have adopted the role of tastemakers — determining merit, pronouncing on aesthetics, bestowing gifts of patronage to a chosen few, even writing essays on the true role of photography and books on the medium's history. The directors obviously believe they were specially chosen to direct the future of the medium, as well as gallery sales.

A New Direction

Photography in America is wide open in its possibilities, free in its potentials, heroic in its achievements, and generous in its recognition and rewards to photographers. While these achievements have been won at a high cost, some of the more destructive problems along the way can be corrected. If I was the absolute dictator of photography I would issue the following edicts:

1. The declaration "I am an artist" will be barred from photography. The penalty for use will be scorn and derision by the offender's peers.

2. No photographic group will be allowed to form under any stylistic, sexual, religious, political, artistic, or professional manifesto without at least 50 percent of the membership comprising a mixture of all other persuasions, and at least 50 percent of those representing the antithetical point of view.

3. It would be asserted that standards of quality do exist in photography. These would not be defined, but it would be understood that they are so high that no photographer can reach them without at least ten years of committed hard work.

4. In pursuit of (3), no young photographer will be given a grant, fellowship, or exhibition unless he or she has demonstrated such commitment to the satisfaction of the older generation of photographers for the same amount of time.

5. No photographic journal will be allowed to publish any critical essay that panders to the current fad of unintelligible psycho-babble and that masquerades in the guise of intellectual criticism. No idea will be expressed that is not communicable to the average photographer. The criticism must be constructive and useful.

6. Photographic artists will not be allowed to justify mediocre work by after-the-fact clichés. Quotations by photographers who talk about "redefining space" and similar nonsense will be publicly posted for the amusement of the photographic fraternity.

7. There will be no professional curators or museum directors. Each year the selection of major exhibitions and the purchase of prints for a permanent collection will be made by a photographer who has achieved special status, in any area, among his or her peers. For this year of service to the medium the photographer will be more than amply compensated.

8. The directors of galleries where prints are sold will have the same status as tradesmen in any other field, for example, a bookseller as compared to an author. A commercial gallery director will not be an arbiter of quality and will not therefore sit on grants committees, advise curators, or write and teach about the medium. The distinction between money and art will be made clear.

9. The role of the educator will be to expand the potentials of the student, not limit them by a preconceived dogma. The student will be encouraged to become actually what he or she is potentially. This will demand that the teacher be prepared to leave personal prejudices at home and see his or her purpose as offering the widest possible range of alternatives. The maximum time a person can be a full-time teacher is four years; otherwise he or she must be a continuously practicing photographer while teaching.

10. The final commandment is the most important. Photography is a means to an end; it is not the end in itself. Photographers will be inculcated with a value system that recognizes personal ideals and that asserts that the true nature of all human activity is the aspiration and striving toward Beauty, Goodness, and Truth.